D0290588

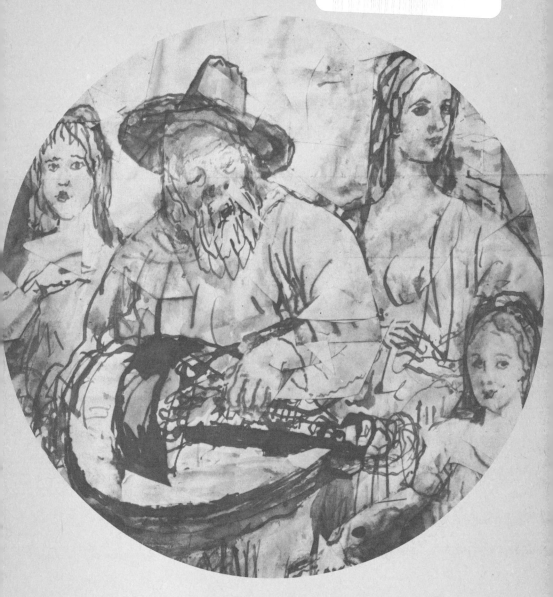

Augustus John

A Biography

Volume II
The Years of Experience

BOOKS BY MICHAEL HOLROYD

Hugh Kingsmill: A Critical Biography
Lytton Strachey: A Critical Biography (2 vols)
Lytton Strachey by Himself (edited by Michael Holroyd)
The Best of Hugh Kingsmill (edited by Michael Holroyd)
Unreceived Opinions (essays)
Lytton Strachey: A Biography
Lytton Strachey and the Bloomsbury Group (criticism)
Augustus John: A Biography (2 vols)

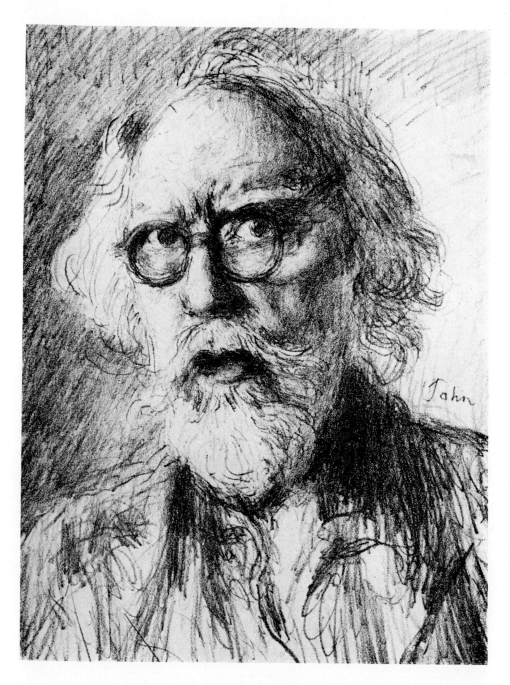

Augustus John. Self-portrait, July 1955

William Heinemann Ltd
15 Queen Street, Mayfair, London W1X 8BE

LONDON MELBOURNE TORONTO
JOHANNESBURG AUCKLAND

First published 1975
© Michael Holroyd, 1975

SBN: 434 34580 6

Printed in Great Britain
by W & J Mackay Limited, Chatham

AUGUSTUS JOHN

A BIOGRAPHY
by
MICHAEL HOLROYD

VOLUME II

The Years of Experience

*'Moral sentiment corrupts the young. Children are th
to lose their innocence, artists the second: idiots never.'*

(Augustus John. *Chiaros*

HEINEMANN : LONDON

67775

Contents

Illustrations

Acknowledgements

This biography, which was first authorized by Dorelia John, has been made possible by her son and daughters, and by the children of Ida John. From them I received very many letters, photographs and other documents; and much information. Admiral of the Fleet Sir Caspar John and Mr Romilly John, as Dorelia's executors and representatives of the family, have checked my book for facts; but neither of them are responsible for its presentation or opinions. I would like to exonerate and express my thanks to them and to all the family.

I must also record my indebtedness to the many people who in one way or another have helped me: Sir Robert Abdy, the late Lady Aberconway, Sir Harold Acton, Mr Reginald A. Addyer-Scott, the late Lady Adeane, Mr Noel Adeney, Mr Hubert Alexander, Mrs Marcia Allentuck, Mr Antony Alpers, Mr Gordon Anderson, Lord Annan, the late Boris Anrep, Lord Antrim, the late Simon Asquith, Mrs M. V. Atkinson, Dr Ronald Ayling, Mr and Mrs Michael Ayrton, Mrs Nora Back, Mrs Barbara Bagenal, Mr Raymond Bantock, Dr Wendy Baron, Mr Douglas Bartrum, Miss Diana Batchelor, Mr Howard Batchelor, Mr Ernest Bateman, Mr David Batterham, Mr Adrian Beach, Sir Cecil Beaton, Mr F. N. Beaufort-Palmer, Professor Karl Beckson, Professor Quentin Bell, the late Count William de Belleroche, Miss Miriam J. Benkovitz, Mr Anthony Wedgwood Benn, Mr Villiers Bergne, Mr Sven Berlin, Mrs Martin Birkbeck, Mrs Deirdre Bland, Miss Philippa Bone, Miss E. J. Boyte, Mr Laurence Bradbury, Mr Gerald Brenan, the Hon. Miss Dorothy Brett, Mrs Robin Brook, Mr Humphrey Brooke, Miss Lillian Browse, Mr Thomas B. Brumbaugh, Mr Russell Bryant, Mr Richard Buckle, Mr John M. Bunting, Mr Tom Burns, Miss Lynn Bushell, Mr Arthur Byron, Mr Arthur Calder-Marshall, Mr David Campbell, Mrs Roy Campbell, Mr Richard Carline, Mr Noel Carrington, Miss Juanita Casey, Mrs Thelma Cazalet-Keir, Lord David Cecil, Mr George Charlton, Miss Josephine Cheeseman, Lord Clark, Mrs Deirdre Clarke, Lady Clarke Hall, Mr Cyril Clemens, Mrs Madeline Clifton, Mrs Betty Cobb, Commander Kenneth Cohen, Mr and Mrs Tristan de Vere Cole, the late Maurice Collis, the late Tony Commerford, Mrs Jane Connard, Mr Cyril Connolly, Mrs Thomas F. Conroy, Mrs Hope Consett, Mrs Diana Cooke, Mrs Sally Cooke-Smith, Mr Egerton Cooper, Lord Cottesloe, Mrs Andrea Cowdin, Mr John Craigie, Lord Croft, Mrs

Anthony Crossley, Mrs Violet Crowther, Sir Michael Culme-Seymour, Mr Adrian Daintrey, Mr and Mrs Theo Dampney, Father Martin D'Arcy S.J., Mr Rhys Davies, Mr Terence Davis, Mr Guy Deghy, Miss Nicolette Devas, Mr Anthony d'Offay, Mr C. W. K. Donaldson, Mrs James Dowdall, Lord and Lady Drogheda, Mrs Honor Drysdale, Miss Janet Dunbar, Sir Philip and Lady Mary Dunn, Dr Malcolm Easton, Mrs Mary Edwards, Mrs Bettina Ehrlich, Mr Malcolm Elwin, Professor William Empson, Lady Kathleen Epstein, Mrs Rosemary Everett, Mr Dennis Farr, Mrs Margaret Morris Fergusson, Mrs Xan Fielding, Mr and Mrs Harry Fisher, Lady Fisher, Mr Constantine FitzGibbon, Miss Amaryllis Fleming, Mr Richard Fleming, Mr Brinsley Ford, Mr Malcolm Foster, the late Mrs Jeanne Robert Foster, Mrs Jane P. Fothergill, Mr Thomas Fox Pitt, the Rt Hon. John Freeman, Mr Peter Fullar, Dr George Furlong, the late Tony Gandarillas, Mr David Garnett, Mr Jonathan Gathorne-Hardy, Mr William Gaunt, Mr Elmer Gertz, Mr Peter Gibson, Mr Brendan Gill, Mr Douglas Glass, Mr Mark Glazebrook, Senator Oliver D. Gogarty, Mr J. W. Goodison, Lord Adam Gordon, Mrs Constance Graham, Mr Duncan Grant, Mr Robert Graves, Miss Mair Griffiths, Mrs Pamela Grove, Mrs Suzanne Guinness, Mr Peter Gunn, Mr Philip Guy, Mr Allan Gwynne-Jones, Mrs Joan Haig, Miss Kathleen Hale, Mrs Cynthia Hall, Mrs Karin Hall, Mr Robert Halsband, Mrs Doreen Hammersley, Mr Charles Hampton, Mr James Hanley, Mr Peter Harris, the late Sir Basil Liddell Hart, Mrs Maria Harrison, Mr Wilfred Harrison, Mr Duff Hart-Davis, Mr Edward Harvane, the late Ethel Hatch, the late Alfred Hayward, Lady Dorothea Head, Miss Fiore de Henriques, Mrs Vivien Henriques, Mr Norman Hepple, Miss Zoe Hicks, Mr Brian Hill, Mr Bevis Hillier, the late Inez Holden, Mrs Didy Holland-Martin, Mr and Mrs Ensor Holliday, Mr Mark Holloway, Miss Diana Holman-Hunt, Mrs Nicandra Hood, Lieutenant-Colonel W. V. Hope-Johnstone, Mr Felix Hope-Nicholson, Mrs Jean Hornack, Mrs Cecily Hornby, Lady Howard de Walden, the late Irene Huddleston Mr Derek Hudson, Mr Richard Hughes, Mrs Patricia Huskinson, Mr Ferdinand G. Huth, Mrs St John Hutchinson, Mr Sidney C. Hutchison, Mr Daniel Huws, Mr H. Montgomery Hyde, Professor Samuel Hynes, Mr Derek Jackson, Mr G. Douglas James, Mr Darsie Japp, Mr I. E. Tregarthen Jenkin, Mrs Margaret Jennings, Mrs Betty Jewson, Miss Sandra Jobson, Mrs Betty John, Miss Rebecca John, Miss Sara John, Miss Gwyneth Johnstone, Dr R. Brinley Jones, Mr David Jones, Mr J. E. Jones, Miss Josette Jones, Mr O. Jones-Lloyd, Mr E. D. Kamm, Mrs Mary Keene, the late Paul Keiffer, the late Sir Gerald Kelly, Mr John Kelly, Mr Jascha Kessler, Mrs Anita Leslie King, Mrs William King, the late Eve Kirk, the late Dame Laura Knight, Mrs Oscar Kokoschka, Mr Henry R. Labouisse, Mrs Mary M. Lago, Lady Pansy Lamb, Mr

George Lambourn, Mr Dan H. Laurence, Mrs Julia Chanler Laurin, Mr James Laver, Professor A. W. Lawrence, Mr Bernard Leach, Miss Kate Lechmere, Mr Cliff Lee, Miss Rosamond Lehmann, Mr Robert Lescher, Mr Seymour Leslie, Mrs Juliette de Baivacli Levy, Mr Paul Levy, Mrs Margaret Lewthwaite, Mr Dwight N. Lindley, the late Countess Lloyd-George, Mr Stanley Loomis, Mrs Violet Lort-Phillips, Mr John Lumley, Miss Moira Lynd, Mr David Machin, Mrs René MacColl, the late Compton Mackenzie, the late Yvonne Macnamara, Mrs Mary Mailes, Mrs Mary Manson, Miss Penny Marcus, Miss Miriam Margolyes, Mrs Brigit Marnier, Mrs Dorothy Marston, the Hon. Mrs Marten, Mr George Matthews, Mrs Murial Matthews, the late Lady Mayer, the late F. H. Mayor, Mr Alastair McAlpine, Mr Alexander K. McLanahan, the late Frances McLanahan, Mr Ruari McLean, Mr Tony Measham, Gwen Lady Melchett, Mrs Yvonne Meo, Miss Alice Methfessel, Mr Walter Michel, Mr Dillwyn Miles, Miss Mollie Mitchell-Smith, Mrs Curtis Moffat, Mr and Mrs Alan Moorehead, Mrs Peggy Morgan, Mr A. M. Morley, Mr Richard Morphet, Lady Diana Mosley, Lord Moyne, Mr Rodrigo Moyniham, Mr Malcolm Muggeridge, Mr Frank Muir, Dr A. N. L. Munby, Miss Winifred A. Myers, Mrs Ulla Nares, Mr John Nash, Mr Benedict Nicolson, Miss Lucy Norton, Mr Breon O'Casey, Mrs Sean O'Casey, Mr Ulick O'Connor, Mrs S. J. Olivier, Mr Stanley Olson, Miss Iris Origo, Mr Roderic Owen, the late Arnold Palmer, Mrs Ralph Partridge, Miss M. Patch, Mr Michael Orr Paterson, Professor Norman Holmes Pearson, Mr Anthony Penny, Mr Bernard Penrose, Mrs Jessie Petrie, Mr Wogan Philipps, Mrs Eric Phillips, Professor Stuart Piggott, the late Reine Pitman, Miss Phyllis Playter, Mr Tom Pocock, Lady Polwarth, the late Hugh Pooley, the late Michaela Pooley, the late Lord Portal, Mr Reginald Pound, Mr Anthony Powell, Mrs Christopher Powell, Mrs Philippa Pullar, Miss Diana Pullein-Thompson, Mr Peter Quennell, Mr George Rainbird, Mrs Monica Rawlings, Mr Herbert Rees, Mr Dominic Reeve, Professor Ben L. Reid, Sir Paul Reilly, Mr Kenneth Rendall, Mr Peter Rhodes, Mr William Rider-Rider, Mr Vivian Ridler, Mr Ivor Roberts-Jones, Mrs Primrose Roper, Professor Pat Rosenbaum, Mr Anthony Rota, Sir John Rothenstein, the late E. J. Rousuck, Mr Eric Rowan, Dr A. L. Rowse, Mr Hilary Rubinstein, Mrs J. J. Rudder, the late Leonard Russell, the late Lord Russell, Mr David Rutherston, the late Louise Salaman, the late Michel Salaman, Mr Raphael Salaman, Mr Anthony Sampson, Mr Guy Rayne Savage, Mr Arnold T. Schwab, Mrs Randolphe Schwabe, Dr Clifford Scott, Mrs Martin Shaw, Mr Dale Shute, Sir Sacheverell Sitwell, Mr Adrian Slade, Mr Christopher Slade, Mr F. W. Slade, Mrs Lilian M. Slade, Mr Richard H. W. Smart, Professor Grover Smith, Mr W. Roger Smith, Mr Ben Sonnenberg Snr., Mr

Robert Speaight, Mr Gilbert Spencer, Mr Stephen Spender, Professor
Walter Starkie, Mrs Sally Stephen, Mr James Stern, Miss Julia Strachey,
Mrs Jenny Stratford, Mrs Valerie Stewart, Viscount Stuart of Findhorn,
Mrs John O. Stubbs, the late Gerald Summers, Mrs Holman Sutcliffe,
Mr John Symonds, Mrs Mary Taubman, Professor A. J. P. Taylor, the
late Mrs Teltsch, Sir Charles Tennyson, Mrs Dylan Thomas, the late
J. F. Thomas, Mr Lately Thomas, Mr W. A. Thomas, Mr A. R.
Thomson, Mr Ruthven Todd, the late Dudley Tooth, Mr Felix Topolski,
Mrs Theodosia Townshend, Mr Christopher Turton, the late Jean
Varda, Mrs Ithiel Vaughan-Poppy, Miss Gillian Vincent, Mrs Igor
Vinogradoff, Miss Pauline Vogelpoel, Mr R. V. Walling, Mr G. A.
Walters, Mrs Rachel Ward, Mrs Sheilah Wardrop, Mr Nicholas Watkins,
the Viscountess Waverly, Mr W. J. Weatherby, Mr James M. Wells,
Lady Wharton, the late Sir Charles Wheeler, Sir Mortimer Wheeler, Mr
Henry Williamson, Mr John Wilson, Mr Clough Williams-Ellis, Miss
Jane With, Mr John Woodeson, Mrs Oliver Wood, Mr J. H. Woods, the
Rt. Rev. K. J. Woollcombe, Mr John Worsley, the late Dora E. Yates,
Mr Michael Yeats, Mr H. W. Yoxall.

I have also received help from the Allbright-Knox Art Gallery,
American Archives of Art, *Apollo Magazine*, Arts Council of Great
Britain, Beaverbrook Library, Bodleian Library (Department of
Western Manuscripts), British Broadcasting Corporation, the British
Museum, Buffalo and Erie County Historical Society, *Burlington Maga-
zine*, the University of California, Jonathan Cape Ltd., the Carnegie
Institute, P. and D. Colnaghi and Co., Ltd., Contemporary Art Society,
Cornell University Library, Dalhousie University Art Gallery, Dorset
Natural History and Archeological Society, Fitzwilliam Museum Cam-
bridge, the University of Glasgow, Gypsy Lore Society, Harlech Tele-
vision, David Higham Associates Ltd., Historical Manuscripts Com-
mission, the Houghton Library, Cambridge, Mass., the Henry E.
Huntington Library, University of Illinois, the Imperial War Museum,
Kensington and Chelsea Public Libraries, King's College Cambridge,
Kingston Galleries Inc., the Law Society Services Ltd., Liverpool City
Libraries, Lloyds Bank Ltd., Martins Bank Trust Company Ltd.,
McMaster University, Ministère de la Défense Nationale, Canada, the
Morris Library Southern Illinois, National Book League, National
Gallery London, National Portrait Gallery London, the Newberry
Library, the New York Public Library (Manuscript Division; Berg
Collection), New York University Libraries, the Pembrokeshire Country-
side Unit, Pembrokeshire Local History Society, Pembrokeshire
Record Office, Public Record Office, General Register Office, Musée
Rodin, Royal Academy of Arts, Royal College of Surgeons, Slade
School of Fine Art, Sterling Memorial Library Yale University, the

Strachey Trust, Tate Gallery, Texas University Library, State Library of Victoria, National Library of Wales, National Museum of Wales, University of Wales, Widener Library Cambridge Mass., R. T. P. Williams and Sons, Haverfordwest.

I am grateful to Mr Rex De C. Nan Kivell for permission to quote from the unpublished letters of Christopher Wood.

Poor soul, the centre of my sinful earth,
Fool'd by these rebel powers that thee array,
Why dost thou pine within and suffer dearth,
Painting thy outward walls so costly gay?

 Shakespeare, Sonnet CXLVI.

———————————————

And if I drink oblivion of a day,
So shorten I the stature of my soul.

 Meredith, *Modern Love.*

———————————————

TO
THOSE WHO SUFFERED
BECAUSE OF THIS BOOK

Before the Deluge

'I saw in Augustus and Dorelia two of that rare sort of people, suggestive of ancient or primitive times, whose point lay rather in what they were than in what they said or did. I felt that they would have been more at home drinking wine under an olive tree or sitting in a smoky mountain cave than planted in this tepid English scene. But at least they were bohemians and kept up with style and lavish hospitality the old tradition of artistic life that had come down from William Morris and Rossetti. This I thought was important . . .'

Gerald Brenan. *A Life of One's Own*

1. A SUMMER OF POETRY

That summer of 1911 was oppressively hot. The heathlands of the Wimborne Estate were turning brown, and from time to time fires would break out sending columns of smoke far up into the blue skies.

The carts and wagons, with their wildly singing children, rattled past miles of dry gorse, pines and irregular groups of Scotch firs motionless in the sun. Then, swerving off the narrow road, they entered a drive lined, like a green tunnel, with rhododendrons tall as trees. They turned left; and there, before them, lay a curious low pink building, an elongated bungalow with Gothick windows and a fantastic castellated parapet: Alderney Manor.

It looked, at first sight, like a cardboard castle from some Hans Andersen story – a fragile fortress, strangely misplaced, which an army of toy soldiers might suddenly emerge from, a puff of wind knock flat. The smooth stucco surface, once a proud red, had faded leaving patches here and there of the cardboard colour. With its single row of windows pointing loftily nowhere, the house seemed to be smiling, full of teeth, as if embarrassed by its own absurdity. 'But its poetry even outdid its absurdity. . . . There was something fantastic and stunning about it.'[317]

Alderney was to be the Johns' home for sixteen years. Like Fryern Court, into which they moved afterwards, it became Dorelia's creation and the most eloquent expression of her personality. The rich colours – yellows, browns and mauves – the arrangements of flowers everywhere lighting up the rooms, the delicious meals – huge soups, stews and casseroles with rough red wine, and Provençal salads with plenty of garlic, tomatoes and olive oil – the wood fires filling the air with their fragrance, contributed to a pagan love of the beautiful. They were not tidy places, these houses. A happy disorder embellished the scene – Lord

David Cecil remembers leaving his hat on the floor one evening, and returning six weeks later to find it undisturbed. Nor was the régime formal: guests were seldom introduced to one another and might be confronted on arrival by an animal silence from the whole John pack. Sometimes, having accepted a pressing invitation, visitors would turn up to find no one in the house at all, though all doors and windows lay open as if everyone had just vanished through them. When the Spencer brothers, Gilbert and Stanley, came to stay

'we found the children frightening. At bed time everyone seemed to fade away but no one attempted to "show us to our bedrooms" until we decided that you slept as you fell but took the precaution of falling on odd pieces of furniture which made things easier . . . Requiring a lavatory I decided to seek one unaided. Having no luck I opened the front door very quietly and crept out into the darkness. Dorelia went into another room and noticing a bowl of dead flowers, opened a window and flung them out smack into my lap.'[318]

Yet the atmosphere had a magic quality that cast its spell on almost everybody. 'The life, the atmosphere, the freedom, the presiding figures were all unique and irresistible,' wrote Romilly John:[319] 'it was like a royal household in the heroic age, at once grand and simple'. For many it became a place to run away to, a place where someone, calling for tea, might stay a week, a month, even a year. These guests perpetually filled Alderney, overflowing into the blue and yellow caravans and the 'cottage' – a mellow red-brick building, actually larger than the 'Manor', standing invisible a hundred yards off behind a range of rhododendrons. 'This intervening vegetation made comings and goings difficult on wintry nights,' Romilly recalled: 'those unfamiliar with the route would bid a cheerful good night to the house-dwellers, launch out into the dark, and presently find themselves struggling amid a wilderness of snaky boughs.'

At one end of Alderney was the dining-room with its long oak table and, on one side behind the benches, a row of windows through which, at mealtimes, the horses would poke their heads, and doze. At the other end, looking on to beech trees, towards the orchard and the walk to the sand-pit, was the kitchen. In between lay the bedrooms, and below the capacious cellars.

The kitchen, noisy with helpers, full of the savour of bubbling stock, crusty bread baking in the oven, was ruled over by Dorelia's sister Edie. Small, with very dark hair, a mixture of black and brown; large brooding eyes, their upper lids curiously straight giving them a strange rectangular shape; a mouth rather prominent, curving downwards: Edie's expression was sardonic yet vulnerable – an index of her life to

come. Into her care were given the youngest children and much of the cooking.

By helping to run things inside the house, Edie enabled Dorelia to devote herself more to the gardens. Under her management, Alderney became an almost self-supporting community, flowing with milk and honey. Her first venture was, appropriately, an Alderney cow which gave them colossal quantities of cream so rich it had the taste of caramel. This cow was soon followed by 'a large black beast called Gipsy, an adept in the art of opening gates and leading off the increasing herd to unimagined spots in the remote distance,'[320] to which a team of children would be sent off to shepherd them home. The children were also trained to help Dorelia milk the herd, to skim the milk, and – an eternal task – make the butter with a hand-operated churn.

To the cows, at one time or another, were added, less successfully, a dovecote of pigeons (which all flew away); and, briefly, a 'biteful' monkey; then an entire breeding herd of pedigree saddle-back pigs; various donkeys, New Forest ponies and cart-horses, all with names; miscellaneous groups of dogs and, among the teacups, endless cats – Siamese, white, tabby and black – which bore unheard-of relationships to one another. Finally came twelve hives of dangerous bees that stung everyone abominably.

'People who were staying at Alderney would come and watch the operations from a distance, whereupon a detachment of bees made a bee-line for them, alighting on their noses and cheeks and in their hair, which would cause them to rush round and round the field beating their heads like madmen. The next day everybody would present an extraordinary and uncharacteristic appearance. People who had usually long solemn faces would appear with perfectly round ones, and a perpetual clownish smile. Eyes would vanish altogether, and once or twice the victims retired to bed with swollen tongues, convinced . . . they would be choked to death. . . . At last we resorted to a couple of old tennis racquets. . . . Anybody at a little distance might have imagined that we were playing some very intricate kind of tennis, with special rules and invisible balls.'[321]

In all things Dorelia seemed to rely on instinct rather than planning. She invented as she went along, and although there were occasional disasters, she seemed to have an innate gift for knowing what was right. 'With an air of complete ease and leisure, without hurrying or raising her voice, her long pre-Raphaelite robes trailing behind her as she moved, she ran this lively house, cooked for this large family and their visitors, yet always appeared to have time on her hands,' wrote Gerald Brenan.[322] '. . . I remember her best as she sat at the head of the long

dining-table, resting her large, expressive eyes with their clear whites on the children and visitors and bringing an order and beauty into the scene.' She seemed perfectly at one with her surroundings, and from them to derive a natural co-ordination, the faculty for effortless action compared with which others appeared bustling and vociferous. Nature and human nature, garden and house were perfectly combined. The windows at Alderney stood open, and into the house flowed the produce of Dorelia's 'home farm' – piles of fresh vegetables from the kitchen gardens; blue and brown jugs of milk and cream; jars of home-made mead tasting like a light white wine; the honey and the butter; lavender in the coarse linen – and everywhere a profusion of flowers.

Flowers she loved. Almost every kind of tree and shrub flourished at Alderney with an abnormal vigour: ilex and pine, apple and cherry and chestnut, pink and white clematis, old-fashioned roses. The circular walled-in garden with its crescent-shaped flower-beds over which simmered the bees and butterflies became an enchanted place. 'The peculiar charm of that garden was its half-wild appearance,' wrote Romilly John:[323]

'The grass was seldom as closely shaven as orthodoxy demands, and great masses of lavender and other smelling plants sprawled outwards from the concentric beds, until in some places the pathways were almost concealed. Tangled masses of roses and clematis heaved up into the air, or hung droopingly from the wall. The pond in the middle became hidden by the high screen of flowering vegetation. . . . In summer the composite smell of innumerable flowers hung upon the still air. The wall was overtopped most of the way by a thick hedge formed by the laurels that grew outside, and a eucalyptus, which had escaped the frosts of several winters, lifted high into the air its graceful and silvery spire.'

Dorelia's influence extended far beyond the walls of this garden, affecting many she never met. For three decades her taste in clothes became the fashion among art-students. She ignored the genteel manners and sophisticated fashions of London and Paris, and the brash styles that succeeded them. Her style was peculiar to herself and no one could carry it off with such hypnotic dignity.* She was a skilled dress-

* 'To have known Dorelia was the most important experience of my whole life,' Kathleen Hale wrote to the author. 'She was the most beautiful woman I have ever seen . . . I remember one Christmas at Alderney, when all the decorations were fixed and everything set for the fun and sing-song, the last to arrive was Dorelia. She appeared on the top step of the room in a white woollen gown, her dark hair looped and braided as always, but so different to the arty hair-do's of the artistic set. Her warm brown skin glowed in the whiteness of her softly gathered white bodice. Translucent green earrings dangled from her ears – they may have been only of glass

maker. From cotton velveteen or shantung in bright dyes and shimmering surfaces; from unusual prints, often Indian or Mediterranean in origin, she evolved clothes that followed the movement of the body, timelessly, like classic draperies. Her long flowing dresses that reached the ground, with their high waistline and long sleeves topped by a broad-brimmed straw hat, its sweeping line like those of the French peasants, became a uniform adopted by nearly all the girls at art colleges, and a symbol, in their metropolitan surroundings, of an unsevered connection with country things, with the very substance of the country.

For the boys she also invented a costume which, with its long-belted smock over corduroy trousers, together with their bobbed hair, gave them the appearance of fierce dolls. 'Our hair was long and golden,' Romilly remembered,[324] 'with a fringe in front that came down to our eyebrows; we had little pink pinafores reaching to just below the waist, and leaving our necks bare; brown corduroy knickers, red socks and black boots completed the effect.' Later on, Dorelia dressed her daughters in buff-coloured woollen dresses, rather draughty, with thin criss-cross lines, saffron-yellow ankle socks and square-toed black slippers. Their hair, also bobbed, was shoulder-length, and their frocks, which they learnt to manipulate with dexterity when climbing off floors or clambering into chairs, reached almost down to their feet. It was as if Augustus's pictures had come alive and were walking about. Here, in a coach-house converted to a studio, he painted 'Washing Day',[325] 'The Blue Pool',[326] numerous drawings and panels of the children alone or in groups, portraits of the many visitors from Francis Macnamara[327] to Roy Campbell,[328] and studies for the figures in his large decorative groups 'Forza e Amore',[329] 'The Mumpers'[330] and 'Lyric Fantasy'.[331]

At Alderney, Augustus kept himself in the background. His presence, like that of a volcano, was often silent, sometimes threatening, always impressive. A quiet, swiftly-moving, dark-bearded figure, with a wide-brimmed hat, tweeds and a pipe, he patrolled Alderney, watching everyone with fierce intentness, disconcerting them with his penetrating stare, his sudden eruptions. No longer was he the wild youth 'Gus John'; he had flowered into the full magnificence of 'Augustus John', soon to be truncated to the moody, monosyllabic 'John'. On many mornings he was morose, merely issuing a rumbling summons 'Come and sit!' He would collect some guest, or two or three children, take them off and by lunch produce a panel of one of the boys with a bow-and-arrow, or Dorelia leaning against a fir tree, or a series of drawings.

but no emerald could have been more beautiful. They were the only colour she wore. She stood quietly surveying us, unaware of the impact she made.'

As the day wore on his mood lightened. Often he would suggest taking out the pony trap and driving through the country lanes to the White Hart or King's Arms, small favourite pubs with sawdust on the floors and the reek of shag and cool ale, where he would play shove-ha'penny and drink beer. But it was in the evening, seated at the head of the refectory table, that he came into his own. Within the arena of this hospitality, his melancholy would thaw, allowing his natural good humour to come out. Sometimes he would permit the children to stay up on these gorgeous occasions so as to wait at table. 'The table seemed to groan under the weight of innumerable dishes,' Romilly remembered,[332] 'and to be lighted by a hundred glittering candles in their shining candlesticks of brass. Dorelia and John appeared, for the first time in the day, in their true characters and proportions; they were like Jove and Juno presiding over the Olympian feast.' Sometimes, too, there were terrific parties with bonfires and dancing, and John, rolling his lustrous eyes like marbles, a wild enigmatic smile on his face, his body still, would sing songs between long puffs of pipe-smoke.

> *In Jurytown I was bred and bornn*
> *In Newgate gaol I'll die in scornn*

He threw himself into these highwayman's songs with intense concentration; but it was a strange thing, one of his listeners noticed:[333] 'as he sang his body seemed to grow small. It was as if it all went into his voice. He dwindled.'

> *At seventeen I took a wife*
> *I loved her as I loved my life.*

It was often a point of honour that these parties continue till early morning, and so many people came that huge wigwams had to be constructed from branches and brown blankets, like the tents in *Prince Igor*, to accommodate everyone in the garden. On hot nights they would make up a communal bed in the orchard, nine-wide and full of bracken that crackled when anyone moved. Then, first thing in the morning, John would arrive and, while the others were still lying where they had fallen, lead off some girl or child.

The children played a natural part in this community. They were always out-of-doors, immersed in their secret games in the dark undergrowth. They would shin up the trees in bare feet, run with a pack of red setters, wander into Dorelia's enchanted garden, plunge into the frog-laden pond and, to the distress of the parson, dash naked about the place getting dry. Sometimes they played hide-and-seek on the horses,

or harnessed a tin bath to one of the pigs which towed them across the grass. One favourite place was the brick-yard over the road with its great clay-pit and little trolleys pulled along miniature railway lines; and another, a large sand-pit enclosed by pine trees. The many-shaded sand-cliffs could be tunnelled into and carved out in paths and bear-holes. At the top where the sand joined silver-grey and black earth, the smell of heath and dank sand seemed to give the aroma of heaven. They would set up shop here with different coloured sands, an absorbing game: then the lunch bell, erected at the top of a high post at the back of the house, echoed across the fields, and they would pelt back through the orchard, naked or otherwise, and greedily line themselves along the refectory table. On windless days this bell could be heard all over the estate, alerting whole troops of poachers and stealers of wood, who had to be chased off between courses.

After lunch, they were off again, fighting a fire on the heath or, more mysteriously, entering their private world of rites and humours, games of their own invention such as 'Bottom First' inaccessible to the untrained mind, and cults that embraced strange moaning choruses, 'Give us our seaweed!', accompanied by side-splitting yells of laughter.

They were not pampered, these children, but increasingly as time went on put to work sawing logs, digging, grooming the horses, collecting hens' eggs, tarring fences, minding the farm, doing all the chores of the house and, from time to time, answering the patriarchal summons to sit. It was a hard, unorthodox upbringing, permissive yet oppressive. But this first summer, while the house was still empty and they slept in tents and every day the sun shone, Alderney seemed idyllic.

2. THE SECOND MRS STRINDBERG

Dorelia made Alderney a harbour. John kept on his studio at the Chenil Gallery and would stay there for much of the week; then, at week-ends, or in moments of sudden revulsion from town life, he appeared at Alderney to pursue his work inside the converted coach-house. It suited him in many ways, this dual existence, giving a constructive pattern to his restlessness, a momentum supporting his work: and it enabled Dorelia to look after him without obviously appearing to do so. She was an anchor, discreetly out of sight.

'He behaves very well,' she admitted to Charles Tennyson, ' – *if I keep my eye on him*'. The eye she kept on him was at first pretty fierce. Over the early years at Alderney a pattern of existence developed between them that became roughly acceptable to both. He carried on two lives; and so, eventually, did she. In London he enjoyed affairs with models,

art-students, actresses, dancers – anyone new. These amatory exercises
seemed almost obligatory. 'The dirty little girl I meet in the lane,' he
declared,[334] 'has a secret for me – communicable in no language, estim-
able at no price, momentous beyond knowledge, though it concern but
her and me.' It was of some concern to Dorelia, nevertheless, when
these girls appeared down at Alderney. For she would surrender to
nothing easily, knowing that were she to do so John, like a child, would
seek to push things further. It was a struggle to test who, finally, con-
trolled whom. 'I want to live with you when I come down,' John wrote
from London, 'but I don't like imposing myself on you.' From Dorelia's
point of view this seemed a promising start. Her most useful card was
Henry Lamb. Whenever Lamb wanted to see her, she would ask John,
almost formally, whether he minded. Surprised, he would disclaim any
objection to 'the poor agneau' coming to Alderney – provided, of
course, Dorelia didn't mind. But when he inflicted his girls on her, or
inconsiderately hared off in pursuit of them, he would find at moments
particularly inconvenient to himself Lamb happily installed there again.
He hadn't imagined Lamb's company was so 'indispensable', he sar-
castically remarked.

The guidelines Dorelia laid down were swept aside whenever John
was suddenly taken over by some infatuation. Many of these romances
were short;* others, drifting into the shallower waters of affection,
lasted years. 'You may be sure I want you a great deal more than any
other damsels,' he once wrote to Dorelia: but he wanted them as well.
In all his painting, whether landscapes or portraits, he depended upon
some extreme instinctive relationship to develop that would take hold
of him and guide his brush. In the case of women, this miracle was
almost impossible to achieve if his concentration was constantly fretted
by unsatisfied physical desire. Under such unnatural conditions, his
shyness stood like an intolerable barrier between him and his sitter. It
was to this argument, which it is perhaps over-easy to caricature, that

* The painter Jean Varda remembers a characteristic affair with the extravagant
dancer Lady Constance Stewart-Richardson – reputedly 'the worst dancer in the
world but one of the most remarkable athletes', as described by Aldous Huxley,
'whose strength is as the strength of ten'. Their liaison began in 1914 and 'for being
unrequited lasted longer than his [John's] periodic infatuations. At Lady Constance's
studio (in her performance of the sword dance) he took a violent dislike to me and in
fits of prodigious eloquence cursed me with a wealth of abuse and vituperation, the
like of which I never encountered in my life. . . . It was a great treat to hear these
gorgeous syllables delivered with the grandiose emphasis of a Mounet Sully of the
Comédie Française.' Varda at that time was Lady Constance's perspiring partner in
the dance. A few years later a calm seems to have descended and at Evan Morgan's
birthday party in July 1917 Aldous Huxley records: 'in one corner of the room Lady
Constance supported John on her bosom'. She was, he adds, 'profoundly exhausting
company'.

Dorelia listened with most attention. No worthwhile man, she once told Amaryllis Fleming, was easy. By such a definition John was extremely worthwhile. There were those who wondered how, stoical and acceptant of life as she was, Dorelia could put up with as much as she did. She did not do so without a struggle. In their long tug-of-war, the rope between them almost snapped. Although John felt more for Dorelia than for anyone, this did not stop him, when the evil was upon him, from purging his guilt by wounding her. She endured this not for love but from belief. She believed he was a great artist whose vocation demanded that he throw himself into every form of life. She scorned people's conventional indignation, often expressed on her behalf, about his 'goings-on'. But if he were not to prove a great artist, she once told Helen Anrep, then her life had been wasted. Her strength – or at least her calm – was fed by another world into which she would often disappear. For like him she led a second life – not among people or in London, but lost in her garden with her flowers and growing things.

She saw her job as lifting some of the responsibilities, irrelevant to painting, from his shoulders. She would untie the cords and give him back his freedom. When he had illegitimate children she did not leave him, but sometimes helped to look after them. He could go where he wanted, do what he wanted, return when he wanted. If he needed clothes or tobacco, she got them. But ultimately everything depended upon him.

It seemed, at times, as if Dorelia had entered the plant world more completely than the world of human beings, as if flowers meant more to her than people: perhaps, eventually, they did. There were interruptions in her calm – violent, terrifying fights with John: but over such issues as (to take an actual example) whether or not, on some half-forgotten occasion, Caspar had had toothache. She examined small things under a microscope; but the large events of life she appeared to look at, as it were, through the wrong end of a pair of binoculars so that they never overwhelmed her, never came too close. This protective philosophy is well caught by a conversation she had in about 1939 with Richard Hughes. One afternoon, when the two of them were walking in the garden with a boy of about four believed to be John's youngest illegitimate son, Dorelia suddenly came out with: 'There's one thing about John I've never got used to, not after all these years.' Richard Hughes glanced apprehensively at the child, but she continued: 'I don't know what to do about it. Time after time, *he's late for lunch*'.

The girls John brought down to Alderney were accepted with suspicion by Dorelia and were not helped much by John himself. She tolerated them, half-ignored them, almost as if they knew a different John, while, in the words of Iris Tree, 'she guarded his higher ghost'.

Some she positively frightened, being known by them as 'the yellow peril'; others, through exceptional qualities, she came to accept as allies.

But there were limits. Her censure usually fell hardest on the girls themselves rather than on John, for it was not justice that interested her but practicality. A friend who lived near by remembers one incident that shows her shorthand methods of dealing with anything unacceptable:

'One afternoon I had gone up to Alderney Manor to learn from Dorelia how to "turn a heel", so I would be able to knit socks for my two boys. We were having tea when a vehicle came to the front door. Dorelia went to see who it was, some luggage was dumped in the passage, a girl was brought in, introduced, and politely asked to have some tea. The conversation dragged, neither Dorelia nor I were any good at "chatting". Soon I got up to go, but Dorelia asked me to stay on . . . Dorelia then turned to the girl. "What train are you catching?" she said. The girl looked surprised. "There is a good train to Waterloo you can get if you go now, the next one is much later. I will see that you are driven to the station." Before Dorelia had reached the door, the girl blurted out in an offended voice: "Augustus asked me to stay". "But Augustus is not here," answered Dorelia calmly, and went out . . . She politely and firmly got the girl and luggage out of the house without raising her voice, without losing her temper, without even looking upset, so it all seemed a most ordinary affair. "I am not going to have Augustus's girls here when he is not present" – that was all she ever said about that interlude'.[335]

It was this version of a welcome (emphasized by an adhesive dart shot at her by one of the children) which was extended to that 'Walking hell-bitch of the Western World', the second Mrs Strindberg, who, rising vigorously from her death-bed in the Savoy (upon which, she boasted, John had deposited her), called on Dorelia one Christmas Eve. Her visit, wearing a nightdress, was brief and represented the latest in 'a long series of grotesque and unedifying adventures'[336] to which this tiger-woman from Vienna was, John claimed, subjecting him. For two years, in Paris, Liverpool and London, she had dogged his heels, buying up pictures that were not for sale and presenting in various directions large cheques that baffled Knewstub, infuriated Quinn, and eventually found their way, via her maid, back into her own pocket.*

By all accounts Frida Strindberg was a remarkable woman. After ten years in a convent 'among the brides of Christ', she had been let out to serve, for a further two years, as 'the beautiful jail keeper' of Sweden's chief dramatist. Their marriage had been an exhausting comedy of love,

* Once, when she was bartering with notes, John put them in an envelope and forwarded them to Bazin, the bird-man of Martigues.

the tone of which was set at the wedding when the parson, addressing his question to Strindberg rather than to Frida, demanded: 'Will you swear that you do not carry another man's child under your heart?' While Strindberg nervously denied being pregnant, Frida interrupted with volleys of hysterical laughter.

In the tilts of untarnished romance Frida was anybody's superior. A determined admirer of the hero in man, she had sharpened up a ravenous appetite, given somewhat to indigestion, for men of genius. On catching sight of such a specimen she would burrow ruthlessly under his spell, and there was little he might do to extricate himself from the rigours of such devotion. For the quality of her worship was not meek, but un-remitting. Melodramatic even at the age of nineteen, she had as she grew older gathered force until she arrived in London an Amazon. The inheritance of a large sum of money had done nothing to reduce this velocity. Never a woman for compromise, she had become aware within herself of brilliant gifts as a journalist – a breed allergic to John – and now conducted her life as if it were the daily material for front-page headlines. In 1910, while on the track of the fleeing Wyndham Lewis, she had called at Church Street and, expecting to quarry him there, found herself briefly in bed with John.[337] 'I then dismissed the incident from my mind,' John recorded,[338] 'but it turned out to be the prelude to a long and by no means idyllic tale of misdirected energy, mad in-comprehension, absurdity and even squalor.'

What happened over the next two years has been brilliantly sum-marized by Strindberg's biographer John Stewart Collis:[339]

'John frequently made elaborate efforts to evade her. In vain, it appears. He came to the conclusion that she possessed second sight and the gift of obliquity. If, without telling a soul where he was going, he sought refuge in some obscure café in Paris or London, Frida would know and appear on the scene. If he boarded a train for the country, there she would be on the platform to bid him good-bye or to follow him. And it was advisable for him to watch his step in his treatment of her even when dining with her in company, for if he were discovered paying too much attention to another female member of the party she would pay a man to take up a concealed position and aim a champagne bottle at his head; and on one occasion, in Paris, when he imagined that he had been successful in eluding her by a series of swift changes of scene, he was informed through an anonymous and illiterate note that he would *again* be beaten up if his behaviour towards a certain lady did not improve – for evidently someone had been mistaken for John and had innocently suffered the attack.'

There are no photographs of Frida Strindberg nor any record of John

having drawn or painted her – for she saw herself not as another model but as his benefactress and saviour. In her late thirties, she was still a very cordial woman, her good figure ill-concealed, her face wreathed in dangerous smiles and, we are told,[340] 'eyes of that shade of dark and lively brown which so often prove irresistible to men'. Perfect beauty intimidates – but seldom to the extent to which John felt intimidated. 'I–admit', he conceded,[341] 'that the sight of Mme Strindberg bearing down on me in an open taxi-cab, a glad smile of greeting on her face, shaded with a hat turned up behind and bearing a luxuriant outcrop of sweetpeas – this sight, I confess, unnerved me.' He held his ground – then ran; but whichever way he went, there she was with arms out-stretched to welcome him. Sometimes he ran directly towards this apparition, and still failed to avoid her. He was never safe, and nor was she. Their reproaches were often antiphonal: 'I am worn out!' she cries. 'I am suffering more than I have strength to bear!!' But he too is suffering: 'Can you seriously think I *enjoy* this business,' he asks, 'that I *glory* in it???' Their complaints and punctuation marks multiply. She speaks eternally of love and death, and swears that he does not under-stand her. He hears only the voice of power, and objects: 'It is this *constant* misunderstanding of my character which is the fatal element in the whole affair. When you are not annoying me with hyperbolic eulogies you are outraging me with the vilest suspicions and accusa-tions.' Their accusations turned simultaneously into the avenues of law. 'They are serving you a subpoena or will try to do so to-day,' she promises him. 'I want to attack you by the Law!!!' he bursts out.

What has survived of their correspondence reveals the secret of Frida's ubiquity. When unable to accompany John on his wild flittings to and fro, she would arrange for him to be shadowed by a nervous private detective. He was never lonely. Frida's letters to him were often prompted by this detective's reports rather than anything John had written, and it is round the competence of this man's work that many of their arguments revolve.

Each claimed that the other was making a public exhibition of them both. 'If all Chelsea is aware of your existence it is simply because you have a genius for advertising it,' John blandly concluded. Frida's chief complaints centred on the company he kept other than her own. 'You write love letters to all the girls in London, which they all read aloud,' she objected. One girl, in a leopard skin, had recited nine pages to music the other night; and another, unaccompanied, had danced a dance of jealousy. Was it any wonder, then, that Frida 'felt like murder yester-day – I was mad, mad, mad'. In the intoxication of this madness, she persistently denied the most extravagant charges, assailing John (some-times as late as 1.30 in the morning 'when I was in bed and disposed to

sleep') with her eloquent defences. It was untrue, she suddenly pro-
tested, that his girl friend Edith Ashley ('a silly Kensington girl from a
penny novel') had 'been bribed by me not to see you, that I had twice
tried to murder her, once by poison, once by pushing her from a cliff'.
All this, she repeated, was positively untrue.

John refused to disbelieve her. These inventions 'have rekindled your
imagination to fresh horrors,' he told her, '. . . as a means of revenge
for quite hypothetical injuries, you are determined to be melodramatic
to the last!' Nevertheless he felt imperilled by these non-confessions and
threats of love, recognizing in her gratuitous pleas of not guilty 'an
audacious attempt at intimidation'. For she had sensed his fear of
publicity and was constantly playing on it. 'I was born as the only
woman of one man,' she was to write in her autobiography.[342] For all
time, for the time being, that man was John. She therefore refused to be
supplanted by other women who, unlike herself, did not share John's
Creative Urge.

'John, dear, dear John – *What* have they made of you – what have
you made of *me*? You say my dignity is gone. Yes, John – far, far away.
You tore it down for over a long year to the ground, in the mud – and I
let you, as I let you do everything . . . You have gone so far with them
all that it is scarcely possible for you to come back – unless I publicly
unmask them all. I have shunned it until now for your sake.'

Accompanying such threats were erratic demands to 'help me, be-
friend me . . . for heavens' sake, for your wife and children's sake'.

John read her message plain. Either he had to live with her in London
or else she would, by means of the courts and press, disrupt his life, so
lately established, at Alderney. To forestall this he had already made
Frida into a figure of fun for Dorelia – a process he exploited still further
in *Chiaroscuro*. It was not so much what Frida might reveal about her-
self as about others that he feared. She had one very potent weapon:
death. It happened that she was very strong on suicide. She thrived on
regular doses of veronal, swallowing them down with Bovril, then
dispatching her abominably pretty maid to John with the news that she
had tossed down this fatal cocktail and was about to die. Indeed, she
was dying – but only to see John.* For when, in terror of some farewell
message for the coroner and press, he hurried to her bedside, there
would always ensue an intolerable interview; and on one occasion,
having seized his hat and bolted down the hotel corridor, he was over-
taken by the dying woman in the lift.

* 'When I was ill in December, on the day on which I regained consciousness, I
thought I should not outlive it . . . I was dying – to see you, my dear man . . .
there was nothing to which I should not have forced myself only to see you once
again ! ! !' Frida Strindberg to Augustus John (undated).

In *Chiaroscuro* John makes well-rehearsed comedy out of such episodes, though it appears from contemporary documents that he was sometimes seriously disturbed by them. To John Quinn, revisiting London at the beginning of September 1911, he unburdened himself. Quinn's diary entry for 3 September records that John, at the Café Royal, 'sober but normal looking', told him that, in response to four or five pleading letters from Frida, he had just gone to see her at the Capitol Hotel. He was resolved that, however tempted, he must not lie. Nor did he. He advised her that she had made 'a damnable nuisance of herself', and that their relationship must end. She 'clutched and raved', but though he felt sorry for her, he steeled himself not to surrender. Later that night, in his studio at Chenil's, he learnt that she had again killed herself and was not feeling well. Next morning Quinn called round: 'Awful tale about Madame Strindberg all right,' he confirmed in his diary. '. . . Mme S. had taken poison and the doctor said she would not last the night. John shaken but game & determined not to give in. I felt sorry for him and did my best to brace him up. I don't think he had slept very much. This damned Austrian woman has wasted John's time – upset his nerves – played hell with his work . . .' At two o'clock that afternoon Innes arrived, his black hair flat over his forehead, like Beardsley, his face very pale, his teeth missing, wearing a dark green tie and a big black felt hat. 'A lot of talk about the Austrian woman,' Quinn wrote, ' – John very quiet & Innes a little scared. Both felt very sorry for her as a human being. John sent wire and we all walked to the Queen's restaurant near Sloane Square . . . I advised John if Mme S. *did* die to "beat it" – clear out of the country. I amused Innes and John by a description of John in the witness box . . . Both laughed like kids. John is really a combination of boy and man – but a man of the highest principle.'

As a result of their discussion, John made up his mind, whatever happened, to accompany Quinn to France. 'I find it difficult to decide to go,' he wrote to Dorelia. '. . . Would you come over too? . . . we could persuade Quinn to eat in modest restaurants.' But Dorelia was involved in her garden and could not join them. Disappointed, John met Quinn at the Café Royal next evening determined to call the journey off, but reports of Frida Strindberg's worsening condition altered his mind very wonderfully. Instead of Dorelia, he arranged for the two of them to be accompanied by Euphemia Lamb and another model, Lillian Shelley, 'a beautiful thing . . . red lips and hair as black as a Turk's, stunning figure, great sense of humour'.[343] Exhilaration and exhaustion struggled for possession of Quinn, but he was increasingly under John's spell. At midnight, he allowed himself together with Innes, Shelley and Euphemia Lamb, to carry on their celebrations in

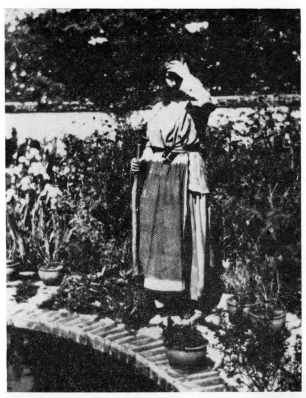

Dorelia at Alderney Manor. John's
portrait is reproduced by permission
of The National Museum of Wales

Ambrose McEvoy

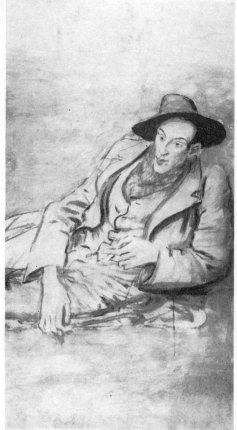

J. D. Innes (by permission of The
National Museum of Wales)

John's studio. 'All drunk,' he rejoiced, 'and John sang and acted wonderfully. Two divans full – L[illian] the best natured'. After breakfast Quinn ordered four tickets, and John (whom he had just paid two hundred pounds for some pictures) bought 'a swell automobile coat & cap'.[344]

John was looking forward to 'a few days' peace'; Quinn, more nervously, hoped that 'the trip will be pleasant'. The two of them arrived punctually at Charing Cross station, but the girls did not. Instead, upon the platform stood Frida Strindberg, her only luggage a revolver. Quinn's notes at this stage become shaky, though the word 'carnage' is deceptively clear. From John's account it appears that she urgently pressed upon them the favour of her companionship. 'Only by appealing to the guard and the use of a little physical force were we able to preserve our privacy.'*[345] Undeterred she followed them on to the boat at Dover. John hurriedly locked himself into his cabin, but Quinn, relishing this contact with Bohemian life, bravely offered the huntress a cup of tea. John was appalled when he heard of this errand: 'She spoke to Quinn on the boat and tried to get him into partnership with her to run me!!' he protested in a letter to Dorelia. To this purpose she had made an appointment to see Quinn the following day in Paris. But in the interval, possibly with John's aid, Quinn's ardour cooled and instead of keeping his appointment he took John to the Hotel Bristol to meet an American copper king, Thomas Fortune Ryan; a tall elderly southerner who talked wearily in immense sums of money and pessimistically chewed upon an unlit cigar. That evening they went to the Bal Tabarin and were joined by a young Kabyle woman. 'This dusky girl's whole person exhaled a delicious odour of musk or sandalwood. A childlike candour illuminated her smouldering eyes.'[346] At two o'clock that morning they returned to their hotel: 'finally to Pl. Panthéon,' Quinn noted wearily, '& John went with the girl'.

By now Madame Strindberg was also at their hotel and, mortified by these events, committed suicide. Since she was never more active than when laid out on her death-bed, they hurriedly borrowed Ryan's seventy-five-horsepower Mercedes touring car, manned by 'the best chauffeur in Europe',[347] a German. There was not a moment to lose. Setting off at once they 'careered over France ruthlessly'.[348]

The prospect of a week with Quinn in such delightful country depressed John unutterably, and he proposed reviving their earlier scheme by fetching over Shelley and Euphemia. Quinn was game, but Dorelia, to whom John suggested this by letter, was not: and the scheme was reluctantly abandoned. For much of the ensuing time John was sullen;

* In *Chiaroscuro*, John was careful to write of 'passive yet firm resistance' at the railway station. But in a letter to Dorelia he is more direct: 'I shoved her out.'

silent sometimes and at other times attempting, it seemed, to provoke a quarrel. 'O these Americans!!!' he burst out.[349] 'I don't think I can stand that accent much longer . . . their naiveté, their innocence, their banality, their crass stupidity is unimaginable.' Yet Quinn stayed doggedly optimistic. 'John and I had a great time in France,' he loyally declared.[350]

What they achieved in this breathless ellipse to and back from the Mediterranean was a forerunner of the modern package tour.* 'It was like a nightmare'. From the start they fuelled themselves against the ordeal with prodigious quantities of champagne. 'The first day out we started on champagne at lunch,' Quinn told James G. Huneker (15 November 1911):

'That night at dinner, feeling sure that I would be knocked out the next day, I might as well go the limit and so we had champagne at dinner. I slept like a top, woke up feeling like a prince, and did a hundred and fifty miles next day, and from then on and every day till we returned to Paris we had two and sometimes three quarts of champagne a day – champagne for lunch, champagne for dinner, liqueurs of all kinds, cassis and marc, vermouth, absinthe and the devil knows what else.'

For John, who had counted on Quinn retiring to bed most days with a hangover, such resilience was disappointing. But there were many hair-raising misadventures to enliven this excursion 'into that labyrinth of platitude and bluff, the American mind'.[351] Their progress was punctuated by several burst tyres and encounters with chickens and dogs. At one point they knocked down a young boy on a bicycle and themselves leapt wildly down a steep place into a ploughed field. 'We landed after about three terrific jumps,' Quinn reported,[352] '. . . just missed bumping into a tree which would have smashed the machine . . . the kid's thick skull that got him into trouble saved him when he fell'. Having taken the child to a doctor, they raced on expecting at every town to be arrested. 'Quinn's French efforts are amazing,' John wrote in a letter to Dorelia. 'Imagine the language we have to talk to the chauffeur. Desperando!' Descending a tortuous mountain road, Quinn had inquired the German for 'slow'. 'Schnell', John replied. 'Schnell!' Quinn

* In a letter to Huneker (15 November 1911) Quinn gave the inventory of this tour. 'We did Chartres, Tours, Amboise, Blois, Montélimar, Le Puy (a wonderful old place), Orange, Avignon, Aix en Provence (where we saw some of the most wonderful tapestries in the world), Marseilles, Martigues (where John spent over a year), Aiguemortes, Arles and Nîmes; back by way of Le Puy, St Étienne, Moulins, Bourges and into Paris by way of Fontainebleau. John knew interesting people at Avignon, Aix, Marseilles, Martigues, Arles and Nîmes . . . We careered through the heart of the Cévennes twice . . .'

shouted at their burly driver who obediently accelerated. 'Schnell! Schnell!' Quinn repeatedly cried. They hurtled down the mountain at breakneck speed and arrived at their hotel 'in good time for dinner' – though on this occasion Quinn retired to bed at once.

In a letter to Conrad [353] Quinn recalled 'feeling like a fighting man' during this journey. But the points were building up in John's favour, and Quinn's nerves grew badly frayed. At night he was haunted by 'horrible shapes – stone houses, fences, trees, hay stacks, stone walls, stone piles, dirt walls, chasms and precipices advancing towards us out of the fog, all to fade away into grey mist again'. On one occasion, John recounts in *Chiaroscuro*,[354]

'when the car was creeping at a snail's pace on an unknown road through a dense fog in the Cevennes, the attorney suddenly gave vent to a despairing cry, and in one masterly leap precipitated himself clean through the open window, to land harmlessly on the grass by the road-side! He felt sure we were going over a precipice.'*

Quinn secretly, and John openly, were much relieved when their tour came to an end. 'We were not quite a success as travelling companions,' John conceded.[355] The motor car, he had been driven to the conclusion, 'is a damnable invention'. Travelling on foot or by diligence was the only proper progress for a painter. 'Motoring is a fearfully wrong way of seeing the country but an awfully nice way of doing without railway trains,' he instructed Dorelia. 'It makes one very sleepy.' Nevertheless, it had been impossible to overlook everything, the countryside, the cathedrals at Bourges and Chartres 'veritably miraculous and power-communicating. The Ancients,' he told Will Rothenstein, 'did nothing like this.'

Another success had been their final shaking-off of Mrs Strindberg. Two days after their return, Quinn embarked for New York; and John, having heard that Frida was again becoming 'very active in London', slipped quietly down to join Innes at Nant Ddu. 'It has been impossible to do any work travelling this way,' he had written to Dorelia from a brothel in Marseilles, 'but one can think all the same'. Now, in the peace of Wales, he could transfer these thoughts into paint.

3. CAVALIERS AND EGGHEADS

One of the earliest visitors to Alderney was John's father. He was a

* Quinn's biographer, B. L. Reid, seems sceptical of this incident. 'Quinn's journal says nothing of this,' he points out (p. 106). But in a letter to James Huneker (15 November 1911) Quinn describes it in full: 'I threw myself out of the machine and somehow landed on my feet, but I turned a complete somersault. How I did it without breaking my neck or leg or arm is a mystery.'

model of patience. For hours he would sit strictly motionless and then move quietly about the garden, hoping to be photographed. Every day he put on the same costume he wore for promenading the beach at Tenby: a sober suit, leather gloves, dark hat, wing collar and spats. He too had recently moved, a distance of several hundred yards, to 5 Lexden Terrace overlooking the sea. In this desirable residence he was to linger a little uncertainly some thirty years, with the weather, a few illnesses and his 'specimens of self-photography' as constant companions. Occasionally he was visited by grandchildren, and more occasionally by John himself. It was a life spent waiting, for nothing.

From Dorelia's family there came, among others, her mother – a very straight-backed old woman with shiny white hair and a comforting round farm face. She spent her days quilt-making, and in the evenings would take a hot brick from the fireplace, wrapping it in cloth to warm her bed.

From 1912 onwards the guests, permanent and recurring, began to assemble at Alderney. There was Iris Tree, with her freckles and blue shadows, gliding between the trees in a poetic trance; Lytton Strachey who came chiefly to see Dorelia and who amazed the children by claiming he felt so weak before breakfast that he found it impossible to lift a match; Fanny Fletcher, a poor art-student later revered for her potato wallpapers, who arrived for a few weeks, knitted herself into the household with her cardigans and gained the reputation for being a rather inefficient witch whose salad dressings were said to contain spells; there was also a Polish doctor of music, Jan Sliwinski, who became expert at tarring fences, mending walls and cataloguing books; the Chilian painter Alvaro Guevara with tales of terrific boxing-matches in Valparaiso where he had been a champion; and an Icelandic poet who had written a play in which angels somehow figured and who was now heavily involved in defeating the law of gravity. Very often Henry Lamb would ride over on a pony-cart to play duets with Dorelia at the upright piano. Sounds of Mozart and of Bach fugues would float out of the open windows into the garden, sometimes followed by heated words as to who had played the wrong note and, more implausibly, whether or not there was a deity – for Dorelia was an agnostic, staunchly vague, and Lamb an atheistic God-botherer, and the two of them would often argue over what neither of them believed. Horace de Vere Cole, the country's most eminent practical joker, who claimed descent from Old King Cole, was another visitor. More cavalier still was the farmer, archaeologist* and anti-aircraft pioneer, Trelawney Dayrell Reed, who

* He was the author of *The First Battle of Britain* and *The Rise of Wessex*, two extra-ordinary archaeological works interspersed with pages of his own poetry. Later he became curator of the Farnham Museum, from where he waged war against the

dropped in for a cup of tea one afternoon, hung on a few years, then bought a farm near by into which he settled with his grim mother, unmarried sister and some eighteenth-century furniture. Black-bearded and fanatic, he looked like a prince in the manner of El Greco, and was much admired for the violence of his Oxford stammer, his endless loud check tweeds, and socks of revolutionary red. An occasional poet, he also took to painting, executing in his farmhouse a series of vigorous and explicit frescoes. He was attended by two spaniels and his 'man', a wide-eyed factotum named Ernest, and would assume in this company an air of utmost refinement which regularly infuriated John. 'Huntin' does give one the opportunity of dressin' like a gentleman,' he would drawl, adding: 'But I've always thought the real test was how to undress like a gentleman.'* In song his voice was powerful and tuneless, assisted by free-flowing exotic gestures with which he would conduct ballads of extreme bawdiness. A great hero to the children, he was master of many accomplishments from darts to the deepest dialect of Dorset. He was also a professional landscape-and-market gardener and a scholar, in Latin, of hollyhocks and roses – his chief love. It was in defence of these blooms, his dogs, pigs and an apple-tree that he served his finest hour. Every afternoon he would go to bed to nurse his ill-health; and every afternoon he was woken by aeroplanes which had selected his cottage as a turning-point in their local races. He wrote letters, he remonstrated, he complained by every lawful means: but the flying monsters still howled about his chimney pots, creating havoc among his household of cattle and female relatives. Then, one afternoon, it happened once too often. Awakened by a deafening racket, he sprang from his bed and, rushing into the garden, let fly with a double-barrelled shotgun, winging one of the brutes. Although no vital damage was done, Trelawney was arrested and tried at Dorchester Assizes on a charge of attempted murder. In opposition to the judge, a man much loved for his severity, the jury (being composed mostly of farmers like himself) acquitted Trelawney: and there was a grand celebration.

To be brought up amid such people, it might be thought, constituted an education in itself. John, however, pressed matters to extremes: he hired a tutor. As long ago as May 1910 he had been persuaded that 'the immediate *necessity* seems to be an able tutor and major-domo for my

archaeological establishment. In the opinion of Stuart Piggott (to whom he introduced John) his archaeological work was 'crazy, but occasionally contained passages of inspired instinct'. He also published a useful manual on shove-ha'penny.

* Trelawney was also a country homosexual. When asked once whether he had pigs on his farm, he replied: 'No. The boys have the pigs. I have the boys.'

family'.[356] If the search had been long and hesitant, this was because he needed someone remarkable whom he could trust not to give his children the sort of education from which he himself had benefited. On 16 August 1911 he reported to Quinn that 'I have just secured a young tutor who really seems a jewel'; and a month later[357] he was telling Ottoline Morrell that 'our tutor is an excellent and charming youth'.

His name was John Hope-Johnstone, and he was then in his late twenties, a man of many attainments and no profession. He had been educated between Bradfield, Hanover and Trinity College, Cambridge, which he had been obliged to leave prematurely when his mother abandoned her second fortune to the roulette wheel. From this time onwards he lived, pennilessly, by his wits. But, as Romilly John observed,[358] 'he was very unfortunate in combining, at that time, extreme poverty with the most epicurean tastes I have ever known'. He had a hunger for the possession of knowledge that ranged from the intricacies of pronouncing Arabic to the address of the only place in Britain where a certain toothpaste might be bought. There was nothing haphazard about all this: it was part of a relentless programme of theoretical self-perfection to which he had dedicated himself pending the death of eleven persons which, he had mathematically calculated, would bring him into a fortune and, more dubiously, a title. As a believer in the beauty of uselessness, he strove to make himself its chief embodiment. Undeterred by a complete lack of 'ear', he mastered the penny whistle and then, by sheer perseverance, the flute.* His abstract enthusiasms and remoteness from ordinary human desires gave him an aura of romance. He was a confirmed wanderer. Before taking up his post as tutor, he had spent some years pushing a pram charged with grammars and metaphysical works through Asia reputedly in pursuit of a village where chickens were said to cost a penny each.

He never found it, but arrived instead at Alderney into which, for a time, he fitted very well. Slim and well-built, with finely cut features,

* He even became, with Compton Mackenzie, joint-editor of *Gramophone*, in which he reviewed the latest records under the pseudonym 'James Caskett'. In Octave 5 of *My Life and Times*, Compton Mackenzie recounts that he first met Hope-Johnstone in Greece in 1916. 'John Hope-Johnstone had arrived by now from Corfu with a kitbag containing a few clothes, one top-boot, several works on higher mathematics and two volumes of Doughty's *Arabia Deserta*, a pair of bright yellow Moorish slippers, a camera and a flute. He was ten days older than myself and among the friends with whom I've enjoyed good conversation I bracket Hope-Johnstone with Norman Douglas at the top . . . When war broke out he was more than half-way on a journey to Baghdad and in spite of having to wear very strong glasses nothing escaped him. He enlisted at the beginning of the war, somehow cheating the military authorities over his eyesight; then his myopia was discovered by his having saluted a drum he had mistaken for the regimental sergeant-major.'

dark hair and ivory pale skin, he wore heavy horn-rimmed spectacles, an innovation at the time. It was not long before he conceived an immense admiration for John and Dorelia and the romantic life they led in and around their absurdly battlemented bungalow. With their *entourage* of gypsy caravans and ponies and naked children they belonged in his imagination to the race of Homeric gods. As a mark of admiration he took to wearing a medley of Bohemian clothes – buff corduroy suits cut by a grand tailor in Savile Row after the style of a dress suit, with swallow tails behind, a coloured handkerchief or 'diklo' round his neck and, to complete the bizarre effect, a black felt hat of the kind later made fashionable by Anthony Eden, though with a broad brim. To John's eyes he was every inch a tutor.

It is doubtful if his pupils benefited as much as John and Dorelia did from the tutelage of this walking encyclopedia. 'For Hope the argument – long, persistent, remorseless, carried back to first logical principles – was an almost indispensable element in the day's hygiene,' his friend Gerald Brenan recorded.[359] It began at first light. He would sit over the breakfast table dilating before Dorelia upon Symbolic Logic or Four Dimensional Geometry while the children fled on to the heath. Then Dorelia, who in any case did not believe in education, would murmur: 'Never mind. Leave them for to-day,' and the tutor would be free to retreat into the cottage kitchen, which he had converted, with retorts and bottles of coloured fluid, into a laboratory for his malodorous chemical experiments. At other moments, possibly when it was raining, he would lead the older boys off into their sanctum of learning and propound to them the Latin gender rhymes and the names of the Hebrew kings. He also made a speciality of the Book of Job, parts of which he made them learn by heart in order to train their ears for sonorous language, provide them with a sense of the remote past, and instil patience.* He was not entirely popular however with the children, chiefly because of his greed. At table, when the cream jug was passed round, he would 'accidentally' spill most of it over his own plate, leaving nothing for them.

To Dorelia, with whom he was a little in love, he made himself more helpful. He was a scholar of ancient herbs and jellies, and she made use of his extensive book-knowledge in the kitchen and when laying out her garden. To John also he tried to make himself of value by persuading him to buy an expensive camera with which to photograph his paintings. But Hope's technique perfected a gradual fading away of all the prints into invisibility. It was an accurate record at Alderney of his waning

* 'Hope-Johnstone used to try and explain relativity to me when I was about 10,' Romilly John admitted. 'I still remember the horror of his subsequent discovery that I had not yet wholly mastered vulgar fractions.'

popularity. John had warmed to him at first as someone magnificently irrelevant to modern life – an authentic eighteenth-century dilettante. He had been impressed by his reputation as a mathematical genius and amused by his amazingly well-informed conversation – there must have been few people who could speak with such perceptible pleasure on Phonetics, for instance, exploring all the entertainment the subject provided. He had liked, too, the way the tutor dived into their rigorously easygoing way of life, accompanying, unshaven, the barefoot boys through the Cotswolds to North Wales with a pony and cart. Then John began to tire of him, as he did of everyone whom he saw regularly. He had encouraged Hope as an entertainer, and within a year his repertoire of tricks and stories had run out. John was never one for *encores*: they bored him, not just negatively but with a burning antagonism; the tutor did not find it difficult to fan this. His capacity for absorbing knowledge, which appeared to be limitless, was replenished by his growing library and by John's depleted one. As a future editor of the *Burlington Magazine*, it was necessary that he should study art closely, but not perhaps by the method of absconding with John's own pictures, of which he amassed a fine private collection. His passion for argument pierced through the barrier of John's deafness and especially when it developed into vast literary quarrels with Trelawney or with Edie, whose reading was confined to the *Daily Mirror* and romantic novels from Parkstone Station lending library. So it was with some relief on all sides that in the last week of August 1912, with his entire capital of £16, a camel-hair sleeping-bag and a good many grammars, he wheeled his perambulator off once more in the direction of China. Although he had been tutor for little more than a year, he was regularly to re-enter the lives of the Johns, in Spain, in Italy, at the corner of Oxford Street. Gerald Brenan, with whom he set out for the borders of Outer Mongolia, gives as Hope's reason for this sudden journey the rainy weather in North Wales, where he had passed a few weeks with the Johns. Another more pressing reason, it was inaccurately suggested, was a plan John had hit on to marry him off to one of his models who, about this time, gave birth to a child.

After Hope's disappearance the children's education stumbled on along slightly more conventional lines. 'The boys go to a beastly school now and seem to like it,' John complained to their ex-tutor (20 November 1912). Dane Court was a new school, not outstandingly orthodox, that had been started by a newly married comic couple, Hugh and Michaela Pooley. Hugh Pooley, a hearty player of the piccolo and owner of a rich baritone voice, took music classes. When not playing or singing, he was usually laughing greatly; and when doing none of these things he was incomprehensible. 'He lectured us in the dormitory on

the dangers of masturbation I now realize,' recalled Romilly,[360] 'though I was puzzled at the time.' If Hugh was the symbol of a headmaster, his wife, a tremendous devotee of bicycling and an emotional speech-maker, was the 'progressive' force in the school. She had the enviable ability to miss church on Sunday, and busied herself on weekdays in French. She was a Dane* and the daughter of an artist and museum director: 'so,' she concluded, 'the Johns' home came as a refuge to me'. On the strength of her parentage she would bicycle up uninvited to Alderney with her husband and a tin of sardines to supplement the rations, and seemed deaf to the loud groans which greeted her arrival. While Hugh sang in his baritone for supper, Michaela would swivel her attentions upon John himself, whom she treated as one of the more backward boys in her class. The retired colonels and civil servants with which Hampshire and Dorset seemed brimming over were, she con-veyed, very little to her *smörgåsbord* tastes, whereas John was an 'attractive man, who made one feel 100% woman – a quality I missed in most Englishmen at that period'.

Dane Court had eleven pupils and, since its future depended upon swelling this number, the Pooleys had been delighted to receive one morning a letter of inquiry from Alderney Manor – a large place, they saw from the map, on Lord Wimborne's estate. An interview had been punctually arranged, and the Pooleys had prepared themselves to meet some grand people.

'From our stand by the window we saw a green Governess cart drawn by a pony approaching up the drive,' Michaela Pooley remembered.[361] 'A queer square cart – later named "The Marmalade Box" by the boys in the school – and out stepped a lady in a cloak with a large hat and hair cut short . . . After her a couple of boys tumbled out, their hair cut likewise and they wore coloured tunics. For a moment we thought they were girls . . . It was soon fixed that the three boys aged 8, 9, 10 should come as day boys. When Mrs John was going, she turned at the door and said: "I think there are two more at home, who might as well come." '

* 'We considered her rather a witch-like figure, though I daresay she was quite handsome in a Danish way,' Romilly John recalled. '. . . On parents' day Mrs P. invariably gave the same speech, in which she told, with considerable emotion, how she was enlightened as to the meaning of the word "gentleman", presumably there being no equivalent in Denmark either of the word or the thing. One day she had seen from an upstairs window one of the 12 older boys (*not* a John) stealing goose-berries. This boy had subsequently owned up to the theft, an instance of gentleman-liness the like of which Denmark could afford no equal. It was this boy who at a later date was employed as a tutor to Edwin and me.' Romilly John to the author, 15 November 1972.

That was the beginning and it was not easy for them, knowing only the Latin gender rules and part of the Book of Job. But they were quick to learn, being, the Pooleys judged, 'a fine lot . . . intelligent and sturdy, good at work and good at games'. With their long page-style hair and belted pinafores (brightly coloured at first, then khaki to match the brown Norfolk suits the other boys wore) they felt shamefully conspicuous. Yet since they numbered almost half Dane Court and stood shoulder to shoulder against any attack, their entrance into school life was not so painful as it might have been. They formed a community of their own, a family circle with doors that could be opened only from inside. But gradually they edged these doors ajar and exerted a considerable influence on the school, Eton collars giving way, under Michaela's reforming spirit, to allow corduroy suits and earthenware bowls to become the order of the day.

'David and Caspar now are expert cyclists,' John reported to Mrs Nettleship after their first term (8 January 1913). '. . . Mr Pooley wants them to be weekly boarders, he thinks they'd get on much faster – and I think it's no bad idea.' First the three eldest, then the others boarded and immersed themselves more deeply in an atmosphere altogether different from that of Alderney. They grew more self-conscious, more vulnerable to parent-embarrassment at sports days. So far as was possible they tried to keep the two parts of their lives – and the Nettleship part too – within separate compartments. Details of their home life were guarded from their friends, while about Dane Court they were seldom pestered for information by John and Dorelia.

'I was especially afraid that one of my brothers would let out some frightful detail of our life at Alderney, and thus ruin us for ever,' wrote Romilly;[362] 'a needless alarm, as they were all older and warier than I. I contracted a habit of inserting secretly after the Lord's Prayer a little clause to the effect that Dorelia might be brought by divine intervention to wear proper clothes; I used also to pray that she and John might not be tempted, by the invitation sent to all parents, to appear at the school sports.'

The boys did well at school; especially David, who was head boy for two years. As the eldest he felt himself to be at least as much a Nettleship as a John and was more successful when away from Alderney: but it was Caspar, the second son, who cut loose. He had been given a copy of *Jane's Fighting Ships* and, looking through the lists of warships, two-thirds of them British, came to the conclusion that 'here was a new and orderly society . . . This was the world for me'.[363] With Hugh Pooley's encouragement, he eventually approached his father with the notion of making the navy his career. It was a difficult interview. Since John

plainly thought it stupid voluntarily to subject oneself to such harsh exterior discipline, he did not scruple to say so. 'Think again,' he advised, and brushed the idea aside. When Caspar persisted he came up against other obstacles – the naval cadet uniform alone cost a hundred and fifty pounds. But once John appreciated that his son was set on the navy, he paid all bills without objection. Almost certainly it was Dorelia who engineered this change of mind. She had no more interest in the sea than in schooling, but she wanted to get at least one boy off her hands and see him settled. So she organized everything, eventually driving him to Portsmouth – to make sure.

Caspar was the only one of John's children brought up at Alderney who, like Thornton, Gwen and Winifred from Wales, left home and made for himself a life that became rooted elsewhere. The others left too late or too incompletely, as John himself had done. Although one or two of his later illegitimate children, raised with their mothers, felt themselves deprived by not living at Alderney or Fryern, Ida's and Dorelia's children needed to escape these places – and for many of the same reasons that old Edwin John's family had fled Tenby. The atmosphere was very powerful and, as the boys grew older, it seemed to become less sympathetic. John loved babies. When they were very small he used sometimes to bath them, and in such a role they preferred him to anyone else. But, as a man of strong vitality, he found it hard to bear the physical presence of his maturing sons. Overawed by his great presence they fell, one by one, into privacy and other lines of self-preservation. It was the beginning of a long defensive war no one could win. Even now, he ruled them, so Caspar recalled, 'with a rod of iron',[364] so that there was not 'a great deal of sympathy' in the climate at Alderney. Partly this was due to Dorelia who, at least under John's influence, was not overtly a loving person. Ida had been warmer, and with her death her children were deprived of this physical warmth. It was not that Dorelia was unfair, but that only her own children seemed able to sense, rather than see, her fondness for them. John was inhibited from expressions of tenderness. 'He intensely disliked seeing parents *fondling* their children and this may partly have accounted for my mother's inhibitions in respect of us children,' remembered his daughter Vivien.[365] 'In fact we never embraced our mother until the ages of 12 and 15, when Poppet and I made a pact to break this "spell" in order to be like other families'. But this was later, and for the most part Dorelia acquiesced in this stern régime. So the atmosphere, for all its perfume of Bohemianism, was almost Victorian in its rules of reticence.

The current of children to and from Alderney over the next years was continuous. By the autumn of 1911 Dorelia was again pregnant and, since this was against her doctor's advice, the cause of some anxiety. In

the event everyone except Dorelia fell ill.[366] By the end of February 1912, John was already confessing to 'feeling so sick . . . Dorelia is expecting a baby momentarily . . . Pyramus mysteriously ill'. In the following week this illness was diagnosed. 'Little Pyramus is fearfully ill – meningitis, and I can't believe he can recover, though I do hope still,' John wrote to Ottoline Morrell (5 March 1912). 'Last night I thought he was about to die but he kept on. Dorelia behaves most wonderfully – though she is expecting her baby at any moment. It will be terrible to lose Pyra . . .' In desperation John had tried to get 'the best specialist in London, perhaps in Europe,'[367] but the man was in Europe, not London – and besides what was there he could do? 'There is no treatment for the disease.'

On 8 March Dorelia's labour pains began and she 'had to take leave of Pyramus and go and have her baby' which 'turned out a big nice girl'. They told Dorelia that Pyramus was already dead, but for four more days the child lay on his bed quite close to her, still just alive. 'Pyra is still breathing feebly but happily has been unconscious for the last 2 or 3 days,' John told Ottoline on 10 March. 'I do not think he will outlive to-day. He was indeed a celestial child and that is why the Gods take him . . . The mind refuses to contemplate . . . such an awful fact.' While Dorelia grew stronger, John continued to sit by their son, without hope, waiting for the end. 'It was a terrible event,' he wrote afterwards (9 May 1912) to Quinn. '. . . I must say the Missus behaved throughout as I think few women would – with amazing good sense and a splendid determination not to give way to the *luxury* of the expression of grief.' It was this silence, outwardly, they shared. 'I can't talk about Pyra,' Dorelia told Ottoline a year later (10 March 1913); and John wrote to Albert Rutherston: 'It is indeed a terrible thing to have lost darling little Pyramus – the most adorable of children. Of course I can't find words to say what I feel.' But their silence was not the same. Dorelia's was natural, and her grief private. John admired this: there was no falsity to it. When he spoke of feeling, as from time to time he was tempted to do, he always regretted it for the words seemed to let him down, making the reality into something acted. When unhappiness threatened, he feared giving way to it because he knew the depths of depression of which his nature was capable. He concentrated therefore on the birth of his daughter: 'Le roi est mort, vive la reine'.[368] They called her Elizabeth Ann – at least that was their intention. But somehow these names never stuck. Then, one day, after contemplating her some time, Caspar chanced to remark: 'What a little poppet it is!': after which she was always known as Poppet.

Pyramus was cremated at Woking. Returning by train with the ashes – 'one more urn for my collection'[369] – John placed the receptacle

carefully on the rack above his seat, and then forgot it. It was later found, and sent to Alderney.

4. CHRONIC POTENTIAL

'All are well at home,' John reported philosophically,[370] ' – the baby-girl a god-send. My missus keeps fit. We have disturbances of the atmosphere occasionally but have so far managed to recover every time.' He seldom stayed at Alderney long. For one of his temperament it was insufferable to be tied to a large family, however elastic the bonds. He preferred to visit rather than to live with them. 'It is pleasant enough down here,' he remarked to Ottoline Morrell (25 July 1913), 'but a little uninspiring.'

Inspiration lay further off, waiting to be taken by surprise. In the summer of 1912 he had set off with his family to Wales – then, abandoning them at Nant Ddu, hurried on by himself to Ireland. 'Like a lion' he entered Dublin, remembered St John Gogarty;[371] 'or some sea king' . . .

> *'Or a Viking who has steered,*
> *All blue eyes and yellow beard.'*[372]

This was John's first meeting with stately, plump, buck Gogarty, professional Irishman of many parts – quick-witted and long-talking, a poet and busybody, surgeon, litigant and aviator, wearer of a primrose waistcoat and owner of the first butter-coloured Rolls-Royce. John had sought him out in the Bailey Restaurant, Dublin's equivalent of the Café Royal, on the advice of Orpen and, despite Gogarty's 'ceaseless outpour of wit and wisdom', confessed to being 'immensely entertained'[373] by him. Gogarty, 'all agog with good humour', fell headlong under John's spell, describing him as 'a man of deep shadows and dazzling light . . . When I saw him for the first time I noticed that he had a magnificent body . . . He was tall, broad-shouldered and narrow-hipped. His limbs were not heavy, his hands and feet were long.'[374] 'The aura of the man! The mental amplitude!' It was extraordinary. Overwhelmed by these sensations, Gogarty suspected he had trespassed into 'the majesty of genius'.[375] Even so, he could not fail to notice that John was 'a moody man'. There was always the problem of what to do with him. In his Ode 'To Augustus John', he celebrates the light and deep shadows of his personality, and explains the open-mouthed effect it had on him:

> *You who revel in the quick*
> *And are Beauty's Bolshevik;*
> *For you know how to undress*
> *And expose her loveliness . . .*
> *Suddenly profoundest gloom*

Wrapped you as you gazed apart,
And not one of us had heart
To inquire what was the matter.
So we kept our frantic chatter
up to save an awful pause
Guessing what could be the cause
Of your sudden, silent mood,
What in daylight made you brood . . .
Enough! There is no need to tell
How I broke the gloomy spell,
What I was inspired to give –
By bread alone does no man live,
And water makes a man depressed:
Maybe silence had been best.

But Gogarty was incapable of silence: his tongue could not master it. Being in his company was like crossing a Sahara of words – hectic, brilliant, utterly exhausting. His friendship with John was largely an ear-and-mouth affair. As an ear-nose-and-throat specialist, he once examined John's ears and pronounced them to be the very Seat of his Melancholy: in which case, John felt, he had much to answer for. Gogarty was not simply a raconteur but a verbal exhibitionist and monopolizer of all conversation. His talk was copious; and, as if he did not have enough words of his own, he borrowed other people's, so he was never at a loss. Only once did John ever arrest him – and then drastically by flinging in his face a bowl of nuts.[376] Usually he would accept Gogarty's injunction to 'float his intellect' while in Dublin, and drink huge tumblers of whisky until the chatter retreated to a distant murmur. John Jameson was what Gogarty was 'inspired to give' with almost sinister generosity. 'It was very pleasant, this bathing in the glory of Augustus,' Gogarty remembered[377] – adding, to John's chagrin: 'I felt myself growing so witty that I was able to laugh at my own jokes'.

But still there was the problem of what to do with John. Gogarty put him up in lodgings next to the Royal Hotel, Dalkey, overlooking Shanagolden Bay. His presence there, at the window, was a constant invitation to take the day off. 'We would pick up Joe Hone, who lived at Killiney, and go to Glendalough, the Glen of the Lakes, in Wicklow,' Gogarty wrote.[378] '. . . On through the lovely country we went. Augustus, who was sitting in the back, could not be distracted by scenery, for beside him sat Vera Hone.

'. . . We bowled along the Rocky Valley. Suddenly I heard the word "Stop". As it evidently was not meant for me, I didn't stop. Joe Hone did not turn his head, so why should I?'

This was the propitious beginning to a lifelong, infuriating friendship commemorated by John with two fine portraits* of Gogarty, and by Gogarty with two fine 'Odes and Addresses'. The fascination Gogarty felt for John did not diminish with the years, and in a tiny fragile verse at the end of his poem 'To Augustus John', he set down how much, despite all its difficulties, this friendship meant to him:

> *When my hawk's soul shall be*
> *With little talk in her,*
> *Trembling, about to flee,*
> *And Father Falconer*
> *Touches her off for me,*
> *And I am gone –*
> *All shall forgotten be*
> *Save for you, John!*

But still there was the problem of what to do. He had been offered the freedom of the island by another new friend, Francis Macnamara, 'poet, philosopher and financial expert',[379] and though payment for such freedom could be heavy, he willingly accepted it. Macnamara was another 'bright gem' John now added to his adornment of friends. From a career in the law, from Magdalen College, Oxford, from his father the High Sheriff of County Clare, Francis Macnamara had violently rebelled in order to devote himself to speculations of a literary and philosophical complexion. He had married a girl very pretty and small, Quaker and quite French, and lived with her, an even prettier sister-in-law, and a multiplying family of blond and beautiful children. Over six feet tall, golden-haired and with bright blue eyes, he carried himself (as John's portrait of him clearly reveals) 'like a conqueror'.[380] Famous for his courage and wild deeds, he subsisted on theories which embraced every subject from Bishop Butler to tar water, admitted to being (by vocation) a poet, and claimed, by way of trade, to teach poetry. 'He has shown me a manuscript which seems to me most remarkable,' John

* Painted in August 1917, the best-known portrait depicts Gogarty as a rather flagging dandy lit up with what Ulick O'Connor called 'elfin vitality' – though to Gogarty himself this image looked

> *like Caesar late returned*
> *Exhausted from a long campaign.*

In his poem 'To My Portrait, By Augustus John', he reveals that the painting provoked some deep questions.

> *Is it a warning? And, to me,*
> *Your criticism upon Life?*
> *If this be caused by Poetry*
> *What should a Poet tell his wife?*

confided to Quinn (6 August 1912). 'He has put soliloquies into the
mouths of personages from the Irish legends and he has made them talk
quite modern language albeit in free verse – the result is amazingly
vivid and vital. The people live again!'

Macnamara nurtured a Chekhovian stamina for procrastination.
'There were schools of poetry in Ireland where the pupil had to study
for fourteen years before he was considered proficient,' Gogarty re-
cords. 'Francis studied all his days,' he had assumed, perhaps too pre-
cociously, the cumbersome mantle of the sage, but 'would sometimes
divest himself of this,' John noted,[381] 'together with his messianic
responsibilities, and warmed by what he called "the hard stuff" became
popular, genial, and even, as the police were apt to think, dangerous'.

It was Francis's pride, his daughter Nicolette later wrote[382] with a
little exaggeration, 'to introduce Augustus to Ireland, to County Clare,
Galway and Connemara; the land the Macnamaras had roamed since
history began.' Though living in London, he owned a house in Doolin,
a small fishing village 'seven Irish miles away from Ennistymon', and
it was here that John arrived at the end of July.

It was a lonely place, and wild. The troughs and furrows of the land,
'like an immobilized rough sea',[383] were crested with outcrops of grey
rock and ridden by a net of stone walls. Except for a few obstinate trees,
stunted and windswept like masted wrecks, and sudden calm surges of
lush green grass, it was a barren landscape, frozen from times of primi-
tive survival: the very place for painting. When the mood was on him,
Macnamara would harness his horse and cart and ride off with John for
days on end, explaining the countryside. Several times, either by steam-
ship or, more recklessly, by native currach, they crossed over to the Aran
Islands. The great Atlantic waves that thundered in from Newfound-
land and Greenland and charged into the granite boulders of the Doolin
coast had protected the islanders from invasion by the monsters of
modern civilization. They remained part of their Island, living naturally
among the same rocks and wind and weather that had always enveloped
them. They were, as John felt himself to be, throwbacks to an earlier
century, simpler than our artificial age and more remote. Grave, digni-
fied people, speaking English when unavoidable with a rich Elizabethan
vocabulary, these heirs of an ancient people wove their own garments
and supported themselves without interference from the mainland.
'The smoke of burning kelp rose from the shores,' John recorded.[384]
'Women and girls in black shawls and red or saffron skirts stood or
moved in groups with a kind of nun-like uniformity and decorum. Upon
the precipitous Atlantic verge some forgotten people had disputed a
last foothold upon the ramparts of more than one astounding fortress
. . . who on earth were they?'

It was a mystery he shared with them and which, with the bleakness of their lives, made them beautiful to him. Yet because there were so many unco-ordinated sides to his personality, John could not live in such a place: he could only remember and revisit. Their simplicity represented an ideal, a dream without a dream's exactness, visionary and insubstantial. His own life was about to grow more complex, episodic. But like a religion that rises above human performance, the Aran Islands would remain inviolate, floating in his imagination where, gradually deprived of nourishment, they grew vaguer, though never disappearing.

To these islands, to Doolin as the guest of Macnamara, to Galway and the speckled hills of Connemara where Gogarty owned a house John already felt impatient to return, he told Quinn, to paint the landscape and 'some of the women'.[385]

But in order to return he had first to leave. Innes, who was staying with Lady Gregory, had suddenly appeared – 'God knows how'[386] – and together the two painters crossed back into Wales. John had been invited by Lord Howard de Walden, the amateur of all trades and descriptions, to go to Chirk Castle and paint his wife. Having separated from Innes and returned his family, safe and disgruntled, to Alderney, he rushed back to Wales again from the other direction to find Lady Howard de Walden, powerfully pregnant, ready and waiting for him. No foreigner to this condition, he did not hesitate, but took up his brushes and started to paint her, full length. But on seeing what he was up to she was horrified, protesting that the picture was cruel, while he endeavoured to explain that 'lots of husbands want it like that, you know'.* In the saga of this picture, and John's many visits to Chirk in order to complete it, lies much of the pattern his life would follow. After this first visit he wrote to Quinn (11 October 1912): 'I enjoyed my stay at the mediaeval Castle of Chirk. I found deer stalking with bows and arrows exciting. Lord Howard goes in for falconry also and now and then dons a suit of steel armour . . .' In such an atmosphere there was room for his ideas to expand without hindrance. 'Howard de W ought to be taken in hand,' he was soon telling Dorelia. His host had allowed second-rate people to 'impose themselves on him'. By way of a new regime he suggested substituting himself in their place as artist-in-residence. He would decorate, on a vast scale, the Music Room at

* John had painted a full-length portrait of Ida when she was pregnant. It is now in the National Gallery of Wales, Cardiff. 'It is a picture of a pregnant woman, painted with the assured brushwork of Hals or Manet, and a tenderness reminiscent of Rembrandt's,' wrote R. L. Charles, the Keeper of Art: 'mastery, depth and intimacy combined in a way hardly paralleled in British painting of its time.' *Amgueddfa*. Bulletin of the National Museum of Wales. 12. Winter 1972, p. 29.

Chirk: it was a grand scheme. But first there was the problem of her ladyship's portrait. It was, he told Quinn, extremely promising. He waited patiently till after the birth of her twins, started again, exhibited it half-finished, recommenced, changed her black hair to pink and threatened to 'alter everything'. Years went by: wars came. Her ladyship's nose, John complained, was an enigma. Finally he spoilt the painting beyond redemption, offering her in its place another picture. The Music Room was never begun. But he was not idle at Chirk; he painted all the time – small brilliant panels of the Welsh landscape which he conceived to be preliminary studies for his big non-existent Music Room decorations.

Chirk was a precursor of his later career. It saw the preliminary miscarriage before his birth as erratic portrait painter of fashionable and aristocratic sitters;* and, more indirectly, it saw too his death as a brilliant symbolist painter. 'Do you mind if I bring a friend?' he once asked Lady Howard de Walden. This was Derwent Lees. Recently John's opinion of Lees's work had risen. Despite his wooden leg, Lees had climbed up the outside of the Chenil Gallery and entered upon a seven-round combat with Knewstub:† it was impossible to think badly of such a man even when, to everyone's surprise, he suddenly got himself married to a model. 'I too was astonished by the Lees marriage,' Innes admitted to John (4 August 1913). '. . . I think I felt rather jealous of him. Well they looked very happy and so good luck to them.' A year later Innes was dead, but Lees could not take his place. He looked lost and white when John brought him to Chirk during a very smart week-end party and, it later transpired, was under the impression he had arrived at an expensive lunatic asylum. At night he would stand rigid in the corridors, a helpless pyjama'd figure, and when called upon for some explanation, whisper: 'I'm frightened. Can't sleep.' He had developed a short-hand method of speaking, like a child. 'Want to go for walk,' he would say. But when Lady Howard de Walden soothingly offered to accompany him, Lees objected: 'Can't. No gloves'. He did not feel safe without gloves. It was a symptom of the mental illness that by the end of the war put an end to his career as a painter and eventually killed him.

Although John obstinately admired the simple life, everything conspired to complicate his own. Chirk Castle was a fine example of this process. For his security John needed plans; but he also needed to

* 'I would much rather just do the things I want to do and leave people to buy if they want . . . I am not likely to make a success of fashionable people even if I tried to.' John to Quinn (29 September 1913).

† On another occasion Orpen aimed a gun at Knewstub, fired it, but missed him and shot a hole through one of his own pictures.

avoid the implications of these plans unless they were to become prisons for the future. He could not edit life, had not grasped the trick of saying no. He was impelled to say yes even when no one had asked him anything. He said yes now to the prospect of Lord Howard de Walden becoming a new patron. The difficulties that might follow with Quinn or even with Hugh Lane, whom he had similarly elected, were of no account. He looked only at the attractive side. He would need, for example, a new house – somewhere close to Chirk. On his first visit he had been introduced to the composer Joseph Holbrooke, 'an extraordinary chap . . . funniest creature I've ever met'.[387] With Holbrooke's friend, the artist Sidney Sime, they had set off on a number of wild motor rides around Wales, knocking up Sampson at Bala, descending on Lees at Festiniog, resting a little with Innes at Nant Ddu 'where I always keep a few bottles of chianti'; then scaling the Park gates at Chirk at three o'clock in the morning. 'The country round Festiniog was staggering,' he reported to Dorelia (September 1912), '. . . I have my eye on a cottage or two . . . I feel full of work.'

Having exhausted the possibilities at Nant Ddu, John decided to throw in his lot with Holbrooke and Sime, and the three of them took Llwynythyl, a corrugated-iron shanty consisting of a large kitchen, a living-room and four small cabins containing bunks, the upper ones reached by wooden ladders. On the inside it was lined with tongued and grooved pinewood planking, lightly varnished but otherwise left its natural colour. Into this remote bungalow in the mountains above the Vale of Festiniog, Holbrooke (who collaborated with Lord Howard de Walden on an operatic trilogy) imported a piano, and John imported Lily Ireland, a model of classic proportions who had never before strayed beyond the slum pastures of London. It was a desolate place, reached by a steep climb from Tan-y-grisiau, the nearest station, up an old trolley-shaft with a broken cable-winch at the top. The bungalow stood on a small plateau and commanded an extraordinary view across the valley to the range of mountains on the other side, above which the endless drama of the sky unfolded itself, and below the breathing land was draped in purple or shone suddenly in a dazzling coruscation of blue and gold.

The place was almost ready, and John prepared himself for a long painting expedition. In December he set off: for France. The weather was so gloomy he had decided to go south 'with the intention of working out of doors'.[388] At the New Year, Epstein reported him passing through Paris 'in good spirits'.[389] He planned to link up with Innes and Lees in Marseilles. From the Hôtel du Nord he wrote to Dorelia:

'Innes came yesterday morning. He looks rather dejected. Lees doesn't

appear to be well yet. He is going back to London. We have been wandering about Marseilles all day. When you come we might get another cart and donkey. I have advised Innes to go to Paris and get a girl as he is pretty well lost alone and must have a model . . . I don't know who you might bring over. Nellie Furr, that girl you said one day might be a bore although she has a good figure and seems amiable enough. It could of course make a lot of difference to have several people to pose.'[390]

Marching off each day into the country to 'look about', John would return late at night to Marseilles – and to Innes who, though invariably talking of his departure, would not leave. 'He is insupportable – appears to be going off his head and stutters dreadfully,' John complained. 'He wanted to come and work with me but I can't stand him for long.'

It was now Dorelia's turn to come south, bringing with her money, underclothing, a paintbox, some hairwash – but no model: and the three of them moved, in some dejection, to the Hotel Basio at St Chamas. 'It is a beautiful place,' John told Mrs Nettleship, 'on the same lake as Martigues but on the north side.' No sooner had they settled in than Innes fell seriously ill. 'He had had a very dissipated time at Perpignan and was quite run down,' John explained to Quinn (2 February 1913). 'Finally at St Chamas . . . he was laid up for about a week after which we took him back to Paris and sent him off to London to see a doctor . . . The company of a sick man gets on one's nerves in the end.'

Though he spent part of August in Paris in the strange company of Epstein, J. C. Squire and Modigliani (from whom he bought 'a couple of stone heads'), John did use his new Welsh cottage during 1913, passing all July there and all September. The paintings he did in these two months were exhibited during November in a highly successful show at the Goupil Gallery. His letters show that he was working in tempera, a technique of painting that had the advantage of putting him physically in closer touch with the fifteenth-century Italians from whom he sought inspiration, and his own recipe for which he passed on to younger British artists such as Mark Gertler.* He was also attempting to work on a larger scale than before. At the end of 1911 his large 'Forza e Amore' had been hung at the New English Art Club to the bewilderment of almost everyone. At the end of 1912 he showed 'The Mumpers'. 'The N.E.A.C. has just been hung,' he wrote to John Hope-

* In the summer of 1912, Gertler wrote that John 'proceeded to give me some very useful "tips" on tempera,' and by September he was writing: 'Just think, I have actually done a painting in that wonderful medium tempera, the medium of our old Great friends! . . . I love tempera.' See *Mark Gertler* by John Woodeson, pp. 81, 100.

Johnstone (20 November 1912). 'I suddenly took and painted my cartoon of Mumpers – in Tempera, finished it in 4½ days, and sent it in. In spite of the hasty workmanship, it doesn't look so bad on the whole. I have also an immense drawing of the Caucasian Gypsies [Calderari].' Again, at the late New English show of 1913, he exhibited another huge cartoon, 'The Flute of Pan', which was the 'chief attraction'.* All these years, too, he had been struggling with Hugh Lane's big picture, subsequently called 'Lyric Fantasy'. On 28 October 1913 he was writing to Ottoline Morrell: 'I am overwhelmed with the problem of finishing Lane's picture.' He had hoped to show it at the next New English. On 29 December he confided to Quinn that it 'will soon be done'; and again on 16 March 1914 he is 'actually getting Lane's big picture done at last'. So it went on until, in 1915, Lane was drowned on board the *Lusitania*, at which opportunity John abruptly ceased work on it altogether. Had Quinn himself had the tact to die prematurely, there seems every likelihood that his big picture 'Forza e Amore' would have survived.† But these gargantuan paintings complicated John's life flagrantly. Despite this epidemic of long unfinished pictures, John was working harder than ever before and producing much of his best work. This was often achieved as an offshoot to what he considered really important – as preliminary studies for larger decorations, panels knocked off while on holiday, or pictures done as designs for Dorelia's embroidery. His output was prodigious. He held shows almost every

* John Currie to Mark Gertler. It comprised three female, four male figures, and a boy, all life size. 'Some say it is the best thing I've done and some the worst,' John told Quinn (26 January 1914).

† This picture had originally been promised to Quinn in 1910. Quinn's inquiries about it met with little response until 19 February 1914 when John announced that he was now able to 'simplify the problem by confessing that I have *painted it out* some time back. I had it down here [Alderney] to work on, and after reflection decided I could not finish it to my satisfaction (without the original models) and thought I would paint you another picture which would be a great deal better. The cartoon lately at the N. English (The Flute of Pan) was started with that object. In course of doing it I added the right portion of the design, consisting of landscape which makes it about a third larger than "Forza e Amore". As to Lane's claim to this last – it originally formed part of a much larger scheme which on my break with him I did not carry out . . . I am damn sorry you were so set on the "F. e A." I was merely conscientious in painting it out as I did. But you will like The Flute of Pan better and the price of course will be the same.'

Quinn was horrified at this news, and John assured him (16 March 1914) he was not alone. 'I was at Lane's lately and told him I had painted out "Forza e Amore". Words failed him to express his horror . . . He implored me to send it up to him and let him have the coat of white I gave it taken off. Shall I? I suppose I was a bloody fool to do it.' Three months later (24 June 1914) he confirmed that Quinn had 'the only real claim to the picture' – adding that he was now certain the white coat could not be removed successfully.

year at Chenil's, sometimes covered whole walls at the New English, struggled on with his private commissions, and regularly sent work in to the Society of Twelve and the National Portrait Society of which, in February 1914, he was elected President. What caused the muddle in his life was also midwife to his best work – a sense of urgency, assisted very often by financial pressure. So as to grapple with his problems John made a habit of externalizing them. But what he grappled with was some phantom rather than the problem itself, at best a symptom. Whenever he felt dull or ill he fixed the blame on people and places, and would demand a change. These changes often brought with them an immediate lifting of his spirits, but would quickly lead to complications even worse than those he had fled from.

For a short time early in 1913 he populated a bewildering number of houses acquired through this process of change. There was Alderney which he shared with Dorelia and his family; Nant Ddu which he shared with Innes; Llwynythyl which he shared with Holbrooke and Sime; the Villa St Anne at Martigues which he shared with the mad bird-man Bazin; and 181A King's Road, Chelsea, which he shared with Knewstub. Nevertheless he felt restless. The cure he settled on was a new London house and studio. Entering a public house in Chelsea, he demanded to know whether there was an architect present and then commissioned a Dutchman he had never met before who happened to be drinking at the bar. The simple part of the business was now over.

Van-t-Hoff, as this architect was called, 'takes the studio very seriously', John promised Dorelia. '. . . He is going back to Holland to *think hard.*' After a long interval of slumbering thought, John was obliged to summon him back by cable. By 13 May 1913 he confidently reported to Quinn: 'My Dutch architect has done his designs for my new studio with living rooms – and it will be a charming place. They will start building at once and it'll be done in 6 months. How glad I shall be to be able to live more quietly – a thing almost impossible in this studio. My lawyer strongly urges me to try and find the money for the building straight away instead of saddling myself with a mortgage. The building will cost £2,200.' John would have liked to offer all the responsibilities for this property to others – looking in from time to time to pass, over the rising pile, his critical eye. But lawyers, estate agents, builders and decorators were constantly importuning him. 'I can't be rushing all over London and paint too, not having the brain of a Pierpont Morgan,' he complained to Dorelia. Nor was it just his time for which these people were so greedy. 'I shall want all my money and a good deal of other people's,' he explained to John Hope-Johnstone (8 September 1913). His letters to Quinn are congested with money proposals, the nicest of which is a scheme to save costs by building two

houses, the second (at some considerable distance from the first) for his patron. 'The materials will be of the best,' he assures him, 'and I think it will be a great success.' His own house continued to rise, his funds to sink and his spirits to oscillate between optimism and despair. He had decided to move in during the autumn, but when autumn came the house still had no roof. 'It'll be ready in January,' he declared: adding with some desperation, 'I feel rather inclined to try another planet.'[391] By February 1914 he had not retreated an inch. 'The house is getting on well and will be done in three weeks Van-t-Hoff thinks,' he informed the silent Dorelia (26 February 1914). Three weeks later it was 'nearly done' and being 'much admired'. By April John is again ready to move – but to Dieppe where he aims to hold out until the house is equipped to receive him. After what turns out to be a fortnight round Cardigan-shire and, in June, one week at Boulogne he returns to Chelsea and, though the house is still incomplete, decides to occupy it and hold a party 'to baptize my new studio'.[392] This party, a magnificent affair in fancy dress, lasts from the first into the second week of July.

'The company was very charming and sympathetic, I thought,' wrote an early guest, Lytton Strachey,[393] " – so easy-going and taking every-thing for granted; and really I think it's the proper milieu for me – if only the wretches had a trifle more brain . . . John was a superb figure. There was dancing – two-steps and such things – so much nicer than waltzes – and at last I danced with him [John] – it seemed an oppor-tunity not to be missed. (I forget to say I was dressed as a pirate). Nina Lamb was there, and made effréné love to me. We came out in broad daylight.'

The site on which John had raised this house was in Mallord Street,* parallel to the King's Road and just off Church Street, where he had lived six years before. It was like a dolls' house, a charming, impractical square place, beautiful but unfitted to contain John and his family. Steep steps led up to the front door, behind which the rooms were poky and, in spite of the sun streaming in from the south over the market gardens, dark. The windows were long and thin and well-propor-tioned; yet they appeared almost unopenable and, when children appeared behind them, looked like iron-barred cages. With its mid-tone panelling it was a gloomy, if not unfriendly, interior. The best feature was the staircase which, copied from Rembrandt's house, floated grace-fully upwards. In the drawing-room Boris Anrep designed a superb mosaic, a pyramid of the wives and children with John at its apex, that glowed a dull green as if from the depths of the sea. At the back lay the

* It was originally No. 5, but the numbering was changed later that year and it became No. 28.

great studio. With its sloping ceiling, deep alcove, two fires burning at opposite corners, it conveyed a sense of hemmed-in space, like the exercise yard of a prison. 'The studio looks fine,' John told Quinn (24 June 1914). But even in these early days he recognized the prison-like atmosphere of the place. 'It is quite a success I think. It has nearly ruined me,' he wrote to John Hope-Johnstone. '. . . It certainly is rather Dutch but has a solidity and tautness unmatched in London – a little stronghold. I hope I shall find the studio practical.' The studio was perhaps the most practical area – a good place to paint and an excellent arena for parties. But within two years the 'little stronghold' had crumbled into 'this damned Dutch shanty'.[394] John felt incarcerated there and his dissatisfaction, which he attributed to the Dutchman's 'passion for rectangles',[395] was added to by Dorelia's dislike of the place – even the roof garden faced north.

By this time he had shed his two Welsh cottages. Nant Ddu went first. Between February 1913 and August 1914 he did not see Innes who, in an attempt to regain his health, had gone to Tenerife with Trelawney Dayrell Reed. Llwynythyl was given up in 1914.* The place had gone sour on him. He tracked down the source of this feeling to the presence of Joseph Holbrooke and the noise he made at meals. 'I don't think I can stand him and will probably leave at the end of the week . . . I could get on with Sime but Holbrooke is too horrible.' While Holbrooke, it appeared, had 'a tune constantly playing in his left ear', the 'man Sime' seemed one of Nature's gentlemen – strongly built, with a cliff-like, overhanging, tyrannous forehead, eyes of superlative greyish-blue and a look (which grew fixed at Llwynythyl) of pathetic patience.[396]

In place of Wales, John had hit upon 'the only warm place north of the Pyramids'[397] during winter: Lamorna Cove, near Penzance in Cornwall where he met 'a number of excellent people down in the little village . . . all painters of sorts'[398] – John Birch, Harold and Laura Knight, and Alfred Munnings† – 'and we had numerous beanos'. These 'beanos', which led to invitations to continue them in London, were

* Llwynythyl was later taken by the composer Granville Bantock. His daughter remembers that John 'had drawn an enormous mural in white chalk of angel figures covering the entire end wall of the sitting-room. . . . We discovered a whole pile of discarded oil paints and brushes, together with many crumpled sketches. We salvaged and smoothed out two of these sketches and I still have one of them . . . an amusing cartoon of a woman sitting at a table and trying to work; around her pots and pans are flying through the air, a tradesman presents bills and a half-naked baby screams on the floor.'

† John went out sketching with Munnings, listening carefully to Munnings's theory that a horse's coat reflects the light of day, and then, after silent reflection, gruffly demanding: 'If you see a brown horse, why not paint it brown?' Many years later John told E. J. Rousuck that Munnings's horses had 'better picture quality,

terrifying affairs. 'We feared,' Dame Laura Knight recalled, 'to shorten our lives.'[399] John would perform all manner of amazing tricks – opening bottles of wine, tenderly, without a corkscrew; flicking, from a great distance, pats of butter into people's mouths; dancing, on point in his hand-made shoes, upon the rickety table, and other astonishing feats until dawn. Then, while the others collapsed into exhausted sleep, out he would go in search of Dorelia, and do little studies of her in various poses on the rocks: 'He never did anything better'.[400] The local community was much agitated by these parties, by the mortal sin of Sunday painting and Dorelia's brazen habit of walking abroad on that day without a hat. But John was delighted with the place. 'I found Cornwall a most sympathetic country,' he wrote to Quinn on his arrival back at Alderney (19 February 1914). '. . . There are some extraordinarily nice people there among the artists and some very attractive young girls among the people.'

John was in the Café Royal the night war was declared. 'I remember our excitement over it,'[401] he wrote. One of their friends carried the news among the waiters, and John, very perturbed, turned to Bomberg: 'This is going to be bad for art.' Much of that August he spent with Innes, who, indifferent to the tremors of war, was dying. To John himself the war threatened to make little personal difference: a disappointing prospect. With Dorelia pregnant once more and, also by John, one of his models, the future seemed to promise simply more of the same. But though he took no exaggerated part in this war, it was to affect him in ways that were lasting.

better groupings' than Stubbs's. See *The Englishman* by Reginald Pound pp. 50, 51, 201.

How He Got On

'Kennington and John: both hag-ridden by a sense that perhaps
their strength was greater than they knew. What an uncertain,
disappointed, barbarous generation we war-timers have been.
They said the best ones were killed. There's far too much talent
still alive.'

T. E. Lawrence to William Rothenstein (14 April 1928)

1. MARKING TIME

'Wadsworth, along with Augustus John and nearly everybody, is
drilling in the courtyard of the Royal Academy, in a regiment for home
defence,' wrote Ezra Pound that autumn to Harriet Monroe. It was the
last occasion John would find himself so precisely in step with other
artists. The war's immediate effect on him had been to clarify life. His
letters grew more portentous, nearer in tone to those of his father: full
of the stuff to give the troops. Already in the first month, the sight of
fifteen hundred territorials plodding up Regent Street swells him with
pride: 'they looked damn fine'.[402] And by the end of the war he was to
feel anxiety lest the Germans be let off too lightly. 'The German hatred
for England is the finest compliment we have been paid for ages,' he
assures Quinn on 12 October 1914. To some extent he seems to have
fallen victim to war propaganda, though never to war literature. 'The
atrocities of the Germans are only equalled in horror by the war poems
of the English papers,' he writes to Ottoline Morrell in 1916. 'What
tales of blood and mud!' In addition to what he reads in the papers, he
absorbs confidential matter from his various khaki sitters, repeating
strange stories of lunatic generals on whom he fixes the blame for all
defeats. 'As for the men, they are beyond praise.'[403] By the spring of
1916 he is looking forward to being able to 'swamp the German lines
with metal'.

John's attitude to the war remained consistent: but his emotions, as
he lived through it, veered hectically. At first he is excited; by the end
it has aged him, and he is no longer the same person. He started out
smartly in step, but it left him far behind, marching on to build a world
where he could never feel at home. From the beginning he wanted to
'join in' – 'it's rather sickening to be out of it all'.[404] His predicament
is set out in a letter (10 October 1914) to Quinn:

'I have had more than one impulse to enlist but have each time been
dissuaded by various arguments. In the first place I can't decide to leave

my painting at this stage nor can I leave my family without resources to go on with. I feel sure I shall be doing better to keep working at my own job. Still all depends on how the War goes on. I long to see something of the fighting and possibly may manage to get in [in] some capacity. I feel a view of the havoc in Belgium with the fleeing refugees would be inspiring and memorable. Lots of my friends have joined the army. The general feeling of the country is I believe quite decent and cheerfully serious – not at all reflected by the nauseating cant and hypocrisy and vulgarity of the average Press. There is no lack of volunteers. The difficulty is to cope with the immense number of recruits, feed and clothe and drill them. There are 20,000 near here, still mostly without their uniforms but they have sing-songs every night in the pubs till they are turned out at 9 o'clock.'

The war intensified John's sense of exclusion; and by curtailing freedom of movement it aggravated his tendency to claustrophobia. Apart from a vain trip to Paris in December 1914 to persuade Gwen to come back to England for the duration of the war,* he did not return to France for three-and-a-half years. 'I feel the nostalgie du Midi now that there's no chance of going there,' he told Ottoline.[405] '. . . I commence the New Year rather ill-temperedly'. The dark days, from which there was now no escape, made work uncertain. It seemed as if his life had all the conditions of an illness, and he began to develop numerous symptoms about the head and legs that 'put me quite out of action'[406] and accounted, as it were, for his long civilian incarceration.

Ireland now took the place of France. He made several visits to Dublin, to Galway and Connemara – but even here there was not the same independence as before. The men were going off 'to fight England's battles', and there was a great wailing on the platforms as their women saw them off. 'I have found a house here,' he wrote to Dorelia from Galway City,[407] 'with fine big rooms and windows which I'm taking – only £30 a year . . . I had a bad attack of blues here, doing nothing, but the prospect of soon getting to work bucks me up.' This house was in Tuam Street and owned by Bishop O'Dea who leased it to John for three years on the understanding that no painting from the nude was to be enjoyed on the premises. John's plan was to execute a big dramatization of Galway bringing in everything characteristic of the place. He explained this scheme to Dorelia (5 October 1915):

'I'm thinking out a vast picture synthesizing all that's fine and characteristic in Galway City – a grand marshalling of the elements. It

* 'I offered to fetch her [Gwen John] over to England but she refused to leave Paris,' John wrote to Quinn on 10 October 1914. Two months later he went over and repeated his offer – 'otherwise she is likely to suffer great hardship' – but Gwen, as he had predicted, stayed on.

will have to be enormous to contain troops of women and children, groups of fishermen, docks, wharves, the church, mills, constables, donkeys, widows, men from Aran, hookers* etc., perhaps with a night sky and all illuminated in the light of a dream. This will be worth while – worth the delay and the misery that went before.'

He went out into the streets, staring, sketching: and was at once identified as a bearded spy. Bathing – 'the best tonic in the world' – was reckoned to be a misdemeanour in wartime; and sketching in the harbour a treason – 'so that is a drawback and a big one'. In a letter to Ottoline Morrell, with whose portrait he was attempting to wrestle from memory, he complained: 'There are wonderful people and it is beautiful about the harbour but if one starts sketching one is at once shot by a policeman . . . It would be worth while passing 6 months here given the right conditions.'

But the right conditions for John's type of work were elusive. The spirit of the place seemed to be evaporating. Without disobeying the letter of Bishop O'Dea's injunction, 'I had two girls in here yesterday,' he admitted to Dorelia, 'but they didn't give the same impression as when seen in the street. I could do with some underclothing.' He was desperately anxious not to return to Alderney 'till I've got something good to take away'. Every day he would go out and look, then hurry back to Tuam Street and do some drawings or pen-and-wash sketches. 'I've observed the people here enough,' he eventually wrote to Dorelia.

'Their drapery is often very pleasing – one generally sees one good thing a day at least – but the population is greatly spoilt now – 20 years ago it must have been astonishing . . . Painting from nature *and* from imagination spells defeat I see clearly.'

Imagination meant in practice memory. His imagination was kindled, by some perception of beauty, instantly: then the good minute went. He had to catch it before it began to fade, rather than try to recollect it in tranquillity. Yet now there seemed no alternative to a retrospective technique – what he called 'mental observation'.[408] After vacillating for weeks between the railway station and the telegraph office, he left. 'It was in the end,' he explained to Bernard Shaw,[409] 'less will-power than panic that got me away.'

He had been at Galway two months. After his return to Alderney he began to work feverishly at a large cartoon, covering four hundred square feet in a single week. Once again he was racing against time. He wanted, before they had clouded over, to use his actual observations – all those one good things a day – to build up a composite picture of an

* A two-masted fishing-boat of Dutch origin used off the west coast of Ireland. John had a scheme for buying one for fifty pounds.

ideal Galway: a visionary city locked deep in his imagination to which, all his life, he was searching to find the key.

War offers some painters a unique opportunity to record and interpret unusual sights. Lamb, Lewis, Paul Nash, C. R. W. Nevinson, William Roberts and Stanley Spencer were among the artists who seized this opportunity and contributed to a group of pictures unexampled in modern British painting. Many of John's friends, such as McEvoy and Orpen,* had long ago succumbed to an unnourishing diet of fashionable portraiture. John, like William Nicholson, also painted commissioned portraits to earn money; but they were not especially fashionable and he had never been corrupted by them. By 1914, in a hit-or-miss fashion, he was still painting in his best vein. 'Of course painters as good as John will always sell,' Sickert assured Nan Hudson, 'war or no war'. But the war put pressures on him. 'I am afraid we are in for thin times over here,' he explained to Quinn.[410] 'No one will want luxuries like pictures for awhile.' Nevertheless he continued to paint those pictures, such as 'Galway', for which, he felt, his talent was best suited: landscapes, decorative groups, paintings of his family. In the past he had sold such work better than any of his contemporaries, but after 1914 this was no longer possible. Partly for financial reasons, but partly also because he did not want his work to be wholly irrelevant to the business of the war, he began to paint a different sort of picture. 'I am called upon to provide various things in aid of war funds or charities connected with the war,' he told Quinn.[411] Among his sitters were several staff officers and in 1916 the bellicose Admiral Lord Fisher who brought in tow the Duchess of Hamilton,† to whom John transferred part of his attentions, while Fisher, with measured quarter-deck stride, explained how to 'end the war in a week'.[412] When this portrait was shown at the N.E.A.C., Albert Rutherston noted that it was 'careless and sketchy';[413]

* 'McEvoy is in a state of exultation bordering on hysteria – the result of painting duchesses and other nobilities.' John to Dorelia (1915). Many years later, on 5 January 1944, John wrote to D. S. MacColl: 'I have always thought the absurd superstition that Orpen was in any sense an artist should be scotched. Personally he had nice qualities though he had all the disadvantages of arrested growth.'

† This commission to paint Lord Fisher had come through Epstein, who had recently done a bust of Fisher for the Duchess of Hamilton. 'Fisher, while I was doing the bust, asked me if I knew of a painter who I thought would do a portrait of the Duchess for him; and said he thought of getting Laszlo the Austrian to do it,' Epstein wrote to Quinn (14 June 1916); 'but I told him he *must get John*, so I've been arranging to have John paint the Duchess's portrait. . . . I couldn't see Laszlo preferred to him.' When the proposal reached John, it was to do a portrait of Fisher – with a chance of painting the Duchess of Hamilton afterwards if there was time: an arrangement that may have accounted for his rather hurried treatment of the Admiral. John began a portrait of the Duchess and visited her on several occasions.

and the *Times*[414] critic observed that John had really painted a zoo
picture of Fisher as a 'Sea-Lion . . . hungering for his prey'. On the
whole these public portraits of war celebrities are not good, perhaps
because John could not orchestrate his public sentiments with private
feelings. In his correspondence he is often generously approving of
these bold statesmen and soldiers; but when he actually came face to
face with them he felt unaccountably bored. In the circumstances he did
not think it proper outrageously to caricature them as he had done the
Lord Mayor of Liverpool. Some satire, in a muted form, does come
through: but seldom convincingly.

Perhaps the most interesting of these war pictures was that of Lloyd
George. It was towards the end of 1915 that Lloyd George surrendered
to the proposal that John should paint him. A suitable canvas had been
bought by Sir James Murray in aid of Red Cross Funds, the arrange-
ment being that John would paint whomever Murray, a friend of Lloyd
George, designated. Like some marriage broker, Murray settled up the
agreement between them, then discreetly retired, confident that the two
Welshmen would get on like fireworks. In fact, since they had just the
wrong things in common, they did not take to each other. The poetry of
their natures was rooted in Wales: England had magnetized their ambi-
tions. But their ambitions were different. Happy as a child, pampered by
his family, Lloyd George was greedy for the world's attentions. John in
his childhood had felt deprived of love, and sought to evoke an ideal
world set in those places of natural beauty politicians call the wilder-
ness. 'I feel I have no contact,' Lloyd George once told Frances
Stevenson. John too had no contact by the end: but he had been reach-
ing for other things.

In public, at least, John admired Lloyd George. He was 'doing good
work over Munitions' and would surely have made a better business
than Asquith of leading the country to victory. 'One feels that what
really is wanted is a sort of Cromwell to take charge,' he told Quinn,[415]
'having turned out our Parliamentarians into the street first'. The Welsh
wizard who was to play the part of Cromwell does not seem to have
dazzled John when they first met a year before in Wales; and as a sitter
he was highly unsatisfactory. He had agreed 'to sit for half an hour in
the mornings'[416] but, John complained, was 'difficult to get hold of'. The
portrait lurched forward in short bursts during December, January and
February. On 16 February 1916 John wrote to Quinn: 'I have finished
my portrait of Lloyd George. He was a rotten sitter – as you say a "hot-
arse who can't sit still and be patient".' It was a restlessness, eventually
dissolving into incoherence, that consumed them both. Lloyd George
may not have appreciated being placed, in order of priority, behind the
actress Réjane whom John was then also painting, and indiscriminately

shoulder to shoulder with 'some soldiers'. According to Lloyd George's mistress, Frances Stevenson,[417] 'the sittings were not very gay ones'. Lloyd George was 'in a grim mood', suffering, in addition to toothache, from the latest Serbian crisis. Nevertheless, this cannot wholly account for his testy expression – 'a hard, determined, almost cruel face,' Frances Stevenson noted angrily in her diary,[418] 'with nothing of the tenderness & charm of the D[avid] of everyday life'. 'Do you notice what John says about pictures which he does not like?' he had asked her. 'Very pleasant!' He was 'upset', she realized, 'for he likes to look nice in his portraits!' Another worry was Frances herself. Though professing to find John 'terrifying', she acknowledged him to be 'an uncommon person . . . extraordinarily conceited . . . nevertheless . . . very fascinating.' Lloyd George responded to this threat with a most practised performance. He discouraged her from having her own portrait painted by John (though she generally admired his work) and, to her disappointment, expressly prohibited her from accepting invitations to his parties. Confronted by John's 'unpleasant' portrait he reverted to nursery tactics, gathering his family round him (much to John's irritation) in a chorus of abuse over the object, and provoking in 'Pussy' Stevenson her most protective vein. To account for the cunning, querulous expression, he suggested in public entitling the picture 'Salonika'. Then, having wrapped up this awkward incident, he affected to forget about it.[419] But John remembered. Announcing his first portrait to have been 'unfinished', he caught up with Lloyd George nearly four years later in Deauville,* rapidly drew his brushes and began a second canvas. Under his fierce gaze Lloyd George grew restless again, hurried back to London and, wisely, did not honour his promise to continue the sittings at Downing Street. For John this was a foretaste of how his career as a professional portrait painter, particularly of men in public life, would proceed.† As his powers waned, so increasingly

* At the Villa la Chaumière in September 1919.

† In Winston Churchill, whom he drew after the Second World War, John observed the same strange inability to keep still. Under John's scrutiny, Churchill seemed reduced to the condition of a restless child. His concern, like that of Lloyd George, was for his 'image'. How else to explain, John wondered, 'these fits and starts, these visits to the mirror, this preoccupation with the window curtains, and the nervous fidgeting with his jowl?'

A less quick-footed target was Ramsay MacDonald whom John vainly attempted to paint on a number of occasions. The difficulty here seems to have been that the sitter proved too dim a subject to illuminate the romantic interpretation of a 'dreamy knight-errant, dedicated to the overthrow of dragons and the rescue of distressed damsels' which John, perverse to the point of irony, insisted upon trying to fix on him. 'John's portrait was a melancholy failure,' Ramsay MacDonald admitted to Will Rothenstein (23 August 1933). 'It really was a terrible production, and everybody who saw it turned it down instantly. He wants to begin again, but I am really

he relished the prospect of meeting the famous. But invariably the prospect was better than the experience – except, sometimes, in the case of other artists and writers.

These portraits, especially of writers, comprise a separate section of his work – not private in the same way that 'Washing Day' or 'The Red Feather' are private, but not to be classed among what Quinn fretfully described as his 'colonels and fat women, and . . . other disagreeable pot-boilers'.[420] Among the writers who sat to him in the war years were W. H. Davies,[421] Ronald Firbank, Gogarty and Arthur Symons. The most celebrated was Bernard Shaw, of whom, during May 1915, he did three portraits in oil.

Shaw was staying at Coole over Easter with Lady Gregory when his unresting industry was suddenly halted by an atrocious headache. 'Mrs Shaw was lamenting about not having him painted by a good artist,' Lady Gregory wrote to W. B. Yeats,[422] 'and I suggested having John over, and she jumped at it, and Robert [Gregory] is to bring him over on Monday.' In the event John seems to have travelled more erratically, catching 'a kind of cold'[423] in Dublin on his way and arriving very morose. His symptoms deepened on discovering that Lady Gregory had used Shaw as bait for a portrait of her grandson 'little Richard'* whom, until now, he had successfully avoided. Although John made no secret of his preference for little Richard's sister, Anne Gregory, 'a very pretty little child with pale gold hair,' Lady Gregory insisted that it must be the son of the house who was honoured. So he began this 'awful job', producing what both children found 'a very odd picture . . . [with] enormous sticky-out ears and eyes that sloped up at the corners, rather like a picture of a chinaman . . .'†[424]

tired. The waste of my time has been rather bad. He made two attempts and an earlier one some time ago. In all I must have given between 20 and 30 sittings of 1½ hours' average, and I cannot afford going on unless there is some certainty of a satisfactory result . . .'

The most satisfactory result among John's flock of prime ministers was achieved at the expense of A. J. Balfour who, under the acid test of his pencil, fell asleep. His philosophy of doubt, which always appealed to John, seemed to coincide with his appearance and reached a culmination in his slumbering posture. 'I set to,' John records, 'and completed the drawing within an hour.'

* Lady Gregory remembered this rather differently. In *Coole*, she wrote: 'John asked while he was here if he might paint Richard, and I, delighted, reading a story to the child, kept him still for the sitting. I longed to possess the picture but did not know how I could do so without stinting the comforts of the household, and said no word. But I think he must have seen my astonished delight when he gave it to me, said it was for me he had painted it. That was one of the happy moments of my life.' She also added: 'I had from the time of his birth dreamed he might one day be painted by that great Master, Augustus John, yet it had seemed but a dream.'

† 'Augustus John had been very annoyed at being thwarted, and had given

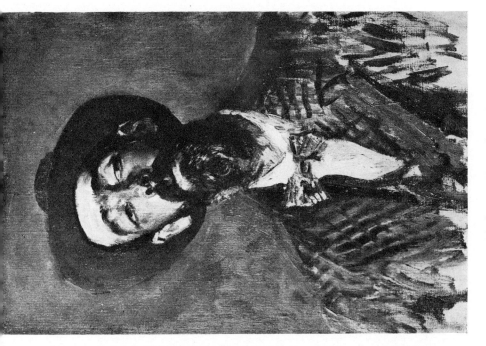

Trelawney Dayrell Reed

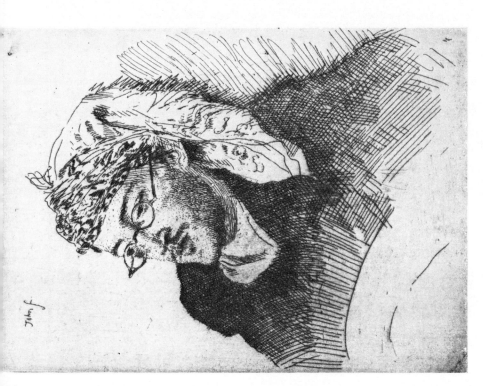

John Hope-Johnstone

Dorelia, Vivien and Poppet John

Meanwhile, in his bedroom, Shaw was preparing himself. He had recovered from his headache to the extent of having his hair cut, but in the excitement, Lady Gregory lamented,[425] 'too much was taken off'. Despite Shaw's head and John's cold, both were at their most winning by the time the sittings began.

Each morning John would strip off his coat, prop his canvases on the best chairs and paint several versions at one sitting. Whenever he was dissatisfied he washed the whole canvas clean and started another in its place. 'He painted with large brushes and used large quantities of paint,' Shaw remembered.[426] Over the course of eight days he painted 'six magnificent portraits of me,' Shaw wrote to Mrs Patrick Campbell.[427] '. . . Unfortunately as he kept painting them on top of one another until our protests became overwhelming, only three portraits have survived'.

Between sittings John went off for 'some grand galloping'[428] with Robert Gregory, or, more sedately, would row Mrs Shaw across the lake. 'Mrs Shaw is [a] fat party with green eyes who says "Ye-hes" in an intellectual way ending with a hiss,' he divulged to Dorelia. Over thirty years later, in *Chiaroscuro*,[429] John described Shaw as 'a true Prince of the Spirit, a fearless enemy of cant and humbug, and in his queer way, a highly respectable though strictly uncanonical saint'. In his letters to Dorelia at the time he refers to him as 'a ridiculous vain object in knickerbockers' and describes the three of them – Lady Gregory and the Shaws – as 'dreadful people'. Such discrepancies were odd notes played by John's violently fluctuating moods which, from about this time onwards, were to grow more exaggerated. Together they orchestrate his personality on an increasingly discordant pattern: but in isolation they are almost meaningless – unconnected points in a contour-map that, to the untrained eye, can be misleading. It is the published, retrospective account that, strangely, gives more of the truth than the correspondence. What lies concealed under a patina of public deference is the extraordinary inconsistency that was becoming so characteristic of him. His admiration of Shaw was qualified by the extreme awe radiated towards him from the women in the house. This veneration combined with John's hearty silence to stimulate in Shaw the kind of brilliant intellectual monologues to which John (only partly for reasons of vanity) was allergic. What, after all, is more boring than 'brilliance'?

'I find him [Shaw] a decent man to deal with,' John notified Quinn,[430]

Richard that funny look to pay Grandma out! The picture of Richard was hung in the drawing-room, on the left of the big fireplace.' Anne Gregory also remembered that John 'was large and rather frightening to look at, and we felt he might step on us, as he seemed to stride about not ever looking where he was going'. *Me and Nu*, Chapter VIII.

after Shaw had decided to buy one of the portraits for three hundred pounds – the one with the blue background.* His head, as Shaw had pointed out, had two aspects, the concave and the convex. John produced two studies from the concave angle, and a third (with eyes shut as if in deep thought) from the convex – 'the blind portrait' Shaw called it[431]: adding in a letter to Mrs Patrick Campbell that it had 'got turned into a subject picture entitled Shaw Listening to Someone Else Talking, because I went to sleep . . . '. With this sleeping version John was never wholly satisfied. 'It could only have happened of course in the dreamy atmosphere of Coole,' he suggested[432] to Shaw.†

On the whole Shaw was delighted with these portraits, especially the one he held on to all his life – 'though to keep it in a private house seems to me rather like keeping an oak tree in an umbrella stand'.[433] In the regular Irish manner, like Yeats, he boasted that 'John makes me out the inebriated gamekeeper'; but in later life he would tell other artists wishing to paint him that since he had been 'done' by the two greatest artists in the last forty years, Rodin and John, there was no room for more portraits.‡

John exhibited the portrait with the blue background at the summer show of the N.E.A.C. in 1915; and in February 1916 he held an exhibition of twenty-one paintings and forty-one drawings at the Chenil Gallery. It was, perhaps, his last effort to pursue something of what he had been doing before the war. The tone of many reviews was caught by the *Times* critic who, under the heading 'Empty Accomplishment',

* Of the three portraits Shaw temporarily owned two. In 1922 he presented one of these to the Fitzwilliam Museum, Cambridge. 'I note that you are keeping the best – with the blue background – which I suppose still adorns one of the top corners of your room at Adelphi Terrace,' John wrote to him (24 March 1922). This portrait is now at Ayot St Lawrence and belongs to the National Trust.

† He attributed the expression to Shaw's intake of midday vegetables, though admitting (16 May 1915) that 'the one in which you have apparently reached a state of philosophic oblivion is perhaps liable to misinterpretation'. It was originally credited with the title 'The Philosopher in Contemplation' or 'When Homer Nods'. It was bought by an Australian who later sold it in London where it was purchased by the Queen. It now hangs in Clarence House.

‡ Between John's portrait and Rodin's bust, which had been done a few years earlier, Shaw differentiated. 'With an affectation of colossal vanity, Shaw gestured and genuflected before the Rodin bust of himself when I once visited him,' Archibald Henderson wrote (*George Bernard Shaw: Man of the Century*, 1956 edn., p. 789); 'but during a later visit delightedly rushed me into the dining-room to see the Augustus John poster-portrait, in primary colours – flying locks and breezy moustaches, rectangular head, and caricaturishly flouting underlip. To the John portrait he pointed with a delicious chuckle: "There's the portrait of my great reputation"; then pointing to the Rodin bust, he breathed: "Just as I am, without one plea". But it is arguable that, by 1915, Shaw's protective covering was complete, and G.B.S., the public personality, had eclipsed the man as he was.

concluded that 'Mr Augustus John continues to mark time with great professional skill'. The eyes of critics and painters were now fixed on him to see in what new direction he would set off.

2. THE VIRGIN'S PRAYER

'A house without children isn't worth living in!' John had once pronounced. His sons, no longer to be classed simply as children, now passed much of their time at schools and colleges: but the supply of fresh children to Alderney went on unchecked. In March 1915, in a room next to the kitchen, John presiding, Dorelia gave birth to a second daughter, described as 'small and nice',[434] whom they named Vivien. By the age of two she had grown into 'a most imposing personage – half the size of Poppet, and twice as dangerous'.[435] Through the woods she liked to wander with her nanny, 'a beautiful Irish setter called Cuchulain . . . he patiently bringing me home for meals at the toll of the great bell'.[436] Unlike the boys, neither Poppet nor Vivien was sent to school. 'We roamed the countryside,' Vivien recalled, 'and a tutor cycled over from Bournemouth to teach us. Finally we punctured his bicycle . . .'

In 1917 four more children had joined the Alderney gang – John, Nicolette, Brigit and Caitlin. These were the son and daughters, 'robust specimens' aged between seven and three, of Francis Macnamara, who, after seven years of happy and unfaithful marriage, had left home permanently to live with Euphemia Lamb (who had briefly left someone else's home to live with him). Cut adrift, his children had circled slowly in the wake of their mother who, helpless and half-French, was eventually towed down to Alderney out of reach of the zeppelins. Because of this splintered upbringing one of the children, Nicolette, elected John as her second father. On the strength of her confinement at Alderney over one summer – an unremarkable period for visitors to stay on following a cup of tea – she invented Alderney as her new home and conceived for the John ménage an exaggerated loyalty not always wholeheartedly appreciated by them. Yet her feelings give an intensity to her memories of Alderney, despite some lapses from fact:

'In my memory the bedrooms were small boxes with large double beds. Poppet and Vivien shared one of these. On occasions we three Macnamara girls squashed in beside them for the night. In the morning we always woke up with hangovers from an excess of giggling . . .

'. . . Poppet and Vivien, the younger boys, my sisters, splashed naked in the pond, while my mother and Dodo stood by with their arms full of flowers. Edie held out a towel for a wet child. And like some mythical god observing the mortals, Augustus the Watcher sat on a

bench leaning forward, his long hair covered by a felt hat, his beard a
sign of authority.

'It was in this garden that I first experienced ecstasy. And to-day the
memory of this impact of ecstasy is as fresh as it was at the time. There
has never been another garden like it; it excited me in such a way that it
became the symbol of heaven.'[437]

For those who, like the Macnamara or Anrep children, continually
came and went, Alderney might seem an Eden; but for the John children
themselves it was an Eden from which they needed to be expelled in
order to be fully born into the world outside. While for a third group,
a race of demi-Johns, it was also an Eden, but, seen from a place of exile,
a purgatory.

The first of this race 'not of the whole blood' was the daughter of a
music student of generous figure and complexion called Nora Brown-
sword, twenty years younger than John and known, bluntly, by her
surname. On a number of occasions she had posed for him mostly for
wood panels, and on 12 October 1914 he wrote in a state of some finan-
cial panic to Quinn: 'By-the-bye I've been and got a young lady in the
family way! What in blazes is to be done?' But Quinn, who to John's
chagrin saw the problem simply as geographical, suggested exporting
the lady to France. In any event this advice, which arrived safely at
Alderney almost five months later, was invalid by the time John read it.
Yet the problem remained. What in blazes *was* to be done?

John explained the position as clearly as he could in another letter to
Quinn[438]:

'Some while back, I conceived a wild passion for a girl and put her in
the family way. She has now a daughter and I've promised her what she
asks: £2 a week and £50 to set up in a cottage. I never see her now and
don't want to, but I'm damned if I see where that £50 is to be found at
the moment. Her father is a wealthy man. He has just tumbled to the
situation and I suppose he'll be howling for my blood.'

Dorelia's attitude, once she knew of this pregnancy, was one of stern-
ness and calm. If matters were made too easy, then the same thing might
well happen over and over again. So she hardened herself. In John's
letters to her at this time there is a new note of diffidence mingling with
reminders that 'I cannot exist without you for long, as you know'. He is
apologetic too for not meanwhile having painted better. 'Sorry to be
so damn disappointing in my work. It must make you pretty hopeless
at times, but don't give me up yet. I'm going to improve.'

In Dorelia's eyes he could only exculpate himself through his work:

and that was fair. But if the work did not improve, then his guilt would
rise up and stifle him. As a civilian in wartime he felt as if at the dead
centre of a hurricane. It was this awful sense of deadness that tempted
him to rush into new love-making, as the only excitement, the only
means of self-renewal available. Extricating himself from the conse-
quences of his affair with Brownsword seems to have taken consider-
ably longer than the affair itself, and was the antithesis of excitement.
Brownsword had often visited Alderney during her holidays from
music college; after the birth of her daughter she never went back there.
The romance was over. 'She must on no account come to Alderney,'
John instructed Dorelia. '. . . For God's sake don't worry about it –
don't think about it.'

This advice, for Dorelia somewhat tautological, John made many
lusty attempts to pursue himself. It was not easy. Brownsword had
been anxious to shield the news from her parents – which, since they
could far better afford to look after the child than he, irritated John. In
due course she went to live in Highgate, where John sometimes turned
up – Brownsword hiding herself away at his approach. She had become
extraordinarily elusive and when John did catch up with her he felt
doubly impatient. 'I dined with her and wasn't too nice,' he admitted to
Dorelia, 'but tried to keep my temper and it's no use allowing oneself to
be too severe. . . . She showed every sign of innocent surprise when I
asked her why she had bunked away without warning.' In a less severe
mood still, he confided on one occasion to Theodosia Townshend:
'I'd marry her if necessary – Dodo wouldn't mind'. To what extent he
believed this it is impossible to be sure: probably a little, once it was out
of the question. Certainly it was not more fantastic than some of the
other plans which, unknown to Brownsword herself, were manu-
factured to meet the crisis. 'The Tutor's plan I think the best,' John
had affirmed in another letter to Dorelia. The boys' ex-tutor, John
Hope-Johnstone, stopped in his tracks somewhere in Europe by the
world war, had re-appeared in London and secretly offered himself in
the rôle of the baby's legal father. 'I must say,' John acknowledged, 'the
tutor is behaving with uncommon decency.' From Brownsword's
point of view this 'best plan' contained disadvantages. Although Hope-
Johnstone entertained some romantic attachments for young men of
under twenty, he was physically attracted to girls – but of ten or twelve,
towards whom he would proffer timid advances, placing his hand on
their thighs until, their mothers getting to hear of it, he was expelled
from the house. The prospect of having a young daughter in his own
house was certainly inviting; and it seems probable that he sniffed
money in this *mariage blanc* – to the extent at least of buying a household
investment, 'a most expensive frying pan'. But Brownsword was not a

party to this. The punning surname she gave her daughter Gwyneth
reflects the fact that hope never entered this relationship.

In his letters to Dorelia, John makes no single reference to Nora
Brownsword that can be construed as sympathetic. He appears to have
believed that he offered her money, but that she accepted nothing. She
remembers asking for £4 a week for the baby, not herself: and receiving
nothing. That nothing positively changed hands on a number of occa-
sions appears indisputable. Having a musical degree she was just able
to support herself and her daughter, and their independence was com-
plete. It was only casually, years later, that John learnt she had married.
As for Dorelia, she provided Brownsword with a ring; and within
limits she was kind. But her aloofness was not welcoming: deliberately
so. Everyone, whoever it might be, she let sink or swim – that was her
philosophy: to accept only those who, sometimes against odds, made
themselves acceptable. Against her dislike there was no appeal on what-
ever grounds. Like God, she allowed help only to those capable of
helping themselves. She offered to take the baby and bring it up as one
of the family, provided Brownsword never saw it again. But since this
was unacceptable to Brownsword, she took no further interest in the
matter.*

The Brownsword affair shot a warning across John's bows, but
though his progress became more rocky it did not slacken. Through the
deep gloom of war he needed, like pilot lights, a girl to ring and a girl
to play. But soon the process had cemented itself into a formula. After
one party at Mallord Street, Dorelia and Helen Anrep could hear him
shuffling about in the entrance hall and, with hushed intensity, confiding
to a procession of female guests: 'When shall I see you again? You know
how much it means to me.' Each time, for a moment, the acting and
sincerity would merge, and the tone carried conviction. His need
seemed, if almost indiscriminate, almost real. Without these girls he
was in the dark. He was not hypocritical, but being self-deceived, con-
stantly deceived others, and could not stop himself. At the beginning
and in the end, he drank: first to make contact, then to forget; finally
to destroy himself.

The roll-call reverberated on. Lady Tredegar with her strange gift
for climbing into trees and arranging nests in which polite birds would

* Some years later, when John was visiting Jack Moeran the composer in Norfolk,
he called on Brownsword; and continued to see her later still after she was widowed,
'always on friendly terms'.

'Gwyneth became a talented painter, and mixed with the Johns after she had
grown up, but remained outside the family circle, although she was always very fond
of Augustus, and would frequently see him in London, and lent him her studio to
work in occasionally.'

later settle; Iris Tree, with her pink hair and poetry, 'someone quite marvellous'; Sylvia Gough, with her thin loose legs, who later paid him the compliment of including his name among the list of co-respondents at her divorce case; Sybil Hart-Davis, nice and apologetic and 'determined to give up the drink';[439] a famous Russian ballerina, from whose Italianate husband John was said to have 'taken a loan of her': these and others, many others, were among his girl-friends or mistresses over these few years. Not all the voluminous gossip that rose up round him was true, not all: but the smoke did not wholly obscure the flames. Even before the war his reputation, along with that of the solo-dancing, velvet-jacketed American poet Ezra Pound, had been popularly celebrated in the 'Virgin's Prayer':

> *Ezra Pound*
> *And Augustus John*
> *Bless the bed*
> *That I lie on.*[440]

Of such notoriety John was growing increasingly shy. 'The only difference between the World's treatment of me and other of her illustrious sons is that it doesn't wait till I am dead before weaving its legends about my name,' he complained (February 1918) to Alick Schepeler. By becoming more stealthy he did not diminish this legend, but gave it more zest. The addict's spell is written in the many moods of revulsion and counter-resolution, the promises, promises, that chart his downhill fight. Sometimes it seemed as if Dorelia alone could arrest this gradual descent. 'If you come here I'll promise to be good,' he wrote to her from Mallord Street at the end of the war, '. . . I am discharging all my mistresses at the rate of about 3 a week – Goodbye Girls, I'm through'.

3. CORRUPT COTERIES

Alderney had changed since the beginning of the war. Vague visitors no longer floated in and out in such abundant numbers. Henry Lamb had left, and the piano duets were stilled. After drawing up his first Will and Testament, and solemnly handing it to Dorelia during a miserable farewell party at Alderney,* he had gone, looking 'very sweet in his uniform', to serve as an army doctor in France. Deprived

* In the last week of January 1915. Lamb had been in Guy's Hospital for an operation. 'I have written to Dodo to know if she can pick me up . . . It all depends on whether J[ohn] will be gone: his temper not being considered good enough to stand the strain of a visit from me,' Lamb had explained to Lytton Strachey (15 January 1915). After his visit, he wrote (31 January 1915): 'They have been discussing the moral effects of being in hospital, saying that one's sensitiveness is apt to become magnified. I wonder if that is the reason why I was miserable at Parkstone.'

of 'poor darling Lamb',[441] Dorelia dug herself more deeply still into the
plant world. She had been assured by John that 'in a week or two
there'll be no money about and no food,' so now she surrounded her-
self with useful vegetables. They clustered thick about her, giving com-
fort. 'It's rather a sickening life,' she confessed to Lytton Strachey,[442]
'but the garden looks nice'.

God came to Alderney less often these days: God was Dorelia's new
name for John. The war had thrown shadows over both their lives, and
between them. 'Do you feel 200 ?' he asked her once, ' – I feel 300'. But
superannuation affected them differently. While Dorelia immersed her-
self in the non-human life of the soil, John sought distraction at the
clubs and parties in London. Though he still drank elbow-to-elbow
with poets and prostitutes under the fly-blown rococo of the Café
Royal, the place was beginning to revolve almost too crazily. There
were the raucous-voiced sportsmen; the grave contingent from the
British Museum with their academic squeaks, like bats; the well-
dressed gangs of blackmailers, bullies, pimps and *agents-provocateurs*
muttering over plans; the intoxicated social reformers and Anglo-Irish
jokers with their whoops and slogans; the exquisite herd of Old Boys
from the 'Nineties 'recognizable by their bright chestnut wigs and
raddled faces' whispering in the sub-dialect of the period; a *schlemozzle*
of Cubists sitting algebraically at the domino tables; and, not far off,
under the glittering façade of the bar, his eye fixed on the fluctuating
crisis of power, the leader of the Vorticists keeping company with his
lieutenants. Decidedly the place was getting a bit 'thick'.[443]

Throughout London a bewildering variety of clubs and pubs had
sprung up offering doubtful consolations. First among these was the
astonishing 'Cave of the Golden Calf', a cabaret club lodged deep in a
Soho basement where the miraculous Madame Strindberg was resur-
rected. As Queen of this vapid cellardom, wrapped in a fur coat, her face
chalk white, her hair wonderfully dark, her eyes blazing with fatigue
and laughter, she drifted among her guests diverting their attention
from entertainments that featured everything most up to date. Under
walls 'relevantly frescoed' by Spencer Gore and Charles Ginner, beside
a huge and hideous raw meat drop curtain designed by Wyndham
Lewis, and watched over by the heads of hawks, cats and camels
that, executed by Epstein in scarlet and shocking white, served as
decorative reliefs for the columns supporting the ceiling, couples
sagged through the latest obsolete dances, the Bunny Hug and Turkey
Trot. Between dances there were violent experiments in amateur
theatre, assaults upon foreign folk songs led by an Hungarian fiddler
and the spectacle of performing Coppersmiths. Everything was expen-
sive, but democratic. Girls, young and poor, were introduced to rich

men on the periphery of the art world; various writers and artists, including John, found themselves elected honorary members 'out of deference to their personalities' and given the privilege of charging drinks to non-artistic patrons in their absence. Into this vicious, pleasant establishment slunk the Vorticists, 'Cubists, Voo-dooists, Futurists and other Boomists[444]' for whom it was transfigured into a hole-and-corner headquarters. But not for long. As war advanced from the East, so Madame Strindberg went west. 'I'm leaving the Cabaret,' she wrote to John. 'Dreams are sweeter than reality.' Stripping the cellar of everything she could carry, she sailed for New York. 'We shall never meet again now,' she wrote from the ship.* '. . . I could neither help loving you, nor hating you – and . . . friendship and esteem and everything got drowned between those two feelings.'

Long before Madame Strindberg left, John had absconded to help set up a rival haunt in Greek Street. 'We are starting a new club in town called the "Crab-tree" for artists, poets and musicians,' he wrote to Quinn. 'It ought to be amusing and useful at times'. The Crabtree was opened, at John's instigation, in April 1914, and for a time it tasted sweet to him: the only thing wrong with it, he hinted darkly, were the crabs. Like the 'Cave of the Golden Calf' it was a very democratic affair, and provided customers with what John called 'the real thing'. Euphemia Lamb, Betty May, Lillian Shelley and other famous models were there night after night wearing black hats and throwing bottles: and for the men there were boxing matches. Actresses flocked in from the West End theatres to meet these swaggering painter-pugilists and the atmosphere grew wildly extravagant. 'A most disgusting place!' was Paul Nash's recommendation in a letter to Albert Rutherston, 'where only the very lowest city jews and the most pinched harlots attend. A place of utter coarseness and dull unrelieved monotony. John alone, a great pathetic muzzy god, a sort of Silenus – but alas no nymphs, satyrs and leopards to complete the picture.'

* In *Chiaroscuro* John records: 'I received a letter from her, written on the ship. It was a noble epistle. In it I was absolved from all blame: all charges, all imputations were withdrawn: she alone had been at fault from the beginning: though this wasn't true, I was invested with a kind of halo, quite unnecessarily. I wish I had kept this letter; it might serve me in an emergency.' This letter, written from the R.M.S. *Campania*, has since come to light. In it she writes: 'The chief fault others had, who interfered with lies and mischief. The rest, I take it, was my fault – and therefore I stretch out my heart in farewell . . . You are the finest man I met in this world, dear John – and you'll ever be to me what the Sun is, and the Sea around me, and the immortal beauty of nature. Therefore if ever you think of me, do it without bitterness and stripe [*sic*] me of all the ugliness that events have put on me and which is not in my heart. . . . Goodbye John. I don't know whether you know how awfully good at the bottom of your heart you are – *I* know. And that is why I write this to you – Frida Strindberg'.

Much the same spirit of tense tedium and relaxed excitement saturated the atmosphere of the Cavendish Hotel in Jermyn Street which outlasted all these clubs. This was owned by Rosa Lewis, a kind and sinister nanny, who ran it along the lines of a plush lunatic asylum in her own Welfare State. For those who went to bed early and locked their doors, it was possible to detect little that was different from the expensive mediocrity of the usual hotel. But for connoisseurs there was nothing like the Cavendish, its multitudinous pictures; its acres of faded red morocco, and hideous landscape of battered furniture, massive and monogrammed; its perpetual parties. Beneath every cushion lay a bottle, and beside it a girl. The place flowed with brandy and champagne, paid for by innocent millionaires who had been equipped with mistresses. Much of this money came from America, among whose well-brought-up young men, bitten with the notion of being Bohemians Abroad, Rosa Lewis became a legend. Financially it was once again the artists, models and other poorer people who benefited: but for those who did not own John's constitution it was a risky lair. John himself scented no danger, and continued intermittently to use it over many years.[445]

In quieter vein, he would appear at the Café Verrey, a public house in the Continental style in Soho; then, for the sake of the Chianti – though he always 'walked out nice and lovely' – at Bertorelli's; and, a little later, also in Charlotte Street near the Scala Theatre, at the Saint-Bernard Restaurant, a small friendly place with an enormous dog, the mascot and name-giver, that filled the alley between the tables to the exclusion of the single waiter and Signor del Fiume, the gesticulating owner. But of all these restaurants the most celebrated was the Eiffel Tower in Percy Street, 'our carnal-spiritual home' as Nancy Cunard called it.[446] The story is that one stormy night, John and Nancy Cunard found refuge there, and taking a liking to its genial Austrian proprietor Rudolph Stulik, transformed the place during these war years into a club patronized chiefly by those who were connected with the arts. Something of the Café Royal atmosphere was transported, but on a scale much simplified. Its series of windows, each with a daffodil-yellow half-blind looking wearily up Charlotte Street, became a landmark of the metropolitan art-and-vulture world until the Second World War. The decor was simple, with white table-cloths, narrow crusty rolls wrapped up in napkins beside the plates and long slender wine glasses. The food was elaborate ('Canard Pressé', 'Sole Dieppeoise', 'Chicken à la King' and 'Gâteau St Honoré', a large circular custard tart ornamented round its edges with big balls of pastry, were among its specialities); and it was costly. For the art-students and impoverished writers drinking opposite in 'The Marquis' it represented luxury. To be invited there,

to catch sight of the elegant figure of Sickert amid his entourage; of the Sybil of Soho, Nina Hamnett, being helped home, a waiter at each elbow; of Herbert Asquith in poetic travail; of minor royalty slumming for the evening; of actresses and Irishmen, musicians, magicians, cosmeticians; of a pageant of Sitwells, some outriders from Bloomsbury, a yapping kennel of politicians: to be part of this glorious constellation even for a single evening was to become a man or woman of the world.

Those who were well looked upon by Stulik could stay on long after the front door had been closed, drinking into the early hours of the morning mostly German wines known collectively as 'Stulik's Wee'. Stulik himself spoke indecipherably in galloping, broken-back English, hinting that he was the result of an irregular attachment 'in which the charms of a famous ballerina had overcome the scruples of an exalted but anonymous personage' – a story that, reduced to the commonplace, became that he had once been chef to the Emperor Franz Josef to whom he bore an uncertain resemblance. He was assisted in the running of the place by a team of tactful waiters, a parrot and a dog.

Upstairs, touched by the paintbrush of Wyndham Lewis, lay the private dining-room, small, stuffy with aspidistras, glowing dully under a good deal of dark crimson. Here secret liaisons were intended to take place, grand ladies entering by the side-door and ascending the hen-roost stairs for private debauches with raffish character-actors. Those modestly sitting below could feel tremors of equivocal excitement and, late at night, hear mouse-scufflings up and down the narrow staircase.

Then, on the topmost floors, 'dark and cluttered with huge articles of central European furniture',[447] were the bedrooms, between which a vigorous scampering to and fro was carried on – and no questions asked.

The high prices were partly subsidized by young diplomats on leave, and the tariff was tempered to the visitor's purse. John was a popular host, sometimes even in his absence. 'Stulik's friends could run up enormous bills,' Constantine FitzGibbon recalls.

'Augustus once asked for his bill after a dinner party, Stulik produced his accumulated account, and Augustus took out £300 from his pocket with which to pay it. One result of this was that Stulik himself was sometimes penniless. On one occasion when John Davenport ordered an omelette there, Stulik asked if he might have the money to buy the eggs with which to make it. On another occasion, when Augustus grumbled at the size of his dinner bill, Stulik explained calmly in his guttural and almost incomprehensible English that it included the cost of Dylan [Thomas]'s dinner, bed and breakfast the night before'.[448]

Such bursts of generosity were followed by periods of financial remorse deepened by the weight of Dorelia's disapproval. But for John

money was an exit, and he could not tolerate being imprisoned by the lack of it. As his correspondence shows, money worries buzzed about him like flies, persistent though unstinging. A request by post from a deserving relative, if it arrived in the wrong hour, would detonate a terrifying explosion of anger. But he did not covet money. It was not beyond him to bargain over a price for a picture, obtain it, then absent-mindedly light his pipe with the cheque. And once, at Mallord Street, when he was grumbling about having so little money available, his friend Hugo Pitman offered to search through the house and came up with, in notes and uncashed cheques, almost twelve thousand pounds.

His generosity was unpremeditated. He preferred to give in kind rather than in cash. Money was important to him for his morale not his bank account. He needed it about his person. All manner of creditors, from builders to schoolmasters, would queue many months for their bills to be paid, while he graciously entertained his debtors at the Eiffel Tower. In times of war, he would explain with some severity, it was necessary for everyone to make sacrifices. But he himself could not sacrifice popularity. Among the art-students he was a fabled figure, a king of Chelsea, Soho and Fitzrovia. 'I can see him now walking . . . beneath the plane trees,' recalled Sir Charles Wheeler.

'. . . He is tall, erect and broad-shouldered, wearing a loose tweed suit with a brightly coloured bandana round a neck which holds erect, compelling features . . . He is red-bearded and has eyes like those of a bull, doubtless is conscious of being the cynosure of the gaze of all Chelsea and looking neither to the left nor the right strides on with big steps and at a great pace towards Sloane Square, focussing on the distance and following, one imagines, some beautiful creature he is intent on catching . . .'[449]

Dorothy Brett remembers her first sight of him from a bus in the King's Road – 'Tall, bearded, handsome, shaggy hair with a large black homburg hat at a slight angle on his head, some kind of black frock coat. I think I must have been staring with my mouth open at him, he shot me a piercing look, and the bus rolled away.'[450] Later on, he would call at the Slade for Brett and two other students, Ruth Humphries and Dora Carrington, and take them out on grand pub crawls, or to the Belgian cafés along Fitzroy Street, and once to call on a group of gypsies 'beautiful, dark-haired men and women and children, in brilliant-coloured clothes,' Brett recalled, in a room full of bright eiderdowns.

Best of all were the parties in Mallord Street. Invitations would arrive on the day itself – a telephone call or a note pushed under the door or a shout across the street urging one to 'join in' that evening. Carrington,

in a letter to Lytton Strachey[451] (23 July 1917), gives a voluptuous description of one of these events:

'It had been given in honour of a favourite barmaid of the Pub in Chelsea, near Mallord St, as she was leaving. She looked a charming character, very solid, with bosoms, and a fat pouting face. It was great fun.

'Joseph, a splendid man from one of those cafés in Fitzroy St., played a concertina, and another man a mandoline. John drunk as a King Fisher. Many dreadfully worn characters, moth eaten and decrepit who I gathered were artists of Chelsea . . .

'John made many serious attempts to wrest my virginity from me. But he was too mangy to tempt Me even for a second. "Twenty years ago would have been a very different matter my dear sir". . . . There was one magnificent scene when a presentation watch was given the barmaid, John drest in a top hat, walking the whole length of that polished floor to the Barmaid sitting on the sofa by the fireplace, incredibly shy and embarrassed over the whole business, and giggling with delight. John swaggering with his bum lurching behind from side to side. Then kneeling down in the most gallant attitude with the watch on a cushion. Then they danced in the middle of the room, and every one rushed round in a circle shouting. Afterwards, it was wonderful to see John kissing this fat Pussycat, and diving his hand down her bodice. Lying with his legs apart on a divan in the most affected melodramatic attitudes!!'*

The spirit of London during the war, its spiral of gaiety and recrimination, is wonderfully caught by the affair of the Monster Matinée

* Of another party, Carrington wrote (2 November 1920): 'How it brought back another world! . . . Dorelia like some Sibyl sitting in a corner with a Basque cap on her head and her cloak swept round her in great folds, smiling mysteriously, talking to everyone, unperturbed watching the dancers. I wondered what went on in her head. I fell very much in love with her. She was so amazingly beautiful. It's something to have seen such a vision as she looked last night . . . I had some very entertaining dialogues with John, who was like some old salt in his transparent drunkenness.

' "I say old chap will you come away with me"
D.C. "But you know what they call that".
"Oh I forgot you were a boy".
D.C. "Well don't forget it or you'll get 2 years hard".
"I say are you insinuating," drawing himself up and flashing his eyes in mock indignation, "That I am a Bugger".
D.C. "My brother is the chief inspector of Scotland Yard".
"Oh I'm not afraid of him". But in a whisper. "Will you come to Spain with me? I'd love to go to Spain with *you*".
D.C. "This year, next year, sometime".
John. "Never". Then we both laughed in a roar together.'

performed on 20 March 1917 at the Chelsea Palace Theatre.[452] This jumbo pantomime had been organized in aid of Lena Ashwell's Concerts at the Front. 'It was to be a sort of history of Chelsea,' Lady Glenavy wrote, 'with little plays about Rossetti, Whistler and others, with songs and dances ending up with a grand finale in praise of Augustus John.' Everyone in the polite world was soon elbowing his way into this charity-rag; a Committee of Duchesses gave birth to itself; and the arrangements spread up a crescendo of smart houses – John himself being given the scent to hunt out a musician. During rehearsals fashionable ladies gathered together for gossip about him, vying with one another to tell the most succulent story of his dreadful deeds. But when he appeared, 'Birdie' Schwabe noticed, such was his presence that they would all stand up to greet him with their best smiles. The last scene of the show featured 'Mrs Grundy and the John Beauty Chorus',* in which a band of Slade girls – Brett, Carrington, Barbara Hiles and others – shouted out:

> *John! John!*
> *How he's got on!*
> *He owes it, he knows it, to me!*
> *Brass earrings I wear,*
> *And I don't do my hair,*
> *And my feet are as bare as can be;*
> *When I walk down the street,*
> *All the people I meet*
> *They stare at the things I have on!*
> *When Battersea-Parking*
> *You'll hear folks remarking:*
> *'There goes an Augustus John!'*[453]

But not everyone was approving. Peering out from the jungle of the art world, Epstein sniffed a plot within the matinée, with John its Machiavelli. At the start of the war Epstein had written to Quinn:[454]

'My business as I see it is to get on with my work and to get things in hand finished . . . Everybody here is war-mad. But my life has always been war, and it is more difficult I believe for me here to stick to the job, than go out and fight or at least get blind, patriotically drunk'.

He seemed determined to be disliked: 'As an artist I am among the best-hated ones here,' he boasted,[455] 'and the most ignored.' Perhaps through negligence, John and he seem to have remained on good terms. In January 1917 Epstein did a portrait head of John which, seen from a

* See Appendix.

certain angle, gives him the aspect of a devil;* and this, a little later that year, was what he became. Compulsory conscription had now been introduced and Epstein found himself called up. It was obviously the result of this monster pantomine – he saw that clearly:

'My enemies have at last succeeded in forcing me into the army,' he expostulated. 'I have not been averse to joining, but [I] really am too important to waste my days in thinking of matters military. When the last tribunal gave me three months' exemption there was organized a deliberate conspiracy in the press against my exemption; bad painters and bad sculptors wrote and howled, men like Brangwyn. One Sir Philip Burne Jones, a son of old B.J., a social nincompoop, and sculptors whose names you've never even heard of; but the actual organizing of this conspiracy to commit me to the army was mainly engineered by a sycophant of John, and it is him I blame chiefly for the whole affair. John has been behind the whole nasty business ever since the war started, but I first found it out when in a theatrical show got up for charity, he had me caricatured on the stage; he was one of the chief organizers of this dastardly business and ever since then I understand the low, base character of the man. This so-called charity performance was the work of our "artists" mostly hailing from Chelsea, and I was chief butt, partly on account as I take it, of the great public success of my exhibitions of sculpture at the Leicester Gallery . . . To be attacked in the press is now my almost daily portion. I loom too large for our feeble small folk of the brush and chisel. Even my existence is a nuisance to them. They shall have their reward.'[456]

This outpouring was the result of a collision between two gifted paranoiacs. The conspiracy, to the extent that it existed, was a conspiracy of one – the professional joker Horace de Vere Cole. Making a tour of rival sculptors, he had guided their hands in the writing of some extraordinary letters to the *Sunday Herald*[457] opposing Epstein's military exemption. Walter Winars, a sculptor of horses, wrote from Claridges; Derwent Wood went on record as disliking Epstein personally, and John Bach came up with the notion that there were too many artists in the country anyway. In a sane world, such a correspondence could only have been interpreted as support for Epstein. But the world was not sane, it was at war; and Epstein came to believe that, back in 1914, it must have been Cole who, travelling widely, had actually initiated that war. In any event, the anti-Epstein conspiracy was now rampant, and this deeply laid pantomime revealed its leader to be the most popular artist of the day, Augustus John. Nothing less would satisfy Epstein.

* 'I wanted to capture a certain wildness, an untamed quality that is the essence of the man,' Epstein wrote. *Epstein. An Autobiography* (Hulton Press 1955), p. 89.

John was certainly capable, when the mood was on him, of doing ugly and ungenerous things. But he was allergic to conspiracies and could never have sustained over years a campaign of hate. In fact he had no part in Cole's joke, and his letters show that he actually wanted Epstein to escape conscription. Quinn, who gave generous support to Epstein's fantasy, calling John 'malicious, for what you describe is pure malice and meanness and dirt', failed to tell Epstein that John had written to him on 18 August 1916: 'I saw Epstein lately: he is in suspense about being taken for the army. I sincerely hope they'll let him off.'

Friends did bring the two artists together again following this pantomanic break and a reconciliation was arranged at a hotel in Brighton. Unfortunately a parrot belonging to the hotel exploded with some abusive remarks just as Epstein entered the restaurant, and he rushed out swearing that John was up to his tricks again.*

Epstein had objected both to John's singular place among British artists at this time, and to his untroubled exemption from conscription. While in Ireland with Gogarty, John had injured his knee jumping a fence. Despite months encased in plaster of paris, the knee had not mended and he consulted Herbert Barker the specialist in manipulative surgery. 'The celebrated "bone-setter" having put me under gas . . . carrying my crutches, I walked away like the man in the Bible.'[458] Not long afterwards, with another insufficient leap, he successfully damaged the other knee – 'bang went the semi-lunar and I nearly fainted'. Again he sought out Barker, this time at a remote village in North Devon.

'I invited him to my private sitting-room and examined his knee,' Barker records. 'It was swollen, bent to a considerable angle and both flexion and extension were painful even to attempt. It was a typical case of derangement of the internal semi-lunar cartilage.'[459]

This time there was no anaesthetic and the knee snapped back into place while John smoked a cigarette. 'I feel rather like a racehorse come down in the world and pulling a fourwheeler must feel,' he wrote afterwards (18 August 1916) to Quinn. 'But both knees will get strong again in time.'†

* Information from Sir Sacheverell Sitwell. Later in life, while not seeing much of each other, Epstein and John remained friendly. Lady Kathleen Epstein remembers that they met once in a street and, in answer to a question, Epstein said he was doing good work but could not sell it and was very poor. John at once took out a cheque book and wrote him a cheque 'which we will never refer to again'. This was in the 1930s.

† By way of payment John offered to 'do a head' of Barker. 'If you will rattle my bones, I should be more than repaid!' This portrait, the first of two painted during the war, is now in the National Portrait Gallery, London. Barker, who often slept

They were not strong enough for the medical authorities who examined him later that year at Dorchester barracks and who, while insisting that he be re-examined periodically, rejected him for military service. There followed a year in limbo, with the constant threat of being compelled to do office work – a prospect far more alarming than trench warfare. On the bright surface of things he was enjoying a brilliant career in London, admired by the young and lustfully pursued by the smart. But below this surface, a lake of black despair was forming. He was petted and flattered; he still roared, but he had been coaxed, it seemed to some, into a cage and the door was closing behind him. All the sweetmeats poked through the bars he gobbled up at once: he liked them, but they did not satisfy him, so he ate more until they began to sicken him. He was painting less well, and though he could blink this fact he could not blind himself to it. 'I wish it were not necessary to depend so much on rich people,' he confessed to Handrafs O'Grady. 'They don't really buy things for love – or rarely'. He had developed a technique of 'boldly accelerated "drawing with the brush".'[460] Once he had mastered this, he could almost never unlearn it because anything else was slower.

In November 1917, at the Alpine Club, he held the largest exhibition of his pictures ever assembled. He was now, in the words of *The Times*,[461] 'the most famous of living English painters'. But he had reached a watershed in his career. He did not paint to please the public nor, wholeheartedly, to please himself: but as if he were simply passing the time. He seemed poised between two worlds, uncertain of which to enter and unable, eventually, to enter either.

'He seems to have, with the artistic gifts of a man, the mind of a child,' wrote one critic of this show. '. . . Life to him is very simple; it

during the sittings, nevertheless observed: 'It was a wonderful thing to watch John at work – to note his interest and utter absorption in what he was doing. . . . The genius of the born craftsman was apparent in every look and movement. He had a habit when most wrapped up in some master-stroke or final touch of running backwards some feet from the canvas with his critical eyes bent upon the painting. Once when doing this he tripped and almost fell heavily over the stove near by.' The portrait used to hang in Barker's waiting-room to encourage the patients. Variously described as 'Satanic' or like 'a Venetian Doge', it was, Barker bravely maintained, one of John's 'best male portraits': adding 'I look upon John as one of the greatest portrait painters who has ever lived'. John himself described the painting, in a letter to Hope-Johnstone, as 'just like him, stuffy and good'. Early in March 1932 John saw Barker again, this time in Jersey. 'You have always done me good, and I feel it is high time I put myself in your hands again,' he had written (17 September 1931). During this visit he began a third portrait. See *Harley Street* by Reginald Pound (Michael Joseph, 1967, pp. 80, 123–4). Also unpublished correspondence at the Royal College of Surgeons.

consists of objects that arouse in him a *naïve* childish curiosity and
delight; but he has been artistically educated in a modern, very un-
childish, world, and has learnt very easily all the technical lessons that
the world has to teach. The consequence is that he is too skilful for his
own vision, like those later Flemish Primitives who were spoilt by
acquiring the too intellectual technique of Italy. Constantly one feels
the virtuoso obtruding himself into a picture that ought to be as *naïve*
in execution as it is on conception; and often, where there is no concep-
tion at all, one sees the virtuoso trying to force one'.

The change that was spreading over his pictures may be measured by
the kind of enthusiasm they provoked. Shortly before the war Osbert
Sitwell had visited the Chenil Gallery

'and saw a collection of small paintings by Augustus John: young
women in wide orange or green skirts, without hats or crowned with
large straw hats, lounging wistfully on small hills in undulating and
monumental landscapes, with the feel of sea and mountain in the air
round them . . . By these I was so greatly impressed that I tried to per-
suade my father to purchase the whole contents of the room . . .
Alas, I did not possess the authority necessary to convince him. . . .'[462]

The new exhibition this autumn was also impressive, but in a manner
less painterly and to a different public.

'If you will go to the Alpine Club on Mill Street off Conduit Street
you will see an unprecedented exhibition of paintings of Augustus
John,' wrote Lord Beaverbrook to F. E. Smith (28 November 1917).
'Every picture in the room is painted by John. If you judge for yourself
you will conclude that John is the greatest artist of our time and pos-
sibly of any time. If you refuse to follow your own judgement you must
listen to the comments of your fashionable friends who are flocking to
John's Exhibition. I saw some of the female persuasion there to-day
gazing on John rather than on his pictures.'

It was Sickert, the previous year, who had warned his fellow painters
against the mistake of inverted snobbery:[463] 'you are reflecting whether
it is not high time to throw Augustus John, who has clearly become
compromising, overboard. Take my tip. Don't!' But the war had
dimmed his imaginative world: suddenly he was an artist with a past
and little future. The future lay with those who were abandoning
Naturalism and tradition and who demanded a new art modelled on
the functions of the machine in place of the organic forms of nature.
The war, even the threat of war, had been recognized as an enemy
common to all artists, and they had come together in a profusion of
groups and movements.

They had come together: collided: flown apart. Marinetti's Futurists, Wyndham Lewis's Vorticists, Roger Fry's Omega Workshops: all were adjusting to an industrial age, to discord, to the conditions of war – and all were to be extinguished by the forces that had brought them into being. In the histories of modern art, John has no place with these movements, and it is true that he saw them as revolutions in journalism as much as in art. But he did maintain an important contact on the periphery. When in the autumn of 1914 Wyndham Lewis's Rebel Art Centre in 38 Great Ormond Street destroyed itself, another less well-publicized centre at 8 Ormonde Terrace sprang limping up. It was led by Bomberg, Epstein and William Roberts: and John was asked to be its first president. In their derelict house, leased by 'a dear old humour-ist with a passion for vegetables',*[464] these artists took aggressive refuge from the war, teaching and employing the rooms as studios. In a letter to Evan Morgan,[465] John (who refused the Presidency) explained his views in a manner that defines his relation to almost all the new move-ments:

'I confess I was always shy of the Ormonde Terrace schemes when approached before . . . *I do still think the idea is a very good one*. I only have my doubts of our carrying it to success when hindered by certain personalities – given a nucleus of serious and sensible persons or enough of such to *predominate* I would not refuse my name for any useful purpose. It was for this reason I was so keen to get Ginner and Gilman on the Committee. They are both able men especially the former and would not be likely to wreck or jeopardize our plans by childish fri-volity or lack of savoir-faire. Given such conditions, I say, B[omberg] and the rest could take their chance . . . I am quite game to go on with the affair and do all I can. But I can't go and identify myself publicly with a narrow group with which I have no natural connexion. You must see that I have arrived at greater responsibilities than the people we are dealing with. My own "interests" lie in *isolation* as complete as possible. I have never studied my interests but experience teaches me at least to avoid misunderstandings. I would be quite ready to waive my "interests" damn them! pour le bon motif, but I don't want a fiasco . . . It's impossible for a painter to be also a politician and an administrator. We ought to have [A. R.] Orage as dictator . . . I was loath to act as captain to a scratch crew and seeing nothing but rocks ahead.'

This letter points to several developing strains in John: the almost mediaeval fear of failure, of contagious 'bad luck', and an impatience with himself for succumbing to this; an apprehension of press and publicity; the film of 'greater responsibilities' that was clouding his

* Stuart Gray, an ex-lawyer, hunger-marcher and future 'King of Utopia'.

natural vision; common sense and a sure instinct as to where his talent lay. Only isolation could uphold this talent, but to isolation he was by temperament allergic. The groups and movements he so sensibly shunned had, as they exploded, flung their adherents into the forefront of the war where, instead of the collective despondency they expected, they found inspiration. John too had long wanted to hurry to the front.

'I have had the idea of going to France to sketch for a long while and I have hopes now of being able to do so,' he had written on 26 April 1916 to Will Rothenstein. 'But I am still in suspense. I have applied for a temporary commission which I think indispensable to move with any freedom in the British lines where the discipline is exceedingly severe . . . there's enough material to occupy a dozen artists. Of course the proper time for war is the winter and I very much regret not having managed to go out last winter. I cannot say I have any personal influence with the powers that be . . . I have been advised at the same time to keep my business quite dark. You might suppose I could do something with Lloyd George but I fear that gentleman will never forgive me for painting a somewhat unconventional portrait of him . . .'

Another winter came and went, and John continued to keep his business dark, remaining sombrely at home. During 1917 he began to drift, not altogether gracefully, into the McEvoy world of 'Duchesses'. One sitter who occupied him that year was Lady Cynthia Asquith,* some of whose diary entries give revealing glimpses of him in this new milieu.

Friday 27 April 1917.
'. . . I had never met John before. He is very magnificent-looking, huge and bearded. His appearance reduced Margot [Asquith]'s two-year-old girl to terrified tears. I like him but felt very shy with him . . . Mary [Herbert] and I both exhibited our faces, hoping he might want to paint us. He is doing a portrait of Margot and at one time asked her to sit for the "altogether", saying she had such a perfect artist's figure . . .
'. . . Margot once asked John how many wives he really had (he is rather a mythical figure), saying she heard he was a most immoral man. He indignantly replied, "It's monstrous – I'm a very moderate man. I've only got *one* wife!'

Tuesday 9 October 1917.
'. . . He has a most delightful studio – huge, with an immense window, and full of interesting works. The cold was something excruciating . . . I felt myself becoming more and more discoloured. His appearance is magnificent, straight out of the Old Testament – flowing,

* She also sat persistently to McEvoy, and to Sargent and Tonks.

well-kept beard, hair cut *en bloc* at about the top of the ear, fine, majestic features. He had on a sort of overall daubed with paint, buttoning up round his throat, which completed a brilliant picturesque appearance. He was "blind sober" and quite civil. I believe sometimes he is alarmingly surly. Unlike McEvoy, he didn't seem to want to converse at all while painting and I gratefully accepted the silence. He talked quite agreeably during the intervals he allowed me. He made – I think – a very promising beginning of me sitting in a chair in a severe pose: full face, but with eyes averted – a very sidelong glance. He said my expression "intrigued" him, and certainly I think he has given me a very evil one* – a sort of *listening* look as though I was hearkening to bad advice.'

Thursday 1 November 1917.

'Bicycled to John's studio. John began a new version of me, in which I could see no sort of resemblance to myself. The [D. H.] Lawrences turned up. I thought it just possible John *might* add another to the half dozen or so people whose company Lawrence can tolerate for two hours. It was quite a success. John asked Lawrence to sit for him,† and Lawrence admired the large designs in the studios, but maintained an ominous silence as regards my pictures. He charged John to depict 'generations of Wemyss disagreeableness in my face, especially the mouth', said disappointment was the keynote of my expression, and that what made him "wild" was that I was "a woman with a weapon she would never use" . . . He thought the painting of Bernard Shaw with closed eyes very true symbolism.'

'*Come quickly*, like Lord Jesus,' John had urged her, 'because I've got to go away before long.' After eighteen months at the starting line he

* 'You are too much like the popular idea of an angel!' John wrote to her (5 October 1917), '(not *my* idea – which is of course the traditional one).' This portrait (oil 34 by 25 inches) was bought in 1933 from Arthur Tooth and Sons for £1,400 by the Art Gallery of Ontario. 'At the time of the purchase we were requested to hang it as *Portrait of a Lady in Black*,' the Curator wrote, 'and not refer to the fact that it was a portrait of Lady Cynthia.' In 1968 it was reproduced as the frontispiece to Cynthia Asquith's *Diaries*.

† In *Chiaroscuro* John reveals that Lawrence, despite his eagerness to have Cynthia Asquith portrayed disagreeably, protested that he himself was 'too ugly' to be painted. 'I met D. H. Lawrence in the flesh only once,' John wrote, and adds that Cynthia Asquith 'treated us to a box at the Opera that evening'. In fact they met twice, the visit to *Aida* taking place twelve days later, on 13 November – a meeting Cynthia Asquith describes in *Haply I May Remember* and Lawrence in *Aaron's Rod*. Of John's portrait Lawrence remarked that it had achieved a certain beauty and had 'courage'. In 1929, when Lawrence's pictures were seized from the Warren Gallery and a summons issued against him, John added his name to the petition in Lawrence's support and stated that he was prepared, if it came to trial, to go into the witness box.

was still hourly expecting his call to the Front – of if possible to several Fronts in succession, with intervals at home during which he would work up the results of his sketching into pictures. 'I very much want to do a great deal in the way of military drawings and paintings,' he told Grant Richards,[466] who had written to him proposing a book of such drawings. The authorities, however, held out against permanent exemption being granted to him. Its rule was that all artists must be called up, after which the War Office could then apply to the army for their artistic services. Because of his recurring exemption, John was unable to force his way into the army in order to get seconded out of it. To his considerable frustration, he had become the centre of a bureaucratic stalemate.

On 7 September 1917 he underwent another medical examination. 'I was not taken on the 7th,' he wrote to Campbell Dodgson.[467] 'On leaving, my leg (the worst one) "went out" so I had physical support for spiritual satisfaction.' He had already informed the War Office that he had no objection to his work being used for Government publications, and had produced for a Ministry of Information book, *British Aims and Ideals*, a hideously symbolical lithograph, 'The Dawn'. In a letter to C. F. G. Masterman, Campbell Dodgson wrote: 'I am of opinion that it might be the making of John to be brought into contact with reality and the hard facts of warfare, instead of doing things out of his own head as he does at present, except when he has a portrait to paint.' Impressed by these arguments, and by John's obvious eagerness, the War Office capitulated, inviting him to act as one of its official artists: and John refused.

The invitation had come just too late. Through the good offices of P. G. Konody, John had volunteered to work for the Canadian War Memorials Fund, a scheme started by Lord Beaverbrook (then Sir Max Aitken) to assemble a picture collection that would give a record of Canada's part in the war. The Canadian War Records Office now granted him, with full pay, allowances and an extra £300 expenses, an honorary commission in the Overseas Military Forces of Canada, in return for which John agreed to paint a decorative picture of between thirty and forty feet in length. 'I had almost forgotten about this project which Konody talked to me about some months ago. I had given up hope of it,' John explained to Campbell Dodgson. '. . . The Canadians would be, I imagine, far more generous than the British Government.'

London that autumn saw the contradictory sight of John attired as a Canadian major. 'I have lunched in the Café Royal with Major John in Khaki!' exclaimed Arthur Symons in a letter to Quinn.[468] 'The uniform does not suit him . . . I never saw John more sombre and grave than to-day. He is brooding on I know not what.' Lytton Strachey, who had

observed him looking 'decidedly colonial' at the Alpine Club, took a
more hostile view of this development. 'Poor John,' he lamented.[469]
'. . . Naturally he has become the darling of the upper classes, and
made £5,000 out of his show. His appearance in Khaki is unfortunate –
a dwindled creature, with clipped beard, pseudo-smart, and in fact
altogether deplorable.'

Strachey was one of those who 'joined in' a farewell party at Mallord
Street – a fantastic all-night affair, very much en bohème. Early next
morning, John's military figure, immaculately great-coated and spurred,
with leather gloves, a cane, and riding boots laced up to the knee,
picked his way nimbly between the prostrate bodies, and strode off to
the war.

4. NOT MYSELF

'John is having a great time!' William Orpen wrote[470] excitedly from
northern France. '. . . in the army [he] is a fearful and wonderful
person. I believe his return to "Corps" the other evening will never be
forgotten – followed by a band of photographers. He's going to stop
for the duration.'

He was billeted at Aubigny, a small village that had been designated a
'bridgehead'. Though there were intermittent shelling and occasional
raids, one of which removed the roof of the château where he lived,
John discovered Aubigny to be a dull place. Nevertheless he was 'over-
joyed to be out here'.[471] The old London life that had clung to him so
damply seemed to be dissolving, and he felt renewed. Over the last two
years his letters had been weighed down with confessions of a despair
that leaves 'me speechless, doubting the reality of my own existence'.[472]
He complained of a 'sort of paranoia or mental hail-storm from which
I suffer continually',[473] and of curious states of mind when he was 'not
myself'. Often he felt 'horribly alone',[474] knowing that 'there is no one
I can be with for long'.[475] In a letter to Cynthia Asquith he accused him-
self of owning 'a truly mean and miserable nature. Obviously I am ill
since I cannot stand *anybody*.' This meanness infected everything with
which he came in contact and he could see 'no good in anything.'[476]
While submerged in such moods he had a way of hopelessly shaking
his head. There were other signs, too, of this devouring melancholia.
In August 1917, after observing him closely one evening at the Margaret
Morris Theatre 'with two very worn and *chipped* ladies', Katherine
Mansfield wrote to Ottoline Morrell:

'I seemed to see his [John's] mind, his haggard mind, like a strange
forbidding country, full of lean sharp peaks and pools lit with a gloomy
glow, and trees bent with the wind and vagrant muffled creatures

tramping their vagrant way. Everything exhausted and finished – great black rings where the fires had been, and not a single fire even left to smoulder. And then he reminded me of that man in *Crime and Punishment* who finds a little girl in his bed in that awful hotel the night before he shoots himself, in that appalling hotel. But I expect this is all rubbish, and he's really a happy man and fond of his bottle and a goo-goo eye. But I don't think so.'[477]

It was the business of the artist, John believed, to be young. But he was now in his fortieth year, and age had begun to inflict upon him its humiliations. 'I am waiting for a magic elastic belt to prevent me from becoming an *absolute wreck* at 35!' he had written to Ottoline. 'It doesn't sound very romantic does it?' His deafness too had worsened and partly accounted for his great bravery during air-raids. 'I'm stone deaf myself,' he shouted at Dorothy Brett, 'besides having a weak knee and defective teeth and moral paralysis.'[478] This last condition was a wartime virus. 'As for me I can only see imminent ruin ahead – personal I mean, perhaps even general,' he had confided to Evan Morgan. Inevitably the war had subordinated the individual to the State, and in such an atmosphere John could hardly breathe – he was 'neither fish, flesh, fowl nor good red herring'.[479] His work too afforded him little certainty – painting for money, against time: an abuse of his skill. Some break had to come. His translation into a Canadian major appeared to offer him a new life, a fresh stimulus for his painting. It had arrived just in time.

The relief was enormous – to be caught up by events, to be on the move again. The blood began to surge more rapidly through his body; cheerfulness broke through. With his elevated rank came a car and a batman, and before long he was energetically patrolling the Vimy Front. 'I go about a good deal and find much to admire,' he wrote to Evan Morgan.[480] In particular he had discovered 'quite a remarkable place which might make a good picture'. This was a mediaeval château, converted into a battery position, with towers and a river running through it, at Lieven, a devastated town opposite Lens. Near by were several battered churches standing up amid the general ruin and, further off, a few shattered trees and slag-heaps, like pyramids against the sky. It was here, among this strange confusion of ancient and modern, that he planned his big 'synthetic' picture, bringing in tanks, a balloon, 'some of the right sort of civilians', and a crucifix. 'There is so much to do out here,' he wrote to Arthur Symons.[481]

'All is glittering in the front; amidst great silence the guns reverberate. I shall take ages to get all I want done in preparation for a huge canvas. France is divine – and the French people.'

The desolation seemed to exhilarate him. It was 'too beautiful', he told Dorelia, adding: 'I suppose France and the whole of Europe is doomed.'

Also stationed at the Château, in the transparent disguise of an ex-battery officer, was Wyndham Lewis. For both these war-artists it was an untypically peaceful time: guns were everywhere, but for painting not firing. John, Lewis noted with approval, did not neglect the social side of military life and was everywhere accorded the highest signs of respect, largely on account of his beard. 'He was the only officer in the British Army, except the King, who wore a beard,' Lewis explained.[482]

'In consequence he was a constant source of anxiety and terror wherever he went. Catching sight of him coming down a road any ordinary private would display every sign of the liveliest consternation. He would start saluting a mile off. Augustus John – every inch a King George – would solemnly touch his hat and pass on.'

On one occasion, after a specially successful party, the two war-artists commandeered a car and careered off together almost into enemy lines. It was the closest John ever got to the fighting, and Lewis, the ex-bombardier, was soon poking fun at his friend's mock-war experiences. But John, noticing that Lewis had retreated home following their exploit, pursued him vicariously. 'Have you seen anything of that tragic hero and consumer of tarts and mutton-chops, Wyndham Lewis?' he asked Alick Schepeler. 'He is I think in London, painting his gun pit and striving to reduce his "Vorticism" to the level of Canadian intelligibility – a hopeless task I fear.'

Occasionally John would 'run over' to Amiens, Paris or, more surreptitiously, back to London. At Amiens he had 'found Orpen',[483] whose welcome seemed a little agitated. 'They are trying to saddle me with him [John],' Orpen protested to Will Rothenstein, '– but I'm not having any! Too much responsibility.'

In Paris he called persistently on Gwen, catching her at the fourth call 'and borrowed a fiver off her . . . She says my visit did her a lot of good', he told Dorelia. '. . . One might send her some photographs, and perhaps a Jaeger blanket as she admits the cold keeps her awake at night. The Lord only knows how she passes her days.'

He was staying at the Palais d'Orsay and being escorted everywhere by Lord Beaverbrook, who had arranged some extra special entertainment for his 'Canadians' in a suite at the Hotel Bristol.[484] At supper, John recalled, 'the guests were so spaced as to allow further seating accommodation between them. The reason for this arrangement was soon seen on the arrival of a bevy of young women in evening clothes, who without introduction established themselves in the empty chairs.'

These girls, the pick of the local emporium, came strongly recommended for their efficiency: 'one or two of them were even said to be able to bring the dead to life'. Beaverbrook, at this critical moment, tactfully withdrew, and was hurriedly followed by the impetuously cautious Orpen. Bottles of champagne were then handed round and the atmosphere became charged with compulsory conviviality. 'Yet as I looked round the table, a curious melancholy took possession of me,' John recorded. '. . . I had no parlour tricks, nor did my companions-in-arms seem much better equipped than I was in this line; except for one gallant major, who, somehow recapturing his youthful high spirits, proceeded to emit a series of comical Canadian noises, which instantly provoked loud shrieks of appreciative laughter.' To keep his melancholy at bay, John also attempted an outburst of gaiety, raising 'in desperation' one of the girls to the level of the table and there effecting 'a successful *retroussage*, in spite of her struggles'.

Despite all this 'rich fun', he felt curiously islanded. The conditions of war were forcing a crisis within him. Before starting out, he had promised Cynthia Asquith to keep a diary while at the Front, but 'the truth is I funk it!'

'I am in a curious state,' he explained, '– wondering who I am. I watch myself closely without yet being able to classify myself. I evade definition – and that must mean I have no *character* . . . To be a Major is not enough – clearly – now if one were a Brigadier-General say – would *that* help to self-knowledge if not self-respect . . .? I am alone in what they call the "Château" in this dismal little town. I am very lucky, not having to face a *Mess* twice a day with a cheerful optimistic air. When out at the front I admire things unreasonably – and conduct myself with that instinctive tact which is the mark of the moral traitor. A good sun makes beauty out of wreckage. I wander among bricks and wonder if those shells will come a little bit nearer . . .'

The wearing of a uniform seemed to have imposed another self on him, and he had no centre from which to combat this. He reflected the devastation of the fields and trees. The military rhythm of his life was destroying even the reassurance of habit. In company, at Beaverbrook's party or in the mess, he could not lose himself; alone, in the château where there was 'no romance', he felt characterless. Yet he knew that to paint well he had to establish a strong sense of character, and if he could not do this then it might be better to be killed, suddenly, pointlessly, by some shell. He watched himself. The crisis mounted within him until culminating in a sudden act of self-assertion when he knocked out one of his fellow officers, Captain Wright. 'The gesture had only an indirect relation to my codpiece,' he assured Gogarty.[485] Unwittingly

Captain Wright had said something that, interpreted by John as an insult, acted as the trigger movement for this explosion. The situation was serious and John was rushed out of France by Lord Beaverbrook. 'Do you know I saved him [John] at a Court-martial for hitting a man named Peter Wright?' Beaverbrook complained in a private letter to Sir Walter Monckton (30 April 1941). 'I cannot tell you what benefits I did not bestow on him. And do you know what work I got out of John? – Not a damned thing.'

John arrived back in London at the end of March 'in a state of utter mental confusion'.[486] There was no chance of returning to France, and for four months the threat of some military humiliation hung over him. 'I think this trouble must be over,' he eventually wrote to Gogarty on 24 July 1918. 'The Canadian people seem to think so, and it's now so long since.'

It remained to be seen whether he could salvage something from his few months at the Front. 'I am tackling a vast canvas,' he had told Innes Meo (22 February 1918), '– that is, I shall do'. Cynthia Asquith, who saw this canvas on 29 July, recorded her impressions in a diary:

'It is all sketched in, but without any painting yet. I was tremendously impressed. I think it magnificent and it rather took my breath away – splendid composition, and what an undertaking to fill a forty-foot canvas!'

This canvas went on view in January 1919 when the *Observer* art critic P. G. Konody organized a Canadian War Memorials exhibition at Burlington House. 'Even Mr Paul Nash may grow old-fashioned with the years,' commented *The Times*[487] 'but it is hard to imagine a time when Major John's cartoon (not yet finished) "The Pageant of War" will not interest by its masterly suggestion of what war means.'* Intermittently during that year John grappled 'with my Canadian incubus . . . I must try to get quit of the whole business. No more official jobs for me.'[488] By January 1920, while altering its name from time to time, the picture was no further off from completion. But by then the erection of the art gallery in Ottawa, planned to house the entire Canadian War Memorials collection, had been postponed. Forty years on Beaverbrook and John were still in close correspondence about this, Beaver-

* John Singer Sargent was less impressed. 'I have just come from the Canadian Exhibition, where there is a hideous post-impressionist picture, of which mine ['Gassed'] cannot be accused of being a crib,' he wrote to Evan Charteris. 'Augustus John has a canvas forty feet long done in his free and script style, but without beauty of composition. I was afraid I should be depressed by seeing something in it that would make me feel that my picture is conventional, academic and boring – whereas.' For a different point of view by another artist on this exhibition see William Rothenstein's *Men and Memories*, Vol. II, p. 350.

brook asking after the picture, John parrying with inquiries about the gallery.* When John died the painting was still obstinately unfinished; and by the time Beaverbrook died his gallery remained stolidly unbuilt. But he had erected a gallery at Fredericton, and John had completed several smaller war pictures, some of which went to the Canadian National Gallery at Ottawa. Among these were numerous solid and precise drawings of soldiers, and some oil portraits done in thick juicy textures – studies in military boredom.

But there is one large oil painting, 'Fraternity',[489] that justifies the time he spent in France. Executed in muted greens and browns, it depicts three soldiers against a background of ruined brickwork and shattered trees, one giving another a light for his cigarette. It is a touching picture, emotionally and literally in the swirl of arms and the two cigarettes held tip to tip: a gesture, unexpectedly moving.

The war was over. On Armistice Day, John made his appearance at an endless party at Montague Shearman's flat in the Adelphi 'amid cheers, in his British [*sic*] officer's uniform, accompanied by some land-girls in leggings and breeches who brought a fresh feeling of the country into the overheated room'.[490] He seemed to be enjoying himself, and communicating enjoyment, more than anyone. The following month he wrote to Quinn: 'London went fairly mad for a week but thank the Lord that's over and we have to face the perils of Peace now.'

His 'bad period', that had begun in France, was still with him. 'Rather dreadful that feeling of wanting to go somewhere and not knowing where,' he noted.[491] 'I spend hours of anguish trying to make a move – in some direction.' In this whirlpool of inactivity he grew more dependent on other people. One was Lady Cynthia Asquith. 'Of you alone I can think with longing and admiration,' he declared. 'You have all the effect of a Divine Being whose smile and touch can heal, redeem and renew.' For Cynthia Asquith, herself close to a nervous breakdown, admiration was a medicine to be swallowed as 'dewdrops' – though when it took the form of 'an advance – clutching me very roughly and disagreeably by the shoulders – I shook myself free and there was no recurrence'.[492] What John responded to, felt companion-

* 'My dear Comrade,' Beaverbrook wrote to John on 26 August 1959, '. . . I was quite willing to build a Gallery in Ottawa but the Canadians did not have a suitable site and also there seemed little enthusiasm for the project.

'Now there is a beautiful Art Gallery by the River in Fredericton built by me and in it you will find two John drawings and two John paintings with a third on the way.

'How I wish that big picture might be handed over to us for exhibition there.'

Among those pictures owned by Beaverbrook Foundations is a small version (oil on canvas $14\frac{1}{2} \times 48$ inches) of his large war picture, entitled 'Canadians at Lieven Castle'. The cartoon was rescued by Vincent Massey who took it to Canada.

ship with, was the unhappiness far below her giddy exterior. He understood her need for such an exterior, could relax with her, talk. 'I bucked up somewhat,' he told her. 'Such is the benefit we get from confessing to one another.'

The war was over, but the trappings of war remained. In the spring of 1919 he was invited to attend the Peace Conference in Paris. Lloyd George had proclaimed that the conference should not be allowed to pass 'without some suitable and permanent memento being made of these gatherings'. The British Government had therefore decided to 'approach two of the most famous British artists and ask them to undertake the representation of the Conference'. The two selected were John and Orpen, and both accepted. Terms were generous. They were to get a subsistence allowance of £3 a day, expenses, a Government option to purchase each of their pictures for £3,000, and a £500 option price for the portraits of visiting celebrities, many of whom, Sir George Riddell assured the Government, 'are most anxious to be painted'. In John's case there was an immediate obstacle. Unaccountably he was still in the Canadian Army, and special arrangements were rushed through enabling him officially to be 'loaned to the War Office'.

He dreamed of being flown to France but, after three days of waiting in foggy weather, went like everyone else by train, finding himself in 'a charming flat . . . almost too dream-like' on the third floor of 60 Avenue Montaigne. Here as the guest of Don José-Antonio de Gandarillas, an opium-eater with dyed hair, attached to the Chilean Legation, he stayed during February and March. The conference hall was just across the river and he at once rushed over in search of profitable celebrities. 'A certain delay at the start is to be expected no doubt,' he hazarded in a letter to Frances Stevenson.[493] It was Gandarillas who put delay to flight. He knew everyone, and invited everyone to his flat. The parties they gave in the Avenue Montaigne became the talk of Paris. 'My host Gandarillas leads a lurid and fashionable life,' John admitted.[494] An orchestra, played ceaselessly all night and the spacious apartment was thronged with the *beau monde*. Rather nervously John began to infiltrate these parties, entering for the first time 'as dream-like a world as any I had been deprived of'.[495]

He had not thought of obtruding himself – certainly he had no wish to dance: he had come prepared to 'stand apart in a corner and watch the scene'. What happened astonished him. He talked, he laughed, he danced: he was an extraordinary success. Paris this spring was the hub of the social and political world; and amid the galaxy gathered there this son of a Pembrokeshire solicitor was acknowledged to stand out as 'easily the most picturesque personality', Frances Stevenson recorded. 'He held court in Paris.'

All red carpets led to him. The prime ministers of Australia, Canada and New Zealand submitted to his brush; kings and maharajahs, dukes and generals, lords of finance and of law froze before him; Lawrence of Arabia took his place humbly in the queue – and Dorelia wrote to inquire whether he had yet been knighted. More wonderful still were the princesses, duchesses, marchesas who lionized him. His awkwardness departed, confidence surged through his veins. They were, he discovered, these grandiloquent ladies, all too human: they 'loved a bit of fun'. Under a smart corsage beat, as like as not, 'a warm, tender even fragile heart'. It was a revelation.

He had been born quite suddenly into a new world, but it did not take full possession of him. Even now, at the height of his triumph, his 'criminal instincts' reasserted themselves; he hurried away to 'my old and squalid but ever glorious quarter . . . and sat for a while in the company of young and sinister looking men with obvious cubistic tendencies.'[496] A few old friends still roamed Montparnasse, but it was not the same. Something was being extinguished, something was vanishing for ever. Jean Moréas was dead; Modigliani too; Paul Fort had become respectable and the cercle of the Closerie de Lilas was disbanded. Maurice Cremnitz was there, only slightly damaged by the war; but he, who had once likened Augustus to Robinson Crusoe, now gazed at Major John with suspicion. 'I was conscious of causing my friends embarrassment,' John admitted. A doubt sailed across his mind, and vanished. Was he too becoming respectable?

He was doubtful also about his painting. He had begun the peace portraits grudgingly, but his accelerated technique worked well. 'I think I have acquired more common skill,' he wrote to Cynthia Asquith on 24 July 1919, ' – or is it that I have learnt to limit my horizons merely?' In the immense conference hall he had found a room with a high window-niche, and from here he made sketches of the delegates. It was uninspiring labour. Smuts appeared overcome with misgivings; Massey described the proceedings as farcical; Balfour slumbered; the prime minister of Australia, looking like a jugged hare, was learning French. Speech followed speech in a multiplicity of languages: the assembly wilted in boredom. For John these interminable rows of seated figures offered no pictorial possibilities. But he badly needed the three thousand pounds and decided to attempt a more fanciful interpretation of what he saw. 'I do not propose to paint a literal representation of the Conference Chamber,' he promised the Ministry of Information, 'but a group which will have a more symbolic character, bring in motifs which will suggest the conditions which gave rise to the Conference and the various interests involved in it.' So far as he could see, it was a Conference in Spain, and from the point of view of his picture he gave it an appropriate

epitaph: 'I hope to get ahead with it as soon as the Canadian picture on which I am now engaged is finished.'

In April he had moved from Gandarillas's apartment to a private house belonging to the Duchess of Gramont whose portrait he was painting. By May he resolved to quit Paris. He had been spoilt, pampered, dazzled. But now he had had enough: strangers would make better company, or perhaps solitude itself might be best. 'Life in Paris was too surprising,' he afterwards confided to Cynthia Asquith. 'I long for some far island, sun and salt water.' Financial cares anchored him to these northern lands. He had too much work of the wrong sort dotted through France and England, and felt unequal to organizing it all. 'I am very helpless and desolate,' he confessed.[497]

He was still in khaki. Until the autumn of 1919, and increasingly to everyone's consternation, he continued to receive pay and allowances from the Canadians, and for almost seven months from the British War Office also. 'I must drop this commission and get into walking clothes again,' he told Dorelia. 'Would it not be more satisfactory for you to be demobilized?' the authorities tactfully persisted. But every time he prepared to return to civilian life a curious reluctance, not wholly financial, overcame him.* Had he not been 'going for a soldier' even before deciding on the Slade? The uniform, which had caused such embarrassment in Montparnasse, had given him confidence in the Champs-Élysée, and he enjoyed the pantomime.

The inability he experienced to finish either the Canadian War or Paris Peace pictures† made him feel 'very unstable'. His expanding social confidence was constantly being deflated by these anxieties over his work. He tried several methods of restoring this stability. He began to travel again – to Rouen‡ ('nearly died of depression') and, in September 1919, to Deauville as the guest of Lloyd George.

'What a monde he lives in!' he wrote to Cynthia Asquith.[498] '. . . My fortnight here has been fantastic . . . It's a place I should normally avoid. I have been horribly parasitical. I began a portrait of a lady here which promised well – till I gathered from her that if I made her *beautiful*, it might turn out to be the first step in a really brilliant career.'

* His secondment for duty with the War Office was terminated on 22 September 1919; and then, without delay (on 23 September) he was struck off the strength of the Canadian War Records – though with two medals: the British War Medal and the Victory Medal.

† To reimburse the British Government for the expenses it had paid him on his never-to-be-painted Conference picture, he gave the Imperial War Museum eight drawings relating to the war, and allowed the museum to buy at an almost nominal price (£140) his painting 'Fraternity'.

‡ In May 1920, with two of his sons, Edwin and Romilly, whom he was sending to a French school.

In March 1920, once more at the Alpine Club Gallery, John exhibited his war and peace portraits – statesmen, generals and fine ladies. They were not flattering likenesses, nor were they malicious: with few exceptions (mostly the ladies) they were neutral. The tedium released by the company of such public persons is very adequately recorded, and to that extent he remained uncorrupted by this 'exalted company'.[499] But, mainly for financial reasons, he had succumbed to the temptation to waste time. His two exhibitions at the Alpine Club were exercises in the higher journalism of art – pot-boiling commissions that gave little evidence of his genius. John knew this himself. No amount of social success could conceal the truth from him for long. His fits of melancholia persisted, sometimes smothering him with a blanket of depression. In April 1920 he entered the Sister Carlin Hospital for an operation on his nose which he counted on to make breathing easier. He had been 'in a state of profound depression', he told Ottoline Morrell.[500] '. . . I feel always as though practically poisoned and must not shirk the operation. I look forward to it indeed as a means of recovering my normal self.' It was essential to keep morale high. 'It took an uncommon amount of ether to get me under,' he bragged to Eric Sutton.[501] Under the ether, with a deep sigh, he uttered one remark: 'Well, I suppose I must be polite to these people.' He recovered with his usual facility. 'I am doing rather brilliantly,' he trumpeted.[502]

Later that year, following a convalescence, he went with Dorelia and some of the family to stay with his father back in Tenby. A new age was dawning in Britain, and many were curious to know what part John would occupy in it. He was no longer the leader, as the *Observer* art critic had reported in 1912, of 'all that is most modern and advanced in present day British Art'. Nor, in his forty-third year, was he yet a Grand Old Man. To the younger artists he had been the apostle of a new way of seeing; now he was the fugleman for a way of living. If commissioned work had helped to cloud his vision, it did not seem likely he would be content merely to repeat himself. It was time to start again. 'I want to dig myself up and replant myself in some corner where no one will look for me,' he stated to Cynthia Asquith. 'There perhaps – there in fact I know I shall be able to paint better.'

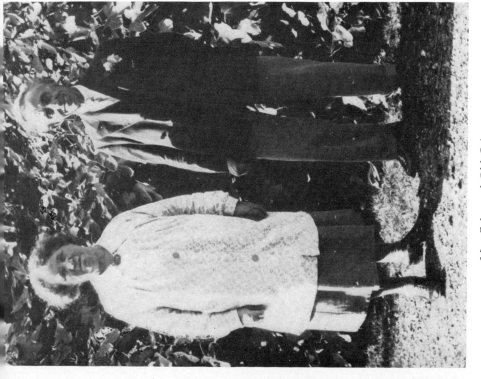

Mrs Cake and Old Cake

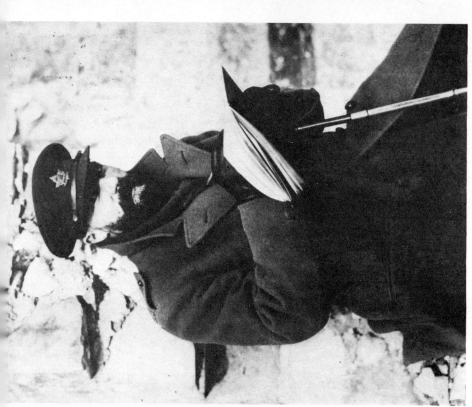

John as a Canadian major

Marchesa Casati representing 'Light'; a costume created by C. F. Worth (Radio Times Hulton Picture Library)

Chiquita photographed in 1924

Artist Of The Portraits

'Having been regarded as a kind of "old master" for a long time
I am now hailed as a "modern" which you must admit is very
satisfactory.'
 Augustus John to Conger Goodyear (4 January 1928).
'I don't find it at all amusing to paint stupid millionaires when I
might be painting entirely for my own satisfaction.'
 Augustus John to Ada Nettleship (1928).

1. EVERYBODY'S DOING IT

*Après la guerre
There'll be a good time everywhere.*

And there was. Everyone wanted to be young. People had grown weary
of big guns, big phrases: they needed to forget – not just the war but
those feigned ideals that had gone down in it. The vast decency smother-
ing the Victorians was at last folded back, and the Victorian relish of
power, which had magnificently raised up the Empire, was deflowered.
Enjoyment was to be the new currency – enjoyment spent as an un-
precedented freedom to act, to feel, to travel. The Continent became
transformed from a battlefield into a playground. It was as if youth had
suddenly been invented and pleasure become compulsory. There was
no one unaffected by those four years of terrible fighting: the whole
country had been scorched. Now it set about applying a miraculous
balm.

To no category of people did this fashionable freedom apply more
directly than the New Woman. During the war her masculine capa-
bilities had been astonishingly displayed as policemen, postmen, com-
missionaires, as workmen in munition factories, gasworks and on the
land. In the 'twenties she grew into a little boy. No longer did she take
up her hair and let down her hems to signify at sixteen that she was an
adult: her hems went farther up and her hair was cut, insisting on a
refusal to grow up.

To revive jaded palates new entertainments were explored – night
clubs, cocktails, cinemas, open-air breakfast parties and the *thé dansant*.
'I have a thé dansant to-morrow,' John announced from Mallord
Street, ' – about 3000 people are coming'. Parties were more informal
and gyrated to more syncopated rhythms, jazz on the gramophone, and
exotic dances – the shimmy, the charleston, the black bottom, the fox
trot. The handsome woman in the hansom cab had been overtaken by a

fast woman in a fast car. She stepped out of the shadows, glittering with painted face and nails, a vibrant brunette or redhead. Glamour had come to London. There was a whirl of glass beads and pearls, sparkling paste, plucked eyebrows, rouge, brilliantined hair, sticky scarlet lips, surprised faces. Coloured underclothes broke out in shades of ice-cream: peach, pistachio, coffee. Young men sported plus-fours, big bow ties, motoring caps, gauntlets, co-respondent's shoes. John himself sprouted a waistcoat and suits of decisive check tweed.

There was an epidemic of health. 'Vapours' were no longer admired, neurasthenia went out of date. Young wives drilled themselves in natural childbirth exercises, practised art and craftwork for charity. At week-ends everyone stayed with everyone else in draughty country houses, playing bridge and tennis. Nature was again important: a million women cycled out beyond the suburbs.

The 'twenties was not a cynical but a sentimental decade. Under the high kicks lay a deep disillusionment, beneath the quick-step slow disintegration. Social divisions were being, creakingly, re-adjusted. The social centre of gravity in Britain was on the move and for this brief artificial period it lodged with the upper-middle class.

To the Old Guard, those dinosaurs from Victorian and Edwardian England, Augustus John was still 'disgusting John', a rascal in sinister hirsute league with those other dangerous spirits – D. H. Lawrence, Bernard Shaw, Lytton Strachey – all of them plotting to do away with what was decent in the country. But to the Bright Young Things, John was a ready-made hero, one of the pioneers of the new freedom.

Although by no means an ideal age for him, the 'twenties seemed more sympathetic to John than any decade that was to follow. He appeared to recover himself and gain a second wind. He travelled further, drank more, made more money, did more portraits. He painted popular people: film actors, airmen, matinée idols, beauties and beauticians, Greek bankers, Infantas, Wimbledon champions, novelists, musicians. The Emperor of Japan called one morning and was polished off in an hour. One problem was that the new cosmetics made a false barrier between the painter and his subject, but he knew about barriers, responded to their painted happiness. His most glittering portraits – of the Marchesa Casati, of Kit Dunn as the arch-flapper, and of Poppet as a provocative sex-kitten – are extraordinarily vivid.

The spirit of the age was a fairweather friend to John. The sun shone, the breeze blew, he sped along: it did not matter where. He was invited everywhere, though his own incompetence and the dark weather of his moods forestalled a measure of temptation. Wherever he went, his gift for boredom dramatically asserted itself. 'What a damnable mistake it is to go and stay with anybody,' he cried out in one letter to Dorelia.

Many of the smart London hostesses were too sophisticated for his appetite. He was sometimes abominably rude to them, but his apologies were full of charm, and all was forgiven this half-tamed society artist.

He had become one of the most popular men in the country. In Soho restaurants 'Entrecôte à la John' was eaten; in theatres any actor impersonating an artist was indistinguishable from him; in several novels he was instantly recognizable as 'the painter'.[503] He began to use a secretary. 'Is there room for Kathleen Hale?'[504] he asked Dorelia somewhat desperately. There was, and he started to employ this young girl (later to become celebrated as the creator of a marmalade cat, 'Orlando') primarily, he explained, gesturing with his hand across his stomach as though guarding against onslaught, to provide a barrier between him and the hostesses, journalists and probationary models who ceaselessly solicited him.

Nowhere was the popular legend of John seen more clearly than at his Petronian parties in Mallord Street. They would begin at five and last till five, and they had what Christopher Wood called 'a remarkable feature . . . there was not one ugly girl, all wonderfully beautiful and young'. Though they regularly ended 'in the most dreadful orgy I have ever seen', Christopher Wood concluded:[505] 'One always enjoys oneself so much at his house, he is such a thorough gentleman'. More coveted still was an invitation to Alderney.

'He has lots of ponies, dogs and all kinds of animals which roam quite wild all round the house,' Christopher Wood told his mother (11 October 1926). '. . . we arrived to find old John sitting at his long dining table with all his children and family followers. We took our places quite naturally at the table where there was a perfect banquet with all kinds of different drinks, which everyone – even the children going down to ten years of age and even seven, and all the cats and dogs partook of. Afterwards we took off our coats and waistcoats and had a proper country dance. John has a little daughter of fifteen, like a Venus, whom he thinks a lot of . . . [He] is the most delightful person, the perfect gentleman, most charming in every possible way'.

Dancing and motoring were the obsessional hazards of the 'twenties, and together they match the rhythm of the age. Dorelia never danced, though she was often near by, watching and smiling. John could not be prevented from taking the floor. 'The tango can't be resisted,' he admitted. More irresistible still were motor cars. He had first been infected with this virus in 1911 when chauffeured through France in Ryan's Mercedes. 'It can't be denied there's something gorgeous in motoring by night 100 Kilometres an hour,' he had told Ottoline Morrell.[506] He had never driven himself until, one day in the year 1920,

he acquired, in exchange for a picture, a powerful blue two-seater Buick with yellow wheels and a dicky. After enduring half an hour's lesson in London, he filled it with friends and set off for Alderney. Apart from barging into a barrel-organ and, so far as the passengers could judge, de-railing a train, the car enjoyed an immaculate journey down – and this despite the fact that John's lesson had not touched upon the philosophy of gear-changing, so that it had been in first gear from start to finish. 'The arrival at Alderney was rightly considered a great triumph,' Romilly John recalled.[507]

'I insisted on being taught to drive immediately, and David, who had never driven a car in his life, but who had had much experience with a motor bicycle, undertook the task. I had often observed other drivers, and was therefore a qualified chauffeur in theory, so that after about half an hour I was considered competent to drive out by myself. It was then Dorelia's turn. By the evening the house was full of newly-fledged drivers, and in a few days it was considered a mere nothing to go spinning along at sixty miles an hour . . . After that we always seemed to be whizzing – the right word for our mode of transit – up to London. In those days the roads were still fairly empty, and motoring was still a sport. We nearly always came up with another fast car, also on its way to town, and then we would race it for a hundred miles. No matter who was driving, we made it a point of honour never to be outdone, and we very seldom were. When our car and its rival had passed and repassed each other several times, emotion would work up to a white-heat, and every minor victory was the signal of a wild hilariousness.'

Though the family inherited his talent, the John style of motoring was seen in its purest form whenever Augustus took the wheel. In fine country, on a good day, he was apt to forget he was driving at all, allowing the car to pelt on ahead while he stared back over his shoulder to admire some receding view. Under this *laisser-aller* the car often performed better than when he bent upon it his fullest attention. Then, roaring like a wounded elephant, it would mount hedges, charge with intrepid bursts of speed towards corners, or simply explode with punctured tyres. Passengers were called upon to assist only during emergencies. Once, when hurtling towards a fork in the road, John demanded which direction to take, and, his passenger hesitating a moment, bisected the angle, accelerating straight into a ploughed field until brought to a halt by the waves of earth. Another time, he 'awoke to find himself driving through the iron gate of a churchyard'.[508] Because of feats like these, the car soon began to present a dilapidated appearance, like an old animal in a circus: the brakes almost ceased to operate, and the mechanism could only be worked by two people

simultaneously, the second taking off the hand-brake at the precise moment when the first, manipulating the knobs, buttons and handles as if performing on an organ, caused the engine to engage with the wheels. Sometimes, 'like a woman', the car refused to respond at all and had to be warmed up, cajoled, petted, pushed. At last, yielding to these blandishments (again like a woman), she would jerk into life and, with her flushed occupants, drag herself away from the scene of her humiliation to the dispiriting cheers of the assembled *voyeurs*. In her most petulant moods she would react only to the full frontal approach. But once, when John was winding up the crank (the car having been left in gear on the downward slope of a hill), she ran him down. His companion, a music critic, 'frantically pushing and pulling every lever I could lay my hands and feet on,'[509] was carried off out of sight, their elopement being eventually arrested by a brick wall.

Though accidents were plentiful there were almost no deaths and the Johns themselves seemed marvellously indestructible. They were, however, extremely critical, even contemptuous, of one another's skill. Dorelia, for example, failed to applaude John's inspired cornering; while he irritably censored her triumphant use of the horn. None of them 'felt safe' while being driven by any of the others, and did not scruple to hide this. 'I will not attempt to conceal,' wrote Romilly John,[510] 'that some of us were secretly glad when some others incurred some minor accident'.

Towards people outside the family, though dismissive of their ability, they were nervously polite. An episode from Lucy Norton's motoring career shows John's kindness on wheels at its most characteristic:

'The incident happened in 1926 or 1927 when I was 23 or 24,' she recounts. 'I had recently purchased a motor-car, and John thought a long country drive would be the thing to give me experience. Night-driving experience, he said, was very important. I picked him up at Mallord Street early on a May morning. He appeared in a beautiful Harris-tweed coat, his usual large gypsy hat, several scarves with fringed ends, a bottle of whisky in case of need, and a bottle of gin for a friend.

'All seems to have gone well until we reached Winchester, when I was turning to the right as John was saying "turn left", and we mounted, very slowly, a lamp-post. John said nothing but I could see he was shaken. We proceeded to Ringwood, had a superlative lunch and about six o'clock started for home.

'I suppose we must have gone about ten miles or so, when I was overcome with the strong suspicion that the back door of the four-doored Morris Cowley (I had bought the cheapest car, so that it would

not matter if I hit things) was not shut. I turned to shut it – not realising
that, as I pivoted with one hand back, the other on the steering wheel
would follow me round. The next thing was a mildly terrific crash, as
the car hit the soft bank at right angles on the other side of the road.
John rose upright in his seat, lifted me also to a standing position behind
the wheel, and clasping me to his shoulder said in tones of sympathetic
disgust: "You simply cannot trust the steering of these modern cars! It's
too bad!"'

Such imaginative courtesy was often useful in Court. Montgomery
Hyde, who happened to be passing one day, observed how John, coming
out of his drive 'fairly rapidly',[512] cannoned into a steamroller which
was doing innocent repairs to the road outside his gate. Very correctly
John reported this incident but the police, having their own ideas,
replied with a summons. In due course he appeared before the local
Bench but was acquitted because, the magistrate explained, he 'behaved
in such a gentlemanlike manner'.

As it whizzed through the 'twenties this car took on many of John's
characteristics. It became, in effect, a magnified version of himself, and
its exploits drew attention to a developing feature of his life. He seemed
to have no nerves or sensitivity to danger. 'How we never got killed in
this car was a miracle,' Poppet recalled.[513] The detached feeling that had
first invaded John at the Front – the calm knowledge that he might be
struck dead at any second – grew more established. 'He might easily
have been killed,' wrote Cecil Gray[514] of one motoring adventure,
' . . . but Augustus has always lived a charmed life where cars are
concerned . . . I recommend anyone suffering from suicidal depression
or a distaste for life to induce my illustrious friend to take him for a
spin in the country and I guarantee that when he returns – if he ever
does return, which is problematical – it will be as a yea-saying Nietzsch-
ean lover of life.'

As John's talent diminished so his melancholia, like a dark electricity,
burnt more deeply within him. To more than one person in his later
years he spoke of suicide: how he must resist the temptation to give into
it. He would not kill himself, but need he

> *strive*
> *Officiously to keep alive?*

His carelessness seemed deliberate, an invitation for Fate to intercede.
The irony was that his negligence was exactly cancelled out by Dorelia's
diligence. As the 'femme inspiratrice', attaching herself to Augustus so
as to nurture his genius, she helped to keep him alive over the thirty
years in which he painted his worst pictures. Sometimes he longed –

or so it appeared – to make what haste he could and be gone: but she would never let him.

So he drove on, recklessly, not knowing where to go. And nothing happened. In spite of all vicissitudes, the Buick continued noisily to function 'and was only abandoned at last,' Romilly remembered,[515] 'somewhere near London, upsidedown and in a state bordering on the chaotic'.

2. WOMEN AND CHILDREN: AN A TO Z

He had said goodbye to his mistresses and also, by the end of the war, to many friends who had been killed. 'What casualty lists!' he exclaimed in a letter to Quinn.[516] 'How can it go on much longer? Among my own friends, and I never had many – [Dummer] Howard, [Ivor] Campbell, Heald, Baines, Jay, [Tudor] Castle, Rourke, Warren, Tennant . . . We must be bleeding white – and it seems the best go down always'. The eccentrics survived: Trelawney Dayrell Reed, aloof and stammering, to be the perfect subject for John's El Greco phase; Horace de Vere Cole, to become a victim of his own practical jokes; Francis Macnamara, John's replica-rival, surrounded by logbooks, bottled ships, thundering treatises, and supported by monkey-glands, to emerge first as Romilly's theological tutor, then (by scooping up Edie McNeill and marrying her) as Dorelia's brother-in-law and after that as the father-in-law of Dylan Thomas. The boys' old tutor, John Hope-Johnstone, also danced back 'like an abandoned camel'[517] and promptly re-engaged himself as Robin's philosopher and guide.

In the eyes of many, John appeared superior to the needs of ordinary friendship. 'Is it because I seem an indifferent friend myself?' he asked Will Rothenstein.[518] 'I know I have moods which afford my friends reason for resentment; but I love my friends I think as much as anybody – when they let me'. What he needed in the way of friends was variety, from which, like notes on a piano, he could select any tune of his choice. Though many had gone down, more were stepping forward, like the fresh row of a chorus, to fill their places. There was Joe Hone, rare phenomenon, an Irishman of impressive silence; Roy Campbell, the big action maverick poet from South Africa, with his black cowboy hat, white face and flashing blue eyes, dressed in clothes that 'appeared to have been rescued from the dustbin';[519] T. W. Earp, ex-President of the Oxford Union, a soft-spoken, gently humorous man, his hair close-cropped, his head shaped like a vegetable, who had taken his lack of ambition to the extreme of becoming an art-critic; Ronald Firbank,[520] wrestling with a shoot of asparagus, his nervous laugh like the sound of a clock suddenly running down, his hands fluttering with embarrassment, trying to live down 'the dreadful fact that his father had been an

M.P.'; and A. R. Orage, John's 'man of sense',[521] the brilliant wayward editor of the *New Age*, who, like a Mohammed always changing his Allah, had first elected Nietzsche as god, then ousted him with the Douglas Credit Scheme which gave way before the deity of psycho-analysis, and was finally replaced, in New York and Fontainebleau, by Gourdjief's box of tricks – at which point John lost him. Like John, he had the mind of a disciple and the temperament of a leader, which led even this last association with Gourdjief to break up. Between the extremes of rhetoric and literature, honesty and sophistry, he passed his life, stimulating where he could not nourish and testifying by his persistent search to the existence of what he could not find.

Such friends provided new worlds for John. Being rootless himself, he was easily transplanted. Having been a Welshman, gypsy, sartorial soldier and leader of the British School of Promise, he was soon to turn academician, stage designer for Sean O'Casey and for J. M. Barrie, illustrator for Ronald Firbank. He had been on friendly terms with Bloomsbury, still maintained good relations with the Sitwells and, intermittently, with Wyndham Lewis. But in the 1920s he moved for the first time into the land of the rich and aristocratic – of Napier Alington, Evan Morgan, Gerald Berners. It would not be true that he never looked back – such was not in his nature. But the distance over which he had to look to connect other parts of his life lengthened.

He had crossed the border into this elevated world at the Paris Peace Conference. It was here that his friendship began with T. E. Lawrence who, singling him out as the perfect image-maker, returned again and again (concealing his hideous motor-bike behind the bushes) for 'fancy-dress'[522] portraits of himself as Café Royal Arab or pale plaintive air-craftsman. But it was the Marchesa Casati, of the archaic smile and macabre beauty, who beckoned him into international society. As Luisa Ammon, daughter of a Milanese industrialist, she had been, it was said, a mousy little girl. As the young wife of Camillo Casati, noblest of Roman huntsmen, she pounced like a panther on to life: and overshot it. The mousy hair burst into henna'd flames; the grey-green eyes, now ringed with black kohl, expanded enormously, amazing false eyelashes spreading and waving before them like peacock's feathers. Her lips were steeped in vermilion, her feet empurpled, her face, transformed by some black-and-white alchemy, became a painted mask, a sphinx. By taking thought she added a cubit to her stature, raising her legs on altitudinous platform heels, and crowning her head with top hats of tiger skin and black satin, huge gold waste-paper baskets turned upside down, or the odd inverted flowerpot from which gesticulated a salmon-pink feather. It was for her that Léon Bakst, soaring on his most extravagant flights of fantasy, designed *incroyable* Persian trousers of the most savage cut;

for her Mariano Fortuny invented his finest fabrics – long scarves of oriental gauze, soaked in the mysterious pigments of his vats and 'tinted with strange dreams'.[523]

She lived, this decadent queen of Venice, in the roofless 'Palazzo Non Finito',* there conducting entertainments of surrealist splendour. Disguised as an animal-tamer in leopard skins from neck to ankle, she would appear with a macaw on her shoulder, an ape on one arm, or a few cobras. As background for these appearances she redesigned her ballroom with caged monkeys which gibbered among branches of lilac as she floated past pursued by a shoal of Afghan hounds and a restive ocelot held on its leash by the negro keeper, his hand dripping with paint. Whenever the guests overflowed she would take over the Piazza San Marco, illuminating it with torches brandished by near-naked slaves. But there were failures. The slaves, painted with gold, expired; her costume – an affair of armour pierced with a hundred electric arrows – short-circuited. By the spring of 1919 she had left Venice and her husband, achieved poetic status as the mistress of d'Annunzio and, having exhausted one huge fortune, was preparing to demolish a second.

Casati's witchlike aspect often provoked terror in her admirers: but John, unlike most of these cavaliers (whom she treated with glorious contempt) was a romantic only by instalments. Visually she stimulated him, but in other ways caused him (between yawns) to 'laugh immoderately'.[524] Where T. E. Lawrence had beheld a 'vampire', John saw only 'a spoilt child of a woman' ringed about with the credulity and suspiciousness of a savage. Taken in small draughts, her presence, with all its malice and extravagance, intoxicated him.

She had been painted by innumerable artists. To Marinetti and the Futurists, she was their Gioconda; to Boldini, who portrayed her smothered in peacock feathers and arched over cushions like a pretend-panther, she was Scheherazade. To John, who painted her twice in April 1919, she was something else again: a truncated, pyjama'd figure,† fantastically mascara'd, and poised, vamp-like, before a view of Vesuvius where, as the unbidden guest of Axel Munthe, she overstayed her welcome by some fifteen years. For once romanticism and irony were perfectly blended to produce what Lord Duveen was to call 'an outstanding masterpiece of our time'.[525]

'He painted like a lion,' sighed Casati. 'Le taxi vous attend,' he writes to her from Paris. 'Venez!' They flung themselves towards each other, but the romance, a brilliantly casual performance, seemed sadly under-rehearsed. Sex was not the real attraction between them. Casati took

* Subsequently converted into the Guggenheim Institute.

† It was, Sir Evan Charteris wrote, 'originally full-length in pyjamas and was cut in half by John himself'.

other people's admiration for granted, using it as an orchestration to her life, a perpetual chorus singing invisibly while she stood on stage alone. Otherwise love-affairs threatened to interfere with her passionate self-love. For she was intensely narcissistic, rather under-sexed and without actual intelligence. As an exhibitionist she needed partners only for her audience. Yet somehow John felt a kinship with her. Like him, she was outrageously shy, concocting, in place of real life, a pantomime.

She wanted for nothing until the 1930s when the last penny of the last fortune had been squandered and the curtain came down on her performance. As Cagliostro at a Magicians' Ball she tempted the Devil once too often. A dreadful storm scattered her guests and she fled from her Palais Rose at Neuilly, penniless, to England. From those who had shared her costume ball career throughout the Continent she knew with a peasant's sharp instinct there would be no compassion, no cash. In England there was charity, a pale but persistent kindness, first from Lord Alington, then, for the last dozen years of her life from a Wode-housean platoon of old fellows – the Duke of Westminster, Lord Tredegar (Evan Morgan) and John himself. 'Je serai ravi de vous revoir, carissima,' he gallantly welcomed her, enclosing 'un petit cadeau'. He warned her that 'Londres n'est pas gai en ce moment,' but she knew there was nowhere else she could shelter. She lived in a small dirty flat within, however, a house that had once been Byron's. The layers of powder grew thicker; the stories of Italy longer; her clothes more faded and frayed; her leopard-skin gloves spotted with holes; her thin figure, like a scarecrow, into a bag of bones. But she had never valued mere comfort and did not miss it now. Despite the squalor, she played, to the last notes, this ghostly echo of the d'Annunzian heroine. 'Bring in the drinks!' she would call, and a bent Italian servant would shuffle forward with a half-empty bottle of beer. What money came in she tended to spend at once, shopping by taxi in Knightsbridge and Mayfair for Spider, her Pekinese. Her one asset was absolute helplessness, which threw responsibility for her survival on to everyone else. To ensure that their help was practical, her friends paid an allowance each week into her bank from where, by taxi, she would grudgingly collect it. Her bank accounts show that, for over a decade, John was her most persistent source of income. She did not need very often to beg from him: he gave spontaneously, regularly, small sums with a there-but-for-the-grace-of-God generosity. 'Ayez courage, carissima, et croyez à mon amitié sincère'. It did not occur to her to do otherwise. 'Je suis bien triste que vous êtes toujours dans les difficultés,' he wrote again, with more apprehension. But when, during the early 1940s, she asked for more money to remove these difficulties, he fell back into explanations: 'Le gouvernement prend tout mon argent pour ce guerre et j'ai des grandes

dépenses comme vous savez.' The aphrodisiac notes now gave way before a crisp commercial correspondence – 'Voici le chèque.' But she did not embarrass him with gratitude and they remained friends until her death. Meanwhile she had been overtaken by a desperate faith in occult power, no longer wasting her time writing letters to her friends but receiving them from the other world; documents in disguised handwriting that prophesied all manner of miracles – the foul death of her enemies; presents of brandy and jewels.

The mercurial Casati occupied a unique place within the latter part of John's life. She should, he once suggested to Cecil Beaton, have been shot and, like Spider, stuffed – she would have looked so well in a glass case. The other women in his life were for more active employment and, from the 1920s onwards, began to arrange themselves into a pattern. There were the occasional models; there was the chief mistress who looked after him in town and abroad when Dorelia was absent; and there was the Grand Lady, to be defined neither as model nor mistress, who conducted his life in society.

John's principal mistress during these years was Eileen Hawthorne, 'an uncommon and interesting type,' he suggested to Maurice Elvey, ' – at any rate she would like to do some work in films'. Young and very beautiful, she did most of her work for artists, with whom she was extremely popular. Pictures of her constantly appeared in the press – a new portrait by Lewis Baumer or Russell Flint; an eager advertisement for bathcubes, lingerie, eau-de-cologne; or simply as 'Miss 1933'. The most extraordinary feature of these pictures was that none of them looked in the least alike. She had developed a most versatile appearance, and as queen of the magic world of cosmetics she could change her looks from day to day. This was her 'mystery'. She was known by the newspapers as the girl of a thousand faces. Each morning she re-created herself, and again each evening. Superficially, it was impossible to tire of her.

She was not a good model for John. Hardly had he begun to apply his brushes than her features would wobble, start to dissolve and, so it seemed, re-form themselves into a different shape. She tried to appear consistent but, having no enthusiasm for it, always painted herself more fluently, it was said, than he did.

There were other problems too. He suspected that she did not possess a flair for discretion. The man who, twenty years before, advised Sampson to 'sin openly and scandalize the world' had grown timid of scandal himself. Experience, like a great wall, shut off his return to innocence. His letters to Eileen Hawthorne exhibit more anxiety than enjoyment. He asks her, because of Dorelia, not to telephone him in the country; he begs her to avoid journalists – especially on those occasions

when she happens to be missing a tooth or unable to conceal a black eye, marks which, he warns her, will inevitably be credited to his infernal 'legend'. He wishes he could trust more wholeheartedly her ability to hide things: for example, pregnancies. Though he shared her favours with the musician E. J. Moeran, it was John who, after some grumbling, paid for the abortions. He had no choice. Otherwise her mother would get to hear of them, and then the world would know.

This climate of secrecy did not suit John, but it was necessary. He divided his life into compartments. It is unlikely, for instance, that Eileen Hawthorne ever met the redoubtable Mrs Fleming who, during the 1920s and 1930s, made herself responsible for much of John's social life. She was the widow of Valentine Fleming, a Yeomanry officer and Member of Parliament for Henley, who had been killed after winning the D.S.O. in the First World War. She was rich; she was handsome – dark, with a small head, large eyes and an affluent complexion. John and she overwhelmed each other. The three portraits he painted of her in her forties show 'a Goyaesque beauty, hard, strong-featured, the self-absorbed face of an acknowledged prima donna used to getting her own way'.[526] Upon her four sons – Peter the author and explorer, Ian the creator of James Bond, Richard a prosperous banker and Michael who died of wounds as a prisoner-of-war after Dunkirk – she laid an obligation to succeed. She believed in success, and herself led an extremely successful life in society. In 1923 she moved to Turner's House at 118 Cheyne Walk, Chelsea. It was a beautiful place, superb for entertaining, with a large studio at the back, all drastically improved since the days when Turner had lodged there. Sitting at the bar of the public house next door 'fortifying the inner man' against his entry into Mrs Fleming's luncheon parties, John sometimes thought of Turner – how he would have preferred the grosser amenities of Wapping. John's own sympathies lay in a similar direction. Often he needed more drink to confront these social occasions, but the money, the aura of success, the opportunities – these could not be denied. Mrs Fleming admired him, he admired her and many people came to Cheyne Walk and admired them both. In such company it was possible temporarily to forget a bad day's work.

In his biography of Ian Fleming, John Pearson describes Mrs Fleming as 'a bird of paradise', extravagant, passionate, demanding, a law to herself. She was, he wrote, 'a rich, beautiful widow – and, thanks to the provision of her husband's Will, likely to remain one'. Nevertheless, at one critical point in the 1920s, she seems to have entertained the possibility of marriage to John. This notion, which offended Dorelia, had as its object the solution to a very real problem that was then advancing upon them.

John Hope-Johnstone had turned up on the doorstep of Mallord

Street one afternoon in the late spring of 1921 with a girl. She was just sixteen, he explained. He had caught sight of her at the Armenian café in Archer Street, introduced himself, then taken her in a cab to meet Compton Mackenzie. They'd had a grand time. Now, since she was an avid admirer of John, they'd come to see him too. Her name was Chiquita. John grunted and let them in.

She was an engaging creature, *mignonne*, very tiny, with a dark fringe and low rippling laugh. Her passport was charm, and she specialized in 'cheekiness'. While the men growled in conversation, she flitted round the enormous studio, aware of John's eyes, like searchlights, travelling all over her as she moved. Soon she began to chatter, telling stories about herself – how her mother had run away to New Orleans with a Cuban leaving her to be brought up by a funny old man with whiskers; how she had been a tom boy, climbing trees, stealing apples, getting spanked and, at the age of fifteen, ran away from school to join a travelling theatre company . . .

'When can I paint you?' John interrupted. 'Come to-morrow at four.'

'I'll come at five,' Chiquita retorted.

It was agreed that she should wear the same clothes – a blue blouse, black stockings, red skirt – and that he would pay her a pound for each sitting: handsome wages. She came at five, carrying as a weapon and badge of her sophistication a long cigarette holder.

John's oil portrait of Chiquita proclaims her to have been a stimulating model. But as a sitter she was frightful. She talked all the time, while John's expression darkened dreadfully. She could not understand why he seemed so 'terribly ratty'. One afternoon he said he would like to draw her, and demanded to know whether she would take off her clothes. She agreed, provided there was somewhere private to undress. She re-entered the studio wearing a dressing-gown. He began to work – then after a few minutes, while she lay there nakedly chattering, he pounced. She remembered him being so old, the coarse beard, smell of whisky and tobacco, no words, just grunting and snorting. . .

Later, on discovering she was pregnant, Chiquita approached Dorelia. It was arranged that she should have an abortion, but Chiquita did not take to the specialist and eventually refused to go through with the operation. 'It was a very drastic time in my life but I was too young to be unhappy,' she remembered.[527] The atmosphere at Alderney was wonderfully comforting. She felt free, yet cared for. 'It was a lovely summer,' she recalled, 'and we slept outside in the orchard in the communal bed there . . . We used to light a little bonfire down our end . . . it was fun – there weren't any strict rules, one could get in through the window without being nagged at'. Pigs and red setters stalked the garden; there were picnics, rides in the pony cart and, under

a sign that read 'Bathing Prohibited' there was bathing. Dorelia was always near 'and she always looked pretty super especially when she wore her sun bonnet and picked currants'.[528] Dorelia never referred to her pregnancy, suggesting, after a few months, that Chiquita wear a cloak 'because she would look so fine in one, and they were becoming very fashionable'.

At the beginning of March they took her to an expensive nursing home where, on 6 March, she gave birth to a daughter whom she called Zoë. John arrived bringing masses of flowers, but when Chiquita came out he had tactfully withdrawn to Spain.

She had a little money, and quickly got some jobs as a photographer's model. Zoë meanwhile was billeted in Islington with a policeman and his wife whose daughter, 'Simon', was later to marry Augustus's eldest son David. One day Chiquita received an invitation to call on Mrs Fleming. The meeting was not easy. Mrs Fleming's imperious personality brought out everything that was rebellious in Chiquita, and when she offered to adopt the baby, provide it with a good home and education, Chiquita refused – though accepting some clothes and the assistance of a nanny. There seems little doubt that Mrs Fleming hoped to build up this pressure of persuasion, but before she had any real opportunity a row broke out over the clothes, all of which were marked 'Fleming'. From this time on the two women stood revealed as enemies. 'If she [Chiquita] had a million pounds a year, I still should not alter my opinion that she ought not to have the bringing up of that baby or of any other,' wrote Mrs Fleming.[529]

Each weekend Chiquita would call at Islington and pick up Zoë. One Saturday the baby was collected early – by Mrs Fleming, who rushed her off to North Wales in the hope that Chiquita would not trouble to pursue them. Over the crisis lawyers now began to circle and the dry corpses of legal correspondence rapidly accumulated. John, on his return from Spain, was horrified. He had supported, in his absence, Mrs Fleming's plan and arranged anonymously through her and a solicitor to pay Chiquita £20 down and £1 a week thereafter in exchange for the baby. But instead of this sensible 'baby agreement' he was faced with a *cause célèbre*. It was possibly his influence that helped to persuade Mrs Fleming to return the baby.

But Chiquita had other allies, in particular Seymour Leslie to whom she blurted out her story one evening at the Eiffel Tower. She was determined to 'fight like a tiger' to keep Zoë, she insisted. 'I trust no one with Zoë's happiness as I do myself. I am waiting for Mrs Fleming to return. I would like to kill her . . .'. Vowing indignantly to help, Seymour Leslie called for pen and ink and drew up a contract, signed by Stulick and the head waiter Otto, undertaking to pay for Zoë

provided Chiquita agreed to live with him as his mistress. This settled, they hurried off to Paris for four days of celebration.

The arrangement lasted some six months. 'I used to lead him a pretty good dance,' she recalled, '. . . tho' he made me happy in a strange sort of way.' He let her have fun, but what she really wanted was marriage. When Seymour Leslie returned from a visit to Russia in the autumn of 1923, he found her married to Michael Birkbeck, a friend of John's and living with him and Zoë in the country.*

Mrs Fleming was not used to being worsted: it unnerved her. 'My dreams of a happy home,' she wrote, '. . . have fallen to the ground'. In their place she was surrounded by clouds of 'reprehensible gossip'. 'It seems to be a mistake to be the good Samaritan or to feel things,' she complained bitterly to Seymour Leslie. 'People don't seem to understand either, and only to imagine the worst motives for one's actions'. The deplorable affair had made her ill. 'I have done my best,' she declared, 'and have had to retire to bed, really exhausted with this worry'. At night she would dream 'of drowned babies with dead faces and alive eyes looking at me.' She had four sons, but she wanted a daughter: John's. It should have all been so easy, so private. John himself felt exasperated by these women. 'I'm so horribly complicated and there's no peace for a *man* at all,' he complained to the Rani. Had Ida lived, he sometimes thought, it might have all been different. 'Failing her, one simply tries all the others in rotation – I've nearly reached the limit.'

Once begun, the ridiculous game had to be played out 'to the last spasm'. Mrs Fleming wanted a child – she should have one. One day she announced that she was going on a long cruise. When she returned, some months later, sure enough it was with a baby – a girl: Amaryllis. Amaryllis's childhood was very different from Zoë's. This 'rare bird'[530] was discreetly hidden away in Turner's House and, in a vague way, it was understood that she had been adopted.†

Zoë and Amaryllis both adored Augustus. In the 1930s and later each of them often stayed with him and Dorelia at Fryern. Once they turned up there on the same day, and John, his eyes glinting, introduced them: 'I believe you two are related'. Amaryllis's success as a 'cellist gave him much pleasure. He listened to her on the radio, wrote her letters of congratulation, attended her first concert where he judged her triumph in terms of the number of people in tears during the slow movement. He felt proud that she with her red hair and the black-haired Zoë were such fine-looking wenches. Each of them sat for him. 'I could paint you on your back . . .' he offered Amaryllis. Zoë, too, who had gone on

* John gave the Birkbecks £1,000 to be invested for Zoë.

† John Pearson refers to her as adopted in his *Life of Ian Fleming*, and so does Cecil Roberts in the fourth volume of his autobiography *Sunshine and Shadow*.

the stage and was everybody's understudy, was 'a first-rate sitter, and useful,' he judged, 'in other ways too'.[531]

3. FACES AND TALES

'Augustus John, whose brain was once teeming with ideas for great compositions, had ceased to do imaginative work and was painting portraits,' wrote Will Rothenstein[532] of these years between the wars. Though he was to return in the next two decades to 'invented' landscapes on a large scale, and though he continued to paint at all times from Nature, adding, on Dorelia's instructions, flower pictures to his repertoire in the 1920s, portraits dominated John's work until the Second World War. He was always 'dying to get through with them and tackle other things', but in vain. 'Alas! that seems to be my perpetual state!'[533]

By popular consent, the finest portrait of this period was of Guilhermina Suggia, the famous Portuguese 'cellist. John began this work early in 1920 and, after almost eighty sittings, finished it early in 1923.[534] It took so long and involved her calling at Mallord Street so incessantly that a rumour spread that they were living there together.

'To be painted by Augustus John is no ordinary experience,' Suggia allowed.[535] ' . . . The man is unique and so are his methods'. Throughout the sittings she played unintermittent Bach, and this, in the most agreeable manner, forestalled conversation – John continuing to hum the music during lunch. 'Sometimes', Suggia noticed, 'he would begin to walk up and down in time to the music. . . . When specially pleased with his work, when some finesse of painting eyelash or tint had gone well, he would always walk on tiptoe.'* As a rule she posed for two hours a day, but by the third year, when John was growing desperate to complete the picture, she would sit for another two in the afternoon.

Those who visited the studio during these years were aware that a terrific struggle was taking place. John was attempting to paint again: that is, not simply draw with the brush. From week to week the picture would change: sometimes it looked very good, sometimes it had deteriorated, and at other times, in spite of much repainting, it appeared almost unchanged. As with a tug-or-war, tense, motionless, no one could tell which way it would go.†

* Suggia continued: 'Directly I heard his footsteps hush and his tread lighten I strained all my powers to keep at just the correct attitude. In a picture painted like this, a portrait not only of a musician but of her instrument – more of the very spirit of music itself – the sitter must to a great extent share in its creation. John himself is kind enough to call it "our" picture.'

† The picture was first shown at the Alpine Gallery in March 1923, and the following year won first prize at the Pittsburgh International Exhibition.

'Suggia' challenges comparison with 'The Smiling Woman' of fifteen years earlier. There is something of the same monumental quality in both paintings, though the mood of 'Suggia' is more dignified than the provocative study of Dorelia. The colour schemes too are similar – dull reds and greens – even if, as Mary Chamot has observed,[536] the 'colours [of 'Suggia'] are no longer as clear cut – there is more fugue in the design'. Suggia herself was 'more delighted with the result than I should have thought possible'. The painting had a strength of composition (the long elaboration of the dress acting as a perfect balance to the awkward shape of the 'cello) that was undeniable.

Something seemed to have snapped in John as a result of the extended effort he put into this picture. Never again did he seriously attempt anything so 'painterly'. The portrait of Thomas Hardy, for example, done some six months after the completion of 'Suggia', is a dry impasto laid straight on to the canvas, which is barely covered in parts (the hairs of the moustache are attached not to the face but to a piece of unprimed canvas). In treatment and colour-scheme it is reminiscent of his three studies of Bernard Shaw.

John had met Hardy at Kingston Maurward on 21 September 1923 and, after several visits to Max Gate, polished off the portrait by the middle of the following month. Hardy was then eighty-three. 'An atmosphere of great sympathy and almost complete understanding at once established itself between us,' John recorded.[537] They did not talk much, but John felt they were of a kind:* 'I wonder which of the two of us was the more naïve!' He painted Hardy seated in his study, a room piled to the ceiling with books 'of a philosophical character'. Hardy wears a serious, querying expression; he looks stiff, but bearing up. It is the portrait of a shy man, full of disciplined emotion. On seeing it, he sighed: 'I don't know whether that is how I look or not, but that is how I *feel*' – a fine tribute for any painter.[538]

In a letter to Hardy,[539] John suggested that this portrait was 'merely preparatory to another & more satisfactory picture which I hope to do with your help, later on'. It was only by labelling his paintings as preliminary studies for more elaborate compositions that he could agree with himself to stop working on them. Where there was infinite time there was infinite delay, infinite painting out and indecision. Critics have interpreted this dissatisfaction as a quest for perfection, but his search was joined to a temperament that frustrated this quest. He could not adjust to difficulties. He painted on without premeditation, sometimes asking his sitters what background colour they would like, whether they

* In a letter to John, Florence Hardy wrote (8 February 1929): 'He [Hardy] had the greatest respect and *liking* for you not only as an artist but as a man. I can think of few people he liked so much.'

thought he should introduce a flower or a bowl of fruit, or posing some ironic demand such as: 'Tell me what's wrong with this arm'. Such appeals, it was alleged, spoke of an amazing modesty. But they told too of the failure of artistic purpose. When Lord David Cecil inquired what aesthetic motive there had been for making the colour of his tie darker that it actually was, John replied that some black paint had accidentally got into the red, and he thought it looked rather good. He had little conscious idea of how a portrait would turn out, though he liked, starting perhaps with an eye, to exaggerate the figure as he worked downwards, as El Greco or Velasquez might, for grand manner. His unfinished work is often better because it manages to convey powers, latent in him, on which he could no longer call. It must be 'hard', T. E. Lawrence sympathized (9 April 1930), 'to paint against time'. But time was a false friend to John – a substitute for deep concentration. It remained to Dorelia and close brave friends to rescue, by one subterfuge or another, what pictures they could before they were painted into oblivion.

As John's powers diminished so it grew more difficult to persuade him to stop. With commissioned portraits there was usually some limitation that imposed a discipline, though it afforded little pleasure. Of all these 'board-room' portraits, his favourite was of Montagu Norman, Governor of the Bank of England. Begun on 1 April 1930, it was completed a year later, Norman's hair subsiding in the interval from grey to white. To John's mind he was 'an almost ideal sitter', taking apparently no interest whatever in the artist or his picture. 'It was in a spirit of severe reserve that we used to part on the doorstep of my house,' John recorded,[540] 'whence, after looking this way and that, and finding the coast clear, Mr Norman would venture forth to regain his car, parked as usual discreetly round the corner'. What John did not know was that, on arriving back at his office, Norman was transformed, regaling everyone with envious and excited descriptions of the Great Artist at work. 'It's marvellous to watch him scrutinizing me,' he would rhapsodize, ' . . . then using a few swift strokes like this on the outline and dabbing on paint like lightning. What a heavenly gift!'[541]

John represents the two of them as sharing one quality: a sense of isolation. Norman's air of preoccupation conveyed that he was 'troubled with graver problems than beset other men', and it was not difficult, John recalled,[542] 'to offset Mr Montagu Norman's indifference to my activities by a corresponding disregard of his'. At rare moments 'our acquaintance seemed to show signs of ripening,' and then, so he told Michael Ayrton, an immense attraction would sweep over him for this dry, semi-detached figure. 'Could there', he hazarded, 'have been something *Greek* about it?' To John Freeman he later remarked: 'It seemed

to give him pleasure.' But he was referring to the sittings, not the portrait itself which, with its hard eyes, nervously taut mouth and haunted expression shocked Norman so much that he refused to let it hang either in his home or at the Bank of England.*

'Sometimes', John recalled,[543] 'Lord D'Abernon would come to chat with my sitter. The subject appeared to be High Finance. I was not tempted to join in these discussions'. D'Abernon was another of John's subjects, whose portrait, completed after Montagu Norman's, had been started early in 1927. As only the second ceremonial portrait of John's career, it invites comparison with the 'Lord Mayor of Liverpool' but falls incomparably short. It is neither caricature nor straight portrait study: it is a false creation. John himself affected to believe it a finer painting than 'Suggia', but this judgement rested on the greater time it had taken him, and on his wish to obtain for it the same price – three thousand pounds. Sometimes, during this five years marathon, he was tempted to give up: then another cheque, for £500 or £1000, would arrive and he was obliged to paint on. To gain wind it was necessary for him to fabricate vast enthusiasm for the ordeal. On 18 December 1927 he writes[544] to D'Abernon that the portrait was 'too fine a scheme' to take any 'risks' with. Since Lady D'Abernon had a villa in Rome, might it not be 'a practical plan', John wondered, 'for me to come to Rome in February where I could use a studio at the British School'. Two years later, on 8 December 1929, Lord D'Abernon notes in a letter to his wife: [545] 'The Augustus John portrait at last improving – the face less bibulous. Seen from five yards off – it is a fine costume picture'. John had brought in a stalwart Guardsman to stand wearing the British Ambassador's elaborate uniform, but eventually this soldier collapsed and John fell back on a wooden dressmaker's model, the character of which is well conveyed in the completed work. Like Macbeth, he had reached a point from which it was as tedious to retreat as to go on. He put the best face he could on it: 'Things bad begun make strong themselves by ill.'

The portrait, now in the Tate Gallery, is dated 1932, in which year it was finally handed over to Lord D'Abernon. It is a sorry sight. 'There are only two styles of portrait painting,' says Miss La Creevy in *Nicholas Nickleby*; 'the serious and the smirk'. 'Lord D'Abernon' is neither. It is a masterpiece of elongated confusion, pleasing no one. In making a solemn attempt to be obsequious John had painted a uniform.

On other occasions, when his soul revolted against such work, he could be less accommodating. After finishing the portrait of the Earl of Athlone, he agreed to show it the following day to the sitter's wife. She arrived with her husband and went into his studio. Two minutes later

* Where, nevertheless, it now hangs.

they burst out, looking furious. John stood in the doorway quietly
lighting his pipe as they drove heatedly off. Egerton Cooper, who had
watched the incident from his studio near by, hurried over to ask what
was wrong. 'I tore the painting to pieces,' explained John. 'I suddenly
couldn't bear it'.

Another time it was the sitter who dismantled a portrait. During part
of the summer of 1920, John had been at work on 'His Margarine
Majesty', the fish and soap millionaire, Lord Leverhulme. Although
'strongly inclined' to have his portrait done by John, Leverhulme had
begun the first sitting by warning him he could spare little time and that
he was an almost impossible subject, no artist (excepting to some degree
Sir Luke Fildes) having done him justice. When the time was up, great
pleasure was lavished over the picture: by John. It seemed, he proclaimed,
to breathe with life and self-satisfaction and only lacked speech. Lever-
hulme himself did not lack speech, and finding the portrait very 'humbl-
ing to pride' and a 'chastening'[546] reflection, argued that neither the
eyes, nor the mouth, nor yet the nose were his – at which, proffering his
palette, John invited his Lordship to make the corrections himself. This
offer was declined and the picture, with all its alleged faults, paid for
and dispatched.

John had then gone down to Tenby. Returning to Mallord Street late
in September he discovered the portrait had been returned to him – at
least that part representing Lord Leverhulme's trunk, shoulders, arms,
hands and thighs, though not his head which had been scissored out.
That evening (31 September 1920) John sat down and wrote: 'I am
intensely anxious to have your Lordship's explanation of this, the
grossest insult I have ever received in the course of my career.'

Leverhulme's reply four days later shone with friendliness. He felt
'extremely distressed at the blunder that has occurred', but added: 'I
assure you it is entirely a blunder on the part of my housekeeper'. He
had intended hanging the painting in his safe at Rivington Bungalow,
he explained, but had overlooked 'the fact that there were internal
partitionings and other obstacles that prevented me doing this'. After a
bold prognosis, he settled on a surgical operation, removing the head
'which is the important part of the portrait', and storing it safely away.
This letter, culminating with an urgent request to keep the matter dark,
was succeeded by an invitation to 'dine with my sister'. To his surprise,
John appeared dissatisfied with this answer, and the correspondence
between them persisted in lively fashion over the next ten days until
suddenly appearing in full on the front page of the *Daily Express*,[547] It
was a case of the Baronet and the Butterfly in reverse. Leverhulme
insisted that he had a right to deal with his own property – a little
trimming here or there – as he chose. Even the copyright, he hazarded,

belonged to him. As for this publicity, it served no purpose and was not of his choosing: 'all that I am impressed by is that Mr John can get his advertising perfectly free . . . whereas the poor Soap Maker has to pay a very high rate for a very bad position in the paper.'

For John it had begun as a matter of principle. He took the Whistlerian view that money purchased merely the custodianship of a picture. After Leverhulme, a self-appointed art patron, had dismembered his portrait he had felt genuinely shocked. Whatever the legal rights, he was convinced of his moral right.

The excitement provoked by this beheading was tremendous. Newspapers throughout Britain, America, on the Continent and as far off as Japan trumpeted their reports of the affair. Public demonstrations sprang into being. Students of the London art schools marched on Hyde Park 'bearing aloft a gigantic replica of the celebrated soap-boiler's torso, the head being absent'.[548] In Paris there was furore; in Italy a twenty-four hour strike was called involving everyone connected with painting – even models, colourmen and frame-makers. 'A colossal effigy entitled "IL-LE-VER-HUL-ME" was constructed of soap and tallow, paraded through the streets of Florence, and ceremoniously burnt in the Piazza dei Signori, after which, the demonstrators proceeded to the Battisteria where a wreath was solemnly laid on the altar of St John.'[549]

Appalled by the rumpus he had invoked, John backed away to Lady Tredegar's home, near Broadstairs; but the reporters discovered his hiding place and besieged him there. 'I did not want this publicity,' he prevaricated. 'I get too much as it is.' Nevertheless some papers were announcing that he intended to press the matter to the courts so as to establish a precedent for the protection of artists. 'The bottom fact of the case is that there is something in a work of art which, in the higher equity as distinct from the law, you can not buy,' declared the *Manchester Guardian*.

' . . . whatever the law may allow, or courts award, the common fairness of mankind cannot assent to the doctrine that one man may rightfully use his own rights of property in such a way as to silence or interrupt another in making so critical appeal to posterity for recognition of his genius. The right to put up this appeal comes too near those other fundamental personal rights the infringement of which is the essence of slavery.'

The country waited for this Wilberforce of the art world to act. There had been a great roll of drums: then nothing. For John, unlike Whistler, had no relish for court work. He did not even have the stamina of his own indignation, and his sense of humour outran his sense of honour. At last the affair subsided into a joke, signalled by

John's exhibiting his portion of the portrait above the title 'Lord Lever-hulme's Watch-chain'. For many years he patiently preserved this decapitated torso while the missing head continued to blush unseen in its depository. Then, in 1954, by what Sir Gerald Kelly described as 'hellish ingenuity',* the two segments were sewn together and the picture elevated to a place of honour in the Leverhulme Art Gallery.

John's portraiture attracted controversy. 'I painted what I saw', he remarked of Lord Spencer's portrait. 'But many people have told me I ought to have been hung instead of the picture.' Men he was tempted to caricature, women to sentimentalize. For this reason, as the examples of Gerald du Maurier and Tallulah Bankhead suggest, his good portraits of men were often less acceptable to their sitters than his weaker pictures of women.

John had painted du Maurier in four sittings during 1928, but the picture had lain in his studio in Mallord Street until Tallulah Bankhead rediscovered it there early in 1930. At her insistence it was shown, with her own portrait, at the Royal Academy Summer Show that year when together they caused a sensation. Tallulah reserved her portrait for the special price of one thousand pounds, but the du Maurier was for sale. Since his knighthood in 1922, du Maurier had become the acknowledged sovereign of the British theatre. He was a figure of much personal charm and decorum. But in John's portrait, one of his most sombre and remorseless studies, there was an expression that seemed almost criminal. Du Maurier had prayed never to see the picture again, and after it was exhibited at Burlington House he issued a vividly distressed statement proclaiming that it 'showed all the misery of my wretched soul . . . It would drive me either to suicide or strong drink.'[550] John, apparently at a loss to account for this response from so fashionable an actor, suggested that perhaps it was insufficiently permeated with sex allure: 'In my innocence I had omitted to repair his broken nose.'[551]

John had imagined the picture hanging at the Garrick Club, but Tallulah herself bought it ('even though I had to go in hock'[552]) and carried it off to America. It was, however, her own portrait that, as her legend grew, became the more celebrated. 'My most valuable possession is my Augustus John portrait,' she wrote in her autobiography:[553] and since Lord Duveen had offered her one hundred thousand dollars for it, this may have been literally true. Opinion since then has moderated. The judgement of one critic in 1930 – that it was 'the greatest portraiture since Gainsborough's "Perdita" ' – now looks excessive.[554] According to some who saw it, John's first image of Tallulah – a thin face blown lightly on to the canvas – had been exquisite. But, as he himself acknowledged, the finished work was something of a disappoint-

* The operation was performed by a Dr J. Hell.

ment. 'Perhaps she has just that initial quality and no follow through,' T. E. Lawrence tactfully suggested.[555] Tallulah's friends objected that the baleful fragility of the painting had little connection with her ravishing beauty – the blue eyes, voluptuous mouth and honey-coloured hair falling in waves on to her shoulders. Yet over the years she suffered a curious change into the very replica of this picture – either an act of will on her part or, on his, of foresight.

Public portraits often paid John well, but they gave him endless trouble. 'I'm not a fashionable portrait painter,' he told John Freeman.[556] The climax of this unfashionable career, and perhaps the most endearingly deficient picture of his life, was the painting of the Queen he failed to finish between the years 1939 and 1961.

John's name had been tentatively advanced as a royal portrait painter by Lord D'Abernon as early as 1925. In his shocked rejection, the King's private secretary Lord Stamfordham replied (11 December 1925): 'No! H.M. wouldn't look at A.J.!! and so A.J. wouldn't be able to look at H.M.!!' The notion merited only a joke. Then, in about 1937, shortly after George VI had come to the throne, Hugo Pitman nervously invited John to meet the new Queen – provided he arrived dead sober. The implications of this proviso angered John. For a moment he looked murderous, then, his face clearing, he inquired: 'Must I be dead sober when I leave?' One way or another the meeting had gone well. The possibility of a portrait had been mooted, though nothing immediate ensued. 'It is very nice to know that the Queen still wants me to paint her,' John wrote to Maud Cazalet two years later.[557] 'Needless to say I am at her service and would love to do her portrait whenever it is possible.' In September the outbreak of war seemed to put an end to this plan, which in any case had perhaps been a day dream. 'No chance of doing Her Majesty now . . .'

But to John's surprise, the Queen did not see the war as any obstacle. In fact it was the catalyst their lethargic negotiations had called for. At this time of crisis, an inspiring new picture of the Queen in Garter robes was what the Nation needed. John, who had overlooked the national significance such a portrait might have, was thinking more informally. His imagination raced away along tracks of private fantasy. The Queen could sit, he thought, during week-ends at Windsor Castle – it would be 'a well-earned rest' for her. 'I would stay in some pub,' he explained to Mrs Cazalet,[558] 'and no doubt there's a suitable room at the castle for painting.' If not, doubtless there'd be something at the pub – 'one could keep it very dark'. The Queen, he hoped, would wear 'a pretty costume with a hat': something 'decolletée'. She would be a tremendous success in Hollywood – the destination he vaguely had in mind for the portrait.

Arrangements were completed in October. The portrait was to be painted in Buckingham Palace where a room with a north-east aspect had been set aside. All painting equipment should be dispatched in advance. John himself must seek admittance by the Privy Purse entrance. It was possible that Her Majesty might be graciously pleased to accept the picture as a token of the artist's 'deep admiration and respect'. The first sitting was scheduled for Tuesday 31 October at eleven o'clock, but the Queen would consent to receive him at 2.45 p.m. on the Monday for a preliminary interview.

John was horrified. By the time Monday came he felt 'very odd' and, finding that he had forced up his temperature, wired to call the meeting off. It had been, he diagnosed, an attack of the influenza, though with a slip of the pen he described himself as suffering from 'the influence'.

The Palace, meanwhile, awaited news from him 'to say when you will feel yourself available again'.[559] Sittings began next month. 'I'm dreading it,' John told Egerton Cooper as he set off in a taxi. What should the Queen wear? At last an evening dress was agreed on, but an extraordinary eagerness to discover fresh difficulties possessed John. 'Is there a platform available at the Palace?' he suddenly demanded. 'It should be a foot from the ground or slightly more'. Could they, he wanted to know, import an easel with *a forward lean*? By the beginning of 1940, the sittings were transferred to another room, where John had installed a new electric day-light system. 'I feel sure it will prove a success and will illuminate Your Majesty in a far more satisfactory way besides rendering one independent of the weather.' It was the weather,[560] nevertheless, that offered the next interruption. 'The temperature in the Yellow Room is indistinguishable to that reported in Finland,' the Queen's private secretary advised, 'and Her Majesty would like therefore to wait until some temperature more agreeable . . . makes resumption of the portrait possible.' There was no difficulty here: John knew how to wait. But when sittings started again in March fresh difficulties had bloomed. 'There is a great lack of back-ground,' John ejaculated. '. . . what is wanted is a tapestry of the right sort – with a bit of sky and landscape. Perhaps I shall have to invent one.' The Palace, anxious for John to avoid invention, hurried in tapestries and decorations from Lenygon and Morant. These, at John's request, were subsequently removed, then more subsequently at John's insistence returned. With and without them, the painting struggled on from one crisis to another. John felt persecuted by kindness. In a panic of claustrophobia he began to perceive spies. 'I wouldn't be surprised if people have been peeping at the beginning of it and seeing it merely sketched out in *green*', he suspected. '. . . I loathe people peeping . . .' Green, he had decided, was a mistake. But when he arrived at the Palace

to change it to blue, Her Majesty was not there. 'As the Queen understood from you that you were going to have your tonsils out, Her Majesty made other arrangements,' her secretary explained.

The source of all these difficulties was John's paralysing shyness. He could not overcome it. 'She has been absolutely angelic in posing so often and with such cheerfulness,' he told Mrs Cazalet on 13 June 1940. But he could make no contact with her – she was not real. He wanted to make her real . . . Good God! It was an impossible situation!

Something of these inhibitions was sensed at Buckingham Palace. In next to no time sherry was introduced into the sittings; and then, in a cupboard reserved for John's painting equipment, a private bottle of brandy. As a further aid to relaxation, the Griller Quartet (unnervingly misheard by John as the 'Gorilla Quartet') was wheeled into an anteroom to play works by old English composers. Eventually it was Hitler who came to the rescue, his blitz on London providing the ostensible motive everyone had been seeking to end the ordeal. 'At this moment, what is described as "the last sitting" is proceeding,' the Queen's private secretary wrote on 26 June 1940. John put his bravest face on the matter: 'it looks very near done to a turn,' he told Mrs Cazalet.

That autumn the portrait was moved to his studio in the country where he continued to brood over it. 'I can see a good Johnish picture there – *not* a Cecil Beaton creation or anything of that sort,' he had claimed. Later, on 10 February 1941, he evolved a new plan 'to bring Mr Cecil Beaton to the Palace to take some photographs of Her Majesty, which should help me to complete her picture'. The Queen agreed to this: she did more. The following year she wrote to remind John of her portrait. 'If you are in London, I could come to your studio if you have any windows, for we have none in Buckingham Palace, and it is too dark and dusty to paint in anyway.'

John felt acutely his sense of failure. He had shut away the portrait and no one was allowed to see it. On December 1948, the Queen wrote again suggesting a drawing of her daughter Margaret: 'I could easily bring her to your studio, and I promise that I won't bring an orchestra with me!' Nothing came of this, and it was not until 1961 that the Queen Mother, as she had become, finally took possession of the portrait. Under thick dust and massed cobwebs, in a world of rats and spiders, it had lain with canvases of all periods, in one of the cellars below John's studio. Here a foraging West End dealer stumbled across it and, at a show of John's 'Paintings and Drawings not previously exhibited' in March 1961, revealed it to the public. Shortly afterwards a shipping company, to commemorate the launching of a large ship, presented it to the Queen Mother. 'I want to tell you what a tremendous pleasure it gives me to see it once again,' she wrote to John on 19 July

1961. 'It looks so lovely in my drawing-room, and has cheered it up no end! The sequins glitter, and the roses and the red chair give a fine glow, and I am so happy to have it . . .'

After almost twenty-two years the portrait had come home where, greatly loved, it has remained. It is not the picture of a queen, nor of a woman: but of a fairy princess. It is disarmingly unfinished; it is no masterpiece. Stern critics have condemned it. Yet, as Tallulah Bankhead did in her portrait, the sitter has seen something to which others are perhaps blind. And who is to say that she is wrong?

4. METHODS AND PLACES

It has been claimed that John prostituted his talent to catch the like-nesses of dukes, actresses and millionaires; that, in pursuing such people, he went over to 'the other side'. More ambiguously it has been urged on his behalf that he did not prefer the company of titled people: he simply wished everyone owned a title.

Although contemptuous of conformity, John responded to the more spectacular side of the establishment. The obverse of this romanticism was a cynical view that saw in a smart clientele his most promising source of money. Yet the exercise of amassing money never excited him, and when an agent once brought him a list of twenty rich prospective sitters, he crossed off all but one name, that of an exceptionally pretty girl.

His greatest portraits are not generally of the great – unless in the field of the arts. From commissioned portraits, with all their rules of vanity and forced politeness, he turned with relief back to the ranks of his family. For them there was little relief. The ordeal of sitting began at the age of two-and-a-half. To the girls, Poppet and Vivien, he was a fearful figure. Each morning they would wait to discover which of them was doomed for the day. Tears were stemmed with lumps of sugar: and the painting went remorselessly on. At all times John insisted upon absolute immobility, the slightest movement of the head or body being corrected with the point of the brush used like a conductor's baton.

The studio was John's battlefield, and his preparatory drill was always the same. Though he might debate with a woman about the wearing, or not, of a particular dress, he seldom posed his subjects. 'Sit down!' was his usual instruction to men on leading them up to the platform. After that a curious impersonality tempered the proceedings, as if the sitter was merely an 'object', a basket of apples. John would come up very close, too close, and stare. It was difficult not to start back at the ferocity of that stare, the eyes, an inch away, seeming like x-rays to pierce through the skull. Then with a grunt he retreated, and battle began.

He painted with intense physical concentration. He worked without words, breathing heavily, occasionally stamping his foot, drawing on

his pipe which gave out a small bubbling sound. Sometimes it appeared as if he had stopped breathing altogether, and then everything seemed to stop – the bees, the birds on the trees. Perspiration broke out on his temples, the pipe trembled between his lips, and the only sound for miles was the brush jabbing on the canvas. Suddenly he would explode, jump backwards knocking over a chair; there was a crash and a curse, and, letting go of his pipe, he would begin pacing back and forwards. The sitter, his body aching as if on the rack, seemed wholly forgotten. Finally a rest was called, like half-time at a football match, and John would sit down for a long look at the canvas. Then, after two or three minutes, he was up and at it again.

There were variations in this drill. Occasionally he played music on the radio, or if things were going well the silence might be splintered with a Welsh poem or a snatch of song. Sometimes he smoked cigarettes instead of a pipe, and as he advanced and retreated before the canvas, he would throw the stubs into a corner, unerringly missing the ashtray and wastepaper basket, and once or twice starting a small fire. For those who were practised sitters it was possible to tell which part of them he was working on, and to keep that part alive: and always when he came to the mouth he would summon his own lips into a rosebud.

Whatever the variations, it was the bursting effort to concentrate that impressed his subjects. The studio seemed to throb with an electric energy as he worked. But somehow the moment of finishing never quite arrived and then, at the bell for tea, he would stop instantly, like a cricketer drawing stumps.

These were unorthodox methods for a painter who was presumed to be growing more conventional: the methods almost of an action painter rather than the Royal Academician he had recently become. Over a number of years his election as an Associate had been painfully imminent – so much so that it had become his habit to leave the country at the time they took place. 'Noticed with the greatest relief that I was not elected,' he wrote from Dieppe to Cynthia Asquith in May 1920. Yet by this time his persistent non-election had in itself become considerable news, pulling the headlines from under the feet of those who had been chosen. 'We learn', announced *The Times* in 1920,[561] 'that Mr Augustus John has received no direct intimation of any decision of the Royal Academy to open its doors to him.' People looked to his election as a symbol of Burlington House being prepared to accept what was called 'broader views and wider sympathies'. When the offer did come in April 1921 he decided to accept: then grew defensive. 'To many', he wrote,[562] 'it seemed to be not a triumph but a surrender. Had I not been a Slade student? Was I not a member of the New English Art Club? Did I not march in the front ranks of the insurgents? The answer to these

questions is "Yes". But had I cultivated the Royal Academy in any way?
Had I ever submitted a single work to the Selection Committee? . . .
History answers "No". Without even blowing my own trumpet the
walls of Jericho had fallen! . . . I acknowledged and returned the
compliment'.

Then, in December 1928, he was elected to full membership and the
process of 'self-sacrifice' as he called it was complete. But his passage
with the R.A. was far rougher than his autobiographical writings allow.
To start with – and that was terrible – his father congratulated him on
achieving the crown of his career. Then Sean O'Casey wrote to commi-
serate, suggesting he was now 'soiled' by contact with the World, the
Flesh and the Devil – 'three excellent things,' John retorted.[563] '. . . I
assure you that it won't make the slightest difference to me,* unless by
stimulating me to greater freedom of expression . . . Perhaps, at any
rate, it will be a useful disguise. Cézanne longed for official recognition
and the Legion of Honour – and didn't get either. Van Gogh dreamt of
electric light, hot and cold water, w.c's and general confort anglais. I
have them all and remain unsatisfied.'

The chief use of Burlington House lay in providing a new market for
his wares at a time when the New English Art Club had faded. John's
attitude to it depended very largely upon the personality of its Presi-
dent. In 1928 he was reasonably happy and exhibiting pictures there; in
1938 he rebelled. It was this year that Wyndham Lewis painted his
portrait of T. S. Eliot. In the spring it was submitted to the hanging
committee of the Royal Academy which, much to Eliot's relief and
Lewis's indignation, rejected it. On learning this, John at once issued a
statement full of powerful negatives for the press:

'I very much regret to make a sensation, but it cannot be helped.
Nothing that Mr Wyndham Lewis paints is negligible or to be con-
demned lightly. I strongly disagree with this rejection. I think it is an
inept act on the part of the Academy. The rejection of Mr Wyndham
Lewis's portrait by the Academy has determined my decision to resign
from that body . . . I shall henceforth experience no longer the un-
comfortable feeling of being in a false position as a member of an
institution with whose general policy I am constantly in disagreement.
I shall be happier and more honest in rejoining the ranks of those out-
side, where I naturally belong.'

* In a letter to his mother, Christopher Wood wrote (22 May 1922): 'Augustus
John has been admitted to the Academy this year. They wouldn't have him before.
I don't think he takes this as an honour in the least, as it doesn't matter much to him
whether he is an A.R.A. or not. He is unquestionably the greatest painter in England
to-day and if he hadn't drunk so much would have been greater than Leonardo da
Vinci or Michelangelo.'

This statement provoked an extraordinary response in the press in Britain, America and, breaking through the walls of art insularity, France. 'Premier May be Questioned,' ran a headline in the *Morning Post*. Elsewhere, with more bewilderment, it was reported that the Academy itself had received no notification of John's resignation. In fact he had written a formal letter to the President Sir William Llewellyn three days beforehand, but neglected to post it. 'After the crowning ineptitude of the rejection of Wyndham Lewis's picture I feel it is impossible for me to remain longer a member of the R.A.,' he told Llewellyn. Although in all the press announcements John confessed to great 'reluctance' in coming to his decision, he had in fact been searching round for an avenue of escape from the Academy, partly because he disliked Llewellyn. The Eliot portrait provided him with a perfect motive, and he wrote to Lewis to thank him: 'I resign with gratitude to you for affording me so good a reason'.

Lewis was delighted, suggesting that all sorts of politico-artistic activities should issue out of this rumpus, including the formation by the two of them of a new *Salon des Refusés*. But John demurred, delivering instead a neatly placed blow, just below the belt, when he let it be known that he had not seen the portrait of Eliot at the time of its rejection but on doing so later felt inclined to agree with the Academy. 'I wasn't thinking of doing anybody a kindness and I don't give a damn for that picture,' he assured Laura Knight,[564] 'but I acted as a better R.A. than you and others who let the show go to pot from year to year. I know I haven't done anything directly to affect the policy of the Institution. It seemed pretty hopeless to oppose the predominant junta of deadly conservatism which rules. If by my beastly action I shall have brought some fresh air into Burlington House I shall feel justified.'

Though anxious not to offend his few friends within the Academy, he kept up these attacks from outside. 'The Academy is stagnant – dead,' he proclaimed.

Two years later, Llewellyn having left, he accepted re-election to become what Lewis described as 'the most distinguished Royal Academician . . . of a sleeping-partner order'. In 1944 he almost woke up to find himself President. Once again the honour attracted him, but common sense counselled refusal: once again he prevaricated. 'I would of course like to do my best for the R.A.,' he confided to Philip Connard,[565] 'and would be fully conscious of the honour of such a position but am only doubtful of my ability to cope with the duties, official and social, it would entail. Here's the snag. Apart from this, as P.R.A. is only an extension of R.A. I would have no logical reason to refuse'. This snag was successful enough to stave off his election, and by 17 votes to 24 he eventually beat Alfred Munnings for second place.

To match this new eminence, John had allowed himself to be over-
taken by several major changes in the gallery world. Once the war was
over, Knewstub, slightly bombed, emerged to dream again. From his
upstairs room at the Chenil he gazed across Chelsea and saw in his mind
a great art centre with himself at its summit.[566] The idea was irresistible.
Although he had no head for business, he was possessed of a genius for
advertisement. He whispered into the ears of the wealthy; he wrote
letters of indignation and enthusiasm; he interviewed reporters. News
of his dreams travelled to Boston and Calcutta.[567] Then, towards the
end of 1923, vast advertisements began to spread themselves across the
press.[568] His arguments were simple. The galleries of London were
closing. The old Grosvenor Gallery had long ago collapsed and its
successor, the New Gallery, converted into a cinema. The Grafton
Gallery, until recently the home of the International Society of Sculp-
tors, Painters and Gravers, was now a dancing arena. The Doré Gallery
and Messrs Dowdeswell's in Bond Street, the Dudley Gallery in the
Egyptian Hall: all had disappeared. The National Portrait Society and
the New English Art Club had no galleries of their own. The Royal
Society of British Artists and the Royal Society of Painters in Water
Colours, in Suffolk Street and Pall Mall East respectively, were threa-
tened with demolition. In such conditions the living artist had almost
nowhere to exhibit his pictures. 'The root of the difficulty is obvious,'
Knewstub proclaimed, 'as is the remedy.' The difficulty was rates and
rents; the remedy decentralization. 'A new and commodious Art
Institution, *untrammelled by the impossible burden of West End expenses*, has
become an urgent need of the day.' Chelsea, with its literary and artistic
traditions, was 'unquestionably the alternative'.

The New Chenil Galleries was an enlargement of old 'Chenil's' on a
Napoleonic scale. The adjoining premises were taken over and, with the
aid of George Kennedy, the Bloomsburgian architect, and the co-
operation of the Cadogan Estate, robust plans were planted for a
'temple of the muses'. 'Under three spacious new roofs,' explained
Knewstub,[569] 'are to be large and small galleries for paintings, drawings,
prints and sculpture; a musical society; a literary club or institution, a
school of art, a large block of private studios, a first-class restaurant, a
café or lounge, a library, and a hall that may be let for lectures, concerts,
dancing, and other social gatherings.'

In a letter (30 January 1924) written for publication, John applauded
Knewstub: 'I consider you deserve great credit for showing the
imagination to conceive and the business ability to bring to fruition so
ambitious an undertaking.' With the significant exception of *The
Economist*,[570] congratulations flowed in from every quarter. Knewstub
was beside himself. He published a Prospectus; he held meetings; he

offered large quantities of shares for subscription; he invented several 'honorary advisory councils' on which John's name was prominent; and he appointed directors including (besides himself) an editor of *The Queen*, the proprietor of a defunct rival gallery, an eminent conductor of music and a catering expert. On Saturday, 25 October the foundation stone was laid. After a few words from John Ireland representing orchestras, John entered the ring amid cheers, smoking a cigarette and with marks of deep concentration on his brow. Baring his head, he spoke. Though inexperienced in laying stones, he had read that it was customary on these occasions to slay a man and lay his corpse in the foundation of the building, so that his spirit would guard the place from malevolent influences: he now appealed for volunteers whom (raising a mason's mallet) he could offer an expeditious exit and any amount of posthumous glory. His large uneasy eyes contemplated a crowd that numbered Augustine Birrell very leonine, the Sitwell brothers in plain clothes, and James Pryde wearing a blue Count d'Orsay coat and soft travelling hat. No one coming forward, John (hoping this would 'do the trick') placed a George V half-crown on the lower stone and energetically applied the mortar, bespattering the noblemen and artist's models in the front row. Suddenly a choir, conjured up by Knewstub, broke into a rendering of 'Let us now praise famous men', while John and the other famous men stiffened to attention. 'In Paris', commented the *Manchester Guardian Weekly*,[571] 'such a figure would be continuously before us on the revue stage and the comic press.'

A year later the building was ready. Much impressed by its 'solidity and elegance', John assured Will Rothenstein that 'Knewstub with all his faults deserves considerable credit'. Knewstub not only deserved it, he needed it. By the end of 1926 he was bankrupt, and had resigned his managing directorship. 'Knewstub was the curse of the place,' John explained to Mitchell Kennerley.[572] The débâcle had been caused, Knewstub told everyone, by the General Strike, the slump, and by John's disloyalty. 'I've known John for twenty-five years,' he said. 'If you'd known him for half that time you'd realise what a feat it was.' To long service, honour is due. But Knewstub's complaint that John abandoned him in this year of need and his personal resentment against John as the one friend who never contributed to his retirement fund are more complicated matters.

On 22 October 1925 John had received a letter from Dudley Tooth explaining that his gallery in Bruton Street was no longer to be exclusively associated 'with the academic works of deceased masters of the British School,' but intended to 'deal in the best modern art of to-day'. The letter, asking John to let the gallery handle all his future work, apparently went unanswered. Then, in 1926, John held a joint exhibi-

tion with his sister Gwen at Knewstub's New Chenil Gallery. When
Dudley Tooth wrote again, on 9 February 1928, Mrs Fleming, acting as
go-between, gave him little chance of success. But by that time Knew-
stub had already collapsed and John, who had tried unsuccessfully to
find someone to take over his Chelsea art emporium, finally decided to
invade the West End. At a meeting on 12 March 1928, Tooth proposed
setting up an agency to deal with all John's pictures (excluding portraits
painted to private commission) and holding a one-man show to identify
the gallery as John's sole agents. To these proposals John agreed, his
first exhibition at Tooth's being held in April 1929.

All this postdated Knewstub's period of utmost need. But it is true
that after 1927 his friendship with John had ceased. When J. B. Manson
appealed for a fund to assist him, he received from John a categorical
reply:[573] 'I shall certainly not help Knewstub or any other crooked
swine.' To many this smelt of rank ingratitude. But from John's letters
to Manson and others it appears that there were two causes for this
vindictiveness. He believed that Knewstub had taken advantage of
Gwen John's financial innocence to cheat her of fifty pounds; and that,
by his suspect dealings, he had been a hole in John's own pocket over a
number of years. Yet he did help Knewstub's wife and at least one of
her children 'on the understanding that K[newstub] is to know noth-
ing,' he instructed Manson.[574] 'I gather that K's family see nothing of
him and don't particularly want to.'

After Knewstub's fall, John refused to see or write to him. For
Knewstub this was a bitter blow. For years he had modelled himself on
John, drinking beer, producing litters of children, training his wife to
resemble Dorelia: and now John had deserted him. He retired to Has-
tings, to the singing of the birds and of his kettle. 'A well-fitted cellar of
the best would certainly rejuvenate me,' he suggested. But in vain. He
fell back pitiably on tea. 'Possibly,' he estimated, 'the outstanding com-
fort I have is being able to make good hot tea *very easily* in the morning.
. . . It is an almost indispensable stimulant and restorative.' It stimu-
lated him to do no work and to luxuriate in the 'humiliation' of National
Assistance – which showed, he insisted, how far 'on the downward
path' he had travelled. John had not helped him – and no one else
should without a struggle. He threatened to 'sell my few possessions',
even his 'worn out lot of rubbish and rags'; he threatened to live to a
hundred so that he might receive a Royal Telegram for his 'dear ones
the generations ahead'; he threatened, in the most embarrassing way, to
start again: 'I think I must somehow refit myself with Evening Dress,'
he calculated. Refitted thus, he proposed to write doggerel for charity,
in particular the Women's Voluntary Service. Or else: 'A lavatory
attendant would not be too great an effort', he told one of his sisters,

John photographed by Vandyk (right) and by Douglas Glass

Henry Lamb Henry "Elffin" John

Left to right: Poppet John, Vivien John, Lady Pansy Lamb (*née* Pakenham)

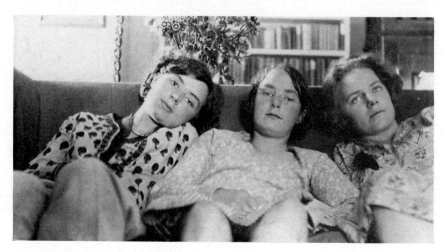

Two portraits of Poppet by Augustus. 'The Girl in Red' (below) is now in The Art Gallery of South Australia

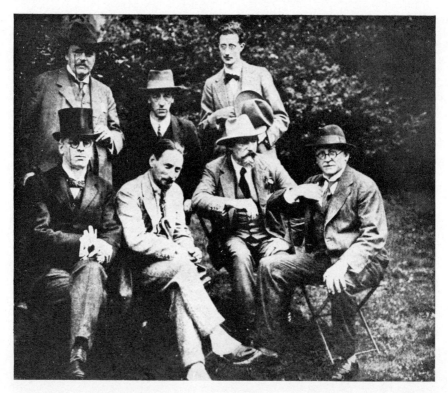

Left to right, *sitting*: W. B. Yeats, Compton Mackenzie, Augustus John, Edwin Lutyens, *standing*: G. K. Chesteron, James Stephens, Lennox Robinson This photograph was taken in summer 1924 at a garden party given by Oliver St John Gogarty at Ely Place, Dublin, on the occasion of a revival of the ancient Tailteann Games

Mortimer Wheeler and Mavis de Vere Cole (*née* Wright) on their wedding day, with Augustus as best man

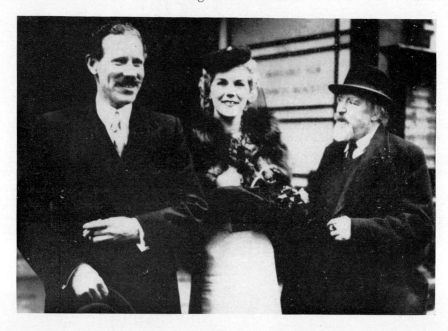

'and would allow me ample time for quiet meditation'. But when the family, responding to this blitzkrieg, implored him to visit them, he shook his head. 'I have had nearly half-a-gallon of my blood drawn from my arm by way of donation to the Blood Transfusion Service,' he explained, refusing the invitation. '. . . I am by far and away the oldest in the whole of this South-East Area service. The true "Blue Blood" is graded "O" – as mine is – and is the most suitable for a child, or even the most delicate of patients. So you will understand, my dear, that I cannot abandon my interests in this town – only a fortnight ago I was called upon for another pint. . . . Courage as always, until the final peace comes to us.'

So this Augustus Moddle of the South-East area lived on, making his relations scale Himalayas of reluctance on their way to Hastings. And what a welcome they received when they got there! Holding them with glittering eye and an endless monologue, he would contrast his dreams of the past – 'something beautiful in Chelsea' – with his present degradation – an old man 'making my own bed; blacking my own grate; washing my own shirt; darning my own socks; and doctoring myself'. Upon his family, bowed in boredom, he took revenge for the bitterness of his life, lecturing them in tones of unctuous self-praise, smiling with steadfast self-pity, bragging of his modesty, rubbing his poverty into their faces like an enormous scab: repeating himself. Had he mentioned the time, he often wondered, Augustus John 'said to me nearly forty years ago that in his opinion your tactfulness was the greatest of your many charms'? He would have liked to remind John of that now, face to face, here in Hastings.

But John, with his nose for boredom, had escaped, and was moving beyond his reach into new territories.

5. UNDISCOVERED COUNTRIES

'Whenever I see a bottle of Chateauneuf du Pape I am reminded of him', wrote the painter A. R. Thomson. Most years, 'to refresh myself', John would ease his way down to Provence, taking to the inevitable wine 'with great gusto'.[575] One day he would announce that they were off, and everything else was dropped. These journeys were great adventures. Cats, daughters, perhaps a son or a governess – all filed into the train and by night meandered through the charging carriages, while John sat peacefully asleep in the corridor.

But Martigues was no longer the place it had been before the war. More cafés were opening up on the Cours de la République, more motor cars herded under the plane trees. A new bascule bridge was put up, useful but unbeautiful. Creeping industrialism was beginning

to mar that air of innocence which had first attracted John to this little community of fishermen. Progress did not stampede through Martigues: it infiltrated. For ten years he and his family continued to come and then, submitting to the advance of commercialism, left for ever.

Bazin, that essayist of the air, was now dead, and his daughter 'rather mad'[576] and, once intended as mistress for the mighty Quinn, was recast as Poppet and Vivien's governess. The two girls loved the Villa St Anne. 'It seems to me', wrote Poppet,[577] 'that life went by very smoothly on these visits to Martigues. There were great expeditions round the country and picnics as many as we could wish for . . . Saturday nights were very gay', dining 'chez Pascal', then descending to the *Cercle Cupidon* and dancing to their heart's content while John, a glass of marc-cassis at his elbow, sat watching them. Like the village girls, Poppet and Vivien danced together until, tiring of this, Poppet took to lipstick. 'After that we hardly missed a dance with the young men.' They would present themselves at John's table to ask for his permission then, after the dance was over, escort the girls back to him. 'Augustus seemed to enjoy watching us and sometimes would whirl us round the floor himself,' Poppet remembered. 'Then suddenly one Saturday night at dinner he looked at me with a glaring eye and growled: "Wipe that muck off your face!" Whereupon Vivien piped up with: "But she won't get asked to dance without it – they'll think she's too young." Augustus was furious. "Wipe it off!" he shouted, "and stop ogling the boys!" Then I lost my temper (always a good thing to do I later found) and I flew at him, telling him it was he who ogled all the time and that I must have picked up the habit from him – also that I noticed the girls he ogled used lipstick and I was jolly well going to do so too! This made him laugh, the whole thing passed off and I continued to dance with le joli garçon every Saturday night. . . . So life went on.'[578]

For John, life depended upon weather, flowers, girls. If the sun shone he was happy. Though 'there was a brothel near John's villa I always found him playing draughts,' protested A. R. Thomson. '. . . He liked to wander in back streets of old France, smell of wine-and-garlic or wine-and-cheese in his nostrils.' Then, if he spotted an unusual-looking woman he would rise and, with swollen eyes, pursue her. But more often he found the models he needed from among his family, posing them in a setting of olive or pine trees, the speckled aromatic hills beyond and, further off, bordering the blue Etang, distant amethyst cliffs.

But there were other days when the sun refused to shine and he would energetically tinker with plans to be off elsewhere. 'The weather is cold

and grey,' he wrote to Dorelia. '. . . There's nothing much in the way of flowers here and I have no models. I might as well be dead.' He would decide to leave, to return to London, paint portraits; he would decide that Martigues was 'revolting' – then the clouds dispersed and he was suddenly negotiating to buy another house there. 'Martigues is like some rustic mistress one is always on the point of leaving,' he confided to Mitchell Kennerley,[579] 'but who looks so lovely at the last moment that one falls back into her arms.'

John's scheme, 'quite wise for once',[580] was to pass his winters in Provence painting intermittently out-of-doors, and then, in the spring or summer, explore new regions. In May 1922 he found himself in Spain. His son Robin, then in Granada studying Castilian affairs with the tutor, seems to have been a less magnetic motive for travel than the faulty English weather. 'I don't know if I can get painting materials in Spain,'[581] he had hesitated; and then: 'Spanish people, I imagine, are hideous.' But he went.

He went first to Paris for a hectic week with Tommy Earp, then descended south. 'Down here in the wilds life is much calmer,' he assured Viva Booth, 'indeed there are perhaps too many vacant moments and unoccupied gaps.' Like other of his random travels, there was no plot or continuity. Spain was a series of impressions: in Madrid the sight of Granero, the famous matador, limping from the ring where, the following Sunday, he would be killed; at the Café Inglès the bull-fighters, in Andalusian hats and pigtails 'looking rather like bulls themselves',[582] vibrating with energy; the blind, hideously deformed beggars crouching in the gutters and appealing for alms; and, at evening, the ladies of the *bourgeoisie* collecting in the pastry-shops to 'pass an hour or two before dinner in the consumption of deleterious tarts and liqueurs'.[583] Then, in the Alhambra, two friends: Pepita d'Albaicin, an elegant Gitana dancer, and Augustine Birrell, until recently Chief Secretary for Ireland – 'a surprising combination'; and at Ugijar the spectacle of Robin full of silent Spanish scholarship and the tutor taking photographs – 'very bad ones, and he's very slow about it, changing his spectacles, losing bits of his machine and tripping over the tripod continually'.[584]

By mid-June his white paint had 'just about come to an end'[585] and he started back, crossing the Sierra and descending on the north to Gaudix, where he was to catch a train. 'The ascent was long. Snow lay upon the heights. At last we reached the Pass and, surmounting it, struck the downward trail. A thick fog veiled the land. This suddenly dispersed, disclosing an illimitable plain in which here and there white cities glittered. The distant mountains seemed to hang among the

clouds. At our feet blue gentians starred our path, reminding me of Burren in County Clare . . . the country became more and more enchanting. As we rode on, verdurous woods, grassy lawns and gentle streams gladdened our eyes so long accustomed to the stark and sun-baked declivities of the Alpujarras.'[586]

Finally, to Barcelona. Spain, John told Dorelia, was 'very fine in parts, but there are *immense* stretches with nothing'. The spirit of the country had come near, but it had not taken hold of him. 'Art, like life, perpetuates itself by contact,' he wrote. The moment of contact came as he was leaving Barcelona. 'I was walking to the station, when I saw three Gitanas engaged in buying flowers at a booth. Struck numb with astonishment by the flashing beauty and elegance of these young women, I almost missed my train.' He went on to Marseilles, but the vision of these Gitanas persisted: 'I was unable to dismiss it.' In desperation he hired a car and returned all the way to Barcelona. But 'of course I did not find the gypsies again. One never does.'

Spain incubated but never hatched. When he flew back there in December 1932 on his way to Majorca, rain had made the world unpaintable; after which Franco, like a hated bird of prey, kept him off until too late.

'I am sure it will stimulate me,' he had written to Ottoline Morrell,[587] 'and I shall come back fresher and more myself'. In fact he came back as someone else. He had seen many pictures in Spain. 'At the Prado I found Velasquez much greater and more marvellous than I had been in the habit of thinking,' he told Dorelia. 'There is nobody to touch him.' He went to the Academy of S. Fernando and the shabby little church of S. Antoine de la Florida to see the Goya frescoes of the cupola: 'My passion for Goya was boundless'. The streets of Madrid seemed to throb and pulse with Goyaesque characters afterwards, bringing the place alive for him. There were other paintings too that 'bowled me over': Rubens' 'The Three Graces' and, 'a dream of noble luxury', Titian's 'Venus'. Only El Greco, at the Prado, disappointed him. Yet, mysteriously, it was El Greco who, in the cock-pit of John's imagination, planted a seed. John's 'Symphonie Espagnole' of 1923 is a self-confessed essay in the El Greco style, a parody that marshals all the mawkishness and conveys none of his ecstatic rhythm. These weeks in Spain form a parallel to his journey through northern Italy in 1910. From Italy he had discovered a tradition to which he belonged; in Spain he lost himself. 'He is painting very much like El Greco now since his visit to Spain,' Christopher Wood noted in December 1922. This influence of El Greco became a mannerism devitalizing his natural talent. The phallic lengthening of the head worked well for very few of his sitters, and the elongation of the body seemed to draw all life out of it. It was an

attempt by John to speak a new language, but he could say little in it that was original.

It was as a Distinguished Guest of the Irish Nation that in the summer of 1924 John went with Mrs Fleming to Dublin. The occasion was a festival of 'fatuous self-glorification' called the Taillteann Games. Oliver St John Gogarty, as commander of the social operations, had billeted him with Lord Dunsany. 'Here I am entrapped,' John wrote[588] desperately from Dunsany Castle. '. . . Mrs Gogarty has developed into a sort of Duchess. I must get out of this.' As a practical joke, Gogarty had warned Dunsany not to give John any alcohol – which made Dunsany determined to offer his guest as much as he could want. This would have suited John well, had Gogarty not confided to him that Dunsany was a fierce teetotaller and would fly into a rage if anyone in his home accepted a drink. The result was that, in an agony of politeness, John persisted in refusing everything until, according to Compton Mackenzie,[589] 'Dunsany started to explain how to play the great Irish harp . . . After they went to bed Augustus climbed over the wall of Dunsany Park and walked the fourteen miles to Dublin.'

The crisis of this festival was a banquet at which the Commander-in-Chief of the Free State Army delivered a long speech in Gaelic. As he stood unintelligibly uttering, the municipal gas and electricity workers decided upon a two minutes' strike. Unperturbed by the blackness, the Commander spoke on. After a minute, John leant over to Compton Mackenzie, and whispered: 'What's going on?' Mackenzie explained. 'Thank God,' breathed John. 'I'm only drunk then. I thought I'd gone mad'.

Mrs Fleming also accompanied him to Berlin. For one month in the spring of 1925 he stayed at the British Embassy and, with a key to the side entrance, was free to explore this 'strange and monstrous city' at all hours. His impressions were scattered – Max Liebermann at eighty painting better than ever; 'some marvellous wall decorations brought back from Turkistan by a German digger;'[590] beer 'like nectar'; and girls, 'hearty creatures and sometimes very good looking' who, on a more vital inspection, were revealed as being men 'devoted to buggery' and 'furnished by the police with licences to adopt female attire'.[591] As for embassy life, it was all very swell but 'too strenuous for me . . . there are hours of *intense* boredom'.

Of the three portraits John painted in Berlin, the most important was of Gustav Stresemann, the German Chancellor. It was Lord D'Abernon who arranged the sittings during which the Locarno Treaties advanced to the point of signature. In Lord D'Abernon's diplomatic language,

Stresemann's 'lively intelligence and extreme facility of diction' inclined him 'to affect monologue rather than interchange of ideas'.[592] The British ambassador could not get a word in. By early March, when sittings began, their negotiations had reached the verge of collapse. It was then that he had his idea. Since John knew no German, D'Abernon reasoned, there could be no grounds for not carrying on their discussions while he worked. The advantage was that Stresemann would be 'compelled to maintain immobility and comparative silence'. John, by treating the German Chancellor as one of his own family, exercised his rôle strongly. At the first sitting, after a sentence or two from Lord D'Abernon, Stresemann broke in and was about to go on at his customary length when John 'armed with palette and paint-brushes' asserted his artistic authority. 'I was therefore able to labour on with my own views without interruption,' D'Abernon records.[593] '. . . the assistance given by the inhibitive gag of the artist was of extreme value. . . . Reduced to abnormal silence . . . Stresemann's quickness of apprehension was such that he rapidly seized and assimilated the further developments to which the Pact proposals might lead.'

The pact was eventually less controversial than the portrait. Stresemann faced it bravely and 'even his wife', John reported,[594] 'admits it's like him at his worst'. To Dorelia he wrote: 'I like Stresemann. He is considered the strongest man in German politics.' But Lord D'Abernon, who now felt some tenderness for Stresemann, thought the painting 'a clever piece of work' though 'not at all flattering; it makes Stresemann devilishly sly'.[595] This proved an accurate foretaste of popular reaction. Nobody much liked Stresemann, and no party trusted him. When the portrait was shown in New York in 1928, John was much acclaimed for his 'cruelty'. Modestly he rejected this praise. 'I have nothing to do with German politics, but I thought Stresemann an *excellent* fellow, most sympathetic, intelligent and even charming,' he wrote on 13 March 1928 to his American dealer Mitchell Kennerley,* adding with less modesty: 'One must remember that even God chastises those whom he loves.'

Apart from Stresemann's silences, John had not greatly relished Berlin. The perpetual motor-cars and hard-boiled eggs, combined with a lack of handkerchiefs, unnerved him. He felt 'very impatient' to go somewhere new, and paint. 'For God's sake learn up a little Italian,' he urged Dorelia. It was May when he boarded the train for Italy, with Dorelia, Poppet and Vivien. Romilly too was coming. 'In a fit of megalomania',[596] he had decided to cross the Alps on foot, aided by the tutor

* Publisher, and director of the Anderson Gallery, 489 Park Avenue, New York. The portrait of Stresemann is now in the Albright-Knox Art Gallery, Buffalo, N.Y.

at the head of fourteen schoolgirls 'on their way to spend a week-end in Paris'.[597] Drifting through Italy, the main party played at being tourists to the extent, in John's case, of losing his wallet with all their money in it. This calamity, credited to the quick fingers of Italian train thieves, may have been attributable to Eileen Hawthorne's abortion for which urgent funds had just then been prescribed. For some days they were stranded in acute luxury within the most expensive hotel in Naples (the only one that would accept their credit), and when they finally approached the 'barbarous island' of Ischia, their destination, they were irritated to see Romilly, his feet in ruins, waving to them from the harbour.

Skirting the shores, John sought anxiously for some pictorial motif. They were to stay at the Villa Teheran, a little wooden house with a veranda, that stood by itself on a miniature bay. It belonged to Mrs Nettleship and, being rich only in fleas, proved uninhabitable: 'it was clear this place offered nothing to a painter'.[598] John marched his family off to Forio, the next town along the coast, and quartered them more happily above some vineyards overlooking the sea. The oleander, nespoli, quince, orange, lemon and pepper trees, 'with the addition of a bottle of *Strega*', contributed greatly, John recalled,[599] 'towards our surrender to the spirit of the place. Indeed, at night, when the moon shone, as it generally did . . . resistance had been folly.' But it was as a holidaymaker, not primarily a painter, that John surrendered. He would float on his back in the phosphorescent seawater for hours, while Dorelia bathed more grandly in a black silk chemise that billowed about her as she entered the water. There were picnics on the beach, sunbathing on the long flat roof of their new villa, and expeditions through the island behind a strongly smelling horse. It was a pleasant life, but tame. 'Apart from drowning, life on the island presented few risks,' John grumbled.[600] Even the werewolves, reported to range the mountain, remained invisible. So, it was back to portrait painting, 'finding myself very well occupied here with the two superbly fat daughters of the local Contessa'.[601] Another picture he painted, entitled 'Sea, Wine and Onions', was a portrait of Tommy Earp. The cook's little girls also came to sit, side by side in a window, wearing alarmingly white-starched dresses. But a portrait of Mussolini, arranged by an ardent fascist they had met, fell through. In his place Dorelia assembled some exotic blooms: and so began John's first flower pictures.

Unlike Columbus, John was destined to cross the Atlantic six times; and, in one form or another, America visited him several times more. The purpose of all this traffic was the innocent one of 'making a useful bit of money'.[602]

He had first attracted attention in America when, in 1910, his portrait of William Nicholson was shown at the Carnegie Institute's International Exhibition in Pittsburgh. When he first went there thirteen years later it was as the guest of the Carnegie Institute, which had invited him to act as the British representative on its jury. He embarked on 28 March 1923, elated to be on his way at last to the lazy New World land of his day-dreams as a boy. 'The Americans all wear caps and smoking-suits in the evenings, and smoke very long cigars,' he wrote to Dorelia from the S.S. *Olympic*. 'They are very friendly people.' When his hat flew off into the sea, they rushed up in numbers to offer him their own which, one by one as he accepted them, also flew off. 'There must be a continuous track of caps along our route.' On board he met a number of passengers who petitioned him to paint portraits: Mrs Harry Payne Whitney, 'quite a pleasant woman but infernally lazy'; a 'big fat sententious oil king . . . who argues with me'; and Arthur Conan Doyle who told him 'startling things about the spook world. It really seems quite a good place somewhat superior to this one in fact . . . Lady Conan Doyle is like people I've met in my youth – all spiritual love and merriment and dowdy clothes.'

Of all contemporary British artists, John was then the best known in America. At the famous Armory Show of 1913 in New York no other modern painter, with the exception of Odilon Redon, had been so well represented.[603] The huge Armory had been packed with the élite of New York 'cheering the different American artists, cheering Augustus John, cheering the French[604] . . .' Critics and journalists had soon been dispatched to interview John, and many reports of his 'recent activities' appeared in the American papers. 'Augustus John is now at the height of his fame,' the New York magazine *Vanity Fair* had declared in June 1916. 'Not even the war . . . has taken public attention off Britain's most conspicuous native painter.'

On arriving, hatless, in New York harbour he was penned down by a press of journalists who, like pirates, boarded the boat even before it berthed. 'They sought to get a "story" out of me. I stood them a drink instead.'[605] They were delighted by his appearance – 'thoroughly consistent in living up to what he ought to look like'; he thought them 'nice boys'.

That evening, after dinner at the Coffee House, Frank Crowningshield whirled him round the city and eventually landed him back at his hotel 'exhausted and bewildered by an orgy of colour, noise, smartness and multitudinous legs'.[606]

Of Pittsburgh, where he arrived next day, John remembered little but the boundless hospitality of its natives and the 'infernal splendour' of their steelworks. He did not stay long. He had been invited to Buffalo

to paint the elderly mother of a general, and after four days hurried off there to keep this assignation.

On the platform General Goodyear was surprised to see hovering at John's elbow the assistant director of the Carnegie Museum, John O'Connor. O'Connor whispered that he had come to explain away the 'extraordinary capacity' of John's drinking habits. 'I replied, somewhat haughtily that I thought Buffalo men could take care of themselves in the drinking line,' Goodyear reported.[607] 'Pittsburgh might have suffered but I had every confidence in my fellow citizens. I was wrong.'

John was lodged at the Saturn Club, reputedly – in those days of Prohibition – 'the most bibulous of our social institutions'. He appreciated the compliment. 'This club is a very good place' he acknowledged,[608] 'full of determined anti-Prohibitionists . . . There is a little back room with lockers all round the walls in which the members keep their "hootch". About 6 o'clock this room gets densely packed with a crowd of vociferating men wildly mixing cocktails. I have the freedom of Conger Goodyear's locker'. For part of the first evening, about which he could recall nothing, the General 'participated lap by lap'. 'The following afternoon and evening I decided to stay aloof and keep count,' Goodyear wrote.[609] 'Some of my friends formed relay teams to pace the visitor. The official score showed seventeen cocktails for our guest without visible effect other than a slight letting down of British taciturnity. There were a few highballs during dinner and after and we sat in a respectful silence as the champion walked a straight path bedwards'.

Work on the portrait sped along intermittently, and sometimes John would escort the old lady politely to the shops. One morning, as she was emerging from her dressmaker, Mrs Goodyear cracked a joke, fell down a flight of stairs and broke her ankle. 'Just my luck!'[610] commented John. That afternoon he left for New York.

Over the next weeks a gradual disenchantment with American life may be traced in his letters. He had hoped to ride over the American West, he told a reporter from the *New York Times*, to set up camp along the prairies, push up the Mississippi, mix with the Negroes on the cotton plantations. His plans were greeted with bewilderment. 'The prairies had been ploughed; the backwoods levelled; the Indians mostly tamed or exterminated; the frontiersmen replaced by "regular fellows".'[611]

In a letter to his ten-year-old daughter Poppet (28 April 1923) he gives his own child's eye view of New York. 'This is a strange country. There are railways over your head in the streets and the houses are about a mile high . . . The policemen chew gum and hold clubs to knock people down. The people don't say "yes". They say instead Yep, yeah, yaw, yawp, yah and sometimes yump. Otherwise they simply say "you bet" or "bet your life". They eat clams, fried chicken, chives, slaw soup and

waffles with maple syrup. They drink soda-ices all the time. The rich
people drink champagne and whisky for dinner and go about with
bottles of gin in their pockets. When a policeman catches them they
have to pay him about 1000 dollars after which he drinks their gin and
locks them up.'

John did not seek publicity in New York: the more publicity the less
freedom. So far as possible he kept his whereabouts secret from journa-
lists.[612] He put up temporarily at the Hotel des Artistes at 67th and
Central Park, then moved to a studio owned by Harrington Mann. To
this studio numbers of Americans trekked, convinced that they were
discovering a new Sargent.* Over their portraits John agonized inde-
finitely. 'It's been a fearful grind,' he wrote to Dorelia. Everyone wanted
to give parties for him and 'I am employed mainly in accepting invita-
tions and getting out of keeping them. The telephone rings continu-
ously.' There was always something to do, a boxing match, a cocktail
party, the theatre, a trip to Philadelphia, another party. His best hours
were in the company of the decorative artist 'Sheriff' Bob Chanler, 'a
Gargantuan creature, as simple as a babe,' with great flapping arms and
hands, at whose house he met 'easy-going ladies, eccentrics and hangers-
on': it was almost like home. But John was cautious. 'I walked down
Fifth Avenue,' he told Dorelia, ' – there were a number of rather tarty-
looking damsels walking about giving glad or at any rate significant
eyes – of course one mustn't respond, for if you as much as say "how do
you do" to a woman, you are immediately clapped into gaol for assault
or otherwise blackmailed for the rest of your life. The country is
chiefly controlled by a villain named Hearst who owns most of the
papers . . . This city at night is dominated by a stupendous scintilla-
ting sign advertising Wrigley's chewing gum. The poor bewildered
multitude seethe aimlessly below.'

He saw the Americans as 'inconceivably naif' though 'not unattrac-
tive', but it is possible to see John himself as floundering naïvely within
the bowl of this highly artificial society. Despite all the hectic enjoy-
ment he was never quite at ease, except in Harlem. It was with great
difficulty at first that he could persuade anyone to take him there. After
that, to the horror of his friends, he went alone and sometimes stayed
all night. 'The dancing that took place in these Harlem clubs was bril-
liant beyond description . . . I was immensely pleased.'[613]

Harlem at that time was not known in polite society and when John
spoke of his plans to paint New York's negroes there was some high-
pitched embarrassment. 'Do you like the mulattoes, or the brown or
black negroes?' one incredulous journalist asked.[614] 'I like them all,' he

* 'Since the death of the American Sargent, nobody scarcely looms so tall [as
John]'. *The Chicago Evening Post*, 16 February 1926.

growled. He was questioned on Harlem as if about some far-off planet. 'They seem to be natural artists,' he told the New York press. 'It seems too bad that when any of them in this country show talent in the graphic and plastic arts, or in any line of artistic endeavour, they are denied an equal chance with other artists.'

John's other area of criticism was Prohibition. 'There's a new rich class springing up,' he told Dorelia, ' – the *bootleggers*. They are the strongest advocates of Prohibition and extremely powerful'. In public he aimed his protest at what appeared to him the most appropriate point. The secretary of the Independent Society of Artists in New York had been convicted for hanging a picture by François Kaufman that showed Christ being prevented by some prohibitionist politicians from changing water into wine, a joke that appealed to John. 'The conviction was an outrage on liberty and art,' he thundered.[615] 'Your prohibitionists seem the richest subjects for satire . . . Prohibition is more than a farce – it is a tragedy. I agree with those who say it breeds disrespect for all laws. It is unjust to the poor, because one doesn't have to be in this country long before discovering that anyone with money can get all the liquor he wants, while it's beyond the reach of those with little money.'

These were scarcely the tones of a new Sargent. Nevertheless, New Yorkers were generously disposed to find him very wonderful. Like the Indians, he could be tamed. 'I could get *any number* of portraits to do if I liked,' he informed Dorelia. The idea of having done them, swiftly, painlessly, profitably, was attractive; but the work itself paralysed him. Letters from Dorelia arrived, describing the flowers in her garden, the girls' new pony, the dogs, cats and vegetables. Amid the sterile canyons of New York, all this seemed infinitely green and desirable, and he longed to be back.

Before leaving, he saw for the last time his old patron John Quinn. Quinn had been dreading this encounter. Having largely lost interest in John's painting, he was then arranging to sell off most of his pictures on the open market. To his relief John 'was very pleasant and did not allude to the episode of my selling the paintings at all,' he confided to Percy Moore Turner. 'I took him out riding with a lady . . .' By admiring his new collection and his young mistress the beautiful Jeanne Foster, John so charmed Quinn as to modify his selling programme. The following year, Quinn was dead. The doctors had given him up months before, but once again he knew better than any of them, and simply would not die. They told him he was suffering from a hardening of the liver; he shook his head. Barely alive, hardly able to move, his body skeletal though swollen with fluid and (except his teeth) yellow all over, he admitted to a small glandular disorder. He was 'run down', he

believed, and must be careful not to catch a cold. Once he had picked up, he would do such things . . . He died, on 28 July 1924, of cancer. 'He was a strange man,' Mitchell Kennerley wrote to John (13 August 1924): 'led a strange life: died a strange death. Properly handled his Collections will ensure his fame.'

In the last week of June, John sailed back on the *Berengaria*. 'The first few days he seemed quite low,' noted Conger Goodyear, who was with him on the same boat. 'He said he thought he had rather overdone it in New York and that he was glad to be getting back from American Prohibition to England and temperance.'

Though affecting a boastful attitude in the wake of this first trip, he seems to have interpreted it as a reconnaissance to be followed up by an intenser campaign. By April the next year he was back in New York in a big bare studio in the Beaux Arts Building at 80 West 40th Street. This second coming, which has been described as 'an electric event . . . that enriched the great saga of John's career,'[616] was largely indistinguishable from the first. 'All the newspapers reproduced photographs of him,' Jeanne Foster wrote to Gwen John. The Mellons and the Wideners queued up for their society portraits; Harlem, all-aglow at night, bewitched him more and more. He was less cautious now. He began painting negresses 'semi-nude'; and he began quarrelling with American dealers from whose 'unctuous greetings' he protected himself with a 'cold zone'. There was something about New York, he discovered, that for all its speed and activity, deprived him of initiative. All around throbbed a deceptive air of industry: yet it was impossible to work.

'Life,' he warned Homer Saint Gaudens, 'is full of pitfalls (and gin)'. This time he was in the thick of it, and rapidly growing impatient. At the end of one dinner he broke his silence and, to everyone's amazement, apologized in booming tones for having 'monopolized the conversation'. At a lunch he was seated next to a lady who pressed him continuously about young artists of the day – what pictures could she buy that would multiply in value ten times within five years? 'But is there no one?' she finally asked in desperation, 'is there no one whom *you* are watching?' His reply ended their conversation: 'I am watching myself, madam, with considerable anxiety.'

John's reputation in America, at this time unnaturally high, was built largely on hearsay. The Carroll Gallery and the Photo-Secession Gallery in New York; the Boston Art Club, the Art Institute of Chicago, the Cleveland Museum of Art and numerous other galleries had been endeavouring over several years to hold John exhibitions. The Carnegie Institute itself had offered to set up a one-man show that would tour the country. All these institutions had the disadvantage of John's active co-operation. He was, as one gallery director put it, always 'cordial . . .

but persistently indefinite'.[617] When his first one-man show in New York was held early in 1928 at the Anderson Gallery, John inadvertently was in Martigues and never saw it. Stevenson Scott, who had brought him over in 1924 to 'secure commissions for the paintings that commemorate his American period', and had undertaken to show the fruit of this period at Scott and Fowles, did not live to see the exhibition take place. It opened, a quarter of a century later, in the spring of 1949.

Perhaps John's best portraits of Americans were done in Europe: of Tom Mix, the movie actor, who visited Mallord Street with a camera team to film the event; and of the musical McLanahans, plumped up with Philadelphian philanthropics, at their aptly named house in the Côte d'Or, Château de Missery. His portrait of Frances McLanahan,[618] a real beauty, large-eyed and oval-faced, is a Swedish study, blue and yellow, of peach-fed innocence. It was eventually brought to fruition in London where, about the same time, he was failing to finish a portrait of Governor Fuller of Massachusetts.

It was in pursuit of Fuller that he made his last voyage to America in 1928 – a journey he never failed to regret. 'I didn't think it was possible to be so bored,' he complained to Carrington. 'Come over and rescue me!' He had been carried off to the Fullers' country house, 'an appalling place' some fifty miles from Boston, and presented with the task of painting the Governor and his problematic children. 'This sort of work is very ageing,' he grieved. 'I have practically no hair left.' One difficulty was that the Fullers 'do not yet grasp the difference between a hired photographer and an artist. As I am their guest I cannot point out the difference as forcibly as I should like.'[619] The children were devilish – in John's picture the son has no feet because 'that boy drives me crazy, swinging his legs about all the time'; and one of the daughters ('a nice young bitch . . . if one could catch her on the hop') he dismissed altogether because 'neither she nor I could concentrate'. Mrs Fuller, a good soul brimming over with imbecile cheerfulness, had 'designs on my virtue', making his position in the house tricky. 'I can't stick this,' he wrote darkly to Dorelia. 'I *can't* tell you *all*.' The Governor himself, John decided, 'is the best of the lot . . . I could make Fuller the most ridiculous figure in two hemi-spheres if I wanted to.' But the opportunity to transfigure him as another 'Lord Mayor of Liverpool' was, despite the flowers painted adjoining the Governor's ears, passed over. 'The game isn't worth the candle. My portraits will probably – like the others I did of Americans – be hidden away carefully.'

As the weeks flowed by, his lamentations reached a comic intensity. 'It's hell and damnation here!' he cried. The prolonged and dreary meals with mushy food and iced-water; the gramophone grinding out all day its bathetic melodies; the political guests with their deadly tales of golf

and fish; the 'advice' on painting; the burden of all their labour-saving devices including a 'ridiculous old ass of a butler' with a pseudo-cockney accent who, John believed, 'was suffering from a disease of the spine till I realized his attitude was merely one of deference'; the gloom, the tears: all these conspired to make the months of August and September 'the most hideous ordeal of my life'.

In the second week of October they moved, *en masse*, to Boston. The Fullers expected John to stay at their official residence, or 'mad house', in Beacon Street, but he had been lent a studio in the Fenway by Charles Woodbury, the marine artist, 'a perfect old dear . . . I could have embraced him'. Though the walls were covered with alarming pictures of sharks leaping from the Caribbean Sea, 'I think I shall recover here,' he assured Dorelia. 'That stay with the Fullers pulled me down terribly. The darkest passage of my life undoubtedly.' He had, he added, devised a 'good method of doing portraits with much use of toilet-paper'.

This autumn marked a watershed in John's American career. Offers for portraits poured in – 'there are millions to be made . . . but I would rather paint vegetables'.[620] He took up his brushes and produced four cyclamen, two begonias and a chrysanthemum. It was a long way to have come for such work. Among his few exciting portraits was one of a coloured elevator girl who offered to return with him to England. He was determined to penetrate the underworld of Boston but wherever he went could see nothing but 'masses of full-grown men dismally guzzling soda-ices'. 'This city is a desert,' he concluded. To the Fullers his behaviour appeared dangerously 'wild'. It was almost as bad for them as the Sacco and Vanzetti trial. No longer did John have to rely on charity for a glass of wine. A coffin-like object in his studio had been filled with drink, and he began to suffer from terrible hangovers. Worse still, he had picked up 'a little actress' with whom he was seen in public. This was Harriet Calloway, the coloured star of *Blackbirds* and famous for her 'Diga Diga Do'. By December the Fullers were as eager as John himself for his departure. 'They seem to think I'm a comic here,' he grumbled. The last laugh was theirs. When the portrait was finished, an official telegram of congratulation was sent from the Governor's residence – to Augustus's father in Tenby.

'How happy I shall be to get on the Ocean,' John had written to Dorelia on 28 November, ' – even if the ship sinks it will be better than staying here, where one sinks only less quickly'. He sailed from New York on 14 December. 'I am a complete wreck,' he warned his family. ' . . . Be ready to meet me at Southampton with a drink.'

John's chief endowment to America was his unfinished work. Over the next thirty years, numbers of ageing Americans continued to throng the Atlantic in vain pursuit of their portraits. One exemplar of this was

Mrs Vera Fearing, a niece of Whistler's. John had begun to paint her in October 1928, but not having completed it to his satisfaction by the time he left, he refused to sign it. She promised to come over. The first time she came, he was ill. Later she followed him to Connemara and then back to England. From August to December 1931 she stayed at Fryern, being painted in the tool shed. In the course of these sittings she changed her dress, he changed his studio. She learnt to drink, helped Dorelia with the housework, met Lytton Strachey, Carrington and Lawrence of Arabia, went for death-defying drives to London. Then, in 1935, she tried again – as Mrs Montgomery with a husband and two children. Everyone was extremely kind, John himself offering to give her a child of their own. But one day – 'one of the worst days I've ever been through' – John decided his studio was haunted and disappeared at midnight to London. So it went on. Telegrams and letters flowed between them, and ruses of all dimensions were engineered to lever the picture from John's grasp. He worked on, sometimes using photographs and the clothes of other sitters, grappling with the abominable job of fitting someone else's body onto her head. 'I want to work some more on your extremities,' he pleaded. She waited: was divorced, remarried, became a grandmother. Her father-in-law, who had originally commissioned the portrait, died never having seen it. War came, went. 'Augustus means you to have it,' Reine Pitman assured her on 13 July 1959, 'but is already slightly baulking, and saying he wants to show it before sending it off'. That autumn it had reached 'an electric fire having its signature dried! So it won't be long now . . .' Then, in 1960, Vera Stubbs (as she had now become) was repossessed of her picture. But her husband didn't care for it and it was hung in a disused hut.

There was another curious aftermath to John's American period. Ann and Joan from New York, Doris from Massachusetts, Karin in *Runnin' Wild*, wrote giving times and addresses. Myrtle, a music student 'particularly interested in art', wondered 'if you would like to see me'; Margaret and her friends wished to know whether he would 'consent to stimulate our interest in art'; could he, another correspondent inquired, 'spare a few moments to look at four paintings by my sister, who is in a lunatic asylum?' Some letters, mentioning cocktails, are anonymous; others, providing names and ages of children, affectionate. Others again, containing financial calculations, were torn up. A 'celebrated squawker' offered her services, as vocalist 'at any social function'. Another Vera, who had stopped him in the street one day to demand his 'opinion as to the future of art' wrote to inform him that 'I interrupted my artists career in order to find out the meaning of things', adding: 'It seems to me that a great figure in the art world like yourself ought to give your contribution to this problem.'

And it was true that, in some manner, John was still 'a great figure in the art world' for the Americans, though they could not see him clearly. It was a mirage: the nearer they approached the more urgently he threatened to vanish. He had come, seen, and turned away. Whenever his name burst into their newspapers – on the cover of *Time* magazine and of *Life*, or as the first artist to wireless a drawing across the Atlantic – curiosity was quickly rekindled. But there was too little of his best work on public view to sustain serious interest, so there remained only a vague impression of his bloodshot personality, some memory of those powerful party manners, a rumour of exploits: then nothing.

On one of his voyages back from America, the ship touching at Cherbourg, John had disembarked. 'I was unable to resist the urge to land first of all on the soil of France,' he explained.[621] 'It was a moving experience after the glitter and turmoil of New York to find myself in the quiet and mellow ambience of a Norman town such as Bayeux and taste again a dish of *moules marinières* with a litre of *rouge* . . .' The gentle aspect of the country, the leisureliness of life, the detachment and intimacy mixed: these were virtues of the Old World that now seemed most appealing to him. In the past, when submerged by spleen or boredom, he had speculated on the existence of a better land to the West. After 1928 he knew it did not exist. When asked whether he would return to America, perhaps to paint Franklin D. Roosevelt, he had answered no: Goethe's dictum 'America is here' was turning out to be literally true, and saved him the journey.

The New World, once it invaded Europe, revealed itself as his enemy. Like a Canute, John held his hand up to halt the tide of history; and such was the force of his personality and the sphere of his influence in style and fashion that, for a moment, he appeared to succeed. The waves held back, there was a frenzied pause – then the sea of modern life flooded past him and he was lost. But in the interval between the Great War and the Great Depression, his values and many that were inimical to them were held in miraculous suspension. To all appearances he was a modern figure, travelling fast.

Travelling downhill. In 1927 began a long process of evacuation. During March that year he moved with his family from Alderney. For a while the strange castellated bungalow, in which they had lived for more than fifteen years, stood empty, a shell behind its broken-down garden wall and the rising screen of rhododendrons. Then it vanished altogether, and in its place stood a brand new housing estate.*

By April the following year, 'in submission to the march of progress

* The old site, purged of its pagan associations, is now consecrated ground, being occupied by the Alderney Methodist Chapel.

as conceived by business men or crooks', they left the Villa St Anne. In their absence, petroleum factories refined the air with their perfume, landscaped the country with their blocks and craters. The fishing village of Martigues grew pock-marked with industrialism: docks and aerodromes besieged it, plastic furniture infested its shops and houses. The Villa St Anne was converted into the Hostelerie St Anne, credited with three knives and forks in the *Guide Michelin*, though still with its 'vue exceptionelle' over the blue Etang de Berre.

In Mallord Street it was the same story. The Chelsea fruit and flower market just opposite their house was obliterated; blocks of flats and a telephone exchange blotted out the sun. In the early 1930s they sold the house to Gracie Fields; the Anrep mosaics were covered up, the basic structure altered, the house and its surroundings made almost unrecognizable.*

Elsewhere too the old world was vanishing, and John was a part of it. Though he might blare his defiance, though he would heave out an announcement from time to time about 'turning a corner' at last, there was only one direction for him to go. The retreat was sounded on all fronts, and everything would depend upon the skill and subtlety with which he conducted it.

* Much of it has been changed back again, as if 'the intervening years had never been', by Nicola Waymouth in the early 1970s.

The Way They Lived Then

'I got stuck here.' Augustus John to Bill Duncalf (22 May 1959).

I. FRYERN COURT

Fryern Court had originally been a fourteenth-century friary which, in
the early nineteenth century, was converted into a farmhouse. Later a
Georgian front had been stuck on to the old farm building, and it was
transformed into a conventional manor house.

It was a secluded place, in fields, on the edge of the New Forest, a mile
from Fordingbridge. A porch 'like a nose'[622] divided the fine long
windows that reached almost to the ground; wings and outhouses
stretched away into garden and meadow. The sitting-room, dining-
room, studies and a fourteenth-century kitchen with carved stone heads
(then heavily painted over) protruding from the walls – all had their
floors level with the ground. But upstairs there was more the feel of the
old farmhouse, the passages rambling crookedly past eight bedrooms.

They moved in early in 1927. Augustus descended from London and
'like the traditional clown'[623] busily did nothing. Everything that could
be removed from Alderney was taken. Poppet and Vivien, in great
excitement, rode over on their horses; the old vans and carts, soon to
be embedded as garden furniture, set out on their last rusty journey;
cats, dogs, pigs joined in the stampede past the large copper beeches,
magnolias, yellow azaleas up the curving gravel drive to their new
home.

The routine and rituals at Fryern were to be arranged as a perfect
background for John: but, as with Alderney, it was Dorelia's arrange-
ment. The beauty she conjured up, plenteous and instinctive, gave him
no cause for plausible complaint, yet it was far removed from the vast
empty scene that stimulated his painter's imagination. He saw all round
a beauty he could not use, and he recognized, with despair, the rich
orchestration that everywhere supported his external needs. 'Here', ex-
claimed Cecil Beaton,[624] a frequent visitor, 'is the dwelling place of an
artist.' The irony seemed invisible, though the changes that were made
to Fryern, in particular a mammoth new studio, on stilts like a child's
plaything and 'entirely based on mathematical calculation',[625] were
expressions of John's discontent. Year by year his painting deteriorated.
In an agony of guilt, disappointment, incomprehension, released in
thunderous bursts of temper, he worked on amid these tranquil sur-
roundings.

Meanwhile Dorelia 'busies herself in the garden', John noted. It was a grander garden than at Alderney, and more formal. The old dark yew trees were neatly clipped; the soft mature lawn, with a pond at its centre, was enclosed by hedges; in the orchard, the pear and apple trees were hung with little bags against the wasps. Up the walls of the house roses and clematis twined, the matted stems making a nest for cats; and on the north side, a hazard for drivers, bunched the holly and laurels. There were garden seats, tables of stone and teak, a hammock strung between the Judas and an apple tree. It was a place for animals and children to play in, a place to relax in and read.

But it was also a place to be used, keeping the house replenished with fruit and herbs, bright yellow goats' butter, quince and raspberry jam, grape-juice from the vine in the greenhouse, sweetcorn, lavender, flowers. During the 1930s Dorelia was helped by two gardeners. One, a fine man, strayed into hospital. The other was Mr Cake. He and his wife, Mrs Cake the cook, had been at Alderney and, though often promising to leave, remained with the family for over thirty years. Old Cake was a small man with a limp and a bright button-hole who would go swinging off each evening to the pub over a mile away. He seldom spoke, and his wife, who 'did wonders' especially with fish, could not read. Larger and more voluble than her husband, and always grinning, Mrs Cake appeared (on account of her wall eye) a fearsome creature. She was immensely proud of her hair, which was long and thick and washed, she would explain, in juice of rosemary. She spoke with a strong Dorset accent. 'Old Cake was very lucky to get me,' she would say. 'All the boys were after me. It was my hair.' Old Cake, pursued by several goats, said nothing.

There was soon much of Alderney about Fryern Court, the same smells of beeswax, pomanders and lavender, wood- and tobacco-smoke, coffee, cats; and the same amiable disorder, spontaneously thrown together, of vegetables, tubes of paint, nuts from the New Forest, saddles, old canvases, croquet mallets, piles of apples. The furniture was not fine nor the pictures very valuable: it was the opposite of a museum. Alongside those paintings of John's which had eluded fire and finish were some lovely Gwen Johns, a watercolour by Augustus's son Edwin, a small Henry Moore sketch, small Wilson Steers, Conders and other contemporary works, in particular, later on, some Matthew Smiths. An Epstein head of a small child stood on a table, and in the hall, crowned with a cactus, one of the two Modigliani stone heads John had bought in Paris. Then there were paintings by friends: Eve Kirk, Adrian Daintrey and a passing number of gypsy artists.

Though far from being a smart house, it had an unpretentious beauty. The colours were rich, but without any premeditated scheme; the atmo-

sphere lavish yet shabby; it had much of the farm about it. The physical fascination it had for people was difficult to analyse. 'There is no beguiling, ready-made impact of beauty,' wrote Cecil Beaton;[626] 'rather, an atmosphere of beauty is sensed. No intention to decorate the house ever existed. The objects that are there were originally admired and collected for their intrinsic shape. They remain beautiful . . . the colours have gratuitously grown side by side. Nothing is hidden; there is an honesty of life which is apparent in every detail – the vast dresser with its blue and white cups, the jars of pickled onions, the skeins of wool, the window sills lined with potted geraniums and cacti . . .'

With its squadrons of guests, its explosive parties, Fryern was the most open of houses, a mandatory first stop between London and the west. Many were invited, many more came. But the informality was rigorous and the welcome, at least to strangers, not always decipherable. Hugo Pitman remembered every window of the house lit up (though it was still light outdoors) when he first approached: 'It was like arriving at a stage set. Through the long windows of the refectory-table room, he saw two figures sitting by a blazing fire. On the other side of the front door, some children moved about in the drawing-room. Upstairs, Augustus could be seen in bed . . . The bell did not work, so they rattled the front door. Instantly every light in the house went out, except Augustus's – and his blind came down immediately.'[627]

John was emphatic about people enjoying themselves. Up in London, his laugh volleying round the Eiffel Tower; or seen striding about the sunlit gymkhanas where Poppet and Vivien loved to ride; or picnicking with the family on the phallic giant of Cerne; or in the evenings, seated at one end of the long scrubbed oak table opposite Dorelia, with twenty people between them, and candles, bottles of wine, he seemed lit up by joie de vivre. Broad-shouldered, athletic still in his fifties, capable of gestures of great warmth and sympathy, there was yet 'a touch of tragedy in his appearance', Adrian Daintrey noted.[628]

Parties were conspiracies of self-forgetfulness. Fierce fits of depression had made him dependent upon the momentary gaiety of a clamorous, adoring public whom he did not honestly admire but whom he allowed to play him out of his gloom into the false light of their fan-club gala-world. Hating publicity, he had become the object of 'image-making'. But the praise they filled him with was counterfeit: hot air. As numerous letters of apology testify, he could behave very rudely when drunk, but there was some truth in this rudeness. The good things they said about him he did not believe. He could suspend disbelief but never long enough to achieve complacency. For this reason he was never the Impostor of a Wyndham Lewis fantasy, even if from time to time he strove to act that rôle. '*La bonne peinture* is all the praise I want!' he

wrote to Will Rothenstein (26 May 1936). This was not vocal approbation, but a sense of right. 'I am painting better than ever before,' he growled one day to Lady Waverley. But when she congratulated him – 'how happy you must be' – he snapped back: 'You have never said anything more silly!'

That it became, with time, more difficult to flatter him stood to his credit. But it did not make him an easier person. False praise, like alcohol, was ultimately a depressant, allowing him briefly to 'take off' while it drilled a deeper cavity into which he must fall back. Among his family who, reflecting only distorted versions of himself, provided no escape, he was often at his most difficult. 'Daddy has returned to the scene so it will be gloom, gloom, gloom,' Vivien wrote in one of her letters from Fryern. Meals could be 'absolute killers' affording all the silence, the strictness and fear that had saturated his father's dining-room at Tenby. When the going was bad, John would sit, a crazed look on his face, his eyes staring out with an insane glare, like a Flaxman horse. Something odd was going on inside him as he sat, deeply silent, watching the gangway of brooding children. Almost anything they did could be a target – the way a knife was held, the expression of a face, a chance sentence. To others he spoke in a mild, cultivated voice, saying something unexceptional, even academic, about the birth of language, the origin of nomads. His speech was exactly calculated. He would chuckle first, as if amused by what was about to come out, then pause, selecting his vocabulary with care, and pronounce the words slowly in old-fashioned English, without short-cuts or slang. Then he would relapse into silence, and again something nameless appeared to be torturing him. But sometimes, when he thought no one could see him, his whole body quivered with silent laughter.

The house was controlled by these moods. Intrigues and hostilities thundered through the rooms, threatening, exploding, blowing over: and all the time something within John was shrinking. His generosity, the largeness of his attitude, these were still communicated. He was a big man: but inside the magnificent shell his real self was diminishing. One sign of this was his handwriting, which had been wild in youth, handsome and expansive in middle-age and, from the 1930s began to contract until, during the last fifteen years of his life, it had become tiny – a trembling crawl across conventional small-scale writing-paper.

Fryern, which would remain their home until they died, was a beautiful cobweb spun by Dorelia round John. Like a fly, suspended, exposed, he buzzed and was silent, buzzed and grew smaller. There was no spider to devour him, no danger, only a gradual diminution towards zero.

And Dorelia was caught too. After the war, Lamb had been invalided back to England 'in a desperate state'.[629] From the General Hospital at Rouen he was sent to a hospital in London where Dorelia went to see him. 'He's not allowed more than one visit a day so it's very maddening,' she had written to Lytton Strachey (11 December 1918). ' . . . his heart and nerves are in a very bad state. He's in a very comfortable place [27 Grosvenor Square] which is a blessing, and being looked after properly for the first time.' In so far as she could – though 'it's very difficult for me to get away' – Dorelia helped him back to health. He was often at Alderney, and to be near her set up house in Poole.* To the children he had been a glorified uncle; to Dorelia he was her other artist, the theoretical alternative reconciling her to life. But for John he was merely some nerve-ridden sparrow imitating an eagle. He knew that Lamb was cleverly critical of his painting, and feared that this might affect Dorelia, on whom he still counted for strength.

Though the atmosphere had sometimes been uneasy, and there were too few opportunities for Lamb and Dorelia to escape together, some aspects of Alderney had been 'perfect' – piano duets, moments alone. But always after a few precious hours, 'that old tarantula Augustus' would reappear 'in his customary nimbus of boredom, silence and helpless gloom', Dorelia would step back into the shadows and Lamb retire bitterly alone. A drawing he did of her in 1925, sensitive and tender, hints at the deep feelings she aroused in him, and his letters to Carrington[630] (who was herself very close to Dorelia) proclaim them. She absorbed his waiting life. When she fell ill he felt 'terrified', blaming John for thoughtlessly loading her with work. He tried to extricate her from the 'perfect cataract' of hangers-on in the country, to rescue her when 'bemallorded with the old monster' in London. 'I find her quite inaccessible,' he sighed to Carrington (12 September 1925), 'and of course she makes no effort.' But there were glimpses of her, secret times when she would slip away to him, bringing plants for his garden or going with him to concerts. For years he persisted in his hope that she would finally come to him 'and then perhaps part of the day dream could be realized. After all there is such fair hope of it all coming off some day when that strange woman is less perplexed and all our nerves less raging'.[631] This hope was extinguished only when, starting a fresh chapter of her life with John, Dorelia moved to Fryern. For Lamb, as for John, it was a crisis. 'The worst of it is,' Lamb complained to Carrington, 'that I think Augustus's threatened breakdown is all fiddle-dedee – just some of his melodramatic methods. Though I suppose he is quite plainly, though slowly, breaking up if not down.'

From this time onwards Lamb's attitude changed. 'I think she

* At No. 10 Hill Street.

[Dorelia] is already pretty well bored there,' he wrote sourly to Carrington not long after the move to Fryern. He had managed at last to get divorced from Euphemia, and the next year, 1928, he married Pansy Pakenham, the eldest daughter of the fifth Earl of Longford, springing the news on Dorelia a few days beforehand.

Dorelia's life with John had grown more difficult. She made at least two attempts to leave. Once she got so far as the railway station. A pony and trap was sent off in scalding pursuit, arriving just before the train, and she was persuaded to return. The letters John wrote whenever he was abroad reveal his dependence on her, and it was this need that finally held her back. After which it was too late, too unthinkable that 'Dodo' as everyone called her, should not always be there. She grew more fatalistic, relying on the swing of her pendulum – a ring harnessed to a piece of string – to decide everything from a marriage to the authenticity of a picture. It was impossible to tell to what extent she counted on blind faith or the subconscious workings of common sense. From anything that might cause pain she averted her inner eye, though she might seem to stare at it without emotion. The range of her interests narrowed. She had stopped drawing, now she read less, eventually gave up the piano, perfected her immunity. Nothing got on top of her, nothing came too near. She had turned her attention to the vegetable world, and conducted, with precision, the times of meals. The sounds at Fryern matched this quiet equanimity: no longer the jaunty duets with Lamb, but a softer noise, the purring amid the pots and plants, of the sewing-machine as she sat in front of it, alone, as if for dear life.

2. A LONG LOVE-AFFAIR WITH DRINK

In the first four years at Fryern a great physical change came over John. 'He had aged very much in those years,' Diana Mosley remembered.[632] ' . . . John was fifty-three in 1931, but he seemed old, his hair was grey, his eyes bloodshot, and he already looked almost as he did in the cruelly truthful self-portrait he painted after the war.'

The immediate cause of this change was alcohol. Almost certainly he had drunk more in the 1920s than in any other decade of his life. 'I drink in order to become more myself,' he stated once to Cecil Gray.[633] Drink banished his awkwardness, carried him across the moat of isolation. At Fryern he was king of the castle; but outside this castle he could feel ill-at-ease, and remained loyal to one or two places – Stulik's or the Queen's Restaurant in Sloane Square – he had made homes-from-home.

Drink changed him into a different person. It was the passport enabling him to go anywhere, giving him the gift of tongues. After a

glass or two he relaxed, the terrible paralysis lifted, and the warmth that had been locked up within him flowed out. But then there was a third stage, when the geniality and amorousness gave way to senseless actions, such as punching out a cigarette on someone's face: of which, afterwards, he felt bitterly ashamed.

It is impossible to be certain what were the predisposing factors in John's character that forced him across the line dividing the social drinker from the man dependent upon alcohol, but a knowledge of his biography does suggest one cause. He had been aged six when his mother died, and though he nowhere laments her death, his obsessive theme as a painter – a mother with her children in an ideal landscape – illustrates the deep effect this loss had produced. If his father, whom he so disliked, represented the actual world, the deprivation of his mother became the source of that fantasy world, happy and beautiful, he created in its place. It was an example of how art can transmute deprivation into an asset. But actual life was always conflicting with this dream world. Alcohol, by blurring the distinction between them, lessened the tension of this conflict.

But in practice, it was impossible neatly to segregate these two spheres. Whenever he felt submerged by day-to-day realism, his inspiration faded and he grew deeply melancholic; whenever he pursued his visions too far into real life, he spread confusion. It was this that had culminated in Ida's death. About her death, as about his mother's, he was reticent, but she had been a casualty in the warring of these worlds, committing him, if he were to justify it, more deeply to the fantasy of his art. The tension grew. Alcohol, by subduing the light of everyday, seemed to enable the moon to shine out more brilliantly in the firmament of his imagination. This, at the start, was its function. The eruption of the First World War had sent his dream-planet spinning off into the unknown. The rest of John's life was the saga of his search to rediscover it. But it was a twilight search, for drink had dimmed his moon as well as the sun.

From this time on, alcohol fulfilled another function: it screened the truth. It did so in many ways, lightening the fatigue of his search, numbing the disappointment, leading him into moods of self-deception, expanding the ego. But while he looked for another world he lived in this one, painting portraits instead of 'invented' pictures, and seldom converting a sitter into one of his own people. He had lost confidence and the courage to experiment. In their place alcohol gave him false substitutes – a bragging that contradicted his modesty when sober; and an expensive life, ostentatiously generous to others, that required more commissioned portraits to finance it.

John was an actor. Amid the fictitious jollity of the bar, he acted

happy and almost felt so; sometimes he even acted drunk. Acting, which had begun as a means to self-discovery, became a method of escaping his sense of exile. It was this remoteness that people sensed about him. 'I'm sure he has no human heart,' noted Hugh Walpole in his diary[634] (3 July 1926), 'but is "fey", a real genius from another planet than ours.' But if he was not of this planet, he did not now belong to any other. 'Sometimes one feels positively the old *horror vacui* overwhelming one,' he admitted to Christabel Aberconway.[635] Although alcohol promoted a temporary sense of well-being, John recognized it as an enemy that could impair his health and competence as an artist. He made many attempts, some of them on paper, to reduce his drinking, or to give it up altogether. 'I feel so restless and agitated I can hardly write,' he told Alice and Will Rothenstein at one point. His withdrawal symptoms seem to have bordered on *delirium tremens*, and he decided to seek medical help. Treatment was made difficult because John never admitted his addiction to alcohol. 'There's nothing the matter with me except occasional "nerves",' he diagnosed in a letter to Ottoline Morrell (8 June 1929). On this matter of nerves he consulted Dr Maurice Wright who was 'very eminent in his own line – psychology, and he is already an old friend of mine'.[636] Discussing his illness, John used a rich supply of euphemisms, inviting the psychologist to treat symptoms which, masking the real complaint, he saw as diseases in themselves. Some of them were so bad, he joked, they could drive a man to drink. 'You are quite right,' he wrote to Dr Gogarty, 'catarrh makes one take far more drink than one would want without it.' Pretending to treat a variety of somatic sicknesses, from lumbago to sinusitis, while achieving a cure for alcoholism was too stern a test for even so eminent a psychologist, and these consultations came to nothing. But by the end of March 1930, on the advice of Ottoline Morrell, John was attending her doctor.

Dr Cameron, 'nerve-specialist', was fairly knowledgeable about alcohol. When drunk one day he ran over a child, and was sent to gaol. But he was a persuasive man, and many of his patients returned to him. Later, after a number of them had died, he went on to commit suicide.

John took to Cameron at once. 'I shall bless you to the end of your days for sending me to Dr Cameron,' he wrote, thanking Ottoline. 'Would that I had seen him years ago. He put his finger on the spot *at once*. Already I feel happy again and ten years younger.' The treatment involved no surrender of pride, and John's relief came from having escaped a long process of humiliation. Both he and Cameron knew that in alcohol lay the real cause of his 'nerves', but they entered a conspiracy to gloss over this truth. 'The defect in my works has been poisoning me for ages,' John reported.[637] 'It explains so much. . . .' Cameron's diagnosis was delivered with a vagueness very dear to alcoholics. John

had been 'overdrawing his bank account' and should go to a con-
valescent home where (though expensive in terms of money) he would
make a sound investment. Under this guise of tackling the rigours of a
rest cure, John allowed himself to be sent to Preston Deanery Hall, a
curious private nursing home in Northampton that had opened in 1929
and was to be closed in 1931. Here, as if by accident, he was removed
from all alcohol though permitted to equivocate as much as he liked. He
was 'travelling in the midlands' he told people, or suffering from a 'liver
attack'. In a letter to Will Rothenstein (May 1930) he explained that he
was undergoing 'a thorough spring-cleaning' because 'my guts weren't
behaving harmoniously'. Expressing her gratitude for Ottoline's 'great
brain wave,' Dorelia wrote on 5 May 1930: 'Of course J. would be
perfectly well without wine or spirits. Many a time I've managed to keep
him without any for *weeks* and then some idiot has undone all my good
work in one evening. He may be impressed this time. All the other
doctors have said the same, Dr Wright included. One can only hope to
do one's best . . .'

What Dorelia did not appreciate was that the first phase of a successful
cure must be the patient's admission that he needs special treatment
for alcoholism. This admission John was never required to make. He
stayed at the nursing home a month, and his treatment appears to have
been largely custodial – abstinence, vitamin supplements and some
tranquillizing drugs served on silver platters by footmen. 'They are
making a good job of me, I feel,' he broadcast.[638] ' . . . I am a different
being and they tell me in a week or two I'll be as strong again as a horse.'
He was allowed out with another inmate for a 'debauch of tea and toast,'
for walks to the church and, more recklessly, drives in his car. In the
absence of gypsies, he made friends with 'some nice animals', cows and
sheep mostly; while indoors there were erotic glimpses of a remarkable
young chambermaid. As always when alone, he read voraciously, but
was sometimes 'rather forlorn'. 'If I were not beginning to feel as I
haven't felt for years I *might* be bored,' he threatened in a note to Ottoline,
who had entered the nursing home herself for a few days, ' – as it is – I
am smiling to myself, as at some huge joke.'

After having 'had it out with the doctor,' John left a week earlier than
planned. 'No doubt I'll have to follow a regime for a while,' he wrote to
Dorelia. 'They say I'll be marvellously well in about 10 days after
leaving.' His after-care came in the form of a diet. 'Unfortunately I have
lost that almost ethereal quality which I had so welcomed,' he told
Ottoline (23 May 1930). ' . . . I blame the cook for giving me un-
authorized potatoes and beef steak.'

'You'd be all right if you lived sensibly,' Eve Fleming instructed
him. 'You're as strong as twelve lions by nature.' But sense of this sort,

careful, programmed, grey, was unavailable to him: 'I who always live from hand to mouth and have so little practical sense'.[639] He was awash with optimism. His strong constitution, with its more than ordinary powers of recovery, quickly misled him. Austerity, he claimed, had made him 'much more like myself' – though he had also bought a new hat which was making him 'a different person and a better'. One way or another he felt like 'a giant refreshed'.[640]

It was not long before he relapsed into drinking, and the deterioration went on. 'John is in ruins,' T. E. Lawrence noted in 1932,[641] 'but a giant of a man. Exciting, honest, uncanny.' He never became a chronic drinker – 'I was never a true alcoholic,' he admitted to Mavis Wheeler – and there were many fluctuating phases in this third period of his drinking. From time to time he went back to doctors who tried to remove him from alcohol altogether. But Dorelia's tactics worked better. She rationed him with lock and key at home, and in restaurants would furtively empty his glass into the potted plants. Without drink he tended to avoid people: 'I find my fellow-creatures very troublesome to contend with without stupéfiant,' he told Christabel Aberconway. He still retreated into the comforting womb of pubs, but 'to get alone for a bit'.[642] A solitary figure in a muffler, booted and corduroyed, he sat quietly in a corner, drinking his beer. Latterly he consumed far less, because his tolerance to alcohol had diminished. Conger Goodyear, who had been so struck by his capacity at the Saturn Club in the 1920s, was regretting by the 1940s that 'his ancient alcoholic prowess had departed,' and after a few drinks 'Augustus did not improve'.[643]

The loss of confidence, upsurges of temper, the tremulousness of his hands, his inability to make decisions – all grew more pronounced. He knew the truth, but would not hear it from anyone. But it amused him sometimes to make people connive at his inventions – then, with disconcerting relish, come out with the facts. 'I have heard of a new treatment for my complaint – it consists of total abstention from liquor'.[644] At other times he would innocently complain of Dodo that she smoked too much; or of J. B. Manson (who was dismissed as Director of the Tate Gallery) that 'the fellow drinks', deliberately slurring his words as he spoke.

He had used alcohol at first to help illuminate that visionary world from which his art took its vitality, his painter's moon. But when that dream was eclipsed, he drank to obliterate the concrete world about him. Long before the end, intermittently between bursts of renewed effort, he was drinking to destroy himself. Painting alone mattered. If he could not paint well, and if he could not disguise his inability to do so, then he would be better dead. But Dorelia, who had tolerated so much, could not tolerate this. Her watchfulness, care, relentless

programme of meals and early nights, propped him up, pulled him through – the ghost of a man he had once been.

3. ODYSSEUS UNBOUND

The first test came that summer of 1930. He had been invited by Gogarty to assist at the opening of his hotel, Renvyle House, in Connemara. Yeats was also coming, and Gogarty arranged for John to do a 'serious portrait' of him. 'I would think it a great honour,' Yeats had murmured. But standing before the mirror, he began to examine himself with some apprehension, 'noticing certain lines about my mouth and chin marked strongly by shadows,' and to wonder 'if John would not select those very lines and lay great emphasis upon them, and, if some friends complain that he has obliterated what good looks I have, insist that those lines show character, and perhaps that there are no good looks but character'.[645]

Yeats, John observed, had made the mistake of growing older. He was 'now a mellow, genial and silver haired old man'.[646] He had put on weight, seemed distrustful and, despite the vastly poetical manner, presented a diluted version of the poet John had met twenty-three years earlier. Somehow he looked less Yeats-like. Studying his own reflection, Yeats had noted 'marks of recent illness, marks of time, growing irre-solution, perhaps some faults that I have long dreaded; but then my character is so little myself that all my life it has thwarted me'. This was a development very close to John's own, explaining why critics of a different persuasion, such as Robert Graves, could dismiss them both as poseurs. John himself seems to have been entertained by Yeats up to, and beyond, the frontiers of boredom. 'Lord and Lady Longford had fetched him over to be painted,' he remembered.[647] 'The conversation at dinner consisted of a succession of humorous anecdotes by Yeats, chiefly on the subject and at the expense of George Moore, punctuated by the stentorian laughter of his Lordship and the more discreet whinny of his accomplished wife. I was familiar with most of these stories before, or variants of them: for the Irish literary movement nourished itself largely on gossip. . . . My difficulties while painting Yeats were not lightened by the obligation of producing an appreciative guffaw at the right moment, and I fear my timing was not always correct.'

It was Yeats's melancholy that John recognized, and shied away from. 'The portrait represents the poet in his old age,' Gogarty records.[648] 'He is seated with a rug round his knees and his broad hat on his lap. His white hair is round his head like a nimbus, and behind him the embroidered cloths of heaven are purple and silver. It is the last portrait of Yeats.'

Once this portrait was finished, John was free to do whatever he wanted. What he wanted was to go to Galway City, and, denouncing the Connemara weather and the atmosphere at Renvyle (too 'new and raw'), he went. From O'Flaherty's bar and from parties flowing with barmaids on and around Francis Macnamara's boat *Mary Anne*, he was eventually fished up and carried back to Renvyle where an admiring entourage had assembled – painters Adrian Daintrey and George Lambourn, and any number of painterly girls including 'the ladies Dorothea and Lettice Ashley-Cooper', and their sister Lady Alington who 'has been posing for him and does not confine it to that'.[649] To this number a beautiful American, Hope Scott, added herself, arriving in Dublin straight from Pennsylvania and being rushed across Ireland in a hearse. Her first sight of John, his beard caught by the sun, his eyes gleaming with anticipation, was at a ground-floor window. The hearse door was flung open, and nearly fainting with terror 'I fell out on my head'.[650]

John was then painting most days, Adrian Daintrey and George Lambourn acting as pacemakers. But every evening there were parties, and the effect of these began to infiltrate the day. Sometimes he was not well enough to paint, and at other times it was the girls he chose. Only occasionally, for 'relaxation', did he turn to the empty landscape. His seclusion in Preston Deanery Hall seems to have precipitated two reactions: a greater urgency in his pursuit of girls, and a crippling anxiety over his work. 'Though I was sitting, I did not lack exercise. Most of Augustus's models found themselves doing a good bit of sprinting round the studio,' recalled Mrs Scott, into whose bed John was prevented from blundering by the presence of a bolster he angrily mistook for Adrian Daintrey. But Hope Scott also noticed: 'He was enormously concentrated, at times he seemed actually to suffer over his work.'

Dorelia and Poppet, who had gone with him to Ireland, left early. To them, arranged as a compliment, he confessed his depression: 'J'étais dans un gloom affreux quand tu et Dodo êtes parties. Tu pourrais bien m'avoir embrassé . . .'

To lose this gloom in something new became the theme of this decade. He travelled to the Hebrides, to Jersey, Cornwall and, for short visits, back to Wales. Now that he no longer had the Villa St Anne, he stayed during part of two winters at Cap Ferrat with Sir James Dunn 'the friendly financier'.[651] But, like Sickert, John failed to please Dunn, who destroyed a conversation piece and promoted two portraits above stairs to his attic. 'Dunn's quarrels with John over the various portraits were furious,' Lord Beaverbrook wrote,[652] 'and much tough language was tossed to and fro, without reaching any conclusion. . . . John, however, gave as much as he got.' Though the hospitality was lavish, sapping his willpower, these fashionable pleasure grounds, full of self-

conscious holiday-makers and millionaire property-owners flying like migratory birds of prey back to Big Business after the season was over, induced a 'period of intense gloom' in John. 'I could find nothing in Cap Ferrat to excite me, and with a violent effort of will we pulled ourselves together and decamped.'

Other journeys were more productive. In October 1930 he set off with Dorelia to see a 'tremendous' Van Gogh exhibition in Amsterdam, and from there went on alone to Paris, where he did some drawings of James Joyce. 'He sits patiently,' John noted in a letter to Dorelia. A photograph of the two of them, in which John appears the more anxious to take part, shows Joyce like a blind prisoner – dark glasses, upright and foursquare, but with his head rigidly tilted back – and John a blind man's protector, gripping him, brandishing his pipe, apparelled in a pugilist's dressing-gown.[653]

All these places – France, which he loved; Wales, where he belonged; Ireland, that had once suggested great pictures to him – inhabited a past he seemed unable to evoke. What he sought now was a fresh scene, without associations. It had been such a wish that persuaded him, in December 1932, to try what he described as a 'health trip'[654] to Majorca. But there had been rain, and heavy air. By nature the island might have been what he was looking for, but 'big operations' were going on 'with screeching rock-drills and a general banging of machinery'. The developers had arrived; he was too late. Feeling 'like death' he returned with the news that Majorca was 'not paintable'.[655]

Back in the mellow atmosphere of Fryern Court, he racked his brains, consulted maps, looked up trains and boats, and, retrieving a plan from the spring of 1912, settled on Venice. His last fortnight in Italy, a tiny trigger movement releasing extraordinary artistic forces, had been nearly twenty-two years ago. Now, entering at a different part, he seems to have tried a similar experiment. With him travelled his daughter Vivien, aged eighteen, 'to keep an eye on the money'.[656] John, 'determined to see all the famous paintings', would go off on expeditions to Ferrara and elsewhere, spending hours in churches and galleries. But though there was much to enchant him, it was the pressure of people once again and not of paintings that predominated. On landing on the steps of his hotel the first day, he had been hailed from a passing gondola by Georgia Sitwell. From that moment, word getting round, he was sucked into a life of Firbankian excess.

The most serious encroachments came from Vivien's admirers, whom he took elaborate steps, on behalf of them both, to avoid. 'We are caught up in the maelstrom of Venetian society,' he wrote to Dorelia (29 August 1933). ' . . . the place is full of bores, buggers and bums of all kinds. Vivien is greatly in request and there are various optimistic

members of the local aristocracy on her tracks. Conditions are not favourable for painting and money goes like water, so I think an early return is indicated.' Much of this time Vivien was in tears, and John, though very protective, had sudden fits of anger, passionately complaining that her clothes were *too smart*. 'The air of Venice was getting me down,' he acknowledged.[657] 'I became more and more indolent . . . it was the people I tired of most. My God, what a set! . . . I was seeing less of Vivien . . . but at last even my daughter agreed it was time to depart.'

He had done no painting. The truth that had eluded him lay in his dreams, which no longer had the power to overwhelm the emotional complications of life. The mother-and-child obsession gave way before a father-daughter possessiveness; the simple life evaporated in the heat of social life. Like some new Ulysses, he had unbound himself from the mast, plugged up his ears, and did not know from where the sirens called him, or if they called at all. Now more than ever, since his life was on the wane, since he could no longer brush aside as fanciful the fear of a fading talent, a yearning for new distant scenes, a craving for freedom, the impulse towards flight, filled him. They filled him, but he could not act on them. Like a giant ship, stranded in shallow water, its propellers grating in the air, he stayed.

But one last voyage awaited him – had awaited him, by the time he embarked, for twenty-six years. 'I think Jamaica would be a nice place to go and work,' he had written to Dorelia. That was in September 1911. 'I think of going to Jamaica,' he insisted in a letter to Vera Stubbs on 4 June 1929. By 1936, the effects of renewed drinking had led him to consult an occultist who, responding to the challenge, proposed casting John's horoscope. This exercise led to the prediction that he would turn up soon in one of the British Colonies. 'I would have been sorry to leave the astrologer's forecast unfulfilled and his prophetic gift in dispute,' John wrote. ' . . . I decided [on] a visit to Jamaica.'

By this time Dorelia was set on joining the adventure. With them went Vivien, Francis Macnamara's daughter Brigit now 'une grosse blonde . . . très aimable'[658] and Tristan de Vere Cole, also blonde, but aged two-and-a-half, who 'imagines himself to be the Captain of this ship'.[659] The tropics suited John. Though the island was 'altogether too fertile', parts of it reminded him of North Wales. The internal conflict he carried with him wherever he went externalized itself in Jamaica very satisfactorily. The enemy were the bridge-playing colonials, golf club members, and the management of the American United Fruit Company. His allies were the natives, dusky beauties, with complexions as various as their fruits. There were the same risks as in Venice, but he controlled them better. 'We are in some danger of being launched into the beau

monde of Jamaica. Nobody believes I am serious when I tell them I am only interested in painting the coloured people,' he wrote to Mavis de Vere Cole (10 March 1938). ' . . . I shall have a mass of work done before I am finished'. To gain extra time, Jamaica being so expensive, he dispatched 'the females and Tristan' back to England after a month, and continued working alone until the rains came six weeks later. In *Chiaroscuro*, where he devotes over ten pages to this time,[660] John records that he felt 'anything but satisfied' with his painting. Like gypsies, the natives were difficult of access. In a perfect world he would have built a 'house of mud, mahogany and palms' and lived there as one of them. Instead – the ultimate degradation – he was taken for a visiting politician. Yet, the place 'suits me and stimulates me', he decided.[661] 'I am painting with a renewal of energy quite remarkable and will not cease till I have accomplished much.'

He could have accomplished more. 'With the rain a great gloom descended upon me, almost depriving me of volition.' He returned on a banana boat to Fryern and struggled to pursue these pictures before the dream slid behind the invisible screen of habit and impaired memory. His portraits of 'Aminta', 'Daphne', 'Phyllis' and many others, which had puzzled the subjects themselves on account of their not appearing white, delighted London when they were exhibited at Tooth's Gallery in May and June 1938. The show, Dudley Tooth noted in his diary, 'has been a tremendous success, nearly everything having been sold at prices between £200 and £550. Among the purchasers were J. B. Priestley, Thelma Cazalet, Mrs Syric Maugham, Vincent Massey, Oswald Birley, Sir Lawrence Phillips and Stafford Cripps, the announcement of whose purchase to his horror was in the *Evening Standard* to-night.'

The most splendid celebration of these Jamaican pictures was sounded by Wyndham Lewis in *The Listener*:[662] 'As one passes in review these blistered skins of young African belles, with their mournful doglike orbs, and twisted lips like a heavyweight pugilist, one comes nearer to the tragedy of this branch of the human race than one would in pictures more literary in intention, such as Gauguin would have supplied us with . . .

'Mr John opens his large blue eyes, and a dusky head bursts into them. His large blue eyes hold fast the dusky object while his brushes stamp out on the canvas a replica of what he sees. But what he sees (since he is a very imaginative man) is all the squalor and beauty of the race – of this race of predestined underdogs, who have never been able to meet on equal terms the crafty white man or the even more crafty Arab.

'In describing Mr Augustus John's assault upon these Negro belles – his optical assault, as his large blue eyes first fall upon them in Jamaica – I was indicating what is, in fact, a good deal his method of work.

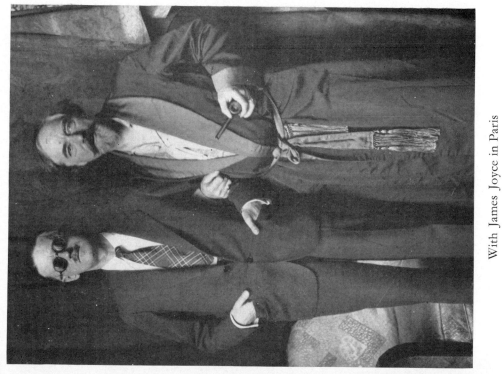

With James Joyce in Paris

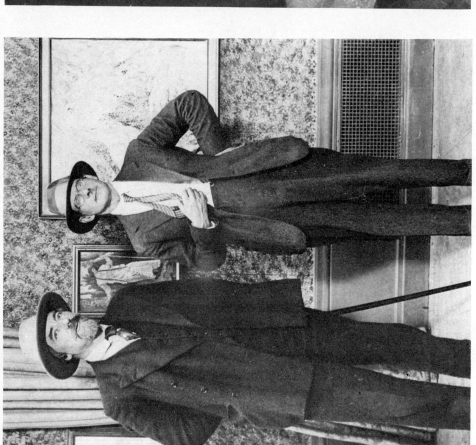

With Sean O'Casey in London

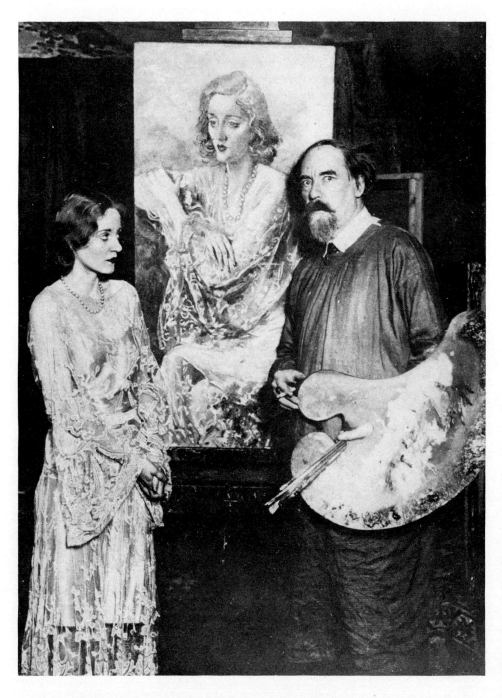

Movie queen in oils: Tallulah Bankhead and John (Keystone Press photograph)

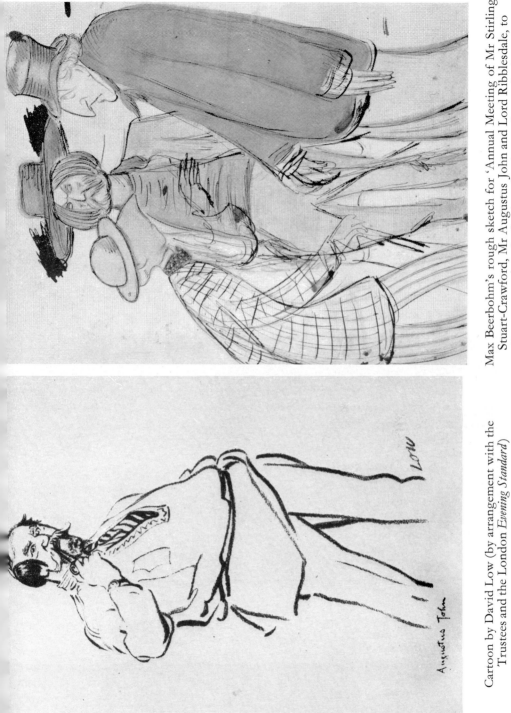

Cartoon by David Low (by arrangement with the Trustees and the London *Evening Standard*)

Max Beerbohm's rough sketch for 'Annual Meeting of Mr Stirling Stuart-Crawford, Mr Augustus John and Lord Ribblesdale, to protest against the fashions for the coming spring', 1909

Forty years on: Augustus John in 1915
and (photograph by Cecil Beaton) in 1955

Nature is for him like a tremendous carnival, in the midst of which he finds himself. But there is nothing of the spectator about Mr John. He is very much a part of the saturnalia. And it is only because he enjoys it so tremendously that he is moved to report upon it – in a fever of optical emotion, before the object selected passes on and is lost in the crowd.'

These Jamaican pictures, constructed rather as a modeller builds up his clay to make shapes, represent the most vigorous body of John's work during the last twenty-five years of his career. There were other fine pictures – the occasional flamboyant flowerpiece, or a portrait of someone he loved or admired – but the general drift was downwards. He sought new subjects to avoid comparison with his past self, and bring about a rebirth of his talent. In 1929 C. B. Cochran had daringly proposed his name for the important second act of Sean O'Casey's* play *The Silver Tassie*. On Cochran's suggestion, and without her husband's knowledge, Eileen O'Casey called on John at Mallord Street like 'an angel rushing in where a devil feared to tread'.663 There was, she noticed, 'a debutante trying to get in, ringing the bell, appearing at various windows'. John ignored this as they talked over the project. The play was fine, but he had qualms. 'I have never done one before; I don't really think I could.' He was, Eileen remembered,664 'extremely shy, though as ever courteous and complimentary, for he liked good-looking women. This helped me to plead my cause.' At the end of the afternoon, she asked: 'Have I persuaded you?' 'I'm afraid you have,' he replied.

Everything had gone with surprising ease. 'I have the Silver Tassie with me,' he wrote from Cap Ferrat on 3 February 1929, 'and I don't see much difficulty about the second act'. O'Casey had described this act in detail: a War Zone, its 'jagged and lacerated ruin of what was once a monastery', the life-size crucifix, stained glass window, and great howitzer with 'long sinister barrel now pointing towards the front at an angle of forty-five degrees'. In a note he had added: 'Every feature of the scene seems a little distorted from its original appearance.' All this approximated closely to what John had wanted to depict as a war artist and, given this new impetus, he turned to his sketchbooks of

* John had met O'Casey through William McElroy, a coal merchant, impresario and part-horse-owner ('the left hind leg, I think it was'). He painted two portraits of O'Casey in 1927, one now in the Metropolitan Museum of Art, New York, the other which he gave to O'Casey as a wedding present. 'Blue-green coat, silver-grey sweater, with a gayer note given by an orange handkerchief flowing from the breast-pocket of the coat,' O'Casey described it; 'the face set determinedly in contemplation of things seen and heard, the body shrinking back right to the back of the chair, as if to get further away to see and hear more clearly; a sensitive and severe countenance with incisive lines of humour braiding the tightly-closed mouth'. It is now in the collection of Eileen O'Casey.

France and produced a set that was as overpowering to the audience as
to the scene-shifters.* O'Casey was delighted by the church window and
sinister gun, and Bernard Shaw pronounced 'the second act a complete
success for both of you'.[665]

John too felt excited by what seemed a completely new arena in which
to exercise his talent. He was already hot with plans for designing the
sets of Constant Lambert's 'Pomona' for the Camargo Society, when he
succumbed to Preston Deanery Hall. In the following years there were
many rumours of his re-entry into the theatre, but all came to nothing
until, in 1935, again at the suggestion of Cochran, he agreed to do the
scenery and costumes for J. M. Barrie's *The Boy David*.

The changes that had overtaken John in the seven years between the
two plays are very clear. On 25 October 1935, co-inciding with an
announcement in *The Times*, Cochran sent John a letter confirming the
details of their arrangement. Less than two months later, on 13 Decem-
ber, he was sending out an S.O.S. for Ernst Stern, who had been the
chief designer to Max Reinhardt, and was the most professional artist
in the theatre of his day. With the exception of Barrie, everyone in the
production had taken to John at once. 'John, in his extraordinary
innocence of the theatre, was never too proud to defer to their ex-
pertise,' recorded Malcolm Easton.[666] 'On them, and on all Cochran's
brilliant band of technicians, he smiled benevolently. From the benevo-
lence, however, proceeded few practical results. . . . John's efforts to
envisage Barrie's characters rarely got further than the upper half of the
body. When it was a question of the precise cut of the skirt of a tunic,
exact length of a cloak, or clothing of the legs, it seemed that, like
Byron, he *never looked so low*'. These tactics had driven the needlewomen
to despair, given Barrie a high temperature and aggravated Cochran's
arthritis for which, at rehearsals, he wore a splint. It was to everyone's
relief, John's included, that Stern took over these costumes.

To Barrie's irritation (he retired to bed shortly afterwards) John had
depicted Bethlehem as a Provençal village, decorated with terraces,
boulders and cypress trees. The principal set, and John's main contri-
bution to the play, was the Israelite outpost of Act II scene ii. For this
he provided 'a dark and lowering sky, with immense rocks in the fore-
ground, from which descended a slender waterfall, giving rise to the

* For whom it was too heavy to move. The set was designed, as an oil painting,
on canvas stretchers. 'John's scene was an exterior with a derelict church, with a fine
stained glass window,' Alick Johnstone remembered. 'He designed this originally
on cartridge paper . . . and I suggested he should do it on a linen panel in thin oils
or aniline dye; which he did, and it was an enormous success, and, as it was in scale
to the scene, was inserted in the church construction'. *Apollo*, October 1965, p. 324
n. 3.

brook from the bed of which David chose the pebbles he was to sling at Goliath'.[667] Although attending a few rehearsals – 'an impressive figure splendidly sprawled across two stalls'[668] – he did not travel up to see the opening night at Edinburgh. The greatest problem that night had been how to force the actors on and off stage. 'Having delivered their exit line,' John Brunskill, the scenery builder, remembered, 'they were forced to clamber over a number of rocks before getting off stage.' By the end of the scene the stage was crowded with these bruised and scrambling actors attempting to reach or retire from their lines. In a desperate move to halt these gymnastics, Cochran again called on Stern, this time to re-design the set. Numbers of rock-units were scrapped, the sky replaced with a white canvas cloth, the inset scenes altered and, worst of all, John's waterfall – 'how charmingly it glittered and fell!' – dried up. Stern, who respected John, describing him as 'the typical painter, and we understand one another', hated this work which went against the 'artists' freemasonry'. Such was the guilt that no one dared to tell John of the alterations. He arrived at His Majesty's Theatre for the London premiere on 12 December 1936 happily ignorant of the fearful mutila-tions to his work.

The change to Act I had been minimal, and John sat through it un-disturbed. But when the curtain rose on Act II, he rose from his seat, hurried from the auditorium, and stayed for the rest of the performance in the bar, pondering this betrayal. 'This play was a complete flop from the start, and I wasn't sorry.' But later, having been handsomely paid by Cochran, he concluded: 'It dawned on me too late that I had neither the technique nor the physical attributes for this sort of work, apart from the question of my artistic ability.' Stern's final comment, which goes wider to achieve unconscious irony, corroborates this: 'How I envy John, as he stands in front of his easel, palette and brushes in hand.'

One advantage of working in collaboration is that it provides people towards whom one may extend the finger of blame. Alone with his easel, palette and brushes, John could only point to failures in geo-graphy, to weather and viruses. In June 1935 he borrowed Vanessa Bell's studio; by November that year he had moved into Euphemia's house at 49 Glebe Place (later owned by Gerald Reitlinger and by Edward Le Bas); then in March 1938 he rented the 'cottage' in Primrose Codrington's estate, famous for its garden, at Park House in South Kensington. From these places he came and went, tampering with their lighting then leaving them for good. In 1940, when bombs began falling on London, the top windows of Park Studio, fantastically illuminated in the night sky, were smashed, and John moved on to 33 Tite Street* in Chelsea where he rested comfortably throughout the blitz.

* Where Whistler had lived during 1882–5, and Sargent between 1887 and 1915.

'My life seems to get more and more complicated,' he wrote wonder-ingly.[669] The multiplicity of studios reflected this confusion. In 1936 Dorelia had rented 'for the large sum' of £12 a year, the 'Mas de Galeron', a little farmhouse 'au ras des Alpilles' behind 'les Antiques' at St. Rémy-de-Provence.* 'There are 3 large rooms and one smaller one,' Dorelia wrote to him. 'One would make a good studio for you. It is quite isolated with a rather rough track . . . There are grey rocks on one side, vines and olives and an immense view from the north . . . Why not come down?'

John went down for the first time in September 1937 and, against his worst fears (he had imagined Dorelia might be mad) loved it. The house was built into the hillside, a little grey old building, its floors uneven, with small surprising rooms turning up round corners and down steps. Outside a hot aromatic terrace, flanked by pine trees, overlooked a field of stones, olives and euphorbias. And just above them ran the rocky Alpilles, dotted with green scrub and the spiky plumes of cypress trees – 'an endless sequence of exquisite landscapes'.[670] Anyone who knows and likes this landscape will enjoy John's paintings of it, recognize how well he has observed it. Yet these paintings lack the inspirational quality of his early landscapes, and he confessed to his neighbour there, Marie Mauron, that 'ces Alpilles attendent encore *leur* peintre – mais ce n'est pas moi. Regardez! Ces jeux de gris, de bleu, de rose, ces touffes de plantes aromatiques, en boules, taches, traits sur le roc de toutes couleurs insaisissables, me désespèrent'.†[671]

The next year he went again, and once more in July 1939 with Dorelia, Vivien, Zöe and Tristan de Vere Cole, intending to stay there three months. 'Il n'y aura pas de guerre,' Derain scoffed as the two artists sat peacefully drinking on the terrace of the Café des Variétés and watching the soldiers and horses crowd through the streets. 'C'est une blague.' But the clouds of war thickened round them and it became, John sus-pected, 'necessary to make a decision'. It was eventually Dorelia, res-ponding to urgent telephone calls from Poppet, who decided. At the last moment they set off, John gaining maximum delay with the aid of dictionaries, by sending a very long telegram to England in correct French. 'C'est la guerre! C'est la guerre!' the farmers cried, as they fumed and thundered through the villages in a furious convoy of two cars. At Orléans they put up for one night, and while Dorelia and

* Now re-named 'Mas de la Fé', it has been taken over by Alphonse Daudet's grand-daughter-in-law.

† But, Marie Mauron went on, 'ce désespoir-là éclatait d'un grand rire car, lui, savait qu'il recommencerait une toile le lendemain. Avec la même obstination, le même 'désespoir', le même enthousiasme, le même amour, vif et sans amertume, rancune ou vanité devant, tout de même de magnifiques réussites!'

Tristan slept, John led out Vivien and Zoë to a night club run by two spinsters from Kensington, and full of gay girls. 'And what do you do, sir?' one of them asked John. 'I am a ballet dancer,' he explained quietly.

Le Havre, which they reached on 2 September, was in confusion. There were no porters, the last boat was preparing to leave and passengers were told they must abandon their cars and only take what luggage they could carry. John's car had now run dry of petrol and come to rest on a rival passenger's baggage. Money changed hands, and somehow the cars were hauled on board. John was the last to embark, tugging a large travelling rug out of which splashed a bottle of Chateauneuf du Pape.

They drove back to Fryern. Next morning it was work as usual. John was painting Zoë in the old studio in the orchard. During a rest, he switched on the radio and they listened to Chamberlain's speech. Then he turned it off and without a word continued painting until the bell rang for lunch.

4. HIS FIFTIES, THEIR 'THIRTIES

'The disastrous decade', Cyril Connolly has called the 1930s.[672] For John, if in no other way a 'thirties figure, it was disastrous – 'the worst spell of my bloody life,' he called it.

The world around him, as it plunged towards war, had become horrific, and in its place he had created little. His artistic philosophy of 'meaninglessness' was not supported, in the abstract sense, by a grasp of form, and his paintings, though skilful, convey a curious emptiness. Once the early lyricism had faded, his flashing eye, searching for something fresh, found nothing on which to focus. The happy accident, travelling through the dark, came to him less often. And beyond this dark, lending it intensity, rose the shadow of Hitler out-topping the more substantial shape of Mussolini. To such sinister circumstances John's pretty girls, wide-eyed and open-legged, his vast unintegrated and unfinished compositions, his vacant landscapes appeared irrelevant.

Yet he worked hard. Reviewing his exhibition at Tooth's in 1938, the *Times* critic had expressed 'admiration for what is achieved and regret, with a touch of resentment, that so great a natural talent for painting, possibly the greatest in Europe, should have been treated so lightly by its possessor. . . . This is not to accuse Mr John of idleness. . . . As everybody knows there is a kind of industry which is really a shirking of mental effort . . .'[673]

In the opinion of David Jones, who admired John, it was the company he kept that finally ruined him: in particular 'that crashing bore' Horace de Vere Cole. John had known Cole since before the First

World War. He was a commanding figure, with needle blue eyes, a mane
of classic white hair, bristling upswept moustaches and the carriage of a
regimental sergeant-major. This exterior had been laid on to mask the
effects of having only one lung, a shoulder damaged in the war and a
considerable deafness. Fighting pomposity was what he claimed to be
doing; but his real enemy, like John's, was actuality. What John liked
about Cole was his way of repunctuating life with absurdity, so that it
no longer read the same. His whoops and antics were often better to
hear about, however, than be involved in. When John learnt how Cole,
dressed as 'the Anglican Bishop of Madras', had confirmed a body of
Etonians, he laughed out loud. But when Cole took some of John's
drawings, sat in the street with them all day in front of the National
Gallery, and, having collected a few coppers, came back with the
explanation that this was their value on the open market, John was less
amused. Cole liked to ruffle John's feelings 'for I think he gets too much
flattery'. Rivalry and rages interrupted their friendship, sometimes with
violence; but the bond between them held. John used Cole as his court
jester; while Cole 'seemed to have no friends – except John,' A. R.
Thomson noted. 'People who knew him avoided him.'

In the autumn of 1926 they had set out together on a walk through
Provence. 'Horace was a famous walker in the heel and toe tradition,'
John recorded,[674] 'and, with his unusual arithmetical faculty, was a great
breaker of records, especially when alone.' Their expedition quickened
into a fierce walking-match and, in the evenings, contests for the atten-
tions of village girls. It was an exhausting programme which they at
last agreed to cut short by taking to a fishing-boat. A. R. Thomson, who
joined them for part of this competitive tour, remembers,[675] 'in the bright
moon, Horace flanked by John and I marched along the bridge over the
Rhone – swinging arms, hats tilted, cigars. John's swaggers were natural,
not put on. I watched Horace impersonating John. His plenty white
hair, busy moustaches, fierce eyes. He was "Super-John".' A caricature
that Thomson drew, 'John and Super-John', catches much of their
pantomine relationship – John leading, Cole an extravagant shadow
behind, mocking, but needing John to parody.

It was a fantasy-friendship they enjoyed, part of a make-believe life;
and when it collided with the actual world, it exploded. The course for
this collision had been set early in 1928. It was this year, in the Café
Royal, that Cole had met Mabel Wright. 'Mavis', as she was always to be
called, was nineteen, a strikingly tall girl with big brown eyes, curly
blonde hair and a fine and friendly figure. About her background she
was secretive, confiding that her mother had been a child stolen by
gypsies. In later years she varied this story to the extent of denying, in a
manner challenging disbelief, that she was John's daughter by a gypsy.

In fact she was the daughter of a grocer's assistant and had been at the age of sixteen a scullery maid. In 1926, clutching a golf club, she arrived in London and, despite her lack of education, took a post as governess to the children of a clergyman in Wimbledon. A year later she had become a waitress at Veeraswamy's, the pioneer Indian restaurant in Swallow Street.

John was one of those that night at the Café Royal who had witnessed Cole break through a circle of men and make an assignation with Mavis. He was not pleased at being out-John'd, but, despite 'our pitched battles',[676] the romance persisted. Two years later, when Cole obtained a divorce from his first wife, they married. It was like a practical joke that misfired, and from that time on everything began to go wrong. But for Mavis it was an extraordinary leap upwards along her altitudinous career. On coming to London she had learnt the astonishing power of sex. This was her gift, her talent. Already a winner of beauty contests, she was naturally affectionate and liked to break the polite distance between people by touching them. But sex, she felt, was not enough; for real security she must acquire education, and she selected Cole to play Professor Higgins to her Eliza Doolittle. To have married him was a triumph, for was he not an Old Etonian and a de Vere, a cousin of Neville Chamberlain, rich, cultivated, famous?

Cole, now fifty and a sufferer from what John called 'pretty-girl-itis', was very possessive of his twenty-two year old wife; but Mavis had no wish to be restricted, and their marriage was full of plot and tension. Under this strain, Cole's antics grew manic. After a hard day's joking, he would set out late at night with bell, candle and shroud to haunt houses. By an unhappy perversion, he had begun to interpret whatever he misheard to his own disadvantage, and reacted excessively. Then, a last bad joke, he lost almost all his money in an unlikely Canadian venture. Reality, which had been leaking into his life for so long, now overflowed. To struggle free, he left Mavis and fled abroad.

It was at this moment that John stepped forward to help – himself. 'You must be frightfully lonely I fear,' he sympathized with Mavis. That year, 1934, she became his mistress and on 15 March 1935 she gave birth to a son, Tristan Hilarius John de Vere Cole. 'What a whopper!' John exclaimed in delight. One thing was certain: Horace, disconsolately exiled in France, could not have been Tristan's father. John himself immediately assumed that role. In a letter to Wyndham Lewis, he explained:[677] 'Tristan is not Cole's son, though born in wedlock . . . at my last meeting with Cole, before he departed for France, he stung me for £20 which, of course, he never repaid. So when Mavis deserted him after four years of matrimonial bliss, I felt no compunction in taking it out in kind.'

But the initiative was less with John than this suggests. Though Mavis was not intelligent, she was shrewd. Her attractions for him were glaring: she was his 'sweet honey-bird', sexy, eye-catching, easy-going. Round those of whom she was fond she spun a protective aura, from which John specially benefited. She brought a zest to his life, made him feel young and vigorous again. He sent her 'tasty poems' about orgasms, did drawings of her with legs kicked high and wide. 'She is really a good wench,' he urged Dorelia, 'and has a good deal of *gumption*.' But Dorelia saw a different Mavis: someone who was using her sex, like honey, to lure John away from Fryern so that she might marry him. One of the guests at Fryern, Andrea Cowdin, remembers Mavis playing on the floor with Tristan, rolling about and laughing and 'being delightful', but always with an eye on John who sat there gloomily without a word or sign. John's letters to Mavis and Dorelia indicate that, if only for the sake of his 'nerves', he wished them to be friends. But, though outwardly polite, they recognized more clearly than he their opposing interests.

Mavis was not perhaps 'mysterious' but she could be elusive. She would disappear down to her cottage in the West, or suddenly stop answering letters. In her absence John became an old man. Sometimes there were weeks of suspense, and 'I cannot bear it'. He knew she had affairs with other men and would imagine her in bed with all manner of commercial travellers from Birmingham, Manchester and Sheffield. 'Try to hold yourself in till our next,' he would beg. Then she would return to London, generous, beautiful, irresistible; the sun would shine again and he was young.

Though Mavis pulled hard, and John wobbled a little, she could not pluck him from Dorelia. By 1936 she had switched tactics. Putting Tristan into a children's home, she went down to Cornwall from where she announced her impending marriage to a man she called 'the Tapeworm', six feet seven inches tall who 'looks as if he has come from another planet'.[678] Dorelia's response was an offer to bring up Tristan at Fryern. John was overjoyed.*

Because of Mavis's passionate indecisiveness, John decided legally to adopt her son. 'Are you clear about adopting Tristan?' he asked Dorelia (September 1936). She was. But Mavis's powers of incoherence were such that no legal formula could be devised to contain them, and when

* 'Mavis was somewhat hysterical and required a good deal of calming down. I think she'll probably marry this man who seems very devoted but she won't tell me anything decisive. I think it's very angelic of you to offer to take charge of Tristan. Mavis has several times asked me if you would. I said I wasn't going to ask you to do any such thing. I don't know if she's really prepared to part with the child.' John to Dorelia (undated).

Tristan went to Fryern in 1937 it was under a wholly informal arrange-
ment. Mavis herself was now free to cast her eyes on a target even
loftier than the tape-worm. In the summer of 1937 she had gone one
day to Maiden Castle, where the archaeologist Mortimer Wheeler was
working. 'I was wandering about at the eastern end of Maiden Castle
when I saw a curious entourage on its way towards me,' Mortimer
Wheeler recalled.[679] 'It consisted of Augustus John and his party, in
the odd clothes they always wore. Mavis was skipping in front on long
legs; very distinctive that skipping walk of hers – I was greatly taken
with her straight away. All work stopped as the cavalcade arrived.'

By the following year Mavis had elected to marry Mortimer Wheeler
and let him 'run in harness' with John. 'It will be like an amputation to
let you go,' John protested. '. . . I felt you were part of *me*.' He did not
accept this operation without a fight. Seeing himself *in loco parentis*, he
simply declined to give Wheeler his consent: 'You must wait. I haven't
finished with her yet.' On one occasion, reduced to 'a mass of nerves
and brandy' by Wheeler's 'grinning mask', he most alarmingly lost his
temper, writing to apologize next day. 'I was in a wrought-up state and
have been for some time. . . . Do write and say you will be friends
again.' In a desperate moment he had challenged his rival to a duel. 'As
the challenged party,' Wheeler related, 'I had choice of weapons. Being
a field gunner I chose field guns.'* John, declaring this to be 'very un-
gentlemanly conduct' bowed to the inevitable, and, putting the best
face on it, advised Mavis to accept this 'distinguished personality' as her
husband. They were married in March 1939,† occasioning a brief inter-
lude in John's relationship with Mavis.

But there was an awkward corollary. In many of his letters to her,
John assures Mavis that Tristan is 'full of beans', 'in the pink', 'incredibly
beautiful' and 'eating well'. 'Don't disturb yourself,' he urges her. 'Dodo
seems absolutely stuck on him'. But Mavis was never reconciled to
leaving Tristan at Fryern, and one day in January 1941 she abducted
him. John at once sent off an indignant letter protesting at this 'Rape of
Tristan' to Mortimer Wheeler who, in his tactful reply (31 January
1941) explained: 'Mavis has always regarded Fryern Court as her real
home and you and Dodo as an integral part of her life. This little
episode is entirely subordinate to that overwhelming factor. . . . The
fact is, Mavis does not want to feel that T's destinies are completely
beyond her control and that she is merely a name in the visitors' book.'

'The Battle of Fordingbridge', as Wheeler called it, was quickly over.

* He later attributed this procedure to a speech made in parallel circumstances by
Shaw's Captain Bluntschli: '. . . I'm in the artillery; and I have the choice of
weapons. If I go, I shall take a machine gun. . . .' (*Arms and the Man* Act III).

† John and A. P. Herbert were witnesses.

John and Dorelia had no legal rights and in any case Tristan continued
to spend a number of his holidays at Fryern. 'The incident is closed,'
John assured Mavis. Almost at once they were back on friendly terms.
But he remembered – this and much else that he tried to drink into
oblivion.

'Soon I will be ready to paint you off in *one go*,' John had written to
Mavis. 'That is what I live for.' But though he drew and painted her
often, this 'supreme picture . . . which I know would come off at the
right time' never did come off. In taxis or at dinner parties, on almost
any occasion, she rejoiced in flinging off her clothes and would strike
provocative attitudes towards John who, when severe, restricted his
drawing to her face. In Cornwall or Provence he led her out into the
country, posed her achingly against some expert expanse of rocks and
trees, then painted. But the finished canvases were of landscapes un-
tenanted by any figure. Yet he needed her company: she gave him the
'authentic thrill'. His feelings for her were intensely sentimental.
Though Mavis could disguise the fact, the pictures proclaim it: he was
losing his sexual drive. At the beginning of the war he was in his sixty-
second year. His age, the psychological uncertainty of his work, and
alcohol which 'provokes the desire and takes away the performance'
had left their mark. His vigorous letters to Mavis, with their characteris-
tic signing off, 'Yours stiff and strong', urge a degree of potency that
only she could summon up. 'I drink but I am not a "boozer". I have
affairs of the heart but I do not womanize,' he wrote in a letter to D. S.
MacColl[680] (14 January 1945). 'Drinking helps (for a time) to overcome
the horrors of a world into which I rarely seem to fit; love renews (alas
for a time) the divine illusion of beauty. By which you may perceive that
my soul is sick.'

This sickness was a pessimistic sentimentality replacing the lyrical
romanticism of his early years and the 'hectic sexuality' of the 1920s.
His portraits of women between the 1930s and late 1940s are sweet and
feeble echoes of eroticism. Far better were his paintings of exotic
flowers to which he responded visually as if they were girls, but which
did not involve his feelings on such a disastrous scale.

Mavis was the chief mistress-model of these years, but his agitation
over her became the reason 'why I haven't had much success painting of
late'. Other models to whom he escaped were sometimes less unsettling.
Of these, two were daughters of his old friend Francis Macnamara:
Brigit (who was briefly engaged to Caspar) and Caitlin (who was to
marry Dylan Thomas). Brigit was the better model. Though John
depicted her as a fit companion for Falstaff,[681] she was a sensitive person.
She had an instinctive sympathy with John, independent of words. 'An

intonation, a pause, a movement from Brigit's . . . hand was answered by Augustus with a smile that started slowly all over his face and faded in his beard. . . . In this shorthand of long term sympathy, the eavesdropper might catch a hint or two, yet the depth of the meaning was a secret kept between them.'[682] She saw the terrifying glare, the tremendous male arrogance: but she saw through them to someone more interesting. He would pounce on girls, but work always came first. Even at sixty, she remembered, his body was good – well-shaped hands and feet, narrow hips, small bones.

Caitlin, her sister, remembers something else. She had been in love with one of John's sons, but this first passion was not returned. 'Almost her second,' according to Constantine FitzGibbon,[683] 'which was returned, was for Augustus himself, though he sometimes became confused and thought she was his daughter as well.' Later she denied this passion for John, claiming only one 'luridly vivid memory . . . pure revulsion . . . and inevitable pouncing . . . an indelible impression . . . of the basic vileness of men'.[684]

She was, John noted, 'apparently in a perpetual state of disgust with the world in general'.[685]

It was John who introduced Caitlin to Dylan Thomas. In Constantine FitzGibbon's version he had met Dylan at The Fitzroy Tavern and it was at another pub, The Wheatsheaf, that he brought the two of them together: 'Come and meet someone rather amusing.' Caitlin, 'quite mute',[686] nervously approached, Dylan at once proposed and 'within ten minutes'* they were in bed together, spending several days and nights at the Eiffel Tower and charging everything to John's account. But however 'deaf and obtuse' John might be, Caitlin charmingly explained, there was a danger he might find out. So they parted, Dylan for Cornwall, she to Hampshire to continue her energetic sittings.

By means of an elaborate plot they met again in the summer of that year, 1936, in Richard Hughes's roofless castle at Laugharne, Dylan in the interval having contracted gonorrhoea. In his *Life of Dylan Thomas*, apparently working under difficulties (he appears repeatedly to misspell his own name), Constantine FitzGibbon gives an account of this episode as part of the turbulent relationship between Dylan and John. Handicapped, perhaps, by a rather erratic primary source and by a dislike for John,† FitzGibbon produced a story aimed at demolishing John's own erroneous account of Dylan Thomas in *Finishing Touches*. In the main I have relied on a third version, that of Richard Hughes,[687] who was not emotionally involved with any of them.

* Dylan's own estimate, cheerfully exaggerated.

† 'I hardly knew him and quite frankly neither liked him as a man nor admired him as an artist'. Constantine FitzGibbon to the author, 17 November 1968.

Caitlin, Hughes remembers, was very pretty and gauche and, though twenty-two years old (she concealed her age from Dylan), impressed him as about 'the equivalent of eleven years of age'. She arrived with John in July and during their stay there was much giggling and kissing in the passages, and no visible evidence, at least to his eyes, of Caitlin disliking this. One morning John (possibly at Caitlin's prompting) suggested that the Hugheses invite Dylan (who had written to say he was 'passing awfully near Laugharne') over for lunch. He came, and stayed the night. Dylan and Caitlin, overacting their parts, gave no sign of having met before.*

John was judging a painting competition at the National Eisteddfod in Fishguard, and motored there next day in his six-cylinder Wolseley, 'the Bumble-Bee'. Dylan and Caitlin went too; but when John arrived back at Laugharne that night he was alone with Caitlin who looked, Hughes noticed, 'like a cat that's been fed on cream'. 'Where's Dylan?' Hughes asked. 'In the gutter,' drawled John, slurring his words horribly as he lurched in. 'What happened?' 'I put him there. He was drunk. I couldn't bring a drunk man to a house like this.'

It transpired that at Carmarthen there had been a fight. All day John had felt irritated by Dylan and Caitlin's public love-making. It may also have been that, knowing of Dylan's gonorrhea, he felt morally justified in protecting Caitlin. At Carmarthen, Dylan had insisted that John drive him back with Caitlin to Laugharne. But John refused and, tempers rising, they raised their fists in the car park. In *Finishing Touches* John pleads that 'he and I never came to blows'; but this can have been literally true only if none of Dylan's wavings in the air qualified as blows, and John needed one good punch to end the battle: which seems probable.

The following morning at Laugharne, just as John was stepping outside into the sunlight, Dylan turned up, and the stage was set for a spectacular farce. There were three doors into the house, and no sooner had Dylan gone out by one of them than John, judging it to perfection, would appear through another. Though the plot was confused, a tremendous atmosphere of melodrama built up. Caitlin was on stage for most of the performance, but when the exigencies of the theatre demanded it, she would exit, while the two men made their entrances. The timing throughout was remarkable, and there were many rhetorical monologues in the high-flown style. To the spectators, wiping their

* John, however, seems not to have been taken in by this pantomime. In a letter to Dorelia (20 July 1936) he wrote: 'I drove down to Wales taking Caitlin who wanted to see Dylan Thomas. We stayed at Laugharne Castle and the next day by a strange coincidence Dylan turned up out of the blue! . . . I drove them to Fishguard, Caitlin and Dylan osculating assiduously in the back of the car.'

eyes, the outcome appeared uncertain. But a year later, after a spell in the Charing Cross Hospital, Caitlin married Dylan at Penzance registrar's office; and when their first child was born, John and Richard Hughes were godfathers.

They had then moved, the Thomases, to Laugharne and, as neighbours of Richard Hughes, were said to feel 'nervous' of John's visits there. John too was nervous. Sometimes he put up at their house, Sea View, for a night or two 'in circumstances of indescribable squalor'.[688] It had been to relieve this austerity that he gave them some furniture, including 'a wonderful bed'. At night, when he went up to his room, Mervyn Levy remembered,[689] John 'used to stuff ten-shilling notes and pound notes in his pockets, rich sort of reddy-brown notes, and hang this vast coat of his over a chair. Then we would creep upstairs and nick a few, because it was the only way of gaining any money from Augustus.' Though 'bloated and dumb from his deafness'[690] John (who helped Dylan in a number of practical ways) was well aware of these raids. In *Finishing Touches*[691] he gives as his interpretation the belief that Dylan had once been a Communist, though 'after that attached himself to no other political movement, unless his propensity for sponging on his better-to-do acquaintances could be dignified by such a name. In any case he could always be relied upon as a borrower . . .'

These facts help to explain the grudging tone of John's essay. Dylan, he owns, was 'a genius' – but his shove-ha'penny was superior far to *Under Milk Wood*, in which 'there is no trace of wit'. Such boomerangs bruised John badly, though they were themselves attempts at wit, the tone of which misfired. 'There is no *rancour*,' he explained to D. S. MacColl, 'only a little playful malice'. The affection between them, much enlivened by this malice, was on Dylan's side partly filial, and within John could only exist behind a prickly barricade of 'unsentimental' jibes. 'Dylan has a split personality of course,' he wrote to Mary Keene. 'He can be unbearable and then something else comes out which one loves.'

Of the two oil portraits John did of him in the late 1930s one, now in the National Museum of Wales, is possibly his best painting of this period – a 'diminutive masterpiece', as Wyndham Lewis described it, that perfectly illustrates his pen-portrait in *Finishing Touches*: 'Dylan's face was round and his nose snub. His rather prominent eyes were a little veiled and his curly hair was red, or auburn rather. A pleasant and slightly sardonic smile registered amusement and, I think, satisfaction. If you could have substituted an ice for the glass of beer he held you might have mistaken him for a happy schoolboy out on a spree.'

Both John and Dylan were 'bad Welshmen' whose ruin was precipitated by America, where they broke new records in drinking. There

are passages in John's essay that could be applied with equal stringency to himself since, perhaps unconsciously, he identified himself with the younger man. Having passed on some of his own traits in this way, he is enabled to deplore them the more heartily. It was a technique, peculiarly successful in the case of Dylan Thomas, he often used to pep up his writing, and it accounts for the paradox that his sharpest sallies are directed towards those with whom he felt most in common.

5. CHILDREN OF THE GREAT

When walking the streets of Chelsea, so the story goes, John had a habit of patting local children on the head 'in case it is one of mine'.* Calculations over the quantity of these children floated high into the land of fantasy reaching, in James Laver's autobiography, a number of three figures at which, in the opinion of Max Beerbohm, John stopped counting.[692]

John was never quick to deny fathering a child. Improbable rumours, incapable of proof, seethed around him. But the basis of this legend was his election by many people he had never met – in particular chronic readers of newspapers – as an archetypal father figure. It is not uncommon for children, especially girls perhaps, as they grow up and away from their parents to wonder for a while whether they are illegitimate. To the imagination of these girls, especially if there was a connection with art or with Wales, the personality of Augustus John came readily to mind. One middle-aged woman in North Wales has written in a Welsh magazine the elaborate story of John's friendship with her mother, ingeniously tracing her own family connections with the Johns to show that, in addition to being her father, John was a cousin. Every detail that can be checked pushes this narrative further into invention.

Another example is sadder and perhaps still more revealing. In about 1930, Sheila Nansi Ivor-Jones, a schoolgirl, was sent by her parents to see a Dr Clifford Scott. Although she was not unintelligent, Sheila had done no good at school, could not stick to any routine, and was either annoyed or made lethargic by school life. Her father, Robert Ivor Jones, headmaster of West Monmouth School at Pontypool, and his wife Edwina Claudia Jones (*née* Lewis) were worried. But Sheila did display some artistic ability and, after going up to an art-school in Tunbridge Wells, blossomed out. Her troubles seemed over. In October 1937 she transferred to the Slade and by the 1940s had become

* But Romilly John remembers that 'as a small boy I frequently encountered Augustus striding arrogantly down the King's Road on his way to the Six Bells. He never deigned to notice one on these occasions. Nor did it occur to me to claim any relationship. We passed as perfect strangers.' Romilly John to the author, 25 January 1973.

an art instructor at the Chelsea School of Art. Then, on 15 February 1948, she again consulted Dr Scott, complaining of terrible nightmares about horses, fighting and hysterical love-scenes; and adding that she had discovered herself to be the illegitimate daughter of Augustus John – to which she attributed this trouble. The nightmares and delusions persisted throughout this year, growing worse. She seems to have neglected herself, lost her job and in February 1949 was admitted to West Park Mental Hospital, Epsom, where on 28 February she died. The cause of her death was recorded as bronchial pneumonia and acute mania.

Sheila Ivor-Jones (she hyphenated her name in London) had been born at Llanllwchaiarn in Montgomeryshire on 28 September 1912 and, from the evidence that exists, it seems most unlikely that John could have been her father. If then, this was fantasy, it seems to have taken possession of her after the death of her real father. She may have seen John fairly frequently in Chelsea since she lived round the corner from Mrs Fleming's house (and no distance from John's various studios) at 77 Cheyne Walk above 'the Cheyne Buttery' – tea and supper rooms and a Guest House run by a man called Stancourt whose christian names were John Augustus.

Whatever the source of her delusion, it represents, in an extreme form, a tendency that was widespread. The irony was that, as an actual father, John was extraordinarily difficult. 'I have no gifts as a paterfamilias,' he admitted.[693] For all his children self-help was the only salvation – the key for entry into, as to liberation from, the powerful John orbit. Fryern Court 'wasn't my home', wrote Amaryllis Fleming,[694] 'but it was the only place I ever felt utterly at home in'. Another daughter who was not often at Fryern felt her exclusion to be a paralysing deprivation of love. But the magnetic field rejecting her trapped others, Ida's sons and the son and daughters of Dorelia, who needed supreme willpower to escape.

John was partly a Victorian father, in part a caricature of modern liberalism. Children were to be seen and not heard, painted and glared into silence. He was particularly alert to table-manners. An incorrectly pronounced syllable or a swear word uttered in front of the girls would provoke a terrible pedantic wrath. 'I have awful memories of those meals,' Poppet recalled. One morning when she arrived at breakfast wearing her dress the wrong way round, she was picked up by the scruff of the neck, deposited behind some curtains, and left. At another time when Vivien committed a social misdemeanour, John refused to speak to her and all communication had to pass via a third party. 'As a child I can only say I feared him greatly,' Vivien wrote, 'and if spoken to by him would instantly burst into tears.'

But he was more severe with the boys. The tension between them was

sometimes agonizing. One of them had a habit of smelling his food before starting to eat, and this infuriated John so much that once he pushed his face hard into the plate. His son retaliated by flinging the plate out of the window, but John made him go out, collect every morsel from the gravel and eat it. It was a battle of wills and John, with all the advantages, won.

John's silences could last thirty hours or more and were echoed back at him by his brooding sons. 'Why don't you say something?' he growled at David, whose silence darkened. But it was the quality of Robin's silence, grimmer than any of the others', seeming to accuse him of something literally unspeakable, that maddened John most. 'He hardly utters a word and radiates *hostility*,' he wrote to Mavis. 'I fear I shall reach a crisis and go for him tooth and nail. That happened once here and I soon floored him on the gravel outside.' He affected to believe that all his sons were slightly mad. Could there be something *glandular*? he wondered. Should he hire strait-jackets? 'Do you think it would be a good idea', he asked Inez Holden, 'to have the lot of them psycho-analysed?'

'As children', Romilly acknowledged, 'we made no allowances for, since we had no conception of, the despairs of an artist about his work.' John's glooms, charged with an intense hostility to those near by, cut him off from easy family relationships. 'They may have been a bid for love and reassurance,' wrote Romilly, 'the psychology of this pheno-menon is a little obscure! Needless to say they produced dread.' Yet he resented not being confided in, and wanted in a discreet way to be loved by all of them. 'On rare occasions when Augustus and I talked, it was almost invariably about Sanskrit,' remembers Romilly, 'a subject neither of us knew much about.' On more intimate matters they were dumb.* At the end of a letter written to a Dartmouth schoolmaster (a retiring bachelor of thirty-eight) John added a timorous postscript suggesting something might be mentioned to his son Caspar about sex: 'Boys of Caspar's age stand particularly in need of help and enlighten-ment on certain subjects, don't you agree?' For almost all his life, John used conversation as a neutral territory where he and his sons might guardedly meet without giving anything away. It was a tragedy, Caspar remembered, that, by the time they could talk on easier terms, John was deaf, and everything had to be conducted with a shout.

* On one occasion when one of his sons wrote to him in personal distress, John confined his reply to matters of prose style which 'I find overweighted with lati-nisms', and to the envelope itself upon which 'you have, either by design or care-lessness, omitted to place the customary dot after the diminutive *Hants*.. In an old Dane Courtier this seems to me unpardonable but I put it down to your recent bereavement.'

To this severity John added a bewildering generosity and the attitude of *laissez-aller*. He gave all his sons good allowances well into their twenties when he could not well afford it. If he was open-handed, he was also open-minded, allowing the boys at the ages of ten or twelve to choose their own schools. David had gone to Westminster, Caspar to Osborne, Robin (briefly) to Malvern and then to Le Rosey in Switzerland, Edwin and Romilly separately to an eccentric school near Paris. As for the girls, when asked at the ages of nine and seven whether they would like to go to school, Vivien burst into tears and Poppet said 'No'. A procession of tutors and governesses (one of whom Romilly married) were erratically employed, but the two sisters passed more of their time with ponies than people, and in later years John would pour scorn on their lack of education. He showed real interest only in their art work, though when Vivien went up to the Slade she was under specific orders that there was to be no instruction. 'Little', she remembers, 'came of this.'

The sisters had served almost as stern an art-apprenticeship as the boys. 'I had to look at him,' wrote Poppet, 'and if I caught his eye he would ask me very politely to come and pose for him, and this would mean the whole morning gone . . . all our plans for swimming at Bicton or riding in the forest with Vivien . . .' These 'gruellings', as Vivien called them, continued until the girls married, 'then ceased abruptly'. There was an occasional attempt at fancy-dress (Vivien, for example, depicted as a Russian peasant after a visit to Moscow) and a considerable number of nude drawings of them both, which, not identified by name, were mostly hurried off to Australia, Canada, Japan.

As they grew up their relationship with their father became more complicated. When Vivien took up dancing, hoping to go on the London stage, John violently objected on the grounds that it was not art but an entertainment for jaded businessmen. Towards both of them he was jealously possessive. No boy friend was good enough, since to be good enough he would have to prove himself better than John. 'Why should you bother with boy-friends when you have such a magnificent father?' he once asked Mollie O'Rourke, and this appeared to sum up his attitude. After Poppet's wedding to Derek Jackson, he hopped into the car at Fordingbridge beside his daughter and, happily acknowledging the cheers, was driven off with her while Jackson sat disconsolately next to the chauffeur.* 'He was like an old stag,' Poppet's second

* These, apparently, were John's usual tactics. In a letter to Richard Hughes (29 March 1939), Dylan Thomas wrote that Augustus is 'out and more or less about now, although Mavis's wedding put him back a few weeks. We saw the newsfilm of the departure from the registry office, and Augustus, blowing clouds of smoke, hopped in the first car before bride and groom could get in . . .'

husband Villiers Bergne observed, 'with his herd of women and children round him. Interlopers were beaten off.'*

If it had been hard for boy friends, it was harder still for husbands. Vivien's husband, a distinguished doctor specializing in research into bone marrow, was known as her 'medical attendant'. At meals, John would sometimes enjoy drawing caricatures of his in-laws, passing them round for comic appreciation; and his letters to all the family contain many invitations to disloyalty between his sons and daughters, their wives and husbands who, at one time or another, were 'revolting', 'villainous', or 'repulsive little swine' and who would generally learn this through some third party. His daughters-in-law ('no oil-paintings'), who he affected to believe had been chosen for their plainness so that his sons 'need fear no competition from me', had a scarcely easier time of it. A favourite theme of his was the grave exploration of how to do away with all this proliferating family. 'I know little of toxology but I have heard the merits of *ratsbane* well recommended. The only question is: should the whelps be included in the purge? Personally I am all for it.'

Possessive over his daughters, he was fiercely competitive with his sons; and it was with them that the most bitter battles were fought. One developed an eczema that would visibly spread over his skin during a quarrel. 'He is quite insupportable. I shall kill him soon,' John promised Dorelia – and in certain moods this did not seem an exaggeration. He genuinely wanted all of them to succeed and would take pleasure in their achievements; but he could not avoid putting obstacles in their path. He gave them money, he introduced them to useful people; but he could not give them any sense of direction. When David wanted to take up architecture, John recommended that he design a lunatic asylum in which he and his brothers could comfortably accommodate themselves. There was only one way for them to please him, and that was to be an unmitigated success, to excel everyone: anything else was rewarded with paralysing sarcasm.

By others, outside the family, the sons were treated like some special branch of the nobility. When they were to arrive at a party, the news

* 'I hope it will be their last visit,' he wrote after Poppet and Bergne had gone to Fryern for the first time. But he made an exception of Wilhelm Pol, the Dutch painter who became Poppet's third husband. 'This time I favour the match,' he told Caspar (1 March 1952). '. . . Poppet, a thorough bourgeoise, provided there is plenty to laugh at, reasonable access of food and drink, and of course the indispensable privileges of matrimony, will stay put.' To others he exclaimed, with an oblique slap at Edwin, Robin, Vivien and perhaps himself: 'Thank God there is a painter in the family at last!' In David Herbert's autobiography, *Second Son* (Peter Owen 1973), Poppet is described as 'extremely attractive, she had almost as many boy friends as her father had mistresses.' p. 61.

was buzzed about: *Augustus John's sons are coming*! They grew anxious to disguise themselves, to avoid this vicarious limelight, play down the possession of the awful name John. David, for example, never referred to 'my father' but always to 'John' as if to underline his detachment.

All of them had talent but, in the shadow of the Great Man, they dwindled. David, who played the oboe for several major orchestras, eventually gave up music and, narrowly missing a career as public lavatory attendant, was appointed a postman, turning in retirement to occasional furniture removals. Romilly, who had joined Francis Macnamara on the river Stour for long philosophical explorations of *Robinson Crusoe* and the Book of Genesis, later became the erratic apprentice to a farmer, then (though despising alcohol) a student inn-keeper at John Fothergill's public house The Spread Eagle at Thame, before at last 'commencing author'. Perhaps his finest book was *The Seventh Child*, a minor masterpiece of autobiography, that John tried to dissuade him from publishing. When Romilly pressed for a reason, he looked harassed and, after casting round in his mind some minutes in silent agony, thundered out that Romilly had misspelt the name of a Welsh mountain.

Robin, it was held, achieved the most bizarre reaction against his father. After leaving school he became assistant to Sir Charles Mendel, Press attaché at the British Embassy in Paris. Despite his dislike of the Press, John accepted this as a fairly honourable beginning. When Robin gave it up to study painting, John was still obstinately delighted, be-lieving that his son had a remarkable talent for drawing. Robin, how-ever, concentrated on the study of colour, especially blue, 'from the scientific or purely aesthetic angle'.[695] It was this apparent neglect of natural ability, infuriating to John, that Robin appeared to perfect. He travelled widely, mastered seven languages, and was silent in all of them. Maddened by this misuse, as he saw it, of 'linguistic genius' John struggled to find him employment – with Elizabeth Arden. More appro-priately Robin took a job 'in the censorship', being transferred to Bermuda and Jamaica where (care of the Royal Bank of Canada) he did fruit and flower farming in the hills, dabbling on lower levels in real estate. Over the years he wandered invisibly from job to job, from place to place, and in 1965 he married. 'I'm sure he [John] regretted our in-ability – as I did – to achieve a friendly and easy relationship,' Robin wrote.[696] 'But the main obstacle was that he – fundamentally – was a rebel against established society and most conventions, while I hated Bohemianism and yearned for a normal life – which made me in my turn also a rebel – but in reverse.'

Some variation in this pattern was offered by Edwin. His gift, in John's eyes, was for clowning, and the stage (which had been forbidden

Vivien) was recommended. 'I feel strongly you yourself could make a great success on the stage,' John advised. 'You have a good voice and ear and an unusual comedic sense.' After studying art in Paris, Edwin accidentally became a professional boxer, winning, as 'Teddy John of Chelsea', seven of his first nine fights. 'Edwin fought a black man last Monday and beat him,' John wrote proudly to a friend. To these ring-side parties John led his family and friends in great spirits; and on one occasion he entered the ring himself, squared up opposite his son and had his photograph taken, bulging with satisfaction. 'I like him [Edwin] immensely,' he wrote to his son Henry. '. . . he has become a tall hefty fellow full of confidence, humour and character'. This delight at Edwin's spectacular success was intensified by his own father's horror. Old Edwin John, he told David, 'is outraged in all his best feelings that Edwyn has adopted the brutal and degrading profession of prize-fighter but everybody else seems pleased except some Tenbyites who, according to Papa, have decided that *my* little career is at an end in consequence of Edwyn's career in the Ring'. But one other person disapproved: Gwen John. She told her nephew he was wasting his time boxing and should become a serious artist. In the pull-pugilist, pull-painter contest that ensued, Gwen won and to John's acute disappointment Edwin threw in the towel. Following Gwen's death, he and not John was appointed her residuary legatee, in charge of all her paintings. Often after this, when father and son inflicted their company on each other, a sense of impotence threatened John. It seemed better to stay apart. 'Is your presence really necessary? . . . my advice is, Keep away.'

Caspar, the one who, from earliest days, had kept away, was the exception. By 1941 he was a naval captain; by 1951 a Rear-Admiral; by 1960 First Sea Lord and Chief of the Naval Staff. Of his son's enthu-siasm for ships and the sea John understood nothing: but he under-stood success. 'My son Caspar hasn't done too badly,' he remarked once to Stuart Piggott. Of course he would make fun sometimes of 'the gallant admiral . . . looking like a Peony in full bloom,' but such sallies had no poison in them. Their relationship seemed a grim enough affair, neither giving an inch, but the more senior Caspar became the more John thawed. 'Still in the navy?' he asked when Caspar returned on leave. But though he took this success lightly, not embarrassing Caspar with encomiums, it afforded him deep satisfaction.

There was another son, Ida's fifth child, Henry: the odd one out. He had been brought up by a stray cousin, Edith Nettleship, in the village of Sheet, near Petersfield. It was an energetic upbringing: long walks in the open, long prayers indoors. While serving as a nurse during the First World War, Edith had been converted to Catholicism. She sent Henry to school at Stonyhurst College where, a little later, he too

suffered conversion to north-sea Catholicism. Sometimes in the holidays, and after he had left school, he would come to Alderney and to Fryern, entering for a week or two the amazing world of his brothers and half-sisters, utterly foreign to anything he had known. It was like a dream – the riding and tree-climbing; the invention with Romilly of a machine that *thought*; the urgent swopping of stories, information, books; the pictures; the endless talk of love and philosophy that continued in Henry's illustrated letters and included his poem about Eden in the style of Edward Lear and a complicated theological essay on 'Girls' Bottoms' much criticized for its inaccuracy. He was a strangely attractive figure to the Johns, with striking good looks, a vehement personality, his laugh fierce, his manner harsh and precise. At Stonyhurst he had gained a reputation as a brilliant scholar, actor and orator, and at weekends would mount a platform at Marble Arch to argue dramatically on behalf of the Catholic Evidence Guild. He was respected, even feared; but he was too unconventional to be a popular boy. The problem was: with all his energy and gifts, what should he do? Father Martin D'Arcy had been sent down to Stonyhurst to meet him and, if he judged him sufficiently remarkable, groom him for the Jesuit priesthood. In his opinion and that of Father Martindale, Henry was outstanding; and so, in 1926, Father D'Arcy carried him off to Rome. Henry's letters from Rome to his father show in what strange way his Catholic training and John-like paganism had become fused into a charming fantasy:

'Another thing which is absorbing is how I am going to bring up my children and how I am going to spend my honeymoon (supposing I don't become a p[riest]). I think the most awful thing that could happen to anybody would be to have horrible children. . . . I should bring them up in some sunny place by the sea, pack their heads with fairy-stories and every conceivable pleasant Catholic custom, be extremely disciplinary when need arose, and make them learn Japanese wrestling, riding, prize-fighting (i.e. not boxing), swimming, dancing, French, Latin, and acting from the cradle. We would have the most glorious caravan expeditions (like you used to do, didn't you?) in Devonshire and France and Wales. The catechism lesson, once a week, given by myself, would be a fête. At Christmas – Xmas tree, stockings, crib, miracle-play, everything. I would take them somewhere where they could play with poor children . . . on at least one day of the week they would be allowed to run about naked and vast quantities of mud, soot and strawberries etc. would be piled up for their disposal. All the apostolic precepts would have to be encouraged. . . . Tell me . . . what amendments you suggest. Quick, else I shall be having them on my hands. The first Communion of the ten small Johns will be a magnificent

affair; if possible it will be on the sands in the sun, and afterwards the whole family will sit round having great bowls of bread and milk. Then we shall go out in sailing ships and have dances when we come back and a picnic with a terrific stew ending up with Benediction and bed.'[697]

Henry had not liked Rome, but everywhere he went, even the zoo, there at his side was Father D'Arcy, 'who is the *paragon*', he told John, ' – he sees every conceivable point of view without being the least bit vague or cocksure, and allows himself to be fought and contradicted perhaps more than is good for me'. In an ejaculation of enthusiasm he invited John swiftly to 'come to Rome' so that he could 'cheer up D'Arcy and paint the Pope (green) and the town (red)'.

It was after his return that Henry decided to commit himself to the priesthood. In 1927 he entered as a novice the Jesuit House, Manresa, at Roehampton. He suffered and survived this rigorous training in spiritual exercises, but it altered him. By the time he went up to Hey-throp College he had become passionately religious, discharging his fervent emotionalism into theology. No longer did the worlds of the two fathers, D'Arcy and John, mingle in happy fantasy; they frothed within him in a continuous chemical antipathy. 'You are like Fryern,' he wrote to Vivien. 'Fryern is a sort of enchanted isle – very beautiful and nice and kind and fantastic; but nobody ever *learns* anything there.' It was strict Neo-Thomist learning that, like some missionary gospel, he strove to implant there. Summoning up all the resources of Farm Street, he rained on them books and words. With time, and lack of consequence, these proselytizing exercises grew more frantic. 'Acquaint yourself with Romilly,' he ordered Father D'Arcy. 'Write to him. Save him from Behaviourism . . . send him something on psycho-analysis. . . . Start on immortality.' And then: 'There is no reason why David should travel separately. Therefore *get hold of him on the platform* and talk to him all the way. [Christopher] Devlin can go to the W.C. Hint forcibly to him that he should seek companions among the other youths . . .' But for conversion, the Johns seemed very unripe fruit, and the only result was 'our vocabularies have increased'.

Top of this Tree of Ignorance was John himself, a mighty plum. To scale such heights was an impossibility, yet Henry did not hesitate. At times, it even seemed to him he was gaining. 'Daddie says there might be "some small corner" for him in the Church,' he hopefully advised Father D'Arcy. But hope sank eternal. 'I'm afraid though we're at a deadlock. He spurns revelation entirely – says he's just as religious as we are.' John's objection to Catholicism was strong, mainly on political grounds, for he saw the Church as a reactionary power. He retaliated to Henry's sermonizing by endeavouring to undermine his faith. 'What

do you believe in?' he asked. 'What you're told I suppose. It would be a grand training for you to get out of your church and take your chance with common mortals. When I'm well and sane I detest the anti-naturalism of religiosity and become a good "Pagan". Chastity and poverty are horrible ideals – especially the first. Why wear a black uniform and take beastly vows? Why take your orders from a "provincial", some deplorable decrepit in Poland. Why adopt this queer discredited pre-medical cosmogony? Why emasculate yourself – you will gradually become a nice old virgin aunt and probably suffer from fits which will doubtless be taken for divine possession. Much better fertilize a few Glasgow girls and send them back to Ireland – full of the Holy Ghost.'

In the hope of miracles, Henry persuaded John to paint him in the robes of a Jesuit saint, but neither mystically nor aesthetically was the experiment a success. The struggle between them, for all its ludicrous aspects, was serious. 'I am a person of absolutely feverish activity . . . I am madly impatient and madly irritable and appallingly critical . . . yet I have an immense desire to be exactly the opposite of what I tend to be,' Henry had written. The Jesuit training, he believed, would teach him the secret of self-renunciation, the absolute submission of his rebellious spirit to the Will of God as manifested in Superiors. Yet while his family remained blatant 'bloody fools' basking in 'flashy old paganism', they were an intolerable irritant. He felt exasperated. 'I cannot *stand* the idea of myself as introspective and hesitating when there are things to be done, souls to be saved,' he burst out in a letter to Father D'Arcy. He had sought sublimation of his will, but confronted by the Johns' refusal *en masse* to be saved, he was unendurably frustrated. The philosophy he had elected to read at Campion Hall gave him no outlet for this turmoil. His letters, written in a shuddering hand, relentlessly illegible, are saturated with violence, page after page like a protracted scream. Watching him, Father D'Arcy (who had advised against philosophy) was increasingly worried by what he called 'your periods of heats . . . the temperature you rise to, the complications . . .'

At the end of his time at Campion Hall, Henry gained Second Class Honours in philosophy; but this was not good enough. That summer he submitted a dispensation of his vows and in August 1934, explaining why 'the Jesuit life is not any longer my cup of tea,' he wrote: 'I am not leaving for intellectual reasons but for physical ones i.e. I do not think I am meant to lead a *life of books only* . . . nor can S.J. Superiors, generous as they are, be expected to cater for a permanent eccentric. . . . Having had a determined shot, I failed. I don't think the chastity question comes into it very much at all – at any rate disinclination for a life of chastity is not a prominent reason in my mind, though of course

it is present. . . . I should not mind if people said I was funking dis-
obedience – for that's quite plausible.'

This letter, far more controlled than anything he usually wrote, was
sent to John via Henry's Provincial 'to make sure things are quite
clear'. But other writings, that sit less politely upon the page, affirm a
different truth. Henry appears to have been highly-sexed. At school he
had had a devastating infatuation for another boy; and during his
noviciate he seems to have become painfully involved, though in a more
sophisticated way, in another unrequited passion. But he was not homo-
sexual: it was simply that he was always in the society of other men. His
correspondence to his Provincial and Superiors was extraordinarily pre-
occupied with birth-control and questions of sexual ethics; while to
others, such as his friend Robert McAlmon, it was 'one long wail about
carnal desire . . . and the searing sin of weakening'.[698] He also did a
series of drawings, harshly pornographic, depicting a Jesuit entering
heaven by violently explicit sexual means.

One of Henry's reasons for becoming a Jesuit had been 'the absence
of any definite and satisfactory alternative'. He had hoped that the
discipline, like that imposed on Caspar in the navy, might supply him
with a purpose. He had won the high opinion of G. K. Chesterton and
of Wyndham Lewis, to follow them would be once more to 'lead a *life
of books only*'. To John, he insisted: 'I have got to make what amounts to
a fairly big fresh start, do a lot more "abdicating".' This took the form
of plunging into the East End of London among the poor. 'He seems as
mad as a hatter,' was John's verdict.[699] 'His highly intensive education
seems to have deprived him of any sense of reality – if he ever had any.
He is studying dancing – for which he shows no aptitude – and the
prices of vegetables.' In the newspapers it was announced that, like
Edwin, Henry had become a boxer and would wear the papal colours
on his pants. John was not pleased. In the past he had often urged his
son to 'quit this stately Mumbo Jumbo'. Yet he had not relished the
manner of his quitting: it reeked of failure. Now he poured scorn on
Henry for not discovering 'your own Divinity', and for still carrying
out to the letter the injunction of Loyola by failing to look 'directly at
any female'.[700] Julia Strachey, who saw him in November 1934, con-
firms this curious obliqueness:

'Henry John to tea . . . Sitting down in the small chair – which he
placed sideways on to me – beside the bookcase, he conducted the whole
conversation – metaphysical almost entirely – with his face turned away,
and looked round at me only three times, I counted, during the whole
session, which lasted from 4.30 till 7. . . . He refused both butter, and
jam, for his scone.'

His experiments at slipping, or barging, from the metaphysical to the

physical world over the next six months were unhappy. His chief girl-
friend at this time was Olivia Plunket-Greene, a disconcerting creature
with bobbed hair, 'pursed lips and great goo-goo eyes'.[701] She be-
longed to a generation that had found in the 1920s a new emancipa-
tion; but her outrageous, Charleston-crazy party-goings-on overlaid a
character that was secretive. She was more fun-loving than loving, more
intimate with crowds than single people, and apparently unwilling to
make friends save from among those who, so Evelyn Waugh ob-
served,[702] 'were attracted by her and forced their way into her confi-
dence'. Waugh had been one of several who fell in love with her, but
she played him off against a formidable rival, the black singer Paul
Robeson. The old inhibitions, that social emancipation was lifting, she
re-applied through religion. One evening, as she was dressing for a
party, the Virgin Mary dropped in with instructions to pursue a life of
chastity. This experience, in Waugh's judgement, was to make her 'one
third drunk, one third insane, one third genius'.[703] She still seemed the
fun-loving, party-going girl; but whenever she took off her clothes she
would hear the Virgin Mary's voice, and immediately dress again. It
was with her that Henry now sought to make his 'big fresh start'.

They held hands; she wrote poems; they talked; she let him kiss her:
and then there were her love-letters. 'You are rather a darling with your
long legs, and your jerky sensitive notions and your mind busy with
acceptance, I would like to give you breasts and knees and curved em-
braces. . . . Wish you hadn't made me think of loving, I need to be
loved, charms and skin and embraces soft and strong. . . . But if I let
you hold me in your arms, it is for a variety of reasons. . . . Your
embraces are lessons, but most enjoyable, like lessons in eating ice-
cream or treacle.'

They had planned to spend part of June at a bungalow belonging to
Henry's aunt, Ethel Nettleship, near Crantock in Cornwall. In the first
week of June he received a six-page letter from Olivia explaining some
of the reasons why she could not have sexual intercourse with him. 'I
never knew how anti-birth control I was before but evidently I am.'
He argued abstractedly; she promised to write again. He drove down to
Cornwall; she did not come. On the evening of 22 June he bicycled to a
desolate stretch of the cliffs, unbroken for miles by any habitation. He
was seen walking along, swinging a towel, his aunt's Irish terrier at his
heels: then he vanished.

Within forty-eight hours police were methodically searching the
cliffs; scouts were lowered down on ropes to explore the caves, aero-
planes circled the region, and motor boats manned by coastguards with
binoculars patrolled the heavy seas. John, who had rushed down, joined
in the hunt. 'I'm searching for my blessed son who's gone and fallen in

the sea,' he wrote to Mavis. 'I have no hope of finding him alive. His corpse will come to the surface after nine days. A damn shame you are not hereabouts. . . . I suppose I'll be here a few days although corpses don't interest me.' The description of these few days he gave in *Chiaroscuro* has been criticized for its unfeeling tone. Partly this was the result of press reporters tracking him for a 'story'; and their melodramatic accounts of the artist 'speechless with grief' and the 'disconsolate terrier' that for days continued to appear in the newspapers. John never revealed guilt; he buried it away to reappear as something else. That the son Ida had died giving birth to should so recklessly have lost his own life tormented him, but he resolved to force the matter from his mind. For the sake of appearance, he stayed in Cornwall a week exploring every detail of the coast, but directing much of his attention to the cormorants, puffins and seals. There was some cheerful weather for the search, and almost without thinking he took a pad of paper and began sketching.

On 5 July, thirteen days after his disappearance, Henry's body was washed up on the beach at Perranporth, dressed only in a pair of shorts. 'Though it was without a face, from the attentions of birds and crabs, I was able to identify it all the same.'[704]

In the press Father D'Arcy was quoted as saying that there could be no possibility of Henry's death having been anything other than an accident. 'In many ways he was a cheerfully irresponsible young man, and I only wonder that he has not had a serious accident before. He always took risks and loved adventure.'[705]

John suspected otherwise. In 1943, travelling from London to Salisbury, the train being held up by an air raid, he suddenly became very talkative with the young man sharing his compartment about 'the suicide'[706] of his son. Otherwise he showed little. To the many people who wrote offering their sympathy he agreed it was a tragedy that, having climbed out of the Society of Jesus, Henry should have fallen into the sea. Dorelia too was calm. 'It's perfectly all right,' she assured Lady Hulse. 'Henry wasn't mine.'

6. BARREN OUR LIVES

'In spite of all,' a friend noted in her diary, 'he wasn't dead yet'. It was the others, family and friends, who kept 'popping off'. 'People seem to be dying off like flies,' he complained.[707] In December 1932 it was Mrs Nettleship. Over the years John and she had reached some sort of understanding – particularly strong when they could unite in disapproval (against, for example, Henry's Catholicism). As she lay dying in Weymouth Street, following a bad stroke, John burst in with two of his sons and a supply of beer. He settled down by the fire in her bedroom, Ursula

Nettleship recalled,[708] 'and talked about his life in France, about French literature, what he had read, about the quayside at Marseilles and the people he'd known there, all night replenishing our glasses from the beer bottles, watching mother . . . had she been conscious she would have vastly appreciated both his presence and the completely unconventional Russian play atmosphere. And somehow, again in all simplicity, proving a very real support . . . a good memory to treasure up.'

The previous year it had been his old crony, the gypsy scholar John Sampson.* 'It's a ghastly blow to me,' John wrote to Margaret Sampson, 'for the Rai was so much part of my life.' He was cremated on 11 November and ten days later his ashes were carried to Wales. In those ten days mysterious messages passed between the gypsies, and the private ceremony was crowded with Woods and Lees, Smiths and Robertses and illustrious enthusiasts from the Gypsy Lore Society, judges, architects, girls, professors and that other great Rai, Scott Macfie, ill but indefatigable, mounted on a Welsh pony. The straggling procession, trailed at a cautious distance by a platoon of pressmen, was slowly overtaken along the way by John in his ulster and flowing scarlet scarf, who had been chosen to act as Master of Ceremonies. He led them panting up the slopes of Foel Goch, a mountain where Sampson had often rallied his crew. Here, eyes fixed in the distance, in his hand a smouldering cigarette, he delivered his eulogium.[709] It was a blue day, his words rang out over the bright green fields, the brown woods below. After this oration was over, a powerful silence. Michael Sampson, expressionless, scattered handful after handful of the ashes which swept in showers of fine white dust down the mountainside. The sun shone, the wind lifted their hair a little, blew the ashes round to land, like dandruff, on their shoulders. Then John, 'with his right hand outstretched in a simple gesture as if actually to grasp that of his old friend',[710] spoke a poem in Romany. Everyone murmured the benediction *Te soves misto* (Sleep thou well) and, as the words died away, the music began – first the strings of the harp, then the fiddles, mouth organ, clarinet and dulcimer. Someone lit a match, started a pipe; and 'we each found our own way down the hilly slopes,' Dora Yates remembered,[711] ' . . . I myself saw the tears rolling down Augustus John's cheeks as he tramped in silence back to Llangwm.'

In 1935, Horace Cole died in exile at Ascaigne. 'I went to his funeral,' John wrote,[712] 'which took place near London, but I went in hopes of a miracle – or a joke. As the coffin was slowly lowered into the grave, in dreadful tension I awaited the moment for the lid to be lifted, thrust aside, and a well-known figure to leap out with an ear-splitting yell. But

* In his Will, Sampson left John 'as a small memento of long friendship my Smith and Wesson Revolver No. 239892'.

my old friend disappointed me this time. Sobered, I left the churchyard
with his widow on my arm.'

But there was one who refused to die, obstinately, year after year:
John's father. Often he had given notice of doing so; and, summoning
his courage, John would journey down to Wales. He liked on these
death-trips to make use of Richard Hughes's castle as an Advance Base,
inviting himself to tea, arriving shortly after closing-time and stabling
himself there for ten days or so. 'My father,' he would say, 'is on his
death-bed, but refuses to get into it.' Every morning he set off for
Tenby in his 'saloon' car with a bottle of rum, stopping on the way to
sketch and then, after a telephone call, arriving back at Laugharne.
Richard Hughes, watching these forays, concluded that he must fear his
father. Then, one day he would finally reach Tenby, find old Edwin
John, like some Strindberg, miraculously recovered, and at once motor
back to Fryern, his duty accomplished. Once, when his father was out
for a short walk, he seized the opportunity and rushed back to Hamp-
shire without seeing him.

'My father writes of the uncertainty of life and his Will – so I suppose
he is thinking of moving onwards,' John notified Dorelia. That had
been in 1925. Shortly afterwards the old man added a postscript: 'He
would prefer to wait till Gwen and I have returned'. No obstacle, John
considered, should be put in his way. In 1927 he advanced Gwen some
money to buy and furnish Yew Tree Cottage* at Burgate Cross, very
close to Fryern, so that the old man could take his leave of them together.
For six weeks during August and September that year Gwen prepared
this cottage, whitewashing its rooms, removing partitions, filling it with
cups, curtains, counterpanes. 'My cottage is *lovely*,' she told Ursula
Tyrwhitt. ' . . . I don't mind seeing Gus now or the family'. She left
England on 19 September, intending to return when 'I have sold 1 or 2
pictures as I don't want to be gêné for money and there is a lot of
expense which Gus has paid. . . . It is such a beautiful place . . . I
sometimes want to be there very much.' She never returned. In her
absence, Fanny Fletcher used the cottage, putting, perhaps, mild spells
on it that may have jarred on Gwen. Or, it may be, she never allowed
herself to sell the few pictures; or, simply, when it came to it, could not
leave her barren room at Meudon.

Old Edwin John had also decided not to leave. He kept in remorseless
touch with his children, his letters exhibiting a constant devotion to the
weather. 'What is the weather like in Paris?' he would ask urgently.
News of its behaviour in parts of America or Canada were passed

* She was by now a woman of property, having bought with the proceeds of her
Chenil Gallery show a shack on a strip of waste ground in the Rue Babie. She con-
tinued also renting her room at Meudon.

anxiously on to France. 'The climate is very hot,' he instructed Gwen of conditions in Jamaica while Augustus was there, ' – but usually tempered by a breeze from the sea.' As for home affairs, he was always finding himself dramatically overtaken by some 'nice breeze', afflicted with 'unbearable heat waves', or 'in the grip of a fierce blizzard'. 'Typical November weather' did not go unobserved, nor the curious fact that 'the cycle of time has brought us to the season of Christmas again'. As he advanced into his young nineties, so the climate hardened, 'the present weather being the worst I think I have ever experienced in my life'. 'How,' he demanded, 'is it going to end?' However it was to end, it never seemed to. After each winter, with its unexampled frosts and snows, he revived. 'I am making good progress to recovery of health,' he assured Gwen on 28 March 1938. 'I eat and sleep well and take short walks daily . . . How near Easter has become has it not? I must really purchase some Easter cards . . .' On the afternoon of 7 April, while he was resting in bed, his housekeeper heard him call out: 'Goodbye, Miss Davis. Goodbye.' When she went up to see him, he was politely dead.

They buried him in the cemetery at Gumfreston, a tiny damp grey church two miles from Tenby where, with deliberation, he had played out the hymns on Sundays. After some delay, an inscription, considered to be definitive, was cut upon his gravestone:

<div align="center">

Edwin William John

1847–1938

With Long Life will I satisfy

Him and show Him my Salvation.

</div>

John and Caspar attended the funeral; Thornton and Winifred were too far off; and Gwen did not come. She seldom went anywhere now. Her passion for solitude was exercised, as John and Rodin had feared, at the expense of her health. She had ceased to paint and was allowing herself to die. The end came in September 1939 when, falling ill, she was overcome by a sudden longing for the sea. She caught a train to Dieppe, but collapsed on arriving there and was taken to the 'Hospice de Dieppe', where she died.* It was characteristic that, though she had brought no baggage with her, she had not omitted to provide for her cats. 'Few on meeting this retiring person in black,' wrote John,[713] 'with her tiny hands and feet, a soft, almost inaudible voice, and delicate Pembroke-shire accent, would have guessed that here was the greatest woman artist of her age, or, as I think, of any other.'

* At 8.30 a.m. on 18 September, not, as has previously been thought, 13 September.

Things Past

'I keep working away – what else is there to do?'
Augustus John to Conger Goodyear
(3 October 1943)

'I was always a success, in spite of my many failures'
Augustus John to Mary Sorrell
(9 June 1948)

1. BLACK OUT

The hectic drive from St Rémy to Fordingbridge in the late summer of
1939 had been for John a journey into old age. The Second World War
cut off his retreat and confined him to a narrower routine. On the
surface there seemed little change: it was business as usual. 'I don't see
what I can do but go on painting.'[714] But there was a difference to his
campaign of work. He had been studying the papers that were coming
to light from Gwen's studio. 'Astonishing how she cultivated the
scientific method,' he exclaimed in a letter to his daughter Vivien. 'I feel
ready to shut up shop.' His own *premier coup* days were long past, and
he sought, adopting some of Gwen's patience, to invest more time than
ever before in one or two imaginative pictures on the grand scale. 'I
want a good 20 years more to do something respectable,' he had told
Sir Herbert Barker.[715]

During the 1940s he laboured hesitantly over a cartoon in grisaille
twelve feet long called 'The Little Concert'. The picture represents three
itinerant musicians entertaining a group of peasants on the fringe of a
land-locked bay. 'Though the conception is romantic, it is carried out
with a classic authority of form,' wrote T. W. Earp when it was first
shown at the Leicester Galleries in 1948,[716] 'and is easily the most
important achievement in English painting since the war.' Wyndham
Lewis, reviewing the same exhibition, described it as 'as fine an example
of Augustus John's large-scale decorative work as I have ever seen'.[717]
Yet it is difficult not to see such words as partisan. John himself felt un-
satisfied, snatched the picture back and after some revision re-exhibited
it at the Royal Academy in 1950, after which it went to a private collec-
tion. Even then he could not think of it as 'finished', and as late as 1957
was proposing to 'warm up' the monochrome.

Over the last twenty years of his life there was always one of these big
decorative compositions 'cooking' in his studio. 'Imaginative things
occupy me mostly now,' he wrote to Conger Goodyear.[718] He worked

on them laboriously, with much anguish and persistence, continually revising and from time to time challenging the public to see in them his finest achievement. 'They interest me very much and take up a lot of my time,' he wrote.[719] 'What will become of them God knows.' This re-absorption into imaginative work shifted the pattern of John's life. Commissioned portraits, he told Dudley Tooth, had rarely paid off and he was tired of making promises he was unable to keep. The artist's loyalty should be to himself. 'The artist doesn't consider the "Public" – which is the concern of the theatrical producer, the journalist, the politician and the whore.'[720] The First World War had obliterated the visionary world he had created in his painting; the Second threatened to devastate the world itself, destroying almost everything from which he might derive spiritual energy. He resolved therefore to use the opportunity war provided to retire into greater privacy, there, by the magical operation of his art, to re-illumine that paradise of sea and mountain, women, children, age and youth, music, dancing that had faded from his mind. From sixty till he died aged eighty-three this task overwhelmed everything else.

It overwhelmed but it never eliminated his portrait painting, for he was still a slave to the visible world. In the war years portraits belonged to two categories: pretty girls and public men. Drawing girls he could not resist. They were to be seen – 'living fragments of my heart'[721] – in shows at the Wildenstein, Redfern and Leicester Galleries: magnified faces, almost identical, large-eyed and honey-lipped.*

After weeks of refuge 'from contact with a depressing epoch', weeks in his studio spent painting 'huge decorations as remote as possible from the world we precariously live in',[722] a longing to paint portraits again, to be swept back into the world as an artist-biographer, would overcome him. It was an honourable pursuit in wartime, he believed, for an artist to paint those men who were leading the fight for one's country. He accepted a number of such commissions, but a lack of interest in his sitters helped to make this wartime portraiture unsatisfactory.† He did

* 'My drawing rather large heads appears to synchronize with wearing spectacles which do distinctly magnify. . . . It often takes me $\frac{1}{2}$ dozen tries before I get any-thing satisfactory: at any rate one can choose the best.' John to D. S. MacColl, 17 January 1945. 26 February 1940.

† 'He [John] was usually asleep when I arrived at Tite Street,' Lord Portal remembered, 'and loud knocks were required to rouse him. When roused he came noisily to the door, greeted me gruffly and started clearing the space for my chair by kicking away any pieces of furniture that were in the way. . . . I did not get the impression that he enjoyed painting me, but he certainly got a wonderful picture after 5 or 6 sittings. He then asked that my wife should come and look at it, which she did and admired it. She told me that while she was actually watching him at work he turned the portrait, in the course of a few minutes, into the "caricature" which

not set out to caricature; he wanted to produce noble painting. But the difficult short sittings and the absence of contact with his be-ribboned subjects would eventually tempt him into ambiguously exaggerated concoctions of paint that pleased no one. The most celebrated of these portraits, mopped-up shortly before the Normandy landing, was of Field-Marshal Lord Montgomery of Alamein. Montgomery would motor in his Rolls Royce each day to Tite Street and sit 'as tense as a hunting dog on a shoot'[723] upon the dais John had positioned for him. 'Monty has been sitting like a brick,' John reported to Mavis, 'and the picture progresses.' But it did not progress well. Montgomery felt downright suspicious of the whole business. It smelt fishy. 'Who is this chap?' he demanded.[724] 'He drinks, he's dirty, and I know there are women in the background!' John painted away in a spirit of deepening gloom. 'It's rather unfortunate the Colonel has to be in the room while I'm working,' he lamented,[725] 'as I feel his presence through the back of my head which interferes with concentration. I seem to be a very sensitive plant.' To improve the atmosphere between the two men, another figure was imported: Bernard Shaw. For an hour Shaw 'talked all over the shop to amuse your sitter and keep his mind off the worries of the present actual fighting'.[726] Then, his hour up, he was driven home by Montgomery's chauffeur (whom he goaded into reaching ninety miles an hour) and sat down to write John two brilliantly nonsensical letters about the portrait.*

According to John, Shaw 'has a wild admiration for Monty';[727] whereas, in Shaw's view, John really was not 'interested' in him. Nevertheless, 'I don't think the result is too bad,' John hazarded after the sittings were over, 'though I haven't got his decorations exact.' Montgomery was appalled when he finally saw the portrait. An unpleasant blue cloud had been suspended over his head, he declared, and it wasn't 'the sort of likeness he would want to leave to his son'. 'I daresay', commented John,[728] 'I stressed the gaunt and boney aspect of his face – the more interesting one I thought.' But he was familiar with dismay from his sitters, accepting it with particular geniality when, as in this instance, it enabled him to sell the picture for more elsewhere.

Though his heart was seldom in such work and it occupied less of his time, he still loomed large in the public mind where even his worst failures were regarded as 'controversial'. The peculiar conditions of war held him in the limelight. He was often asked to open exhibitions, to

she and others think it now is. . . . I don't think he ever asked me what I thought. . . . A powerful character, but I don't think we attracted each other.'

* 'The worst of being 87–88 is that I never can be quite sure whether I am talking sense or old man's drivel.' Shaw to John 27 February 1944. His second letter is dated 29 February 1944.

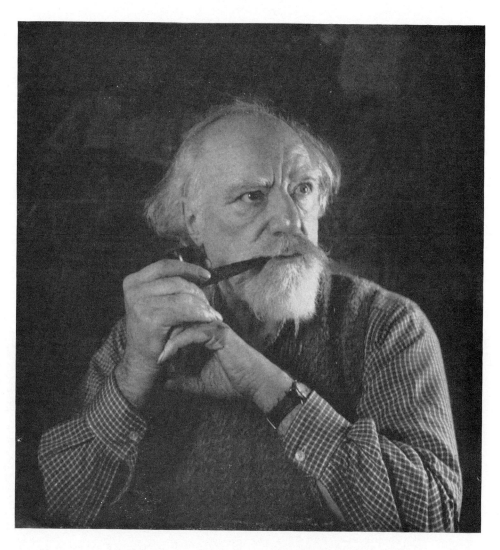

Augustus John O.M. (photograph by Douglas Glass)

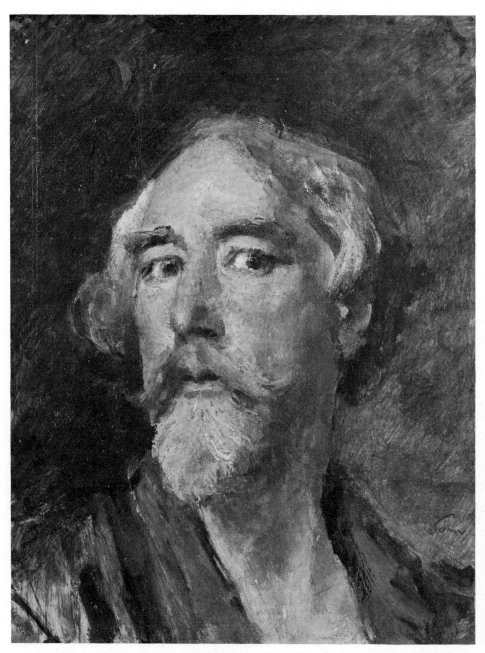

Self-Portrait, *c.* 1930

From left to right: Edwin and Romilly John, Mrs Beckers Wilson, Vivien John behind her, Augustus with Francis Macnamara towering behind him. Trelawney Dayrell Reed, Constant Lambert, Viva King, Robin and Poppet John; in front, Beckers Wilson

With Matthew Smith

With Fiore de Henriques (photograph by Felix Fonteyn)

donate pictures for one or another category of war victims. But it was on behalf of artists he exercised himself most energetically. He had been one of those, along with Eric Gill, Henry Moore and Ben Nicholson, who, in 1933 the year of Hitler's ascendancy, had helped to form the Artists' International Association. The aim of this body had been to establish an army of artists opposing the advance of 'philistine barbarism', to repulse which it erupted with periodic exhibitions 'Against Fascism and War'. In one major objective, which (it noted) was 'preventing war', the association had been defeated. But, believing 'all art is propaganda', it persisted in these war years with shows to which John prominently contributed. He also presented several pictures to sales for raising war funds and used his influence to free a number of German and Austrian refugee artists who had been interned by the British Government.*

Though remote from politics, John was not aloof from the effects of political actions on ordinary people – especially gypsies,† on whose behalf he wrote to newspapers and petitioned members of parliament to the end of his life. But the war, itself a political explosion, affected everyone. 'People carry on marvellously through it all I must say,' he wrote to Conger Goodyear on 19 April 1941. ' . . . Life in London goes on much as usual except that people don't go out so much at nights – though I do.' It was an uneventful time, 'punctuated with pinpricks'. There was less to eat and drink, but they were rich in vegetables at Fryern and from friends and family in America came many parcels of food, whisky, pipes. No longer could he rove and rumble round France, but there was Mousehole in Cornwall where one of his daughters-in-law now lived – 'very pleasant. I go to Penzance for my rum.' Petrol rationing had made travel even in England difficult ('we hardly move a yard'), but the trains still ran between London and Fordingbridge, and since his journeys were 'really necessary' he could admit, in moments of expansiveness, to being 'moderately gregarious'.

The country, in wartime, was 'like a paddock which one grazes in, like a cow, but less productive'. To enliven the scene at Fryern 'we must get a lot of children,' he announced.[729] He was particularly keen to attract

* Among John's papers is a letter from Oscar Kokoschka thanking John for his attempts to help him escape from Prague.

† 'After my election to the House of Commons in 1950,' Montgomery Hyde wrote to the author, '. . . I took up the cause of gypsies. At that time they were being pushed around by the police, particularly in Kent, and Augustus took a lot of trouble in briefing me on the subject of their troubles. He was convinced that their periodic clashes with the police which were reported in a not too favourable press at the time were largely due to a misunderstanding.' His campaign ranged from an article in *Encounter* (1956) to physical intervention in the case of Sven Berlin, whose house the authorities were attempting to convert into a public lavatory.

black children – 'darkies' as he called them – and by the spring of 1940
he and Dodo had five evacuees, all white. Dodo herself appeared to take
no notice of the war, spending it in the garden; but John's letters are
full of jibes against 'old Schicklgruber'. In London no one could ignore
it. 'London is being badly bombed,' he wrote to his sister Winifred on
18 October 1940. 'I was up there with Vivien the other day and saw a
good deal of devastation. Still the people are sticking it out *wonderfully*.
Life goes on as usual – in the day time, and the streets are full of
people and all very cheerful in spite of loss of sleep. The row at night is
hellish.'

He was determined not to allow these disturbances interrupt his work
– a programme that sometimes endangered his sitters. One of them,
Constance Graham, remembers posing for him when an air-raid broke
out overhead. John 'was utterly unperturbed, and we were seated by the
enormous studio window while the bombs buzzed overhead. They
might have been blue bottles for all he cared so of course I felt obliged
to remain equally unmoved.'

London had become a village. People stopped each other in the
streets, swopped stories about last night's raid, drank together, made
one another laugh. John, like a great tree in the wind, swaying from one
pub to the next, was a cheerfully reassuring sight. 'He is like some great
force of nature,' noted Chips Channon,[730] 'so powerful, immense and
energetic.' It was out of the question that anything Hitler could do
might disturb him. While the 'Doodle-Bug' or 'Buzz-Bombs' were
falling, twice 'buggering up' his Tite Street studio, he would sit with
Norman Douglas and Nancy Cunard in the Pier Hotel at Battersea
Bridge, where the 'drink supply had generously expanded – to steady
the clients' nerves'.[731] There was a marvellously enhancing quality about
his presence that seemed to come from the earth itself. After an evening
here, or at the Gargoyle Club in Dean Street, or the Antelope in Chelsea,
he liked to invite his drinking companions, for a last unneeded drink or
two, back to Tite Street. At such times there was something undeniably
lovable about him; by turns generous then angry, an old gentleman
wobbling through the black-out. Back at Tite Street, on one fuddled
occasion, he laid himself down vaguely on top of Michael Ayrton, as if,
Ayrton recalled, quite shocked, 'I were his daughter'. The third member
of the party, Cecil Gray, snatching up his Quaker hat, shouted: 'I'm
not going to remain here to watch this', and opening a door, walked
into the broom cupboard. 'He's gone into the broom cupboard,' John
declared, sitting up. 'By God he has!' Ayrton agreed, also sitting up.
They stared at the closed door from which faint scufflings could be
heard. Then Cecil Gray knocked, came in and took off his hat: 'I think
I'll stay after all'. After which they all went to sleep.

Such stories as these, revealing an innocence not altogether lost, endeared him to his friends. 'Look at Augustus John!' proclaimed Norman Douglas. 'Take away his beard, close-crop his hair and Augustus would be as impressive as before. Him I admire not only as a fine man but for his way of thinking about life. Alas! I fear *he's* the last of the Titans.' In wartime his stature appeared to grow. He was unafraid, and there seemed to be an external enemy to account for his obscure look of suffering. People now needed parties, drink and the boosting of their morale in much the same way as he had needed these things in peacetime. Homes and buildings were everywhere being destroyed; friends, family, lovers killed. The marks of torture on John's face reflected what everyone was feeling. But his real enemy was invisible. Late one night, when Michael Ayrton was being driven home, his taxi, swerving suddenly to a halt, nearly ran over a pedestrian. It was John. Tears were streaming down his face. At Ayrton's insistence he got into the taxi to be taken back to Tite Street. 'It's not good enough,' he kept murmuring to himself. Disliking histrionics, and believing the old actor to be up to his tricks again, Ayrton tried to tease him out of this mood. 'What girl is that, Augustus? What girl's not good enough?' John gave a dismissive wave. 'My work's not good enough,' he said; and Ayrton suddenly understood that this was a deep grief. Nor would John be comforted: 'My work's not good enough.'

It was seldom he could speak of anything for which he felt deeply. 'The only English thing about me is my horror of showing emotion,' he once confessed to Mary Keene.[732] 'This makes my life a hideous sham.' This 'sham' was a necessary covering against what he called 'the ghastliness of existence'.[733] Only those close to him appreciated how much he hated this war. His five adult sons were in different services; Vivien had become a nurse, Poppet worked in a canteen. Everyone, even the girls, seemed to be in uniform. In such circumstances it was 'not amusing' to remain a civilian. 'I think of joining the Salvation Army,' he joked,[734] 'though I believe the training is severe.' What depressed him was 'this foul and bogus philosophy of violence'.[735] It was a world war to end all worlds he could recognize as his own. 'I can hardly bear to think of France being overrun by those monsters,' he told Will and Alice Rothenstein.[736]

He tried to keep working, but felt that he was missing much and that eventually painting might become 'impossible in England. The future for an artist in particular looks very problematic,' he admitted to Evan Morgan.[737] But this war, which was to transform the entire art world, eroding the influence of figurative painters and setting up an international style of art that would be severely abstract, had at first produced the reverse effect. Owing partly to Britain's isolation and the difficult

conditions for young painters, attention was forced back to previous generations of artists, to Whistler, Sickert and John himself. In November 1940, the National Gallery assembled one hundred and twelve Augustus John drawings 'representative of various aspects of my draughtsmanship from student days to the present'. 'It is an astonishing record,' wrote Herbert Read,[738] 'and it is doubtful if any other contemporary artist in Europe could display such virtuosity and skill.' A year later Lillian Browse produced her successful volume *Augustus John Drawings*, and in 1944 John Rothenstein his Phaidon Press *Augustus John* which, despite wartime restrictions, went into three editions in two years.

In June 1942 he was named by George VI to the Order of Merit. Rumours of a knighthood had been blowing about the previous year. The prospect cheered John mightily, but Dorelia would not countenance it. *She* wasn't going to be known as 'Lady John'; it was ridiculous, out of the question. The knighthood receded and for a few moments John was mightily cast down. Then, three months after the death of Wilson Steer, he was offered the O.M. – a far more distinguished award, it was explained: and he brightened at once. 'It is of course a matter both of pride and humility to succeed Steer in this order,' he instructed D. S. MacColl on 25 June 1942.[739] He was engulfed with congratulations: but there were some who deplored the old anarchist accepting recognition from the State. His response to all criticism was that people should be allowed to do whatever they liked, and benefit by whatever gave them pleasure. Of compulsory hereditary titles he disapproved but found in other awards a romantic appeal. He supported Anthony Wedgwood Benn's fight against disqualification as a member of parliament due to peerage.[740] But he defended Herbert Read's 'courageous decision' to take on a knighthood in 1953 when his fellow-anarchists were sharply critical. 'Although we may diverge in some matters, I think you were quite right to accept a knighthood (though I feel it should have been a baronetcy),' John wrote to him.[741] 'If there is one thing certain, it is that there is no such thing as "equality" in human society, and your Order, symbolizing this truth, justifies itself in admitting you.'

As for his own award, though not to be over-valued, it gave him a deal of innocent pleasure. 'Would you believe it?' he exclaimed in a letter to his sister Winifred. 'It is the rarest of all orders.' He treated it in the manner of a private transaction between himself and George VI – and particularly good of the monarch considering how much of his wife's time he had squandered. But he discouraged outsiders from concerning themselves with it. 'I only remember the O.M.,' he reprimanded D. S. MacColl, 'when others forget it.'

2. IN ASKELON

'I am two people instead of one: the one you see before you is the old painter. But another has just cropped up – the young writer.' With these words at a Foyle's Literary Lunch in March 1952, John announced the publication of *Chiaroscuro*, his 'fragments of autobiography'. It had been a lengthy cropping-up – a month or two short of thirty years. 'I think we must all write autobiographies. There would be such side-splitting passages,' he had urged Henry Lamb on 13 June 1907. But it was not for another fifteen years that he was first importuned by a publisher, Hubert Alexander. 'I've been approached by another firm on the subject of my memoirs,' he replied on 21 February 1923. The approaches multiplied, grew bolder; the delay lengthened, became confused. A synopsis – three-and-a-half sides of Eiffel Tower paper in fluent hand-writing reaching forward to 1911 – was probably done before the end of 1923, but sent to no one; and another period of fifteen years slipped by before a contract was signed. The interval was full of rumours: whisperings of vast advances* and extraordinary disclosures, almost all of which were unfounded.

'Other people's writing has always interested me,' runs the first sentence of *Chiaroscuro*. He was surprisingly well-read – surprisingly because he was never *seen* with a book. At Alderney and Fryern visitors were made to feel it was somehow reprehensible to be caught in the act of book-reading. John himself read in bed. He devoured books voraciously, reading himself into oblivion, to escape the horrors of being alone. His library, an unselfconscious accumulation, reflected the wide extent of his tastes – occultism, numerology, French novels, Russian classics, anarchical studies, Kaballah – and the ill-discipline with which he pursued them all.

He had long dreamed of writing. Privately he composed verse – ballads, sonnets, limericks – and was immoderately gratified when Dylan Thomas exhorted him to pack in painting for poetry. But he had also written for publication: first, with the encouragement of Scott Macfie, for the *Journal of the Gypsy Lore Society*; then, with the approval of T. E. Lawrence, a preface for a J. D. Innes catalogue; after that, with the help of T. W. Earp, his eight articles on painting for *Vogue*; finally, with Anthony Powell's support, an essay on Ronald Firbank. He needed encouragement, and when Jonathan Cape offered him a contract in 1938 he responded eagerly.

* 'Did I tell you about August[us] John, whom I duly tackled or rather sounded, weeks ago? He said lots of publishers had been at him. One offered him £10,000 in advance for his memoirs. He said, "Oh, that's not enough: I want £20,000". They rose to £13,000.' T. E. Lawrence to Jonathan Cape. See Michael Howard's *Jonathan Cape, Publisher* p. 151.

This contract is an engaging work of fantasy. John would deliver his completed manuscript by All Fools' Day 1939 'or before'. The length was to be 'at least 100,000 words' and it should be 'copiously illustrated'. The prospect excited everyone. 'I believe this to be a big book on both sides of the water,' enthused his American publisher.[742] Much correspondence crossed this water over the next twelve months from one publisher to the other: but from John, nothing. He had equipped himself with a literary agent* to whom, on 2 May 1939, he expressed his appreciation of their dismay. Nevertheless 'the idea of the book has developed and interests me more and more,' he maintained '. . . when I am quite myself again it will unroll itself without much difficulty and turn out a success'. This game continued for another year. To each fast service he would return the same slow lob. The war, interpreted by his publishers as a cause for acceleration, he re-interpreted as a fresh reason for delay. Yet he continued patiently to play the optimist. Already by January 1940 he had made 'an important step forward in destroying what I have already written,' he promised Cape. In vain his agent would expound John's method of allowing 'his work to accumulate until everybody loses patience and subsequently complete it in an incredibly short time'. It was a case of 'this year, next year, sometime – ' growled Cape.[743] 'Each time I have seen him [John], he has told me how busy he is, painting portraits.'[744] The publishers formally conceded defeat in the autumn of 1940, the fabulous contract expired and this first stage of negotiations was at an end.

But Jonathan Cape himself had not surrendered. 'I have the strong conviction that John is a natural writer,' he had told the American publisher. The book had been conceived; what it now needed was a team of midwives to nurse it into the world. First of these aides memoir was Cyril Connolly, who had recently launched his monthly review of literature and art, *Horizon*. In conversation with Connolly one day, John volunteered to write something for the review, and this led to an arrangement whereby Cape allowed Connolly to have, without fee, what amounted to serial rights in John's autobiography. Between February 1941 and April 1949, when he relapsed with nervous exhaustion, John contributed eighteen instalments to *Horizon*.[745] He liked writing in short sections and, every time he had a few pages ready, he would organize an evening with Connolly in London. Without this constant support, it is unlikely that the book would ever have been written.[746] John's letters are full of author-complaints. 'Writing costs me great pain and labour,' he pointed out to Leonard Russell,[747] 'besides taking up much time.' He seized upon air-raids, black-outs, apple-tree accidents, electricity cuts, bouts of 'Mongolian 'Flu', broken ribs, operations, thunderstorms

* M. S. Wilde of the British and International Press.

– any narrow squeak or Act of God that made painting impracticable – to turn to 'my literary responsibilities'. The guaranteed publication in *Horizon* helped to give him impetus, but his contributions there have a stranded look – unconnected with anything happening in the world or with much else in the review.

At the beginning of 1949 Jonathan Cape tiptoed back into the arena, and John was persuaded to reorganize his *Horizon* pieces into a book. He made heavy weather of this 'colossal task'.[748] Secretaries were provided; he changed his agent; joined the Society of Authors: but the written word was still recalcitrant. In place of Cyril Connolly, Jonathan Cape dispatched John Davenport as literary philosopher and friend, and the two of them 'spent many pleasant days together at odd intervals'.[749]

Back in London, Cape foamed with impatience. He began to petition some of John's friends and, a bad blunder, girl-friends. Learning this, John fell into a passion. His publisher was excavating for 'scurrility and scandal which I'm not able or willing to provide'. To John Davenport he pointed out the terrible lesson this had taught him against over-familiarity with tradespeople. 'I regret having been inveigled into getting on friendly terms with this business man. . . . He had incidentally an eye on Mavis.'

In 1950 Cape sent his last ambassador to Fryern, Daniel George. 'My function was merely that of the tactful prodder, the reminder of promises, the suggester of subjects, the gentle persuader,' Daniel George wrote.[750] John's writing technique, similar to his method of painting, depended upon timeless revision. 'From time to time I would receive from him two or three quarto sheets of small beautifully formed and regular script,' Daniel George remembered. ' . . . On one such sheet now before me are twenty-five lines, only seven of which are without some emendation. One line reads: 'I am a devil for revision. I cannot write the simplest sentence without very soon thinking of a better one". Here the words "very soon" have been changed to "at once".'

John called it 'putting my stuff in order'. Once a few pages had been typed, they were sent back to him, and after further copious corrections he would submit them for re-typing. They were then returned to him and he would set about 'improving certain recent additions and making a few new ones'.[751] This process would jog on until, somewhere on its peregrinations, the typescript was mislaid. 'I am most unmethodical,' John admitted,[752] 'and have been troubled too by a poltergeist which seizes sheets of writing from under my nose and hides them, often never to reappear.' It was Daniel George who released him from this deadlock by inventing a conspiracy of forgetfulness. He 'forgot' to send the revised revisions back to John who forgot never having received them.

It worked perfectly. After this John's area for revision was restricted to the title, which he altered a dozen times before uniting everyone in opposition to his final choice, *Chiaroscuro*.*

The book was reviewed widely and favourably. Lawrence Hayward in *The Guardian* called John 'a writer of genius', and other distinguished authors, including Desmond MacCarthy, Sacheverell Sitwell and Henry Williamson all specially praised the quality of his prose.[753] 'Augustus John is an exceptionally good writer; and upon this most reviewers have dilated, with a tendency to compare him with other painters who have written books,' criticized Wyndham Lewis in *The Listener*.[754] 'This is the obvious reaction, it would seem, when a painter takes to the pen: to see a man of that calling engaged in literary composition, affects people as if they had surprised a kangaroo, fountain-pen in hand, dashing off a note. The truth is that Augustus John is doubly endowed: he is a born writer, as he is a born painter . . . '

These reviews were an accurate measurement of the great affection in which John was held – an affection that ignored the unhappy complications of his character. 'What a pleasure it is to read this robust autobiography of a man who has achieved all he has desired from life,' exclaimed Harold Nicolson in *The Observer*. To the devastating irony of such a conclusion many were blind. Only Tom Hopkinson, in *Tribune*, attacked the book in print; otherwise criticisms were voiced in private. One of the most severe critics was the man who, perhaps more than any other, had helped to get it written: Cyril Connolly. In Connolly's view, despite the long years of preparation, John had not gone through enough agony. 'For someone who was such a brilliant conversationalist he was terribly inhibited when he wrote . . . He would fill his writing with the most elaborate clichés. He couldn't say "she was a pretty girl and I pinched her behind". He would say: "The young lady's looks were extremely personable and I had a strong temptation to register my satisfaction at her appearance by a slight pressure on the *derrière*".'[755]

Only in the opening pages, recalling his boyhood in Pembrokeshire, did John achieve a sustained and imaginative narrative. The rest of the autobiography arranges itself into a scrapbook, broken up into brief, haphazardly plotted incidents without reference to dates or chronological sequence. The absence of any discussion of his work, or any self-revelation, disappointed some readers.† Increasingly he relied on a

* *Painter in Masquerade, A Painter's Life, Painter's Pastime, Painter's Pantomime, Painter's Paradise, Painter's Patchwork, Painter in Patchwork, Many Coloured Life, Episodes and Reticences* and *Who Am I?* were some of them.

† In a passage which the editor J. R. Ackerley removed from Wyndham Lewis's review in *The Listener* (20 March 1952) Lewis had written: 'There is one more thing I would like to say about a future book by John: namely why should there not be

procession of famous names and a chain of indistinct anecdotes relating, with much relish, the misfortunes of his friends and the loss of their women to him – traits that were to be amusingly parodied by J. Maclaren-Ross.[756]

John's preference for a combination of long reverberating syllables to a single short word greatly encumbers his prose, but does not conceal his genuine enjoyment of language. There are many passages of sudden beauty, of wit and penetrating irony: but being unattached to anything they do not contribute to a cumulative effect. He had laboured long at these fragments, but never to connect them, and the result, he concluded, was 'a bit crude and unatmospheric'. Contrasting Caitlin Thomas's *Leftover Life to Kill* with *Chiaroscuro*, he wrote to Daniel George: 'As a self-portrait it's an absolute knock-out. Unlike me she cannot avoid the truth even at its ghastliest.'

There is an obvious parallel between John's writing and his later pictures. In both the many accomplished parts do not add up to an accomplished whole. His talent had been for turning what was visual into something imaginative – the women, children and landscapes had been real. But by transferring his faults, making them objective over a long time, he had helped to contaminate the world around him – the people, even the places. This, the wars and the industrial changes that had taken over France and England, made much of the visible world horrific to him. Latterly he did not attempt to transform reality but to establish a fantasy world in opposition to it. This involved working against the grain of his natural talent, which was for intense observation rather than invention. He was one of those for whom, however long he might shut himself away in his studio, the visible world existed. The intermittent portraits he painted were one sign of this; his continued writing was another.

As soon as *Chiaroscuro* was published he started 'writing on the sly'[757] a second series of fragments. John Lehmann, editor of the *London Magazine*, and Leonard Russell of *The Sunday Times* assisted one section or another into print, and 'Book-lined Dan', as he now called Daniel George, continued with him to the end. As with *Chiaroscuro*, there are good pages.[758] But generally this second volume is scrappier than its predecessor. The fragments are often abrupt and composed with such a wealth of hintings and obscurities that it is difficult to quarry out any meaning. John had become so 'literary' that he could not achieve an

something in the way of a "Confession"? He informs us at the end of "Chiaroscuro" that he does not lay bare his heart, which, he adds, concerns no one but himself. I think he is wrong there, everyone would be delighted to look into his heart; and so great a heart as his is surely the concern of everybody.' John persisted in his reticence, not wishing, he claimed to 'spoil other people's fun' later on.

innocent style. Against the background of his paintings, simple and primitive at their best, the deviousness of this writing is extraordinary. Like a cataract, it had spread over his eyes, obscuring his painting too. In the book he focused his mind retrospectively on the actual world which, in these last years, held for him a lessening interest. His dream world, an anthology of past sights and sensations, lay elsewhere serenading his imagination. In almost ten years he completed a hundred-and-ten pages – and his passion for postponement seemed to extend even beyond the grave. Not until three years after his death and four years following the death of Jonathan Cape was it published, in 1964.

There could be no amendments this time to the title which, unintentionally, summarized all that had plagued him most: *Finishing Touches*.

3. THE MORNING AFTER

Our late Victory has left us with a headache, and the Peace
we are enjoying is too much like the morning after a debauch[759]

For John, the war had been a winter, long, dark, 'immobilizing me for a devil of a time'. Six years: then all at once 'a whiff of spring in the air, a gleam of blue sky . . . renewal of hope and a promise of resurrection'.[760] It was impossible not to feel some tremor of optimism. Though the world had been spoilt 'there must be some nice spots left'.[761] He was still able-bodied – it was time to be on the move again. But moving had somehow become more difficult. 'We sometimes refer to St Rémy,' John wrote to his son Edwin, 'and, in monosyllables, wonder if we might venture there with car.' It was not until the late summer of 1946 that he came again to the little *mas* 'au ras des Alpilles'.

He had left, in 1939, after much anguish and delay. His neighbour Marie Mauron remembered that day: 'Il regarda au mur les toiles qu'il laissait inachevées, les meubles qui avaient charmé sa vie provençale de leur simplicité de bon aloi, les beaux fruits de sa table et de ses "natures mortes", ses joies et ses regrets. . . . Sur quoi, Dorelia et lui, émus et tristes mais le cachant sous un pâle sourire, nous laissèrent les clés de leur mas pour d'eventuels réfugiés, amis ou non, qui ne manquèrent pas, et de l'argent pour payer le loger, chaque année, jusqu'à leur retour.'[762]

Seven years later they collected their keys. St Rémy had been a place of no military importance and the damage was not spectacular. Yet the war had left its shadow. 'Everything and everybody looked shabbier than usual,' John noted.[763] The *mas* had been broken into and a number of his canvases carried off: one of a local girl – 'a woman at St Rémy I simply can't forget' – he missed keenly. French feeding wasn't what it had been once and the wine seemed to have gone off. But in the evening,

at the Café des Variétés, he could still obtain that peculiar equilibrium of his spirit he described as 'detachment-in-intimacy'. The conversation thundered around him, the accordion played, and sometimes he was rewarded 'by the apparition of a face or part of a face, a gesture or conjunction of forms which I recognize as belonging to a more real and harmonious world than that to which we are accustomed'.[764]

To fit together these gestures and faces so that they reflected the harmony that played beneath the discord of our lives – that was still John's aim. 'I began a landscape to-day which seemed impossible,' he wrote to Wyndham Lewis in October. 'At any rate I will avoid the *violence* of the usual meridional painter. In reality the pays est très doux.' For two months he continued painting out-of-doors, and the next year he painted in Cornwall. Then in the summer of 1950 he returned to St Rémy, tried again, 'and I despair of landscape painting'.[765] That summer, as an act symbolizing this surrender, they gave up the lease of the Mas de Galeron. After this there was little point in travelling far. Each summer they would prepare for some journey west or south; the suitcases stood ready but the way was barred by unfinished pictures; autumn came, the air grew chill, and the unpacking began.

There seemed so little time. John could seldom bear to leave the illusory lands he was striving to discover in his studio; for the actual world had little to give him now. He moved about it like a ghost. William Empson recalls a last meeting with him in the 1950s. 'I came alone into a pub just south of Charlotte St., very near the Fitzroy Tavern but never so famous, and found it empty except for John looking magnificent but like a ghost, white faced and white haired. . . . it was very long after he had made the district famous, and I had not expected to see anyone I knew. "Why do you come here?" I said, after ordering myself a drink. "Why do you?" he said with equal surliness, and there the matter dropped. I had realized at once that he was haunting the place, but not that I was behaving like a ghost too. It felt like promotion . . .'[766]

For John, as for Norman Mailer, the 'fifties was 'one of the worst decades in the history of man'. The corrosive blight of the Industrial Age seemed to have attacked everything in which he once took pleasure. Even the public houses were being made hideous by 'manifestations of modern domestic technology' – dreadful wallpapers and monotonous contemporary furniture. Young girls walked about looking like the Queen Mother. The drab clothes, the rationing and restrictions all contributed to 'the sense of futility and boredom which, together with general restlessness and unease, marks the end of an epoch'.[767]

The future looked worse. 'My outlook on life or rather death . . . [assumes] a Jeremy Bentham-like gloom,' John told Tommy Earp.[768]

'We shall have little to do with the New World that approaches and, by the look of it, it is just as well.' He saw a special danger in the effect of architecture upon the philosophy of our lives. Government programmes ran on statistics, their success depending upon numbers. Millions of pre-fabricated bungalows, their concrete uniformity corresponding in no way to variations of local character and environment, threatened to iron all individuality out of their inhabitants. Already 'Paris at night has the aspect of a vast garage'; and as for London 'either it or I or both have . . . deteriorated greatly since our earlier associations which I so much loved'. There seemed nowhere, and he was 'reconciled', he told Mrs Cazalet, 'to a change of planet in the near future. If we are due to be blown to Kingdom Come, it may be our only chance of getting there after all.'

The end of austerity had inaugurated the age of Admass – an unprecedented vulgarity that John identified as another symptom of decadence. But this was also a time of fear. The hydrogen bomb seemed like a giant stride in the march towards self-destruction. The anxiety people felt about their future was something to which John was acutely sensitive. 'The bombs improve,' he wrote to his son Robin, 'the politics grow worse'. He had never been interested in the ephemera of politics. 'I've got a clean slate,' he swore to Felix Hope-Nicholson. 'I've never voted in my life.' But his mounting dislike of politicians – all politicians ought to be 'liquidated' he concluded[769] – marked a late-flowering concern with the political world, born of despair. The endless macaroni of depressing news from the radio coiled itself round the tentacles of his personal disappointments to form an unorthodox political creed. He had brought it into focus with one eye on the Utopia of the socialist philosopher Charles Fourier – a phalanstery where the community, based on natural groups instead of family units, ruled itself on a shareholder basis. The other eye, since the 1930s, had been on the man John saw as arch-villain of modern politics: Franco. In 1942 he had joined the Social Credit Party, 'our only certainty';[770] and in 1945, with Benjamin Britten, E. M. Forster, George Orwell, Herbert Read and Osbert Sitwell, he helped to establish the Freedom Defence Committee 'to uphold the essential liberty of individuals and organizations and to defend those who are persecuted for exercising their rights to freedom of speech, writing and action'.[771]

But John was not a man for committees and political parties. The best elucidation of his beliefs appeared in *The Delphic Review*,[772] a magazine edited in Fordingbridge. 'We are not very happy' – this was his starting-point. Looking round for the cause of this unhappiness, he sees the threat of catastrophe: 'the extinction not only of ourselves, but of our children; the annihilation of society itself'. Left to themselves,

he believed, 'people of different provenance' would not 'instinctively leap at each other's throats'. The atmosphere of political propaganda which we constantly breathed in from our newspapers, radios and television sets had promoted a reversal of our instincts. 'Propaganda in the service of ideology is the now perfected science of *lying* as a means to power.' For someone passionately neutral like himself and 'no great Democrat either', the best course had been silence. But silence was no longer a sufficient safeguard to neutrality. So 'I have decided that a practice of ceaseless . . . loquacity should be cultivated'.

By the end of the 1940s he began using words. National Sovereign States, he argued, were by definition bound to fall foul of one another. All nationalities are composed of a haphazard conglomeration of tribes. But the State, originating in violence, must rely on force to impose its artificial uniform on this conglomeration, transmitting its laws and class-privileges like a hereditary disease. 'The State', he warned, 'must not be judged by human standards nor ever be personified as representing the quintessence of the soul of the people it manipulates. The State is immoral and accountable to nobody.' The real quintessence of all people lay in their 'needs and in their dreams' – their need 'to gain their living; freedom to use their native tongue; to preserve their customs; to practise any form of religion they choose; to honour their ancestors (if any); to conserve and transmit their cultural traditions, and, in general, to mind their own business without interference'. Their need also to get back to the land: though many would not know what to do when they got there. 'The vast Common Lands of England, held by them from time immemorial . . . [were] completely enclosed by Act of Parliament, and only in the last century we have lost our Commons but kept the *House of Commons*, which played this trick and still give our votes to the suppliants who periodically come begging for a seat in the best club in London.'

Greed versus immortality: that was our moral quandary. John's alternative to 'the collective suicide pact' of the 1950s was for a breaking down of communities into smaller groups – the opposite of what has taken place in the last twenty years. He began with hedges. The modern hedge, with which the country had been parcelled out by financial land-grabbers, must be dug up: 'Hedges are miniature frontiers when serving as bulkheads, not wind-screens. Hedges as bulkheads dividing up the Common Land should come down, for they represent and enclose stolen property. Frontiers are extended hedges, and divide the whole world into compartments as a result of aggression and legalized robbery. They too should disappear. There is nothing sacred about them, for they are often shifted, as they have been erected, by force and fraud. They stand for no ethnological distinctions, for all races are inextricably

mixed, and, in any case, should not be divided but joined. Frontiers
serve no useful purpose for, costly as they are to guard, they have
never stopped a conqueror yet, or checked the scramble for *Lebensraum*.
They are obsolete militarily though still an incentive to aggression. They
give rise to the morbid form of Patriotism known as Chauvinism or
Jingoism. Frontiers besides are a great hindrance to trade and travel
with their customs barriers, tariffs and *douanes* . . .'

Without frontiers, John reasoned, the State would wither and the
whole pattern of society change from a heavy pyramid to the fluid form
of the amoeba 'which alone among living organisms possesses the
secret of immortality'. Our monstrous industrial towns, our congested
capital cities with their moats of oxygen-excluding suburbs would melt
away, and a multiplicity of small communities appear, dotted over the
green country, autonomous, self-supporting, federated, reciprocally
free. 'Gigantism is a disease,' he warned. ' . . . Classical Athens was
hardly bigger than Fordingbridge'.

Such beliefs, later commonplace among those advocating an alterna-
tive society to capitalism and communism, sounded strange in the late
1940s. During the last dozen years of his life John found himself part of
a growing minority. What joined him to others was the atomic bomb.
Progress by massacre, historically so respectable, was no longer possible.
Even the last war had shown this. The bomb had been hatched in a
climate of self-destruction. 'With only a limited capacity for emotion,
a surfeit of excitement and horror induces numbness, or a desire for
sleep: even Death is seen to offer advantages.' The malignant glooms
against which John had partly anaesthetized himself, the urgent un-
certainty, ill-thoughts of death – these that he had lived with so long he
now saw reflected in the faces of young people. 'It is impossible not to
be worried about world conditions,' he wrote to Cyril Clemens. 'We are
on the edge of a volcano.'

It was not just his own future now but everyone's that was in jeopardy:
'Since a competition in armaments can only end in collision, we may as
well face realities and decide what to do about it: for we are all respons-
ible. In the practice of some primitive "savages", warfare is a kind of
ritual: should a casualty occur through the blunder of an inexperienced
warrior, a fine of a pig or two will settle the business and everybody
goes home, (except one). Modern warfare is different. We'll all be in it,
the helpless as well as the armed, the women, the children and the aged.
There will be no quarter given, for the new Crusaders have no use for
"Chivalry". War will be waged impersonally from the power-house and
the laboratory. Science, once our servant, is now our master. Civilization
is doomed, our Planet itself in danger, and mankind will survive, if at all,
as brute beasts ravening on a desert island.'

By the late 1950s even words were not enough. John's beliefs had brought him in contact with Bertrand Russell whose anti-nuclear movement of mass civil disobedience, called the Committee of 100, he joined. 'You may count on me to follow your lead,' he assured Russell on 26 September 1960,[773] ' . . . it is up to all those of us above the idiot line to protest as vigorously as possible.' He had planned to participate in the demonstrations against governmental nuclear policy held on 18 February 1961 and on 6 August 1961, 'Hiroshima Day', but early in February suffered an attack of thrombosis that 'forbids this form of exercise'.[774] 'As you see,' he scribbled almost illegibly, 'I cannot write; still less can I speak in public, but if my name is of any use, you have it to dispose of.' Later he made a partial recovery, and came quietly up to London for the great sit-down in Trafalgar Square on Sunday 17 September. 'I have quite lost my hearing and am becoming a nuisance to myself and everybody,' he had told Russell. He loathed crowds, feared policemen, 'didn't want to parade my physical disabilities'; but he would 'go to prison if necessary'. The public assembly began at five o'clock, and until that time John hid. Unprecedented numbers took part in this demonstration. 'Some of them were making what was individually an heroic gesture,' Russell wrote.[775] 'For instance, Augustus John, an old man, who had been, and was, very ill . . . emerged from the National Gallery, walked into the Square and sat down. No one knew of his plan to do so and few recognized him. I learned of his action only much later, but I record it with admiration.'

The following month John was dead.

4. A WAY OUT

He had shrunk into old age. Over his lifetime the changes had been remarkable. Emerging from the little renaissance of the 'nineties, a romantic Welshman in a Guy Fawkes hat, he had imposed a new physical type, almost a new way of life, on British Bohemia. 'Under his influence', wrote Anthony Powell,[776] 'painters became, almost overnight, a bearded, silent, unapproachable caste . . . Huge families, deep potations were the order of the day. A new race of models came immediately into being, strapping, angular nymphs with square-cut hair and billowing smocks. The gipsies, too, were taken over wholesale, so that even today it is hard to see a caravan by the roadside without recalling an early John.'

Then, in his middle years, he had moved from the roadside into the town, a commanding personality in shaggy well-cut suits, embracing whole parties at the Eiffel Tower or in Mallord Street. He had swelled into a national figure, 'the demi-god round which the post-war carnival was danced'.

After the Second World War there had been no carnival, and he retired to a quieter country life. The caravans had halted; the fierce nights in Chelsea and Fitzrovia drifted into dreams; the national figure itself whitewashed and converted into a national monument to be photographed on birthdays. To art-students he was now irrelevant. One of them, visiting Fryern in 1948, found him 'old and very deaf . . . It was rather like visiting Rubens. . . . I noticed various goats and people dotted about in the sun. I noticed too, as we stepped into his surprisingly small and cluttered studio at the end of the garden, that he came alive, his rambling memory returned and he moved about the canvases with the agility of youth.'[777]

Most of his days were passed in this little studio. He painted there each morning, and in winter Dodo would send in to him a little milk-and-whisky. After lunch he slept for an hour, then returned to the studio until tea time when he would come stumping across to the house for two cups of punctual cold tea. His mood depended upon his work, which was never good enough. He would sit with his hands round the cup, growling complaints. In summer he often went back to the studio again and continued painting until half-past six or so. Then out would come the wine bottles from the telephone cupboard, perhaps a visitor or two would call, and he relaxed.

Dodo, who he claimed was becoming more 'tyrannical', treated him as a child. He was sent to bed at about eight and would have his dinner brought to him on a tray. He listened to the radio a lot at night, growing frantic with knobs and the wilful obscurities of the *Radio Times*. In bed he would wear his beret at a revolutionary angle or, when it was mislaid, a straw hat, and often fell asleep in it, his pyjamas smouldering gently from his pipe, the radio blaring around him with competing programmes.

In these last years John and Dodo have been represented as Darby and Joan. The 'resentments had faded away with the years', Nicolette Devas has written.[778] They were 'enviable in the peace between them'. There were days like this, and there are photographs that catch these moments of tranquillity. But difficulties persisted almost to the end. Outrage was never far below the surface of John's melancholia. The fanatical stare put some people in mind of Evelyn Waugh. 'Shocked by a bad bottle of wine, an impertinent stranger, or a fault in syntax, his mind like a cinema camera trucked furiously forward to confront the offending object close-up with glaring lens': Waugh's description of himself is closely tailored to John.

He found it difficult to accept the limitations of old age. The world closed in on him. 'Age in my case brings no alleviation of life's discomforts,' he told Sylvia Hay,[779] 'and the way to the grave is beset with

pot-holes'. He was often breaking fingers, ribs, legs. 'I am too old for these shocks,' he admitted.[780] But it was less accidents that tormented him than galling disabilities. He hated having to rely on spectacles to see, a hearing-aid to understand. He would borrow other people's spectacles – 'I say, these are rather good. Where did you get them from?' But his hearing-aid infuriated him and he would hurl it across the room into a corner where it lay feverishly ticking. The trouble, he explained to friends, was that Dodo grudged spending the money on batteries: it had come to that. He had reached the age 'when one is far too much at the mercy of other people. I shall never get used to it – nor will they.'[781]

Old age had become his schoolmaster but he was always playing truant by darting up to London. 'Augustus, when he comes to town, seems to set a terrific pace,' Mavis wrote in the 1950s.' I wonder how the old boy doesn't drop dead in his tracks.' Almost always he would demand her presence for 'an hour or two's sitting and a sweet embrace.' 'Must get hold of the old cow,' he would gruffly tell other people. She could still – 'how was it possible?' – make him forget his age, and their battles at the bar of the Royal Court Hotel, or at the Queen's Restaurant in Sloane Square, were precious to both of them.

He had given up Tite Street in the autumn of 1950 'and am on the pavement till I find another studio'.[782] The new studio he found was in Charlotte Street, the very one he had shared with Orpen and Albert Rutherston after leaving the Slade. It belonged now to his daughter Gwyneth, who lent him a room there. For an easel he turned a chair upside down, but the light was not good and he did very little work in town.

He came to London to escape the 'decrepit' household at Fryern and, by implication, his own decrepitude, and would put up at 14 Percy Street, where Poppet kept a flat. He never gave warning of these trips, but expected everyone to fit in with him the moment he arrived. Otherwise he would grow depressed and begin dialling girl friends and old cronies – anyone who might be free to lead him astray for a few hours. Robert and Cynthia Kee, who had a room next to his at Percy Street, could sometimes hear the stentorian blast of his snores, mixed with powerful swearing, through the dark. At night, it seemed, he fought again the old campaigns, vanquished long-dead rivals. But during the day his manner was guardedly courteous, sinking periodically to alarming troughs of modesty.

He was still, even to the age of eighty, apparently in the thick of life. 'He could outdrink most of his companions and engage in amorous – if that is the word – relations that would have debilitated constitutions generally held robust,' remembered John Rothenstein.[783] The two of

them would go off into Chelsea and be joined by others. 'After a longish visit to a bar he would apprehend that his guests might be inclined to eat. "I want to stay here for a bit longer. There's a girl who's going to join us. Sturdy little thing . . ." We would wait. Sometimes she would turn up and sometimes not. Augustus did not seem to mind, assured that before the evening was finished there would be others.'

He still distributed love-poems – only now it was the same poem he handed out to everyone; he was still given to sudden lunges at women, but took no offence at their rebuffs. 'May I fig-and-date you?'* he politely inquired of Sonia Brownell. Very often these days he felt relief at being spared such duties, but he was seldom so discourteous as to forget them. Nor were they always refused. Late one night at Percy Street a young girl with long fair hair came beating on the door, shouting that she loved him and must be let in. The Kees cowered beneath their bedclothes, the old man's snoring halted and he eventually heaved himself downstairs. There followed a series of substantial sounds, then silence. Next day several of the bannister supports were missing, there was blood on the floor and, more mysteriously, sugar. John looked sheepish. ''Fraid there was rather a rumpus last night,' he muttered. Later that day he visited the girl in hospital and came back elated. 'Said she still loved me,' he declared wonderingly.

To everyone's consternation he had fallen in love in 1950 with a young art-student. To separate them, Poppet dragged him and Dodo down France to her house at Opio. John arrived very depressed. For days he was abominably rude to Dodo who sat silently absorbing his insults. Eventually Poppet flared up into a red-hot temper. 'Didn't know you had it in you,' John exclaimed, beaming. He seemed delighted, and quickly regained his spirits. 'Not going to lose your temper again, are you?' he would ask hopefully from time to time during the rest of their holiday.

From the prison of old age, he saw his family as gaolers. Dodo, he complained, barred all visitors, never spoke, was 'practically illiterate' and had made Fryern into a tomb. The place was 'infested with relatives'. On good days he took most delight in his grandchildren and liked to league with them against their 'respectable' fathers. On bad days it was often Dodo he attacked, because she was there. 'I begin to think it's about time,' he wrote to Robin on 3 September 1961, 'that I put an end to our relationship. She comes from a stinking cockney breed.' Gwen, he recalled, had felt the same. When the two girls had 'walked to Rome', John had offered Dodo a pistol, but she had preferred to take a passport. It proved what 'a fishy lot' the McNeills were. 'I'm glad you at least are a true-bred Nettleship,' he congratulated

* i.e. fecundate.

David (27 October 1956). This querulousness, which was sometimes violent, masked his real agony: his vanished talent and the irreversible change of life. It was Dodo who had kept him alive and helped, therefore, to make him older. By identifying her as an enemy and deliberately making his complaints absurd, he tried to diminish the pain. As a device it acted like a drug, numbing the truth. But the side-effects were powerful: strong personalities make hypocrites of us all. Then the effects would ebb away and he was confronted by the full horror of his condition. 'Hell seems nearer every day. I have never felt so near it as at Fryern Court. There must be a bricked-up passage leading straight to it from here. I see no way of escape. Meanwhile I have to pretend to work away gaily and enjoy my world-wide renown . . .'

The pretence, though still accepted by the world, had become very brittle. It took little to crack it. Cyril Connolly remembers him having lost his temper with a taxi-driver, bursting out of the taxi and measuring up to fight him in the road.[784] 'I'm sorry, but it's the right fare,' insisted the driver. 'Why, so it is,' hesitated John, lowering his fists. 'I apologize.' In a moment he had changed from an angry giant to a gentle, Lear-like old man, confessing his error and touchingly polite to the driver, who was himself overwhelmed with remorse.

In 1951, though warned by mutual friends against it, Alan Moorehead suggested to John that he write his biography. 'I was captivated by John at that time,' Moorehead records, ' . . . and I believed that my genuine admiration for him would smooth over any difficulties that arose between us'. At John's suggestion they met in the saloon bar of the Royal Court Hotel, a quiet spot, he described it, where they could chat undisturbed. 'Directly he walked in . . . all conversation among the other customers ceased while they gazed at the great man and listened with interest to the remarks I shouted into his hearing-aid.'

John was inclined to think a biography not possible. He had no head for dates and many of his friends were dead 'usually through having committed suicide'. Yet the past for him was not a different country. 'He appeared to look back on his life as he might have looked at a broad large painting spread out before him, all of it visible to the eye at once, and having no connection with time or progression', Moorehead noticed. 'It was the sum of his experiences that counted, the pattern they presented . . . Once one grew accustomed to this approach it had a certain coherence and I believed that with persistence I could enter, in terms of writing, into that close relationship that presumably exists between a painter and his sitter.' It was agreed he should start work at once, calling on those friends who had so far failed to commit suicide and meeting with John from time to time to check his notes. After several months Moorehead ventured fifteen thousand words on paper

'as a sort of sample or blue-print' of the projected book, and sent them to John. 'This typescript,' he records, 'came back heavily scored with a pen, whole pages crossed out and annotated with such comments as "Wrong" and "Liar".' It was accompanied by a letter: '*All* your statements of fact are wrong. I prefer the truth. Your own observations I find quite incredibly out of place. I must refuse to authorize this effort at biography.'[785]

'I can remember,' wrote Moorehead, 'feeling appalled and humiliated – indeed after all these years the rebuff is still fresh and it remains in some ways the worst set-back I have ever experienced in my attempts to write.'

The two of them were due to meet that month at a Foyle's lunch. Moorehead was 'determined to go to this lunch and to have it out with him'. As soon as the speeches were over John made for the door with Tommy Earp, growling out at Moorehead as he passed: 'Come on.' The three of them went by taxi to a Soho wine shop, and there Moorehead tackled him. 'I thought for a moment he was going to strike me. Where, he demanded, had I obtained the information about his father's Will? I had gone to Somerset House, I replied, and had got a copy. What business had I going to Somerset House? That was spying . . .'

The argument went on long, reaching nowhere, until Moorehead revealed that he had abandoned the biography and was sailing to Australia next week. John then grew calmer, the blue eyes glared less loudly, and when they said goodbye he was gruffly amiable. A week later Moorehead's ship reached Colombo. There was a cable waiting for him from John: '*For heavens sake lets be friends*'. 'I remember now the feelings of intense relief, contrition and happiness with which I read those few words,' he wrote. 'In an instant all was well again. . . . After all these years I am left admiring him as much as I ever did. If there was pettiness in his life and much ruthlessness, he was also a mighty life-enhancer and a giant in his day . . . Reflecting, long after our contretemps, about his really passionate anger at my mentioning such matters as his father's Will, I saw that in a way he hated his own wealth and his notoriety. These things diminished his true purpose which was to paint to the final extent of his powers.'

Difficulties, like watch-dogs, lay about his work and it was almost impossible not to stir them up whenever anyone approached him professionally. Over a book of fifty-five drawings that George Rainbird published in 1957, no one escaped censure, because no one was 'able to tell the difference between a drawing and a cow-pat'.[786] Lord David Cecil, who contributed a long introduction, came from a good family but clearly knew nothing about art; Rainbird was a philistine businessman; and from the expert advice of Brinsley Ford, John sought relief

through referring to him by his initials. 'I prefer,' he told Joe Hone,[787] 'to make my own mistakes'. To other people's eyes these mistakes arose from his preference for his current work. 'References to my early efforts sometimes make me sick,' he grumbled to D. S. MacColl, ' – as if I had done nothing since'.

The contrast between the old and new was often painfully marked, particularly when, in 1954, four hundred and sixty exhibits from all periods of his career were shown together in the four rooms of the Diploma Gallery in Burlington House. This great honour John treated as an affliction. For months he worked feverishly in order to have as many of his recent pictures as possible ready for 'this threatening show', which he had successfully postponed for two years. 'I am trying to live down my adolescent past,' he pointed out to John Davenport, 'but I cannot bury it altogether. I have sweet hopes of my maturity though.' For much of the time he was at loggerheads with the hanging committee, especially the President, Sir Gerald Kelly. Shortly before the official opening he was invited privately to go round the gallery and took advantage of this invitation to 'eliminate' about a dozen early canvases ('by no means enough') modestly claiming some of them to be forgeries – a charge that, as soon as it was too late to re-introduce them, he withdrew.

Though he had continued to be ogled by Fleet Street and by the public as the Grand Old Man of Bohemia, he had not received much serious critical attention since the 1930s. This vast Diploma show gave an opportunity for critics to estimate his work again. Apart from a few miscellaneous pictures, the exhibition could be divided into three parts: a dazzling display of early drawings; a compact group of small panels executed between 1910 and 1914; and the portraits. Perhaps the fairest summary of his career appeared in *The Times*.[789] The display at Burlington House, this critic wrote, made his 'neglect seem outrageous, but at the same time explains it'.

'The effect of the drawings, when seen in such abundance, is overwhelming. They do more than explain why Mr John's contemporaries were convinced that here at last was a great modern artist in England; they suggest even now that a genius of that order had really appeared. . . . His power of draughtsmanship would have fitted him to work in Raphael's studio, but in 1900 there was no way in which it could be used directly and with conviction.'

With the panels came John's poetry. Their colour was 'radiant and clear, and the paint, which has aged very beautifully on almost all the small panels of this time, is laid with a sweet and sensitive touch. At the same time Mr John now found expression for the vein of true poetry that runs through the best of his work. In part the sentiment of

these pictures is Celtic, other-worldly, and ideal, but never for a moment did he paint in a Celtic twilight. To these blue distances and golden suns Mr John transferred, not some wraith of the literary imagination, but quite simply and in literal fact his family and friends.'

Finally there was his gift for catching a likeness – at its best not just a superficial resemblance but a physical identity imprinted upon the features from childhood to old age. As a portrait painter he had chosen an art that was guided by fewer standards than formerly. In consequence he was thrown back on his own judgement 'and quite clearly Mr John is not a good critic; the unevenness of his later work is really startling, and this even in the simplest technical matters'. Even so, the *Times* critic concluded, 'he remains a force and a power and every now and then there is a picture, a landscape or a portrait of one of his sons, in which all has gone brilliantly well. But though it is impossible not to see that here is a great man, this is too great a man, one sometimes feels, to practise the painter's slow and nine-tenths mechanical art.'

Ironically, in this last decade, John was applying himself to these mechanical matters as never before. He lacked only the one-tenth of inspiration. However long he waited in his studio, it did not visit him. The only remedy he understood was time; to stay by his easel endless hours hoping for a miracle. But the hit-or-miss stage was over – it was all miss now. He was barricaded in by unfinished canvases. 'I fear I shan't accomplish as much as I intended,' he confessed to Tommy Earp. 'Life is definitely too short.' He had begun to learn something of physical exhaustion, of multiplying illnesses that consumed days and weeks. In November 1954, after two years' medically-supervised delay, he entered Guy's Hospital for a double operation. 'My bloody old prostate might need attending to and also a stone in my bladder,' he told Hugo Pitman.[790] 'Together they are responsible for my condition which has become very troublesome.' He lay in a modest room where 'there is no room for modesty',[791] surrounded by flowers, and sending out in vain for bottles of wine. 'I have instructed . . . [the surgeon] not to make a new man of me but to do what he could to restore the old one to working order,' he informed John Davenport. 'The worst is to stick in this horrible place, attended not by one but by at least a dozen vague females in uniform. I have considered getting away but it's difficult now.' To meet this crisis he inflated himself with optimism: the vague girls blossomed, the invisible future glowed. But after the operation, his relief flowed out unchecked. 'I had a most successful op. and am still considered the prize boy of the hospital,' he boasted to Dorothy Head.[792] 'The only snag is it seems to have increased my concupiscence about 100%! What makes my situation almost untenable is the arrival of a

pure-blooded African nurse from Sierra Leone . . . you may imagine the difficulties with which I am constantly confronted . . .'

Though he had made a 'wonderful' recovery, he was still very weak. Dodo, too, needed a long convalescence. While grappling with some garden creature, a goat or lawn-mower, she had broken her arm. They decided to go away and, on the advice of Gerald Brenan, submitted to Spain. It was a victory of climate over politics, and therefore partly a defeat. 'I would love to visit Spain again,' John had written many years earlier to Sir Herbert Barker, 'but not during the horrible regime of General Franco.' Like many artists he had backed the Republican cause, but his hatred of Franco was personal and recurs obsessionally through his correspondence over twenty years. He believed that Britain's failure to come out against the insurgents had led to the Second World War. 'With our backing the Spanish people would rise and throw Franco and the Fascists into the sea and chase the Germans out of the country,' he had written to Maud Cazalet on 4 December 1940. '. . . Spain is the key country and our potential friend. Meanwhile Franco continues to murder good men . . . Remember the Spanish War was the preliminary to this one and our benighted Government backed the wrong horse. We are now expiating that crime.' With rare passion, too, he spoke of Vichy's handing over to Germany of Republican refugees in France. 'What is he [President Roosevelt] or what are we doing for Franco's million prisoners, imprisoned and enslaved by that foul renegade and his Axis allies?'[793] After the liberation of France ('a real re-birth') and the defeat of Germany, he looked for the freeing of Spain. 'When we have dealt with Franco in his turn Europe will be a hopeful continent again and fit to travel in.'[794] He attended anti-Franco meetings and contributed pictures for the relief of prisoners (though 'I cannot approach anything like the munificence of Picasso or any other millionaire'[795]) up to the end of his life. But for four months, between December 1954 and April 1955, he rested there. Though the outpouring of criticism continued – 'Franco is beneath contempt, he "knows nothing of nothing" I think is the general view'[796] – it dwindled into petty complaints against the postal system.

Romilly had bought their tickets and driven them to Heathrow. 'Almost the last time I saw this remarkable couple together,' he remembered, 'they were standing, arm in arm, at the entrance to the airport, quite clearly petrified by the monstrosities that, unknown to them, had sprung up since the days of their youth. Augustus was glaring angrily at me for having got them into this fearful situation, while Dodo, thinking I was about to desert them, cried out in anguish, "Don't leave us, don't leave us!" '

They had flown to Madrid, travelled by train to Torremolinos where

they took rooms at a hotel, the Castello Santa Clara, belonging to Fred
Saunders, a castrated cockney who had served with T. E. Lawrence.
'This is a Paradise of convalescents, full of elderly English rentiers,'
John recommended on his arrival.[797] '. . . The Bar is hideous.'
Gerald Brenan, of whom they saw much, noted that 'Augustus had
become very genial in his old age'.[798] But much of this mildness was
attributable to post-operative fatigue – 'weaker than any cat and hardly
able to eat a thing'.[799] After a single debauch amid rear-admirals in
Gibraltar, he collapsed. The sun shone every day, he cast lustful eyes at
the 'superb landscape back of here',[800] but contented himself with Edie,
Fred Saunders' wife – though 'my bedroom proved unsatisfactory as a
studio'.[801] Vowing to return to his unfinished canvases in Spain, he left
with some relief for Fryern.

'I get anchored down here,' he had told Matthew Smith,[702] 'with
some endless work.' It was to Matthew Smith that he cast off for his
last journey abroad in 1956. Tickets were bought for him, money of
various denominations placed in his pockets, his clothes in a suitcase,
and reminders of all breeds flapped about his ears. For days the atmos-
phere at Fryern was saturated with time-tables, taxis, trains. A network
of old girl-friends along the route was alerted. Most of this planning was
conducted in whispers, for John would vastly have objected. In Paris,
where he was obliged to change trains, it had been arranged that William
de Belleroche would chaperone him as if by accident from one station
to the other. John blandly accepted the coincidence. 'Extraordinary!
When I stepped out of the train, there was Belleroche who happened to
be passing.' Even so, John lost his tickets. After a few nights with
Matthew Smith and his friends John and Vera Russell at Villeneuve-
les-Avignon, he pressed on to Aix to see Poppet, but failed to turn up at
the agreed meeting-point. They found him, not far off, grazing over
lunch, and took him for a few days to their house near Ramatuelle. But
he felt physically ill away from his paints and insisted on being driven to
St Raphael so as to catch a train direct to Calais. 'I would have liked to
have stayed in Provence,' he told William de Belleroche,[803] 'but felt still
more drawn to my work here. I find I cannot stop working . . .' Yet it
had been a good expedition on account of the Cézanne exhibition at Aix.
'The Cézanne show was overwhelming,' he wrote to Matthew Smith on
his return to Fryern,[804] 'and painting seems more mysterious than ever
if not utterly impossible. Only the appearance of a young woman out-
side, with very little on, restored me more or less to normality and hope.
But she belonged to an earlier and more fabulous age than ours.'

Most fellow-creatures from that age were dead. Among the artists and
writers, Will Rothenstein had died in 1945, 'a severe loss'; Dylan Thomas
in 1953, which 'greatly saddened me';[805] Brangwyn in 1956, though 'he

was a courageous man who made the best use of his talents and could have had nothing to regret'.[806] Gogarty had long before gone to America, a fate worse than death. Among the women, the Rani had rushed off, in which direction no one could tell; Alick Schepeler had disappeared with all her illusory charm, something she had always been threatening to do; and Edie faded virginally away as Francis Macnamara's neglected wife.

One of those whose company John missed most was Tommy Earp, who pursued his solitary recreation, silence, to its ultimate lair in 1958. He was buried at Selborne. 'John came with Dorelia – a quiet little elderly lady by then,' William Gaunt remembers.[807] He wore a black-varnished straw hat, headgear venerable enough for a Dean, yet as he sported it taking on a rakish elegance. 'Painted it myself,' he boasted. 'Best thing you've done for years,' a friend retorted. William Gaunt murmured something about its being a sad occasion. 'Oh, awful!' John thundered enthusiastically. 'I noticed at the same time,' Gaunt records, 'how his artist's eye professionally functioning in a separate dimension was observing the architectural and natural details of the scene: and when all the mourners were assembled in Selborne Church and all was hushed, suddenly a roar reverberated along the nave. It was Augustus with a superb disregard of devout silence. "A fine church", he roared. There was . . . a shocked rustling through the interior. With perfect sang-froid he went on with his meditations aloud. "Norman!" the word pealed to the rafters. There were some who seemed to scurry out into the open with relief at no longer being subjected to this flouting of convention.'

Of the survivors, those who had strayed prehistorically into the bland 1950s, he saw something of Wyndham Lewis. The jousting between these two artists-in-arms continued to the end. Passages of complimentary abuse were interrupted by sudden acts of kindness. When Lewis went blind in 1951, John bragged that he had sent him a telegram expressing the hope that it would not interfere with his real work: *art-criticism*. When pressed to account for this message, he declared that he wasn't, through sentimentality, going to lay himself open to some crushing rejoinder. In fact his letter had not been unsympathetic. 'I hope you find a cure as did Aldous Huxley,' he wrote. 'Anyhow indiscriminate vision is a curse. Although without the aid of a couple of daughters like Milton, I don't really see why you should discontinue your art criticism – you can't go far wrong even if you do it in bed. You can always turn on your private lamp of aggressive voltage along with your dictaphone to discover fresh talent and demolish stale.' At other times he treats this blindness as a gift of which Lewis has taken full advantage. Lewis received these 'impertinent' congratulations with an appreciative

silence. Never once did he allude to his blindness, preferring to make
any accusation obliquely: 'Dear John, I'm told you've mellowed.' John
hotly denied the charge, but Tristan de Vere Cole remembers him
taking Lewis out to dinner shortly before his death, seeing that his food
was properly cut up, deferring to him in their talk and exerting all his
charm for Lewis's entertainment.

Wyndham Lewis died in 1957; Matthew Smith two years later. The
war had devastated him. Evacuated from France, he had abandoned
many canvases and later lost his two sons on active service. In 1944 he
came to Fryern for some months, and in October that year the two
artists painted each other. Smith's portraits of John are wild-eyed and
florid; John's of Smith full of quietness and sympathy – perhaps his
last great portrait.

They were often seen about Chelsea in these years after the war: a
curious couple – Smith 'whose canvases suggest that a stout model has
first been flogged alive, then left to bleed to death, slowly and luxuri-
ously, on a pile of satin cushions'[808] looking timid and myopic, a pale,
spindly specimen like some bankrupt financial expert; John, with his
late-flowering addiction to anaemic prettiness, like an ageing lion full of
sound. 'It is always an amusing experience to see them together,' Peter
Quennell observed, Matthew Smith 'shrinking into his chair and glanc-
ing nervously about the room, John looking too large for the table and
ordering the wine in a voice of rusty thunder'.

They went, regularly, to the Queen's Restaurant in Sloane Square,
where the atmosphere – a little French, a little Edwardian – suited them
well. The menu was always the same and so were the waiters, the tired
flowers on the tables, the potted palm at the foot of the staircase. Having
a large but dispersed clientele, it was haunted by the past – old friends
you could have sworn were long dead appearing there from time to time
like ghosts. 'They were easily distinguishable,' Lucy Norton remem-
bered';[809] 'John with his lion-coloured hair, the wisps drawn thinly
over the top of his head, and the numerous mufflers that he never
seemed to take off . . . the cavalier-puritan hat on the antlers of the old
hat stand, and the black coat below, could have prepared anyone for the
sight of him. Matthew Smith was always in the best place, against the
wall, facing the room, looking very old now, but serene and gentle,
seeming to say very little but a very bright smile unexpectedly lighting
up his face . . . What struck me was John's attitude, his care for the
other old man, the way he turned his attention upon him, leaning for-
wards towards him over the table, encouraging him to talk and listen-
ing to everything he said . . . I used to join them a moment before I
left . . . and I remember talk about Sickert and his odd clothes (no
odder than Augustus's), of Paul Nash's illness and death . . . It was a

totally different side to all that I had ever known of John. He had always been the focus of attention whenever I had seen him. In the very distant past, with a circle of people round him, women particularly, trying to flatter him; in later years, when he was growing old, sitting against a wall muzzy and fuddled with drink, waiting to be rescued, to be taken safely home. To see him thus sober, in command, so wrapped up in someone who took all his interest, was extraordinarily moving'.

The Royal Academy, that 'asylum for the aged',[810] put on a memorial show after Matthew Smith's death. 'Bloody marvel,' John grunted. Some days it seemed he really wanted to die himself but did not know how to go about it. On other days his work kept him alive: it was not good enough yet. During a television interview[811] with Malcolm Muggeridge in 1957 he demanded 'another hundred years' to become a good painter. It was a dog's life, an agony from start to finish. If he had it all over again he would probably do exactly the same.

Early in the 1950s, in an effort to break new ground, he had taken to sculpture 'like a duck to water'. He had met in 1952 the Italian sculptress Fiore de Henriques and 'a new phase in my history opened up'.[812] She was a young woman 'of robust physique', he noted, savagely-featured, with coal-black hair, stalwart legs and a grip of iron. She came to Fryern late that year and 'has done a very successful bust of me'.[813] He could not keep his hands, while she worked, off the clay, and eventually she gave him some with which to experiment. The result was 'a prognathous vision of the young Yeats',[814] followed by busts of some of his family, friends and a model. 'Getting the hang of this medium', as he called it, was as exciting for John as a birth from the womb. 'I visited the Foundry where my busts are being cast,' he told Mary Anna Marten,[815] 'and I saw yours partly emerging from its covering of sand. I feel all the excitement of a Renaissance artist who had happened on a head of Venus of the Periclean age while digging in his back garden.'

It may have been that John hoped to overcome in sculpture some of those muscular vagaries that were so affecting his draughtsmanship and painting. In the opinion of Epstein it was 'the sculpture of a painter; it's sensitive, but you could stick your finger through it. It's interesting, but it's not real sculpture.'[816] John had many mighty plans, in particular for a colossal statue of the mature Yeats to confront all Dublin – 'Would you advise trousers,' he questioned Joe Hone,[817] 'or a more classic nudity?' But within eighteen months this 'new phase' was over, and he was free to pursue with fewer interruptions the big composition upon which the reputation of these post-war years would depend.

The only other interruption was portraiture – often drawings of famous men such as Thomas Beecham, Frank Brangwyn, Walter de la Mare, Charles Morgan, Gilbert Murray, Albert Schweitzer ('sat like a

brick he did'). These drawings provided John with 'outings', moments of adventure and respite from his main work. His studies of old men are probably the best. Of the original talent nothing remains: yet a certain ingenuity has developed, the skill of using a very limited vocabulary. The trembling contours, the blurred and fading lines convey very poignantly the frailty of old age. Some, who guarded their public image scrupulously and would have given much for a John portrait before the war, now refused his requests: among them J. B. Priestley and A. L. Rowse. But one who welcomed him enthusiastically was John Cowper Powys. 'Here *is* Augustus John Himself with his daughter [Vivien] as his driver,' he wrote to Phyllis Playter (26 November 1955). 'Hurrah! Hurrah! Hurrah! – He himself is a splendid picture.' In an hour and a quarter John polished off two drawings, retired for the night to the Pengwern Hotel, then 'like Merlin' returned next morning for another session. When he rose to depart, Powys told Louis Wilkinson,[818] 'I leapt at him exactly as a devoted Dog of considerable size leaps up at a person he likes, and kissed his Jovian forehead which is certainly the most noble forehead I have ever seen. I kissed it again and again as if it had been marble, holding the godlike old gent so violently in my arms that he couldn't move till the monumental and marmoreal granite of that forehead cooled my feverish devotion. His final drawing was simply of my very soul – I can only say it just *awed* me.'

Almost his last 'outing', in October 1959, was to Tenby, which had conferred on him the Freedom of the Borough, its highest honour. Dodo, 'under the impression that it rains perpetually in Wales', did not go, and he was accompanied by his daughter-in-law, 'Simon' John who 'was very much admired',[819] The two of them lingered over dinner with the Mayor while a large audience, waiting impatiently for them in the Town Hall, was assailed by Mussorgsky's 'Pictures from an Exhibition'. At last, to the sound of cheers, the diners clambered on to the flower-camouflaged platform with, *The Tenby Observer and Court News* reported, 'an air of deep sincerity and of historic significance'. John, though 'the piercing eyes still flashed', seemed enveloped by a cocoon of benevolence. Sandwiched between the Mayor and Town Clerk, flanked by aldermen, councillors and burgesses, buffeted by sonorous compliments, he looked 'deeply moved and at times somewhat overcome by . . . an emotion that he did not try to conceal'.[820] As he rose to sign the Freeman's Roll, the audience rose too, singing 'For he's a jolly good fellow!' In a speech of stumbling thanks, he spoke of his walks as a boy over the beaches and burrows: 'I could take those walks again now and I don't think I would get lost,' he declared defiantly. 'I can find my way about still.'

But to many, in these last years, he looked pitifully lost, the beard

stained with nicotine, the deaf eyes glaring, the actions slurred, menacing the traffic. He was shepherded back by Simon 'my eldest son's wife', he explained to his sister Winifred, 'or rather ex-wife for I think they are now divorced'. Simon had come to live at Fryern in 1956 'and to my astonishment is quite a success'.[821] He relied on her as a model (his voluptuous portrait of her, very dashing *en déshabille*, was shown at the Royal Academy in 1959); she was devoted to him, though there was a number of what he lightly called 'fracas' or 'scenes' – matters of words and tablets, after which they would all return to 'friendly terms' again.

John's face – 'one of the most remarkable faces I have ever seen' Maurice Collis called it[822] – appeared on television, was often splendidly photographed for the newspapers, and was occasionally seen at galleries being 'assaulted' by some dear old lady 'whose summer costume quite concealed her identity till a warm embrace on parting brought me to my senses'.[823] He had little to say. Every birthday the journalists telephoned and every time they reported his words: 'Work as usual'. No one seemed interested in this work – it was the past for which he was famous. From time to time phantoms from that past would overtake him, dragging his name into the headlines: Mavis, shooting her lover Lord Vivian in the stomach and being charged at the Assize Court in Salisbury with attempted murder; and Mrs Fleming, aged over seventy, fighting a succession of tough legal battles against the daughter of a Parsee high priest for the affections of Lord Winchester, the sixteenth Marquess, then in his youthful nineties.

But it was to a remoter past that he felt himself tied. The subject of his gigantic triptych, *Les Saintes-Maries de la Mer with Sainte Sara, l'Egyptienne*, had first fired his imagination when, in 1910, he became involved with the pilgrim-mystery of the gypsies. In the years between the wars, the dream symbolized for John by this legend had paled. Then, with the Second World War, he had turned back to the land of his dreams. His first major attempt to re-illumine this land had been 'The Little Concert' which, he told William de Belleroche on 1 April 1948, 'will never be really finished as I want to alter it every time I see it'. He could resign himself to its inconclusive state only by becoming more interested in something else. It was then, in the late 1940s, that his long-slumbering vision of Sainte Sara awoke. It was as if, on opening her eyes, she mesmerized him. 'I am astonished at my own industry,' he declared. She became his reason for not travelling and for not taking on much profitable portrait work. For over a dozen years, with few pauses, she held him, like some siren, calling him back to his studio day after day, and making his nights sleepless. She enchanted, tortured him; she was to be his resurrection or his death.

The saga of this vast mural and John's 'dreadful expenditure of time

and effort' over it can be assembled from his letters. 'There will soon not be an inch of wall-space left for me to disfigure,' he had joked to Doris Phillips on 24 July 1951. The triptych was too big for anybody to accommodate and represented 'a world only remotely connected with our own': yet 'I have never worked so hard or long'.[824] By 1952 the three compositions appeared to be combining harmoniously. 'So much depends on them,' he confessed to Daniel George.[825] 'They wax and wane like the moon.'

The spirit in which he met this challenge is well conveyed in a letter to Alfred Hayward:[826] 'It seems to me one wasted most of one's time when young. At last I feel myself interested only in work and feel always on the brink of discovery. That surely is excitement enough. We are left very much in the dark and have to find a way out for ourselves. One thing becomes clear – nothing worth doing is easy – though it may and should look so, after ages of effort and god knows what failures!'

The months moved on and 'I work from morning to night on the big panels which are developing well but seem to need *years* of work'.[827] In May 1954 he reported that they were showing 'signs of "coming out" like a game of Patience'.[828] But four years later he was still labouring at them and admitting: 'Unfinished things are often the best.' But there was no chance this time of supplanting his obsession with another. For this was love and must give birth to beauty. 'My wall decorations keep changing and evolving like life itself,' he had told Cecil Beaton. But 'the sureness of hand and mind', Sir Charles Wheeler records,[829] '. . . was waning and more than ever he scraped, altered and hesitated. . . . I was charmed by the design which had all the Celtic poetry so charac-teristic of his figure work. Each time I saw it, it became less and less resolved . . .'

At Fryern he could sometimes be heard alone in his studio, roaring in distress. 'What the hell do I know about art?' Hugo Pitman came across him once in tears contemplating an early canvas of Dorelia: 'I can't paint like that now – just can't do it.' His right hand was partly crippled with arthritis and, as he smoked, it trembled. Canvases lay everywhere, hanging on the walls, stacked in cupboards and on ledges, propped up or lying on the floor. People scurried in and out taking what they wanted. John stood, a skull cap on his head, wearing a woollen sweater and denims, scraping and hesitating before the triptych, caring for nothing else. Sometimes he drew in chalk on top of the paint; sometimes he splashed on gold and silver paint, or pasted it over and over again with dozens of pieces of paper to try out modifications; sometimes it seemed to him that even now, after all these years, he was about to pull it back from the precipice and have 'a triumph of a sort'.[830]

He was impatient with sympathy, but longed for the expert en-

couragement of another artist. Over the last two or three years he relied increasingly on the President of the Royal Academy, Charles Wheeler. 'I think he needed someone to lean on,' Wheeler wrote,[831] 'so that I received many letters begging me to visit him at Fryern Court.' They would lunch together with Dodo, then pass most of the afternoon in John's studio discussing the composition. 'When it was time to leave Augustus would hug us and, standing side by side with Dorelia at the tall Georgian windows, wave us goodbye.' He had undertaken to show his triptych at the Royal Academy Summer Exhibition of 1960. The sending-in day was 22 March. On 10 February 'a strange thing happened,' he told Philip Dunn.[832] 'I rapidly made some bold changes and the results have delighted me beyond measure!' A month later he was writing to Charles Wheeler:[833] 'I think it is *impossible* to finish the triptych in time. . . . I shall have to keep the big panels for another time.'

Early in 1961, on the evidence of some photographs[834] of the cartoon, the Abbey Trust offered to purchase the central panel for £5,000 and present it for the decoration of Burlington House. It was hoped that this 'magnificent proposal'[835] would give John the stimulus he needed. In fact it engendered a feeling that had been vaguely pregnant within him a long time. After five agonizing days, he could not keep back the truth any longer: *the triptych was not good enough and never would be*. Before, locked up with his fantasies, he could pretend and try to conjure something from this pretence. But studying the panel with the objectivity that the Abbey Trust's offer now compelled, he could see only the truth. The letter he wrote 'in great distress' to Wheeler on 9 March 1961 bows to this truth: 'I have some bad news for you. After working *harder than ever* I have come to the conclusion that I cannot continue without ruining whatever merit these large pictures may have had, nor can I expect to recover such qualities as have already been lost. I want to ask you to release me from my promise to have these things ready for the coming show while there is still time to replace them. *I cannot work against time*. That is now quite obvious: it will be a disappointment for you, and perhaps a disaster for me. . . . I will not again make unnecessary promises but will return to the work I love with renewed zest and confidence. . . .'

Wheeler at once replied with a wire, following this up with a letter accepting John's reasons and absolving him from his promise: 'They saved me and I am almost myself again,' John answered.

But nothing could be the same. The pretence was threadbare and truth clearly visible through it. In a real sense it had been *against time* he sought to work: to reach out into his own future and reassemble the past – a legendary past that had never existed otherwise than in man's imagination, which is timeless. 'This working from the imagination is

killing me,' he had written to Tim Phillips on 5 May 1960. 'I find myself
so variable that sometimes I lose all sense of identity and even forget my
name.' So, at the end, he had been brought back to the central predica-
ment of his life: 'Who *am* I in the first place?' In the early visual lyrics,
he had revealed a Paradise composed in the image of his desire which,
though mysterious in its origin, was real. But his desire, arising perhaps
from the loss of his mother, had been overlaid by other more super-
ficial desires. What had been killed could not now be rekindled. In his
triptych the dream paled into dreaminess and the Paradise that had once
been earthly became ethereal – nebulous shadows miming the sensuous
beauty, stately gestures of earlier days. With the disappearance of the
mystery, his identity itself had vanished.

John never abandoned the triptych, but was freer in this final year to
turn to 'lesser and handier things'. Almost his last portrait was of Cecil
Beaton. It had been begun in June 1960, but much to John's fury
Beaton left shortly afterwards for America. John felt mollified, how-
ever, on being introduced to Greta Garbo. 'I fell for her of course,' he
assured Beaton.[836] '. . . Quel oiseau! . . . I really must try to capture
that divine smile but to follow it to the U.S.A. would kill me. I wouldn't
mind so much dying *afterwards* . . .' The sittings started up again after
Beaton's return, and became increasingly painful for them both. John
seemed at his last gasp. The portrait would change, change, and change
again. John daubed it with green paint like a cricket pavilion, then with
pillar-box red. He stumped about, lunging at the canvas to add a pupil
to one eye or, it might turn out, a button. His hands shook fearfully,
his beret fell off, he glared; and Beaton, exquisitely posed, watched him
suffer. 'I think,' John puffed, '. . . that this is going to be . . . the
best portrait . . . I have ever . . . painted.'

Sex had been one medicine that, in the past, could lift him clear of
melancholia. In the summer of 1961, Simon John having left to marry a
neighbour, John's daughter Zoë came to stay at Fryern. John, then in
his eighty-fourth year, was sleeping on the ground floor. One night,
carrying a torch and still wearing his beret, he fumbled his way upstairs
to Zoë's room, and came heaving in. 'Thought you might be cold,' he
gasped, and ripped off her bedclothes. He was panting dreadfully,
waving the torch about. He lay down on the bed; she put her arms
round him; and he grew calmer. 'Can't seem to do it now,' he muttered.
'I don't know.' After a little time she took him down to his own bed-
room, tucked him up, and returned to her room. It was probably his
last midnight adventure.

There was no escape now from the tyranny of the present, no land of
hope in his studio, no forgetfulness elsewhere. 'I have been struck deaf
and dumb,' he told Poppet, 'so that the silence here is almost more than

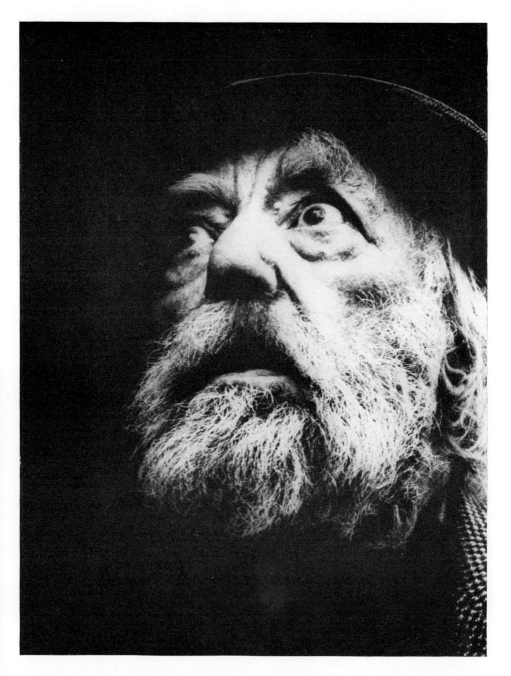

Augustus John (photographed shortly before his death by John Hedgecoe)

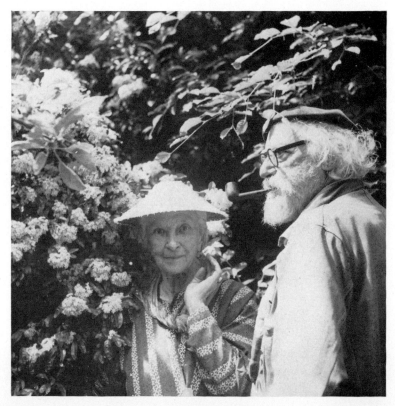

With Dorelia in her garden at Fryern Court (photograph by Cecil Beaton)

Augustus John: the last photograph

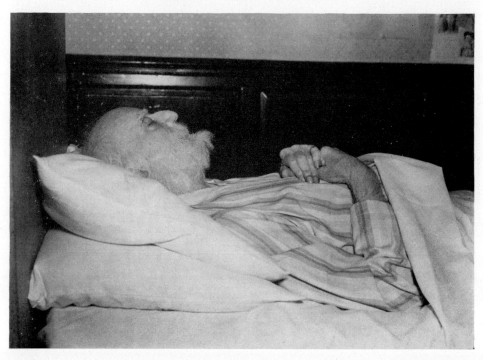

I can bear.' Old age had become a nightmare. 'I feel like a lost soul at Fryern!' he cried out to Vivien. Honours, now that he cared little for them, came to him from America, Belgium, France.* 'I'd like to quit and get away from it all,' he told a friend. 'But where is there to go?'

The end, when it came, was simple. He caught a chill; it affected his lungs; and after a short illness he died of heart failure, his heart having been greatly weakened by previous illnesses.

During the last weeks, his abrupt exterior largely fell away and he revealed his feelings more directly. He was agitated at being a nuisance to Dodo and Vivien, worried lest they were not getting enough rest. The night he died, they left him alone for a minute and he at once got up and sat in an armchair complaining that he could not sleep. 'You try it,' he suggested, indicating the bed. They got him back and, when David arrived later that evening, he was 'breathing very quickly and with difficulty but just about conscious'. Vivien told him that David had come, and he spoke his name. In his sleep he rambled about a picture of an ideal town which he claimed to have finished, but which in fact did not exist. The doctor came and John lay very quiet, rousing himself suddenly to remind the women 'to give the doctor a drink'.

Dodo, Vivien and David took turns sitting up with him that night. At 5.30 a.m. on Tuesday 31 October, with Dodo beside him, he died. 'His face looked very fine,' David wrote,[837] 'calm and smoothed out, in death'.

The funeral service was at Fordingbridge Parish Church. Apart from the many members of John's family, there were few people – Charles Wheeler and Humphrey Brooke from the Royal Academy; one or two students who had 'footed it' from Southampton. Afterwards, at Fryern, they had a party. Dodo, tiny but regal, seemed to have taken it wonderfully well, as if she could not believe yet that John was dead.

He had been buried in an annexe of Fordingbridge cemetery, an allotment for the dead up one of the lanes away from the town. To this rough field, in the months that followed, odd groups of hard-cheek-boned people, with faces like potatoes, silent, furtive-looking, made their pilgrimage. Sven Berlin, man of the road, took Cliff Lee of Maghull. Under the great expanse of sky they stood before the gravestone. 'He rested with councillors and tradesmen of the area,' Sven Berlin wrote.[838] '. . . His name was carved in simple Roman letters. Cliff Lee was moved to grief, as he stood holding a rose he had torn from the hedge on the way.

* He had been elected an honorary member of the American National Institute of Arts and Letters in 1943; in 1946 he became an associate of the Académie Royale de Belgique; and in 1960 he was invited to join the Institut de France.

' "The first time I've seen you take a back seat, old *Rai*," he said, speaking to Augustus with tears falling from his eyes. "Here is a wild rose from a wild man." He threw the rose on the grave and turned away; perhaps to hide from me the grief in his dark face though he was not ashamed.'

The newspapers were full of obituaries, photographs, reproductions of pictures that would soon be hurried back to their dark repositories. 'A man in the 50 megaton range,' wrote Richard Hughes.[839] 'We lose in him a great man,' declared Anthony Powell.[840] He had personified 'a form of life-enhancing exhibitionism,' said Osbert Lancaster,[841] 'which grew up and flourished before the Age of Anxiety'. His death was treated as a landmark. 'In a very real sense it marks the close of an era,' recorded the leader-writer of the *Daily Telegraph*.[842] More remarkable, perhaps, was the affection and admiration he had engendered in artists whose work and manner of life were entirely different from his own: men such as Bernard Leach and David Jones.

On 12 January 1962 a memorial service was held at St Martin-in-the-Fields. Among the large crowd were many who seemed gifted with a similar physiognomy. Caspar read the lesson; Amaryllis Fleming played Bach's Prelude and Fugue from Suite No. 5 in C Minor for unaccompanied 'cello. In his address, Lord David Cecil spoke of the heroic scale of John's personality ('a natural king among men'), of the strength and sensibility of his imagination, and the pictures in which it found perfect expression. 'A visionary gleam pervades these rocky shores, these wind-blown skies; through the eyes of the majestic figures, the soul gazes out lost in reverie. This blend of the earthy and the spiritual in his art expresses the essence of the man who created it . . . it was sacramental; that is to say, it was rooted in the sense that the spiritual is incarnate in the physical, that the body is the image of the soul.'

In questioning how future generations would assess his work, many agreed that it was essential to discount most of what he had done during the last twenty-five years. Public estimation even of his earlier pictures had changed, but would change again. The extreme puritanism that had descended on modern art criticism could not discover in his drawings or paintings the quality of intellectual deliberation it found interesting, could not in a sense 'see' what he had done. But one day his pictures would be brought out again – 'Caravan at Dusk', 'Dorelia Standing Before a Fence', 'Ida in a Tent', 'The Smiling Woman', 'The Red Feather', 'The Red Skirt', 'The Blue Shawl', 'The Mumper's Child', 'Lyric Fantasy' – passing moods and moments of beauty that he had made permanent.

John's reputation, already low in art circles, was sent into a further decline by the many sales and exhibitions that took place just before and

following his death.[843] The market was flooded with his pictures, often very inferior work that he had never intended to be shown, and it has taken over a dozen years to absorb this deluge.

Romilly and his wife Kathie came to Fryern, and Dodo lived on. She still wore the same style of clothes, radiated the same grace, sitting as if posing for, walking as though out of, another John painting. At work in the garden, or seated at the long refectory table over tea – Gwen John's 'Dorelia by Lamplight at Toulouse' behind her – she appeared more like the mythical Dorelia than might be thought possible. 'Her white hair,' noted Mary Taubman, doyenne of Gwen John scholars, ' – strange and unexpected but accentuating the unchanged features . . . very kind and smiled quickly . . . – her whole face quick and intelligent. Self-contained, rather frightening, though charming. Conversation conducted very much on her terms.'

This was how she remained to the end. Brigid McEwen, who visited Fryern in December 1963, noted her 'long dress of saffron cotton patterned in black, a neckerchief, long cardigan, long earrings, pierced ears, rings on wedding finger, white stockings & no shoes. She kept playing with her spectacles rather like an old man. Her asymetrically done hair – a long plait & a white comb. Very young voice . . . and young expressions "Jolly difficult" (to write life of John so soon) . . .'

For years she had been pliant, undemanding. But following John's death she flexed the muscles of her personality and rather enjoyed being 'difficult'. Though she travelled more to France, staying with Poppet, most of this time she remained at Fryern.

Fryern was ageing. Dry rot burrowed through the house; the large studio stood deserted, like an empty warehouse; brambles and nettles made the path to the old studio impenetrable. Vandals had broken in and covered the vast triptych of Sainte Sara with graffiti and explosions of paint. Under Dodo's orders, Romilly laboured heroically in the garden among the wilderness of giant weeds. Yet even in disarray, a magic, like some sultry atmosphere, clung to the place. Kittens still nested in the matted stems of the clematis; the magnolias and yellow azaleas flowered with the same colours John had painted; the hammock still swung between the apple and the Judas tree; the mellow brick, the long windows leading to cool dark rooms, the crazy paving inaccurately sprayed with weed-killer, the roses, the huge yew tree and, outgrowing everything, the mountainous rubbish dump: all were part of this magic.

On 19 December 1968 Dodo was eighty-seven. She had been getting visibly weaker and, to her consternation, able to do less. On the evening of 23 July 1969, Romilly found her fallen on the dining-room floor. He and Kathie got her to bed, and she slept. Next morning when they went in she lay in the same position. She had died in her sleep.

'AUGUSTUS JOHN'

Sung by Mrs. GRUNDY and the JOHN BEAUTY CHORUS.

Music by H. FRASER-SIMSON
Words by HARRY GRAHAM

Some people will squander
 Their savings away
 On paintings by Rankin or Steer;
For Brangwyn or Conder
 Huge sums they will pay,
 And they buy all the Prydes that appear!
But if you'd be smart,
As patrons of Art,
 It's almost a *sine qua non*
To prove your discretion
By gaining possession
 Of works by the wonderful John!
 Augustus John!

Refrain John! John!
 How he's got on!
 He owes it, he knows it, to me!
 Brass earrings I wear,
 And I don't do my hair,
 And my feet are as bare as can be;
 When I walk down the street,
 All the people I meet
 They stare at the things I have on!
 When Battersea-Parking
 You'll hear folks remarking:
 'There goes an Augustus John!'

Chorus John! John!
 If you'd get on,
 The quaintest of clothes you must don!
 When out for an airing,
 You'll hear folks declaring:
 'There goes an Augustus John!'

Good people acquainted
 With Sargent or Strang
 Will sit to them week after week!
It's nice being painted
 By Nicholson's gang,
 And McEvoy's touch is unique!
But if 'in the know,'
You'll hasten to go
 Where all the best people have gone:
His portraits don't flatter
But that doesn't matter,
 So long as you're painted by John!
 Augustus John!

Refrain John! John!
 If you'd get on,
 Just sit for a bit, and you'll see!
 Your curious shape
 He will cunningly drape
 With an Inverness cape to the knee!
 What a wealth of design!
 And what colour and line!
 He turns ev'ry goose to a swan!
 And though you're not handsome,
 You're worth a king's ransom,
 If you're an 'Augustus John!'

Chorus John! John!
 How he's got on!
 He turns ev'ry goose to a swan!
 You needn't be pretty,
 Or wealthy or witty,
 If you're an 'Augustus John!'

Our ancestors freely
 Expressed their dislike
 Of all unconventional styles;
They raved about Lely,
 They worshipped Vandyke,
 And Leighton they greeted with smiles!
To-day if one owns
A Watts or Burne-Jones,
 Its subject seems bloodless and wan!

One misses the vigour,
The matronly figure,
That mark all the drawings of John!
Augustus John!

Refrain

John! John!
How he's got on!
He's quite at the top of the tree!
From Cotman to Corot,
From Tonks to George Morrow,
There's no-one as famous as he!
On the scrap-heap we'll cast
All those works of the past,
By stars that once splendidly shone!
Send Hoppners and Knellers
To attics and cellars,
And stick to Augustus John!

Chorus

John! John!
How he's got on!
No light half so brightly has shone!
The verdict of Chelsea's
That nobody else is
A patch on Augustus John!

Chorus.

Miss SILVIA FAUSSETT BAKER
Miss FAITH CELLI.
Miss VERA BERINGER.
Miss BERYL FREEMAN.
Miss WINIFRED BATEMAN.
Miss MANORA THEW.
Miss ELLEN O'MALLEY.
Miss ELSIE McNAUGHT.
Mrs. CAMPBELL.
Miss ETHEL MACKAY.
Mdme. VANDERVELDE.
Mrs. GORDON CRAIG.
Miss SYLVIA MEYER.
Miss MARGARET GUINNESS.
Miss MARJORIE ELVERY.
Miss EVE BALFOUR.
Miss STELLA STOREY.
Miss DOROTHY GOODDAY.

Miss JANET ROSS.
Miss OLGA WARD.
Miss BARBARA HILES.
Miss PHYLLIS DICKSEE.
The Hon. SYLVIA BRETT.
Miss IRENE RUSSELL.
Miss NORTH.
Mrs. HENDERSON.
Mrs. FRENCH.
Miss EMILY LOWES.
Miss DOROTHY CHRISTINE.
Miss D'ERLANGER.
Miss HONOR WIGGLESWORTH.
Mrs. HANNEY.
Mrs. NIGEL PLAYFAIR.
Masters GILES and LYON PLAYFAIR.
Mrs. DODGSON.
Miss FAUSSETT.
 and
CARRINGTON.

Select Bibliography

Aberconway, Christabel. *A Wiser Woman? A Book of Memories*. Hutchinson: London 1966.

Allinson, Adrian. 'Painter's Portrait: An Autobiography' (unpublished).

Amory, Mark. *Biography of Lord Dunsany*. Collins: London 1972.

Anonymous (Hesketh Pearson). *The Whispering Gallery: Being Leaves from a Diplomat's Diary*. John Lane & The Bodley Head: London 1926.

Asquith, Lady Cynthia. *Haply I May Remember*. James Barrie: London 1950.
Portrait of Barrie. James Barrie: London 1950.
Diaries 1915–18; with a foreword by L. P. Hartley. Hutchinson: London 1968.

Bankhead, Tallulah. *Tallulah: My Autobiography*. Gollancz: London 1952.

Bantock, Myrrha. *Granville Bantock: A Personal Portrait*. Dent: London 1972.

Barker, Sir Herbert A. *Leaves from My Life*. Hutchinson: London 1927.

Barnes, James Strachey. *Half a Life*; with portraits of the author by Max Beerbohm, Augustus John, and Antonio Maraini. Eyre & Spottiswoode: London 1933.

Beaton, Cecil. *The Glass of Fashion*. Weidenfeld & Nicolson: London 1954.
The Years Between: Diaries 1939–44. Weidenfeld & Nicolson: London 1965.

Beaverbrook, Lord. *Courage: The Story of Sir James Dunn*. Collins: London 1961.

Benkovitz, Miriam J. *Ronald Firbank: A Biography*. Weidenfeld & Nicolson: London 1970.

Berlin, Sven. *Dromengro: Man of the Road*. Collins: London 1971.

Bertram, Anthony. *A Century of British Painting 1851–1951*. Studio Publications: London/New York 1951.

Bisson, R. F. *The Sandon Studios Society and the Arts*. Parry Books: Liverpool 1965.

Boyle, Andrew. *Montagu Norman: A Biography*. Cassell: London 1967.

Brenan, Gerald. *A Life of One's Own: Childhood and Youth*. Hamish Hamilton: London 1962.
A Personal Record. Jonathan Cape: London 1974.

Brett, Hon. Dorothy. 'Autobiography' (unpublished).

Brinnin, John Malcolm (ed.). *A Casebook on Dylan Thomas*. Thomas Y. Crowell Company: New York 1960.

Brown, Milton W. *The Story of the Armory Show*. Joseph H. Hirshhorn Foundation: Greenwich, Conn. 1963.

Brown, Oliver. *Exhibition: The Memoirs of Oliver Brown*. Evelyn, Adams & Mackay: London 1968.

Browse, Lillian (ed.). *Augustus John: Drawings*; with 'A Note on Drawing' by Augustus John and a preface by T. W. Earp. Faber & Faber: London 1941.

Bury, Adrian. *Just a Moment, Time. Some Recollections of a Versatile Life in Art, Literature and Journalism*. Charles Skilton: London 1967.

Campbell, Roy. *Light on a Dark Horse: An Autobiography (1901–1935)*. Hollis & Carter: London 1951.

Cazalet-Keir, Thelma. *From the Wings: An Autobiography*. The Bodley Head: London 1967.

Cecil, Lord David. *Max: A Biography*. Constable: London 1964.

Cecil, Lord David (ed.). *Augustus John: Fifty-two drawings*. George Rainbird: London 1957.

Chamot, Mary. *Modern Painting in England.* Country Life Ltd: London 1937.

Chamot, Mary, Dennis Farr & Martin Butlin. *Tate Gallery Catalogues: The modern British paintings, drawings and sculpture.* 2 vols. Oldbourne Press: London 1964–65.

Clemens, Cyril. *My Chat with Thomas Hardy;* with an Introduction by Carl J. Weber. International Mark Twain Society: Webster Groves, Mo./T. Werner Laurie: London, Eng. 1944.

Cochran, C. B. *Cock-a-Doodle-Do.* Dent: London 1941.

Cooper, Lady Diana. *The Rainbow Comes and Goes.* Hart-Davis: London 1958.

Cunard, Nancy. *Grand Man: Memories of Norman Douglas;* with Extracts from His Letters, and Appreciations by Kenneth Macpherson, Harold Acton, Arthur Johnson, Charles Duff, and Victor Cunard; and a Bibliographical Note by Cecil Woolf. Secker & Warburg: London 1954.

D'Abernon, Viscount. *An Ambassador of Peace; Volume III: The Years of Recovery, January 1924 – October 1925.* Hodder & Stoughton: London 1930.
 Portraits and Appreciations. Hodder & Stoughton: London 1931.

Daintrey, Adrian. *I Must Say.* Chatto & Windus: London 1963.

Davies, W. H. *Later Days.* Jonathan Cape: London 1925.

Dean, Basil. *Seven Ages: An Autobiography 1888–1927.* Hutchinson: London 1970.
 Mind's Eye: An Autobiography 1927–1972; the second volume of *Seven Ages.* Hutchinson: London 1973.

Deghy, Guy, and Keith Waterhouse. *Café Royal: Ninety Years of Bohemia.* Hutchinson: London 1955.

Dent, Alan (ed.). *Bernard Shaw and Mrs. Patrick Campbell: Their Correspondence.* Gollancz: London 1952.

Devas, Nicolette. *Two Flamboyant Fathers.* Collins: London 1966.

Dodgson, Campbell. *A Catalogue of Etchings by Augustus John 1901–1914.* Chenil: London 1920.

Dunlop, Ian. *The Shock of the New: Seven Historic Exhibitions of Modern Art.* Weidenfeld & Nicolson: London 1972.

Earp, T. W. *Augustus John.* Nelson: Edinburgh/T.C. & E.C. Jack: London 1934.

Easton, Malcolm and Michael Holroyd. *The Art of Augustus John.* Secker & Warburg: London 1974.

Epstein, Jacob. *Let There Be Sculpture: An Autobiography.* Michael Joseph: London 1940.

Everett, John. 'Diaries' (unpublished).

Everett, Katherine. *Bricks and Flowers: Memoirs.* Constable: London 1949.

Fielding, Daphne. *Mercury Presides.* Eyre & Spottiswoode: London 1954.
 Emerald and Nancy: Lady Cunard and her Daughter. Eyre & Spottiswoode: London 1968.
 The Rainbow Picnic: A Portrait of Iris Tree. Eyre Methuen: London 1974.

FitzGibbon, Constantine. *The Life of Dylan Thomas.* Dent: London 1965.

Fletcher, Ifan Kyrle. *Ronald Firbank: A Memoir;* with personal reminiscences by Lord Berners, V. B. Holland, Augustus John, R.A., and Osbert Sitwell; with portraits by Alvaro Guevara, Augustus John, R.A., Wyndham Lewis and Charles Shannon, R.A. Duckworth: London 1930.

Forge, Andrew. *The Slade 1871–1960.* Privately printed 1961.

Fothergill, John. *James Dickson Innes: Llanelly 1887–Swanley 1914;* with an Introduction by John Fothergill to the reproductions collected and edited by Lillian Browse. Faber & Faber (Ariel Books): London 1946.

Fox Pitt, Elspeth. 'From Stomacher to Stomach: the Meanderings of a Dressmaker' (unpublished).

Garnett, David (ed.). *The Letters of T. E. Lawrence*. Jonathan Cape: London 1938.
 Carrington: Letters and Extracts from her Diaries. Jonathan Cape: London 1970.
Gathorne-Hardy, Robert (ed.). *Ottoline: The Early Memoirs of Lady Ottoline Morrell*.
 Faber & Faber: London 1963.
Gertler, Mark. *Selected Letters*; edited by Noel Carrington, with an Introduction on
 his work as an artist by Quentin Bell. Hart-Davis: London 1965.
Gill, Brendan. *Tallulah: Biography of Tallulah Bankhead*. Michael Joseph: London 1973.
Glenavy, Lady Beatrice. *'Today We Will Only Gossip'*. Constable: London 1964.
Gogarty, Oliver St John. *As I Was Going Down Sackville Street: A Phantasy in Fact*.
 Rich & Cowan: London 1937.
 Collected Poems. Constable: London 1951.
 It Isn't This Time of Year at All!: An Unpremeditated Autobiography. MacGibbon &
 Kee: London 1954.
 Start from Somewhere Else: An Exposition of Wit and Humor Polite and Perilous.
 Doubleday: Garden City, N.Y. 1955.
Goldring, Douglas. *The Nineteen Twenties: A General Survey and Some Personal
 Memories*. Nicholson & Watson: London 1945.
Goodyear, Conger. *Augustus John*. Privately printed.
Gray, Cecil. *Peter Warlock: A Memoir of Philip Heseltine*. Jonathan Cape: London
 1934.
 Musical Chairs, or, Between Two Stools. Home & Van Thal: London 1948.
Green, Kensal (Colin Hurry). *Premature Epitaphs: Mostly Written in Malice*. Cecil
 Palmer: London 1927.
Gregory, Anne. *Me and Nu: Childhood at Coole*; illustrated by Joyce Dennis, with a
 prefatory note by Maurice Collis. Colin Smythe: Gerrards Cross 1970.
Gregory, Lady. *Coole*; completed from the Manuscript and edited by Colin Smythe,
 with a foreword by Edward Malins. Colin Smythe: Gerrards Cross 1971.
Gwynne-Jones, Allan. *Portrait Painters: European Portraits to the End of the Nineteenth
 Century and English Twentieth-Century Portraits*. Phoenix House: London 1950.
Hammersley, Doreen. 'Augustus John' (unpublished).
Hamnett, Nina. *Laughing Torso: Reminiscences*. Constable: London 1932.
 Is She a Lady? A Problem in Autobiography. Allan Wingate: London 1955.
Harris, Frank. *Contemporary Portraits*; Methuen: London 1915; Second Series: 57
 Fifth Avenue, New York 1919; Third Series: 40 Seventh Avenue, New York
 1920; Fourth Series: Grant Richards: London 1924.
Hart-Davis, Rupert. *Hugh Walpole: A Biography*. Macmillan: London 1952.
Hart-Davis, Rupert (ed.). *The Letters of Oscar Wilde*. Hart-Davis: London 1962.
Hassall, Christopher. *Edward Marsh: Patron of the Arts*. Longmans: London 1959.
 Rupert Brooke: A Biography. Faber & Faber: London 1964.
Holroyd, Michael. *Lytton Strachey: A Biography*. Heinemann: London 1973.
Hone, Joseph. *The Life of Henry Tonks*. Heinemann: London 1939.
Howard, Michael S. *Jonathan Cape, Publisher: Herbert Jonathan Cape, G. Wren Howard*.
 Jonathan Cape: London 1971.
Hubbard, Hesketh. *A Hundred Years of British Painting 1851–1951*. Longmans:
 London 1951.
Hudson, Derek. *James Pryde 1866–1941*. Constable: London 1949.
Huneker, James. *Ivory Apes and Peacocks*. T. Werner Laurie: London 1915.
Hunt, Violet. *The Flurried Years*. Hurst & Blackett: London 1926.
Hutchison, Sidney C. *The History of the Royal Academy 1786–1968*. Chapman & Hall:
 London 1968.
Huxley, Aldous. *Point Counter Point*. Chatto & Windus: London 1928.

Israel, Lee. *Miss Tallulah Bankhead.* W. H. Allen: London 1972.

James, Robert Rhodes (ed.). *'Chips': The Diaries of Sir Henry Channon.* Weidenfeld & Nicolson: London 1967.

Jepson, Edgar. *Memoirs of an Edwardian.* Martin Secker: London 1937.

John, Augustus. *Chiaroscuro: Fragments of Autobiography: First Series.* Jonathan Cape: London 1952.

 Finishing Touches; edited and introduced by Daniel George. Jonathan Cape: London 1964.

 The Drawings of Augustus John: with an Introduction by Stephen Longstreet, Borden. Borden Publishing Co., California, America 1967.

John, Romilly. *The Seventh Child: A Retrospect.* Heinemann: London 1932.

Jones, Jo. *Paintings and Drawings of the Gypsies of Granada.* Text by Augustus John, Laurie Lee, Sir Sacheverell Sitwell, Walter Starkie, Marguerite Steen. Athelnay Books: London 1969.

Joyce, James. *Letters, Volume III;* edited by Richard Ellmann. Faber & Faber: London 1966.

Kennedy, Margaret. *The Constant Nymph.* Heinemann: London 1924.

Keynes, Geoffrey (ed.). *The Letters of Rupert Brooke.* Faber & Faber: London 1968.

King, Viva. 'Autobiography' (unpublished).

Kingsmill, Hugh (ed.). *The English Genius.* Eyre & Spottiswoode: London 1938.

Lago, Mary M. (ed.). *Imperfect Encounter: Letters of William Rothenstein and Rabindranath Tagore 1911–1941.* Harvard University Press: Cambridge, Mass. 1972.

Laver, James. *Portraits in Oil and Vinegar.* John Castle: London 1925.

 Museum Piece, or, The Education of an Iconographer. André Deutsch: London 1963.

Lawrence, A. W. (ed.). *Letters to T. E. Lawrence.* Jonathan Cape: London 1962.

Lawrence, T. E. *Letters;* edited by David Garnett. Jonathan Cape: London 1938.

 To His Biographer, Liddell Hart: Information about himself, in the form of letters, notes, answers to questions and conversations. Faber & Faber: London 1938.

 To His Biographer, Robert Graves: Information about himself, in the form of letters, notes and answers to questions, edited with a critical commentary. Faber & Faber: London 1938.

Lehmann, John. *I Am My Brother: Autobiography II.* Longmans: London 1960.

Leslie, Seymour. *The Silent Queen;* with drawings by Nina Hamnett. Jonathan Cape: London 1927.

 The Jerome Connexion. John Murray: London 1964.

Lewis, Percy Wyndham. *Blasting & Bombardiering.* Eyre & Spottiswoode: London 1937; revised edition with additional material; Calder & Boyars: London 1967.

 Rude Assignment: A Narrative of My Career Up To Date. Hutchinson: London 1950.

Lhombreaud, Roger. *Arthur Symons: A Critical Biography.* Unicorn Press: London 1963.

Lipke, William. *David Bomberg. A Critical Study of his Life and Work.* Evelyn, Adams & Mackay: London 1967.

Lloyd George, Frances. *The Years That Are Past.* Hutchinson: London 1967.

 Lloyd George: A Diary; edited by A. J. P. Taylor. Hutchinson: London 1971.

Lockhart, Robert Bruce. See Young, Kenneth.

McAlmon, Robert. *Being Geniuses Together 1920–1930;* revised and with supplementary chapters by Kay Boyle. Michael Joseph: London 1970.

MacColl, D. S. *Life Work and Setting of Philip Wilson Steer.* Faber & Faber: London 1945.

Mackenzie, Compton. *My Life and Times: Octave Three 1900–1907; Octave Five 1915–1923; Octave Six 1923–1930.* Chatto & Windus: London 1964, 1966, 1967.

Maclaren-Ross, J. *The Funny Bone*. Elek Books: London 1956.

Maritain, Jacques. *Carnet de Notes*. Desclée de Brouwer: Paris 1965.

Marriott, Charles. *Augustus John* (Masters of Modern Art). Colour Ltd: London 1918.

Meynell, Viola (ed.). *Friends of a Lifetime: Letters to Sydney Carlyle Cockerell*. Jonathan Cape: London 1940.

Michel, Walter and C. J. Fox (eds.). *Wyndham Lewis on Art: Collected Writings 1913–1956*. Thames & Hudson: London 1969.

Montagu, George, Earl of Sandwich. 'Reminiscences' (unpublished).

Moorehead, Alan. *Montgomery: A Biography*. Hamish Hamilton: London 1967.
 'Augustus John' (unpublished).

Morphet, Richard. *British Painting 1910–1945*. Tate Gallery: London 1967.

Murry, John Middleton (ed.). *The Letters of Katherine Mansfield*. 2 vols. Constable: London 1928.

Nash, Paul. *Outline: an autobiography and other writings*; with a preface by Herbert Read. Faber & Faber: London 1949.

Nehls, Edward (ed.). *D. H. Lawrence: A Composite Biography. Volume One: 1885–1919; Volume Two: 1919–1925; Volume Three: 1925–1930*. University of Wisconsin Press: Madison, Wis. 1957, 1958, 1959.

Nevinson, C. R. W. *Paint and Prejudice*. Methuen: London 1937.

O'Casey, Eileen. *Sean*; edited with an Introduction by J. C. Trewin. Macmillan: London 1971.

O'Casey, Sean. *Autobiographies I: I Knock at the Door; Pictures in the Hallway; Drums under the Windows*. Macmillan: London 1963.
 Autobiographies II: Inishfallen, Fare Thee Well; Rose and Crown; Sunset and Evening Star. Macmillan: London 1963.

O'Connor, Ulick. *Oliver St John Gogarty: A Poet and his Times*. Jonathan Cape: London 1964.

Owen, Roderic, with Tristan de Vere Cole. *Beautiful and Beloved: The Life of Mavis de Vere Cole*. Hutchinson: London 1974.

Paige, D. D. (ed.). *The Letters of Ezra Pound 1907–1941*. Faber & Faber: London 1951.

Pearson, Hesketh. *Extraordinary People*. Heinemann: London 1965.

Pearson, John. *The Life of Ian Fleming*. Jonathan Cape: London 1966.

Pocock, Tom. *Chelsea Reach: The Brutal Friendship of Whistler and Walter Greaves*. Hodder & Stoughton: London 1970.

Pound, Reginald. *Running Commentary*. Rockliff: London 1946.
 A Maypole in The Strand. Ernest Benn: London 1948.
 The Englishman: A Biography of Sir Alfred Munnings. Heinemann: London 1962.
 Harley Street. Michael Joseph: London 1967.

Raleigh, Lady (ed.). *The Letters of Sir Walter Raleigh (1879–1922)*; with a Preface by David Nichol Smith. Volume II. Methuen: London 1926.

Reeve, Dominic. *No Place Like Home*. Foreword by Augustus John, O.M. Phoenix House: London 1960.

Reid, B. L. *The Man from New York: John Quinn and His Friends*. Oxford University Press: New York 1968.

Reilly, C. H. *Scaffolding in the Sky: A semi-architectural autobiography*. Routledge: London 1938.

Roberts, Cecil. *Sunshine and Shadow: being the fourth book of an Autobiography 1930–1946*. Hodder & Stoughton: London 1972.

Rose, W. K. (ed.). *The Letters of Wyndham Lewis*. Methuen: London 1963.

Ross, Margery (ed.). *Robert Ross, Friend of Friends: Letters to Robert Ross, Art Critic*

and Writer, together with extracts from his published articles. Jonathan Cape: London 1952.

Rothenstein, John. *Summer's Lease: Autobiography 1901–1938.* Hamish Hamilton: London 1965.

 Brave Day, Hideous Night: Autobiography 1939–1965 (I). Hamish Hamilton: London 1966.

 Time's Thievish Progress: Autobiography III. Cassell: London 1970.

Rothenstein, John (ed.). *Augustus John* (British Artists No. 2). Allen & Unwin: London 1944/Oxford University Press: New York 1944.

 Modern English Painters. Volumes 1 & 2. Eyre & Spottiswoode: London 1952, 1956. Volume 3. Macdonald & Jane's: London 1974.

 Augustus John 1878–1961 (British Painters). Beaverbrook Newspapers: London 1962.

 British Art since 1900: An Anthology. Phaidon Press: London 1962.

 Augustus John (The Masters No. 79). Purnell 1967.

Rothenstein, William. *Men and Memories: Recollections 1872–1900.* Faber & Faber: London 1931.

 Men and Memories: Recollections 1900–1922. Faber & Faber: London 1932.

 Since Fifty: Men and Memories, 1922–1938: Recollections. Faber & Faber: London 1939.

Russell, Bertrand. *Autobiography. Volume 3: 1944–1967.* Allen & Unwin: London 1969.

Rutherston, A. D. (ed.). *Augustus John.* Ernest Benn: London 1923.

Rutter, Frank. *Evolution in Modern Art: A Study of Modern Painting 1870–1925.* Harrap: London 1926.

 Since I Was Twenty-five. Constable: London 1927.

 Art in My Time. Rich & Cowan: London 1933.

Savage, Henry. *The Receding Shore: Leaves from the Somewhat Unconventional Life of Henry Savage.* Grayson & Grayson: London 1933.

 'Autobiography' (unpublished).

Shaw, Martin. *Up to Now.* Oxford University Press: London 1929.

Sitwell, Osbert. *Noble Essences, or, Courteous Revelations*; being a Book of Characters and the Fifth and Last Volume of *Left Hand, Right Hand!* Macmillan: London 1950.

Sitwell, Osbert (ed.). *A Free House! or, The Artist as Craftsman*; being the Writings of Walter Richard Sickert. Macmillan: London 1947.

Speaight, Robert. *William Rothenstein: The Portrait of an Artist in his Time.* Eyre & Spottiswoode: London 1962.

Spender, Stephen. *World within World: Autobiography.* Hamish Hamilton: London 1951.

Starkie, Walter. *Scholars and Gypsies: An Autobiography.* John Murray: London 1963.

Steen, Marguerite. *William Nicholson.* Collins: London 1943.

Stewart, Jessie. *Jane Ellen Harrison: A Portrait from Letters.* Merlin Press: London 1959.

Stonesifer, Richard J. *W. H. Davies: A Critical Biography.* Jonathan Cape: London 1963.

Sutton, Denys (ed.). *Letters of Roger Fry.* 2 vols. Chatto & Windus: London 1972.

Symons, Arthur. *The Fool of the World & Other Poems.* Heinemann: London 1906.

Tedlock, E. W. (ed.). *Dylan Thomas: The Legend and the Poet*; A Collection of Biographical and Critical Essays. Heinemann: London 1960.

Thomas, Dylan. *Selected Letters*; edited by Constantine FitzGibbon. Dent: London 1966.

Thomas, R. S. *The Stones of the Field.* Druid Press: Carmarthen 1946.

Thornton, Alfred. *Fifty Years of the New English Art Club.* Curwen Press: London 1935.

　　The Diary of an Art Student. Pitman & Sons: London 1938.

Titterton, W. R. *A Candle to the Stars.* Grayson & Grayson: London 1932.

Tree, Iris. 'In Praise of ——' (uncompleted and unpublished autobiography).

Vandon, George. *Return Ticket.* Heinemann: London 1940.

Wade, Allan (ed.). *The Letters of W. B. Yeats.* Hart-Davis: London 1954.

Waugh, Evelyn. *A Little Learning: The First Volume of an Autobiography.* Chapman & Hall: London 1964.

Wheeler, Charles. *High Relief: The Autobiography of Sir Charles Wheeler, Sculptor.* Country Life Books: Feltham, Mx. 1968.

Wilkinson, Louis ('Louis Marlow') (ed.). *Letters of John Cowper Powys to Louis Wilkinson 1935–1956.* Macdonald: London 1958.

Willett, John. *Art in a City.* Methuen: London 1967.

Williamson, Henry. *The Golden Virgin.* Macdonald: London 1957.

　　The Innocent Moon. Macdonald: London 1961.

Winsten, S. *Days with Bernard Shaw.* Hutchinson: London 1948.

Wood, Christopher. 'Letters to My Mother'. 3 vols. (unpublished).

Woodeson, John. *Mark Gertler: Biography of a Painter, 1891–1939.* Sidgwick & Jackson: London 1972.

Woolf, Virginia. *Roger Fry: A Biography.* Hogarth Press: London 1940.

Yates, Dora E. *My Gypsy Days: Recollections of a Romani Rawnie.* Phoenix House: London 1953.

Yeats, W. B. *Autobiographies: Reveries over Childhood and Youth and The Trembling of the Veil.* Macmillan: London 1926.

　　Memoirs: Autobiography—First Draft; Journal; transcribed and edited by Denis Donoghue. Macmillan: London 1972.

Young, Kenneth (ed.). The Diaries of Sir Robert Bruce Lockhart. Volume One: 1915–1938. Macmillan: London 1973.

Yoxall, H. W. *A Fashion of Life.* Heinemann: London 1966.

NOTES

317. *The Seventh Child*, p. 21.
318. Gilbert Spencer to the author, 3 November 1968.
319. *The Seventh Child*, p. 25.
320. ibid., p. 109.
321. ibid., pp. 116–18.
322. *A Life of One's Own*, pp. 241–2.
323. op. cit., p. 134.
324. ibid. p. 58.
325. Tate Gallery, 3730.
326. Aberdeen Art Gallery.
327. Collection Robert Byng.
328. Pittsburgh Art Gallery.
329. This composition, bought in advance by Quinn, 'after undergoing continual alterations became gradually unrecognizable and finally disappeared altogether.' *Horizon*, December, Vol. VI, No. 36, 1942, p. 430.
330. Detroit Art Gallery. 'So that's what became of "the Mumpers",' John wrote to Homer St. Gaudens. 'They will feel more than ever out of place in that hot bed of Ford's.' The picture had been bought at the Quinn sale of 10 February 1927 by René Gimpel. See his *Journal d'un Collectionneur*, p. 327.
331. Bequeathed by Hugo Pitman to the Tate Gallery. See *Two Flamboyant Fathers* by Nicolette Devas, pp. 103–7.
332. op. cit., p. 54.
333. Oliver St John Gogarty. See *It Isn't This Time of Year at All!*, p. 152.
334. John to Alick Schepeler undated.
335. Michaela Pooley to the author 1969.
336. *Chiaroscuro*, p. 103.
337. The source for this is Quinn's diary – John having told him. In John's published account he relates that 'my caller, though uninvited, entered the house and with great good-nature made herself at home.'
338. *Horizon*, February, Vol. V, No. 26, 1942, p. 127.
339. *Marriage and Genius* by John Stewart Collis (Cassell 1963), pp. 117–18.
340. ibid., p. 64.
341. *Chiaroscuro*, p. 116.
342. *Marriage with Genius* by Frida Strindberg (Jonathan Cape 1937), p. 20.
343. John Quinn to Jacob Epstein 7 August 1915. Quinn Collection. New York Public Library.
344. Quinn's unpublished diary page 16.
345. *Horizon*, August, Vol. VI, No. 32, 1942, p. 131.
346. ibid., loc. cit.
347. *The Man from New York* by B. L. Reid, p. 105.
348. John to Ottoline Morrell, 27 September 1911. University of Texas.
349. John to Dorelia, undated.
350. Quinn to James Gibbons Huneker, 15 November 1911.
351. John to Ottoline Morrell, 27 September 1911.
352. Quinn to Huneker, 15 November 1911.

353. Quinn to Conrad, 17 November 1912.
354. *Chiaroscuro*, p. 122.
355. *Horizon*, August, Vol. VI, No. 32, 1942, p. 133.
356. John to Quinn, 23 May 1910.
357. On 27 September 1911.
358. *The Seventh Child*, p. 38.
359. *A Life of One's Own*, p. 147.
360. Romilly John to the author, 9 December 1972.
361. In a letter to the author, January 1969.
362. *The Seventh Child*, p. 62.
363. 'A Name to Live Up to' by Tom Pocock. *Evening Standard*, 5 June 1967.
364. B.B.C. interview, 16 November 1962.
365. Vivien White to the author, 1971.
366. John to Ottoline Morrell, 28 February 1912.
367. John to Quinn, 9 May 1912.
368. John to Ottoline Morrell, 10 March 1912.
369. John to Quinn, 9 May 1912.
370. John to Quinn, 8 May 1913.
371. *It Isn't This Time of Year at All!*, p. 151.
372. 'To Augustus John' by Oliver St John Gogarty. *Collected Poems*, pp. 27–30.
373. *Horizon*, October, Vol. IV, No. 22, 1941, p. 289.
374. *It Isn't This Time of Year at All!*, pp. 150, 151.
375. *As I Was Going Down Sackville Street*, p. 246.
376. *Oliver St John Gogarty* by Ulick O'Connor, p. 149. See also 'Blue Eyes and Yellow Beard' by Ulick O'Connor, *Spectator*, 10 November 1961.
377. *As I Was Going Down Sackville Street*, p. 247.
378. *It Isn't This Time of Year at All!*, p. 153–4.
379. *Horizon*, October, Vol. IV, No. 22, 1941, p. 286.
380. *Two Flamboyant Fathers*, p. 21. There is a reproduction of this portrait facing page 32.
381. *Horizon*, October, Vol. IV, No. 22, 1941, p. 286.
382. In *Two Flamboyant Fathers*, p. 28.
383. ibid. p. 25.
384. *Horizon*, October, Vol. IV, No. 22, 1941, p. 287.
385. John to Quinn, 6 August 1912.
386. *Chiaroscuro*, p. 93.
387. John to Quinn, 11 October 1911. It is an impression of Holbrooke quite different from Beatrice Dunsany's description of 'a pathetic, good-natured deaf child' who played the piano beautifully. See *Lord Dunsany*: a biography by Mark Amory, pp. 104–6.
388. John to Mrs Nettleship, 8 January 1913.
389. Epstein to Quinn, 11 January 1913.
390. John to Dorelia, undated. Written from Hôtel du Nord, Cours Belsance, Marseilles.
391. John to John Hope-Johnstone, undated.
392. John to Ottoline Morrell, July 1914.
393. In a letter to his brother James Strachey.
394. John to Hope-Johnstone, 1916.
395. *Horizon*, August, Vol. VIII, No. 44, 1943, p. 140.
396. See *Lord Dunsany*: a biography by Mark Amory, pp. 73–4.
397. John to Hope-Johnstone, 20 February 1914.

398. John to Quinn, 19 February 1914.

399. Interview with the author, 1969. See also 'Dame Laura Knight' by Margaret Laing. *Evening Standard*, 5 November 1968, p. 12.

400. Dame Laura Knight to the author. She recalled that they were living in three cottages knocked into one, which made a room thirty feet in length.

401. *Horizon*, April, Vol. XI, No. 64, 1945, p. 258. In *Chiaroscuro*, p. 205, 'our excitement' has been changed to 'the general excitement'.

402. John to Dorelia, October 1914.

403. John to Quinn, 12 October 1914.

404. John to Quinn, 13 August 1915.

405. John to Ottoline Morrell, 1 January 1915.

406. John to Quinn, 15 February 1915.

407. Undated, but October 1915. Written from the Railway Hotel, Galway.

408. John to Quinn, 15 November 1915.

409. John to Shaw, 18 December 1915, from Mallord Street. British Museum, Add. 50539.

410. John to Quinn, 10 October 1914.

411. John to Quinn, 12 October 1914.

412. John to Dorelia, undated.

413. Albert Rutherston to William Rothenstein, 8 December 1916.

414. *The Times*, 3 March 1920.

415. John to Quinn, 19 January 1916.

416. John to Ottoline Morrell, undated.

417. *The Years That Are Past* by Frances Lloyd George, p. 84.

418. *Lloyd George. A Diary* by Frances Stevenson. Edited by A. J. P. Taylor, 12 March 1916, pp. 83, 103–4.

419. It is now in the Aberdeen Art Gallery.

420. Quinn to Kuno Meyer, 10 May 1916.

421. See *Later Days* by W. H. Davies, pp. 177–84.

422. Berg Collection. New York Public Library.

423. John to Dorelia, undated, from Coole Park.

424. *Me and Nu: Childhood at Coole* by Anne Gregory, p. 47.

425. Lady Gregory to W. B. Yeats, undated.

426. *Days with Bernard Shaw* by S. Winsten, p. 164.

427. *Bernard Shaw and Mrs Patrick Campbell: Their Correspondence* edited by Alan Dent, p. 175.

428. John to Dorelia, undated.

429. *Chiaroscuro*, pp. 96–9.

430. John to Quinn, 15 November 1915.

431. Shaw to John, 6 August 1915.

432. John to Shaw, 31 October 1916.

433. Shaw to John, 6 August 1915. From the Hydro, Torquay.

434. Dorelia to Lytton Strachey, 16 March 1915.

435. Lytton Strachey to Carrington, 8 March 1917. 'At first she [Vivien] completely ignored me. She then would say nothing but "Oh no!" whenever I addressed her. But eventually she gave me a chocolate – "Man! Have a chockle." – which I consider a triumph.'

436. *Vivien John*. Malaysia: its People and its Jungle. Upper Grosvenor Galleries, 19 January–6 February 1971.

437. See *Two Flamboyant Fathers*, pp. 36–49.

438. John to Dorelia, 7 January 1918.

439. John to Quinn, 13 August 1915.
440. According to Ezra Pound, this verse sprang from 'the Castalian fount of the Chenil'. In a letter to Wyndham Lewis (13 January 1918) Pound noted: '(Authorship unrecognised, I first heard it in 1909). It is emphatically NOT my own, I believe it to have come from an elder generation'.
441. Dorelia to Lytton Strachey, 13 September 1916.
442. Dorelia to Lytton Strachey, 10 May 1916.
443. John to Quinn, 26 January 1914. See also John's Foreword to *Peter Warlock, A Memoir of Philip Heseltine* by Cecil Gray, pp. 11–12.
444. John to Evan Morgan (Lord Tredegar), undated.
445. See *Finishing Touches*, pp. 84–5.
446. 'To the Eiffel Tower Restaurant', *Sublunary* pp. 93–5.
447. *The Life of Dylan Thomas* by Constantine FitzGibbon (Sphere Books 1968, p. 163).
448. ibid., loc. cit.
449. *High Relief* by Charles Wheeler, p. 31.
450. Letter from Dorothy Brett to the author, 7 August 1968.
451. See *Carrington. Letters and Extracts from her Diaries*, pp. 74–5, where it is incorrectly dated 25 July 1917.
452. And repeated on 29 June at the Lyric Theatre. It had been organized in conjunction with the Ladies Auxiliaries Committee of the Young Men's Christian Association. See the Enthoven Theatre Collection at the Victoria and Albert Museum.
453. See Appendix.
454. Epstein to Quinn, 12 August 1914.
455. Epstein to Quinn, 4 September 1914.
456. Epstein to Quinn, 20 July 1917.
457. See, for example, the *Sunday Herald*, 10 June 1917.
458. *Chiaroscuro*, p. 125.
459. *Leaves from My Life* (1927) by Sir Herbert A. Barker, pp. 263–5.
460. The phrase is Dr Malcolm Easton's. See *The Art of Augustus John* (Secker and Warburg 1974).
461. *The Times*, 27 November 1917.
462. *Great Morning* by Osbert Sitwell (St Martin's Library edn, p. 248).
463. In the *Burlington Magazine*, April 1916. See also his article for February 1916 on the New English Art Club.
464. John to Evan Morgan, December 1914.
465. December 1914.
466. John's letters to Grant Richards are in the University of Illinois Library, Urbana.
467. John to Campbell Dodgson, 11 September 1917. Imperial War Museum, London.
468. Arthur Symons to Quinn, 22 November 1917.
469. Lytton Strachey to Clive Bell, 4 December 1917.
470. William Orpen to William Rothenstein, 23 February 1918.
471. John to Tonks, 21 February 1918. The library, the University of Texas at Austin.
472. John to Lady Cynthia Asquith, 5 October 1917.
473. John to Alick Schepeler, 2 February 1918.
474. John to Evan Morgan, 27 October (1915).
475. John to Dorelia, undated.

476. John to Dorelia, undated.

477. *The Letters of Katherine Mansfield* edited by John Middleton Murry (1928), p. 77. John is not identified by name in this published version of the letter.

478. From the Dorothy Brett papers, Dept of English, University of Cincinnati, Ohio.

479. John to Quinn, 13 December 1918.

480. John to Evan Morgan, 1 March 1918.

481. John to Arthur Symons, 22 February 1918.

482. *Blasting and Bombardiering. An Autobiography 1914–26*, London 1937, p. 198.

483. John to Dorelia, 3 February 1918.

484. 'Lord Beaverbrook Entertains' was intended to occupy pages 79–81 of *Finishing Touches* but, for reasons of libel, was dropped at proof stage and the chapter 'Gwendolen John' substituted. This was done by Daniel George, of Jonathan Cape, after John's death.

485. John to Gogarty, 24 July 1918. At the time of writing this correspondence is being bought by Bucknell University.

486. John to Cynthia Asquith (April) 1918.

487. *Times*, 4 January 1919. 'War Story in Pictures – Canadian Exhibition at the Royal Academy'.

488. John to Cynthia Asquith, 24 July (1919).

489. Now in the Imperial War Museum, London. Oil on canvas, $93\frac{1}{2} \times 57$ inch.

490. *To-day We will Only Gossip* by Beatrice Lady Glenavy, p. 111.

491. In a letter to Cynthia Asquith.

492. Lady Cynthia Asquith, *Diaries, 1915–18*, p. 471.

493. John to Frances Stevenson, 13 February 1919.

494. John to Cynthia Asquith.

495. *Horizon*, December, Vol. VIII, No. 48, 1943, p. 406.

496. John to Cynthia Asquith, 1 February 1919.

497. John to Cynthia Asquith.

498. John to Cynthia Asquith, 17 September 1919.

499. John to Gwen John, September 1919.

500. John to Ottoline Morrell, 14 March 1920.

501. John to Eric Sutton, 6 April 1920. Written from the hospital, 12 Beaumont Street, London W.1.

502. John to Cynthia Asquith, April 1920.

503. In Aldous Huxley's *Point Counter Point*, for example, where he appears as John Bidlake, at forty-seven 'at the height of his powers and reputation as a painter; handsome, huge, exuberant, careless; a great laugher, a great worker, a great eater, drinker, and taker of virginities'. Professor Grover Smith, editor of *Letters of Aldous Huxley*, writes (22 February 1970) that 'it is said that John was indeed the prototype of the artist John Bidlake in *Point Counter Point*. Aldous nowhere wrote that this was the case; but he was extremely cautious and tactful where his literary models were concerned'.

John is said to be the prototype of characters in several novels – the artist in Margery Allingham's *Death of a Ghost*; Struthers in D. H. Lawrence's *Aaron's Rod*; Tenby Jones, the 'lion of Chelsea', in Henry Williamson's *The Golden Virgin* and *The Innocent Moon*; the sculptor Owen in Aleister Crowley's *The Diary of a Drug Fiend* (Crowley noted this in his own copy of the novel); the musician Albert Sanger in Margaret Kennedy's *The Constant Nymph* (though in part this may be based on Henry Lamb), Gulley Jimson in Joyce Cary's *The Horse's Mouth*, though popularly supposed to be based on Stanley Spencer, may

also contain some aspects of John – in particular the urge to paint large murals. Cary and John knew each other a little in Paris, when Cary was studying art there. Cary mentions John in his letters and diary of 1909–10; and in the autumn of 1956, writing to Ruari Maclean, he suggested John might do illustrations for the Rainbird edition of *The Horse's Mouth*. Nothing came of this, though John greatly admired the novel.

Of Somerset Maugham's *The Moon and Sixpence* John Quinn wrote (9 September 1919): 'The description of the artist, red beard and all, and his words and manner and the first part of the book up to the time he leaves France, is obviously based upon a superficial study of Augustus John. The second part of the book, the Tahiti part, is obviously based upon the life of Gauguin.'

504. See 'Cat's Whiskers'. Philip Oakes talks to Kathleen Hale, *Sunday Times*, 19 March 1972.
505. Christopher Wood to his mother, September 1925.
506. John to Ottoline Morrell, 29 September 1911.
507. *The Seventh Child*, pp. 165–6.
508. ibid., pp. 167.
509. *Musical Chairs* by Cecil Gray, p. 228.
510. *The Seventh Child*, p. 167.
511. Lucy Norton to the author (undated).
512. Montgomery Hyde to the author, 17 November 1969.
513. Poppet Pol to the author, 27 February 1970.
514. *Musical Chairs*, pp. 228–9. Another description of this incident is given in Adrian Daintrey's autobiography *I Must Say*, p. 126.
515. *The Seventh Child*, p. 168.
516. John to Quinn, 20 April 1917.
517. John to Dorelia undated.
518. John to William Rothenstein, 29 September 1921.
519. *The Seventh Child*, p. 169.
520. John's essay on Firbank was written for Ifan Kyrle Fletcher's *Ronald Firbank*. See pp. 113–15. 'In his life as in his books he left out the dull bits and concentrated on the irrelevant.'
521. See John's tribute to A. R. Orage in the *New English Weekly*, 15 November 1934.
522. T. E. Lawrence to William Rothenstein, 25 April 1925.
523. *D'Annunzio* by Philippe Jullian, p. 182.
524. *Horizon*, December, Vol. VIII, No. 48, 1943, p. 413.
525. Of the two versions of this picture, one was bought by Lord Alington and is now in the collection of his daughter, the Hon. Mrs George Marten. The other, which is misdated April 1918, was acquired in 1934 by the Art Gallery of Ontario from Sir Evan Charteris, through Lord Duveen, for £1,500. In a letter (26 February 1934) to the gallery, Duveen wrote: 'I consider it to be an outstanding masterpiece of our time. It is no exaggeration to say that this will live forever, which is true of very few pictures of modern times. You have bought a masterpiece for practically nothing . . . Such painting of the head, for instance, I have never seen surpassed by any artist, and you can safely place it for comparison alongside the greatest Velasquez, Giorgione or even Titian! That is what I think about this picture.'
526. *The Life of Ian Fleming*, by John Pearson, p. 15.
527. Chiquita to the author (undated).
528. Chiquita to the author (undated).
529. Mrs Val Fleming to Seymour Leslie, 16 May 1923.

530. John to Reine and Hugo Pitman (undated).

531. John to Viva King (undated).

532. *Since Fifty, Men and Memories, 1922–38*, p. 19.

533. John to William Rothenstein, 6 May 1929.

534. The picture (73½ × 65 inches) now belongs to the Tate Gallery (4043) which also owns a charcoal study (4448).

535. 'Sitting for Augustus John' by Mme Suggia. *Weekly Dispatch*, 8 April 1928.

536. *Modern Painting in England*, p. 58.

537. *Horizon*, December, Vol. VII, No. 36, 1942, p. 424.

538. See *My Chat with Thomas Hardy* by Cyril Clemens (T. Werner Laurie 1944), Introduction by Carl J. Weber. See also, for a strange corollary to this portrait, *The Times Literary Supplement*, 16 June 1972, p. 688. The picture was presented by H. T. Riches (for £3,000) to the Fitzwilliam Museum, Cambridge, after J. M. Barrie had refused Sydney Cockerell's petition to present it ('I don't think they ought to ask me to do these things'. See *Seven Ages* by Basil Dean, pp. 212–13). According to Florence Hardy, Hardy himself said that he would rather have the painting bought for the Fitzwilliam 'than receive the Nobel Prize – and he meant it'. See *Friends of a Lifetime: Letters to Sydney Carlyle Cockerell* edited by Viola Meynell, p. 310. The Fitzwilliam also has a drawing of Hardy by John.

539. John to Hardy, 20 November 1923. Thomas Hardy Memorial Collection, Dorset County Museum, Dorchester.

540. *Chiaroscuro*, pp. 148–9.

541. *Montagu Norman*, by Andrew Boyle, pp. 218–20. See also p. 252.

542. *Horizon*, August, Vol. X, No. 56, 1944, pp. 132–3.

543. *Horizon*, August, Vol. X, No. 56, 1944, p. 132.

544. Lord D'Abernon Papers. British Museum 48932.

545. ibid., 48936.

546. Lord Leverhulme to A. Wilson Barrett, editor of *Colour* Ltd. Blumenfeld Papers. Beaverbrook Library.

547. *Daily Express*, 15 October 1920; See also the editions of 8 and 9 October. Also *The Literary Digest*, 27 November 1920 and *American Art News*, 13 November 1920.

548. *Chiaroscuro*, p. 150–1. See also *Horizon*, August, Vol. X, No. 56, 1944, pp. 134–5.

549. Ibid.

550. *Sunday Dispatch*, 28 September 1930. See also *News-Chronicle*, 29 September 1930; *Daily Mail*, 29 September 1930, and *The Scotsman*, 30 September 1930.

551. *Chiaroscuro*, p. 147. See also *Horizon*, August, Vol. X, No. 56, 1944, p. 131.

552. *Tallulah, My Autobiography*, by Tallulah Bankhead, p. 156.

553. Ibid., p. 154.

554. See *Miss Tallulah Bankhead* by Lee Israel, p. 127. Also Brendan Gill's *Tallulah* in which a letter and photo of John are reproduced on page 130, and a drawing on page 131. After Tullulah Bankhead's death, both her John pictures were sold at the Parke-Barnet Galleries, New York. Her own portrait, appraised at $15,000, was sold for $19,500 and is now in the National Gallery in Washington D.C. The portrait of Gerald du Maurier, appraised between $9,000 and $12,000, fetched only $5,000 and is now in the collection of Gerald du Maurier's daughter, Miss Jeanne du Maurier.

555. T. E. Lawrence to John, 14 April 1930.

556. 'Face to Face', B.B.C. Television interview, 15 May 1960.

557. John to Maud Cazalet, 3 March 1939.

558. John to Maud Cazalet, 23 September 1959.

559. Letter from A. Penn, the Queen's private secretary to John, 1 November 1939. Clarence House.

560. John to H.M. the Queen, 20 January 1940.

561. *Times*, 31 March 1920. 'Mr Augustus John and the Royal Academy.'

562. *Horizon*, August, Vol. X, No. 56, 1944, p. 146.

563. John to Sean O'Casey (undated, winter 1928/9).

564. John to Laura Knight, 9 April 1938.

565. John to Philip Connard, 18 January 1944.

566. See *Daily Graphic*, 14 June 1924.

567. *The Christian Science Monitor*, Boston, 17 December 1923. *The Statesman*, Calcutta, 12 October 1924.

568. See, for example, *Colour*, November–December 1923, and January 1924.

569. *Daily Express*, 19 July 1924. 'Culture in Music' by Eugene Goossens.

570. *Economist*, 15 March 1924, p. 592.

571. *The Manchester Guardian Weekly*, 3 October 1924.

572. John to Mitchell Kennerley, 22 November 1926. New York Public Library.

573. John to J. B. Manson, 2 July 1927.

574. John to J. B. Manson, 4 July 1927.

575. John to Wyndham Lewis, 9 December 1927.

576. John to Dorelia (undated).

577. Poppet Pol to the author, March 1970.

578. op. cit.

579. John to Mitchell Kennerley, 22 November 1926.

580. John to Mitchell Kennerley, 22 November 1922.

581. John to Viva Booth, 14 May 1922.

582. John to Dorelia, 13 May 1922.

583. *Horizon*, January, Vol. VII, No. 37, 1943, p. 60. Cf. *Chiaroscuro*, p. 181.

584. John to Dorelia, 20 May 1922.

585. John to Dorelia, 13 June 1922.

586. *Horizon*, January, Vol. VII, No. 37, 1943, pp. 63–4.

587. John to Ottoline Morrell, 1 February 1922.

588. John to Dorelia (undated, July 1924).

589. *My Life and Times*, Octave, 6 pp. 39–40, and *Oliver St John Gogarty* by Ulick O'Connor, p. 212. But for an amended version of this story see *Lord Dunsany: A Biography* by Mark Amory.

590. John to Dorelia (undated, March 1925).

591. *Horizon*, August, Vol. X, No. 56, 1944, p. 129.

592. *An Ambassador of Peace*. Lord D'Abernon's Diary. Vol. III (January 1924–October 1926), p. 15.

593. ibid., p. 16.

594. John to Dorelia undated (March 1925).

595. op. cit., p. 152.

596. *Horizon*, April, Vol. XI., No. 64, 1945, p. 242.

597. *The Seventh Child*, p. 218.

598. *Chiaroscuro*, p. 190.

599. *Horizon*, April, Vol. XI, No. 64, 1945, p. 244.

600. ibid., p. 244.

601. John to Oliver St John Gogarty, 22 May 1925. The two girls, Cleves and Pita, were the daughters of Countess Stead.

602. John to Dorelia, undated.

603. For a list of John's works shown at this exhibition, see *The Story of the Armory*

Show, by Milton W. Brown, pp. 253–5.

604. *The Man from New York*, by B. L. Reid, p. 152.
605. *Horizon*, August, Vol. X, No. 56, 1944, p. 141.
606. *Chiaroscuro*, p. 160.
607. *Augustus John*, by Conger Goodyear, p. 29 (privately printed).
608. John to Dorelia (undated).
609. op. cit., p. 29.
610. John to Dorelia (undated).
611. *Horizon*, August, Vol. X, No. 56, 1944, pp. 141–2.
612. See, for example, his letter of 16 February 1923 to Homer Saint-Gaudens (American Archives of Art). Most of the articles written about him show little evidence of his co-operation – see *New York Times Magazine* (24 June 1923) 'A Much-Talked of Painter'.
613. *Horizon*, December, Vol. XII, No. 72, 1945, p. 418.
614. *Art News* (New York), 16 June 1923, p. 1, p. 4.
615. ibid., p. 4.
616. Introduction by E. J. Rousuck to 'Augustus John', Scott and Fowles catalogue, 21 March–12 April 1949: 'an electric event which produced not only a new group of paintings, but countless anecdotes, legends, friendships that enriched the great saga of John's career.'
617. Homer Saint-Gaudens to Martin Birnbaum, 23 June 1924. American Archives of Art.
618. Now in the National Gallery, Washington, D.C.
619. John to Mitchell Kennerley (undated).
620. John to Christabel Aberconway, 29 September 1928. This correspondence is in the British Museum. See also the correspondence with Nina Hamnett at the University of Texas.
621. *Horizon*, December, Vol. XII, No. 72, 1945, pp. 419–20.
622. *Two Flamboyant Fathers*, p. 65.
623. John to Christabel Aberconway. British Museum Add. 52556.
624. *The Glass of Fashion*, p. 156.
625. For a full analysis of this studio, which was designed by Christopher Nicholson, see *Architectural Review*, February 1935, Vol. LXXVII, pp. 65–8.
626. *The Glass of Fashion*, p. 158.
627. *Two Flamboyant Fathers*, p. 66.
628. *I Must Say*, p. 75.
629. Dorelia to Lytton Strachey, 4 December 1918.
630. Henry Lamb's letters to Carrington are at the University of Texas Library, Austin, Texas.
631. Lamb to Carrington (undated).
632. Diana Mosley to the author, 5 January 1970.
633. *Musical Chairs*, by Cecil Gray, p. 278.
634. *Hugh Walpole*. A Biography by Rupert Hart-Davis, p. 272. John's portrait of Walpole is reproduced opposite this page, and a chalk drawing as frontispiece.
635. John to Christabel Aberconway, 3 November 1928. See also *A Wiser Woman*: A Book of Memories by Christabel Aberconway.
636. John to Ottoline Morrell (undated).
637. John to Ottoline Morrell (undated).
638. John to Ottoline Morrell (undated).
639. John to Ottoline Morrell, 20 July 1932.
640. John to Tallulah Bankhead, 12 May 1930.

641. T. E. Lawrence to G. W. M. Dunn, 9 November 1932. *The Letters of T. E. Lawrence*, edited by David Garnett, p. 752.

642. John to Al Wright, 13 August 1946. *Time* magazine 'Morgue' (8 June 1948).

643. 'Augustus John' by Conger Goodyear, p. 35.

644. John to Viva King (undated).

645. 'Pages from a Diary Written in Nineteen Hundred and Thirty' by William Butler Yeats. The Cuala Press (September 1944).

646. *Horizon*, October, Vol. IV, No. 22, 1941, p. 291. For a variant description see *Chiaroscuro*, p. 101.

647. *Horizon*, October, Vol. IV, No. 22, 1941, p. 291.

648. *It isn't this Time of Year at All!*, p. 242. The portrait is now in Glasgow Art Gallery and Museum, Scotland.

649. Hope Scott to her mother (undated).

650. Hope Scott to the author, 29 November 1968.

651. *Horizon*, December, Vol. XII, No. 72, 1945, p. 428.

652. *Courage. The Story of Sir James Dunn*, pp. 247–8. See also *The Bruce Lockhart Diaries* 1915–38, edited by Kenneth Young, 25 January 1931, p. 149.

653. For Joyce's reaction to these drawings, see *The Art of Augustus John*.

654. *Daily Telegraph*, 1 December 1932.

655. *Daily Telegraph*, 20 December 1932.

656. Vivien White to the author, June 1973.

657. *Horizon*, January, Vol. XIII, No. 73, 1946, pp. 51–2.

658. John to Casati (undated).

659. John to Mavis de Vere Cole (undated; January 1937).

660. *Chiaroscuro*, pp. 264–74.

661. John to Mavis de Vere Cole, 21 February 1937.

662. *The Listener*, 25 May 1938, pp. 1105–7.

663. Sean O'Casey to John, 15 January 1929.

664. *Sean* by Eileen O'Casey, edited with an introduction by J. C. Trewin. Pan edition (1973), p. 77.

665. Shaw to John, 31 October 1929.

666. 'The Boy David: Augustus John and Ernst Stern' by Malcolm Easton, *Apollo*, October 1965, pp. 318–25, to which my narrative owes most of its facts.

667. *Finishing Touches*, p. 89.

668. *Portrait of Barrie*, by Lady Cynthia Asquith, p. 206.

669. John to John Davenport undated.

670. *Chiaroscuro*, p. 257.

671. Marie Mauron to the author, 1969.

672. *The Modern Movement*, p. 67.

673. *The Times*, 21 May, 1938.

674. *Horizon*, August, Vol. VIII, No. 44, 1943, p. 136.

675. A. R. Thomson to the author, undated.

676. Cole to John, 17 July 1930.

677. John to Wyndham Lewis, 15 August 1954.

678. John to Dorelia (undated; 1936).

679. See *Beautiful and Beloved* by Roderic Owen with Tristan de Vere Cole, pp. 89–90.

680. John's letters to D. S. MacColl are in the Special Collections Library at the University of Glasgow.

681. See, for example, John's portrait of her, at the Southampton Art Gallery, clasping a tankard of ale.

682. *Two Flamboyant Fathers*, by Nicolette Devas, pp. 269–70.

683. *The Life of Dylan Thomas*, by Constantine FitzGibbon (Sphere Books), p. 191.

684. Caitlin Thomas to the author, 16 September 1968. 'It was merely a question of a brief dutiful performance for him to keep up his reputation as a Casanova ogre,' Mrs Thomas hazarded. '. . . Not the best introduction to the carnal delights of the marriage bed. I may add that this lofty favour was not reserved for me alone, but one and all of his models, of whatever age and social category, suffered the identical treatment. I hope I have been able to add a drop of at least truthful spice, no doubt unprintable, to enliven your cleaned-up eminently respectable book, plodding in the heavy-going dark (God help you and your public).'

685. *Finishing Touches*, p. 114.

686. 'Aquarius', I.T.V., 3 March 1972.

687. In an interview with the author.

688. John to Vivien John, August 1938.

689. *The Listener*, 5 October 1972, pp. 433–4.

690. Dylan Thomas to Henry Treece, 1 September 1938. *Selected Letters of Dylan Thomas* edited by Constantine FitzGibbon, p. 212.

691. *Finishing Touches*, p. 111.

692. *Museum Piece or The Education of an Iconographer*. In the 1960s James Laver did some preliminary work for a biography of John.

693. John to Amaryllis Fleming, 27 November 1953.

694. Amaryllis Fleming to the author, 25 July 1969.

695. Robin John to the author, 13 January 1969. See also *Horizon*, January, Vol. VII, No. 37, 1943, pp. 64–5: 'Robin displayed also, or rather attempted to conceal, a remarkable talent for drawing; but in the course of his studies lost himself in abstraction, which he pushed finally to the point of invisibility. Thus his later efforts, hung on the walls of his studio, presented no clear image to the physical eye. Refinement carried to such a pitch ceases to amuse. Art, like life, perpetuates itself by contact.'

696. Robin John to the author, 13 January 1969.

697. Henry John to Augustus John, 11 March 1926.

698. *Being Geniuses Together* by Robert McAlmon and Kay Boyle. rev. edn. 1970, p. 26.

699. John to Father D'Arcy (undated).

700. *Chiaroscuro*, p. 212.

701. *Memoirs of an Aesthete*, by Harold Acton, p. 146.

702. *A Little Learning*, by Evelyn Waugh (Chapman and Hall), p. 218.

703. 'The Private Diaries of Evelyn Waugh' edited by Michael Davie. *Observer*, magazine, 6 May 1973, p. 28.

704. *Chiaroscuro*, p. 213.

705. *Daily Mail*, 24 June, 1935.

706. The Rev. Canon K. J. Woolcombe to the author, 24 December 1968.

707. John to Dorelia (undated).

708. In an unrecorded B.B.C. script.

709. The words of this eulogium are given in *My Gypsy Days* by Dora E. Yates, pp. 119–20; also, in a slightly different form, in *The Daily Mirror*, 23 November 1931.

710. *My Gypsy Days*, p. 120.

711. ibid., p. 121.

712. *Chiaroscuro*, pp. 89–90.

713. *The Burlington Magazine*, Vol. lxxxi No. 475 (October 1942), pp. 237–8. Reprinted in *Gwen John*, a retrospective exhibition by the Arts Council, pp. 10–11,

and in *Finishing Touches*, pp. 79–81 where, after page proof stage, it replaced the potentially libellous 'Lord Beaverbrook Entertains'.

714. John to Mrs W. M. Cazalet, September 1939.
715. John to Herbert Barker, 4 February 1938.
716. *Daily Telegraph*, 5 May 1948.
717. *The Listener*, 13 May 1948, p. 794.
718. John to Conger Goodyear, 10 January 1948.
719. John to Conger Goodyear, 8 August 1949.
720. John to T. W. Earp, 6 June 1944.
721. John to Mrs W. M. Cazalet, 10 May 1943.
722. John to Kit Adeane (undated).
723. 'Augustus John', unpublished monograph by Alan Moorehead.
724. *Sunday Times*, 22 July 1973, p. 34.
725. John to Mavis Wheeler (undated).
726. Shaw to John, 26 February 1944. See *Montgomery. A Biography* by Alan Moorehead, pp. 187–90.
727. John to Simon John, 15 April 1944.
728. John to Simon John, 14 September 1944.
729. John to Mrs W. M. Cazalet, 16 June 1941 and 26 September 1941.
730. *Chips. The Diaries of Sir Henry Channon*, edited by Robert Rhodes James, p. 389.
731. *Grand Man*, by Nancy Cunard, p. 195.
732. John to Mary Keene, 26 January 1948.
733. John to Vivien John (undated).
734. John to Winifred Shute, 21 June 1942.
735. John to Winifred Shute, 18 October 1940.
736. John to Will and Alice Rothenstein, 15 June 1940.
737. John to Evan Morgan, 19 October 1940.
738. *The Burlington Magazine*, December 1940, p. 28.
739. John to Dorelia, 21 May 1942.
740. 'I am thoroughly in sympathy with your determination to remain a commoner in spite of antique conventions. May you win the battle!' John to Anthony Wedgwood Benn, 16 March 1961.
741. John to Sir Herbert Read, 18 January 1953. This letter is in the Collections Division of the University of Victoria, British Columbia. Some of the matters in which they diverged are given in a review Read wrote in *The Burlington Magazine* (December 1940, p. 28) where he criticized John's tendency to idealize his types. 'We must say "idealize" in preference to "romanticize" because one has only to compare such drawings with the superficially similar drawings of Picasso's "blue" period to see that, while Picasso has a particular brand of romanticism (a Baudelairean romanticism), he never palliates the underlying drabness and horror. John's gypsies are too coy, and they share this quality with his religious and allegorical figures . . . "Le dessin, c'est la probité de l'art" – Mr John quotes this saying of Ingres' at the head of his catalogue, but it is a maxim with a double edge. In the sense that draughtsmanship is an index to the sensibility and skill of the artist, these drawings are a triumphant vindication; but the maxim might also mean that an artist's drawings betray his limitations – the limitation of his interests no less than the degree of his skill. John is a typical studio artist, and there is little in his work to show that he has lived through one of the most momentous epochs of history. An artist creates his own epoch, it will perhaps be said, his own world of reality; and this is true enough. But surely that world, if it is to compete in interest

with the external world, must be inhabited by figures somewhat more substantial than John's appealing sylphs'.

About John's portraits, however, Read admitted 'there is no denying his superb mastery of this form . . . the pencil already prepares us for that balance out of psychological insight and formal harmony which his brush secures with such instinctive facility'.

742. Alfred McIntyre of Little, Brown and Company to Jonathan Cape, 27 June 1938. The contract with Little, Brown, dated 26 July 1938, gave John an advance on royalties of five thousand dollars and provided for delivery of the manuscript by 1 January 1940. The Jonathan Cape contract, dated 2 May 1938, allowed John an advance of two thousand pounds. Both advances were payable on the day of publication, and both contracts lapsed in 1940.

743. Jonathan Cape to Alfred McIntyre, 24 January 1940.

744. Jonathan Cape to Alfred McIntyre, 15 August 1940.

745. February, Vol. III, No. 14, 1941, pp. 97–103; April, Vol. III, No. 16, 1941, pp. 242–52; June, Vol. III, No. 18, 1941, pp. 394–402; August, Vol. IV, No. 20, 1941, pp. 121–30; October, Vol. IV, No. 22, 1941, pp. 285–92; February, Vol. V, No. 26, 1942, pp. 125–37; August, Vol. VI, No. 32, 1942, pp. 128–40; December, Vol. VI, No. 36, 1942, pp. 421–35; January, Vol. VII, No. 37, 1943, pp. 59–66; August, Vol. VIII, No. 44, 1943, pp. 136–43; December, Vol. VIII, No. 48, 1943, pp. 405–19; August, Vol. X, No. 56, 1944, 128–46; April, Vol. XI, No. 64, 1945, pp. 242–61; December, Vol. XII, No. 72, 1945, pp. 417–30; January, Vol. XIII, No. 73, 1948, pp. 49–61; October, Vol. XIV, No. 82, 1946, pp. 224–31; June, Vol. XVII, No. 102, 1948, pp. 430–41; April, Vol. XIX, No. 112, 1949, pp. 292–303.

746. John's letters to Cyril Connolly are at the University of Texas, Austin.

747. John to Leonard Russell, 20 January 1947.

748. John to T. W. Earp, 20 March, 1947.

749. Introduction by Daniel George to *Finishing Touches*, p. 9.

750. ibid., p. 11.

751. John to Daniel George, 19 October, 1950.

752. John to Clare Crossley, 9 May, 1952.

753. 'Augustus John' by Sir Desmond MacCarthy, *Sunday Times*, 2 March 1952; 'Memories of a Great Artist' by Sacheverell Sitwell, *The Spectator*, 7 March 1953, p. 302; 'Augustus John's Self-Portrait' by Henry Williamson, *John O' London*, March 1952, pp. 296–7. See also 'Self-Portrait' by Harold Nicolson, *The Observer*, 2 March 1952; 'Augustus John: A Self-Portrait' by Denys Sutton, *Daily Telegraph*, 8 March 1952; *The Times*, 5 March 1952; 'Painting with a Pen' *The Times Literary Supplement*, 21 March 1952. The book was also well received in America where it was published by Pellegrini and Cudahy. See, for example, 'Magic-Lantern Show' by Joseph Wood Krutch, *The Nation*, pp. 277–8.

754. *The Listener*, 20 March 1952, p. 476.

755. Harlech Television, 18 July 1968.

756. 'Sfumato', *The Funny Bone*, by J. Maclaren-Ross, pp. 25–9.

757. John to Daniel George, 11 August 1954.

758. 'The piece called "The Girl with the Flaming Hair"—a young woman picked up in Tottenham Court Road – might very reasonably be allowed a place in Villiers de L'Isle-Adam's "Contes Cruels" ' wrote Anthony Powell in the *Daily Telegraph*, 3 December 1964.

759. 'Frontiers', by Augustus John. *The Delphic Review*, Winter, 1949, p. 6.

760. John to Pamela Grove, 25 February 1945.

761. John to Sylvia Hay, 5 June 1959.
762. Marie Mauron to the author, 1969.
763. *Chiaroscuro*, p. 261. See also *Horizon*, June, Vol. XVII, No. 102, 1948, p. 438.
764. *Chiaroscuro*, p. 262.
765. *Horizon*, June, Vol. XVII, No. 102, 1948, p. 440. In a letter to Matthew Smith (5 December 1946) he wrote: 'I thought the country as good as ever but didn't do anything with it.'
766. William Empson to the author, 6 December 1968.
767. *Chiaroscuro*, p. 264.
768. John to T. W. Earp, 20 March 1947.
769. John to Viva King, 16 December 1959.
770. John to David John, 22 June 1942.
771. *Socialist Leader*, 18 September 1948. See also *The Collected Essays, Journalism and Letters of George Orwell*, Vol. 4, *In Front of Your Nose*, 1945–50 (Penguin edn., pp. 505–6).
772. There were only two issues of *The Delphic Review*, Winter 1949 and Spring 1950. John's article 'Frontiers' occupies pages 6–11 of the first issue.
773. John's letters to Bertrand Russell are part of the Russell Archive at the Mills Memorial Library, McMaster University, Hamilton, Ontario, Canada.
774. John to Russell, 6 February 1961.
775. *The Autobiography of Bertrand Russell*, Vol. III, 1944–67, p. 118. See also p. 146.
776. 'The Great Bohemian', *Time and Tide*, 9 November 1961.
777. Preon O'Casey to the author, 7 September 1969.
778. *Two Flamboyant Fathers*, p. 277.
779. John to Sylvia Hay, 7 September 1956. In the collection of Professor Norman H. Pearson, Yale University, New Haven.
780. John to Cyril Clemens, December 1955.
781. John to Sylvia Hay, 7 January 1959.
782. John to Hope Scott, 3 October 1950.
783. *Time's Thievish Progress*, pp. 24–5.
784. Harlech Television, 18 July 1968.
785. John to Alan Moorehead, 31 March 1952.
786. John to John Davenport, 11 March 1956.
787. John to Joe Hone, 4 February 1956.
788. John to D. S. MacColl (undated).
789. *The Times*, 13 March 1954.
790. John to Hugo Pitman, 27 December 1952.
791. John to Hugo Pitman, 10 November 1954.
792. John to Dorothy Head, 16 November 1954.
793. John to Mrs W. M. Cazalet, 16 June 1941.
794. John to Simon John, 14 September 1944.
795. John to Michael Ayrton, February 1961.
796. John to Sir Caspar John, 7 January 1955.
797. John to Edwin John (undated).
798. *A Personal Record* by Gerald Brenan, p. 356
799. John to Sir Caspar John, 7 January 1955.
800. John to Clare Crossley, 12 January 1955.
801. John to Sylvia Hay (undated).
802. John to Matthew Smith, 22 December 1948.
803. John to Count William de Belleroche, 5 September 1956.
804. John to Matthew Smith, 5 September 1956.

805. John to Matthew Smith, 24 December 1953. In a letter to Sir Caspar John of about the same date, John wrote: 'I have been much distressed by the death of Dylan Thomas and have managed to write a note about it for a paper called *Adam* in an edition wholly devoted to the Poet.' John's essay, 'The Monogamous Bohemian', appeared in the January 1954 issue of *Adam Literary Magazine*, and was reprinted in E. W. Tedlock's *Dylan Thomas – the legend and the poet* (1960). Another essay by John, originally appearing in the *Sunday Times* (28 September 1958), was reprinted in J. M. Brinnin's *A Casebook on Dylan Thomas* (1960) and in *Finishing Touches*.

806. John to Count William de Belleroche, 21 June 1956.

807. William Gaunt to the author, 16 October 1971.

808. 'Augustus John' by Peter Quennell, *Harper's Bazaar*, February 1952, p. 45. Photographs by Cartier Bresson.

809. Lucy Norton to the author, 1973.

810. John to Matthew Smith, 1 July 1959.

811. B.B.C. Panorama, 4 November 1957.

812. *The Sunday Times*, 18 January 1953.

813. John to Eric Phillips, 9 December 1952.

814. John to Joe Hone, 9 February 1956. It was purchased by a number of subscribers, headed by Hugo Pitman and Lennox Robinson, and unveiled at the Abbey Theatre, Dublin, in November 1955.

815. John to Mary Anna Marten, 31 January 1953.

816. *Time's Thievish Progress* by Sir John Rothenstein, p. 15.

817. John to Joe Hone, 9 February 1956.

818. *Letters of John Cowper Powys to Louis Wilkinson*, 8 December 1955.

819. John to Winifred Shute, November 1959.

820. *The Tenby Observer and Court News*, 30 October 1959.

821. John to Tristan de Vere Cole, 5 February 1956.

822. Maurice Collis's diary, 9 September 1953. 'His face in old age was very expressive . . . and like an actor's. Affection, intimacy, indignation, sadness flitted across his features. There was emotion of some kind showing all the time . . . not intellectual, not kind, not even very intuitive or sympathetic for others but human and greatly experienced in life.'

823. John to Sir Charles Wheeler, 11 April 1960.

824. John to Mrs W. M. Cazalet.

825. John to Daniel George, 28 September 1952.

826. John to Alfred Hayward, 13 June 1952.

827. John to Doris Phillips, 9 December 1952.

828. John to Edwin John, 30 May 1954.

829. *High Relief*, p. 116.

830. John to Edwin John, 1 December 1960.

831. *High Relief*, p. 116.

832. John to Sir Philip Dunn, 11 February 1960.

833. John to Sir Charles Wheeler, 8 March 1960.

834. Now in the Royal Academy Library.

835. John to Sir Charles Wheeler, 4 March 1961.

836. John to Cecil Beaton (undated).

837. David John to Robin John, 20 November 1971.

838. *Dromengro: Man of the Road*, by Sven Berlin, pp. 196–7.

839. 'Last Words from Augustus' by Richard Hughes. *Sunday Telegraph*, 5 November 1961.

840. 'The Great Bohemian', by Anthony Powell. *Time and Tide*, 9 November 1961.
841. 'Last of the great Unbeats' by Osbert Lancaster. *Daily Express*, 1 November 1961.
842. *Daily Telegraph*, 1 November 1961, p. 12.
843. Tooth's Gallery, 15–30 March 1961, 'Paintings and Drawings not previously exhibited'. Christie's, First Studio Sale, 20 July 1962 (115 drawings, 70 paintings) £99,645. Christie's, Second Studio Sale, 21 June 1963 (103 drawings, 62 paintings) £33,405. Both studio sales were held primarily to pay off death duties, John's estate having been valued at approximately £90,000. A considerable number of other works came up for auction at Christie's and Sotheby's in these years. Among the exhibitions were 'Drawings and Murals by Augustus John', Upper Grosvenor Galleries, 1–30 April 1965; and 'Drawings by Augustus John', 2–18 December 1961 at the Lefevre Gallery. The first finely-selected loan exhibition that marked the beginning of a revival in John's work was 'Portraits of the Artist's Family' compiled and edited by Dr Malcolm Easton, 24 October–14 November 1970, The University of Hull, and at the National Museum of Wales, 21 November–13 December 1970.

Index

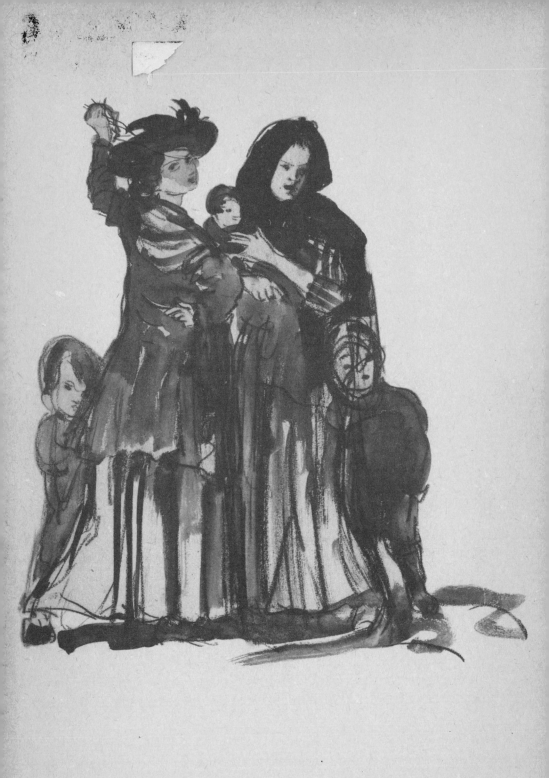